Lumby

sculpture

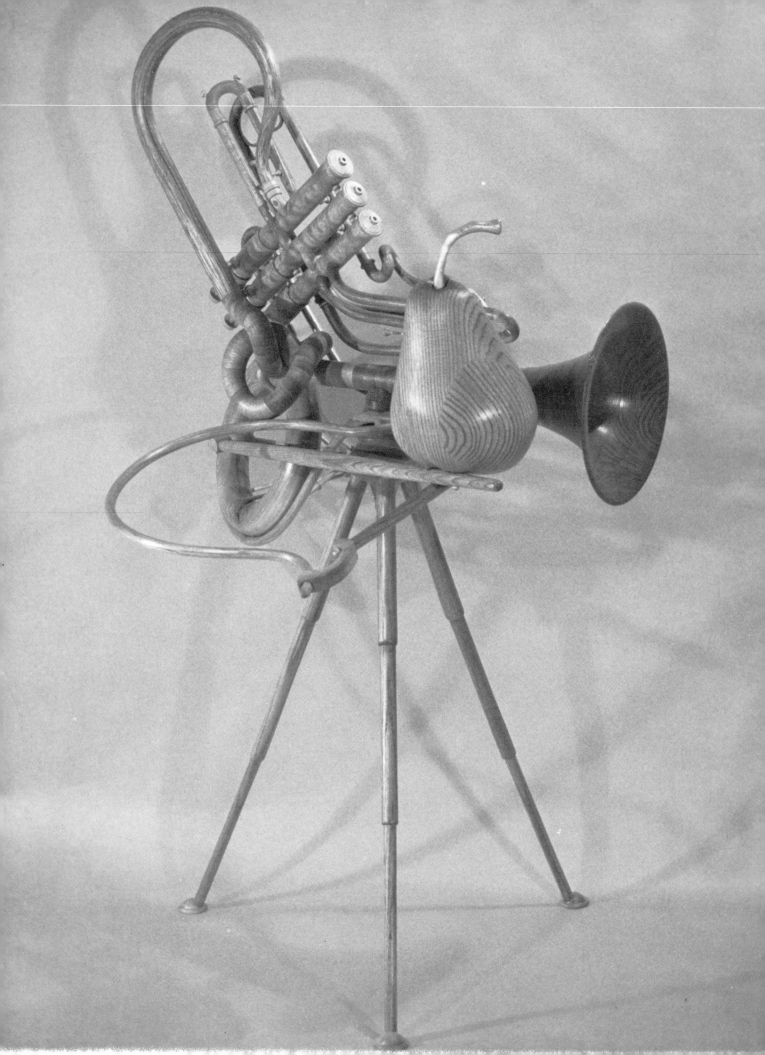

second edition

sculpture
a basic handbook for students

Ronald L. Coleman
Bowling Green State University
Bowling Green, Ohio

wcb
Wm. C. Brown Company Publishers
Dubuque, Iowa

Contents

Foreword

If things were as they should be, but will probably never be, artists, critics, historians, and the public would be sensitive and enlightened and there would be little justification for the spoken or written word in the visual arts except for information storage and retrieval and for technical direction.

Those qualities which make the visual arts artistically unique, have not been translated into verbal symbols. The words which we do use are symbols of the effects of our visual experiences, indicative of value judgment, or are physiologically descriptive.

Sculpture itself is a non-verbal language that can be learned only through constant viewing, interpretation, and production. Each sculptural form is only a phrase in a much larger linguistic body, the body of which is as yet not fully revealed.

With this in mind the bulk of this text will be directed towards introducing processes reasonably available to the beginning sculptor, and for the creation of three dimensional form. There is also some additional commentary related to the artist's three dimensional concept and its fundamentals and the relationship of the development of the sculptural language and its contemporary culture.

Preface

The first edition of *Sculpture* a basic hand book for students was written with the intent of providing the sculpture student with an economical unembellished text containing a generalized sketch of what sculpture has been and why, a more specific outline of the fundamentals of three dimensional form and finally a moderately detailed set of directions for the use of technical methods and the media associated with them. It was written at a time when young artists were breaking away from clay and plaster media and wanted only a brief description of the fundamentals of sculpture and enough technical information to be an aid to their movement into more technical processes.

Contemporary beginning sculptors seem to be less concerned with entering undeveloped technical areas, instead their greatest problem is in familiarizing themselves with the myriad of details of the many technologies already developed. For this reason this edition of *Sculpture* is devoted primarily to the expansion of the technical information for established methods and media and only secondarily to the introduction of technology new to art which may become part of our established media in the near future.

It has become obvious that the majority of beginning sculpture students have had very little training with tools, their uses, and dangers, so a brief description of some common hand and power tools and their safe use has been included in the text. This material will probably delight the teacher because it will save a great portion of teaching time otherwise lost to the identification of the tools and their purpose. This will obviously release valuable class time for the development of visual concepts and aesthetic considerations.

A commitment made in the first edition of *Sculpture* and kept in the second edition to avoid technology, processes, and scale which are unimportant or unavailable to the aggressive beginning sculptor. The majority of photographs used in this edition are unstaged "hands on" shots of students' works in process and in a scale which is within the students' time frame and materials handling capability. Tools shown are "out of the tool crib" in "as is" condition and the battle scarred machinery pictured is not catalogue copy, but "old iron" that has acquired its patina in service.

This commitment to reality along with the desire to keep the cost of the edition within reach of the student, influenced the decision to minimize the number of photographs of high quality works of art by popular contemporary artists, and to recommend the use of supplemental materials wherever reinforcement of preferred visual concepts or aesthetic judgments are necessary. In some instances the works of professional artists have been used to bolster the sense of the potential of a medium.

Because our information storage and retrieval systems are linear rather than three dimensional, any organization of high integrated media and processes is certain to confound as well as clarify. The body of this text is organized around the table of contents which can be used as a study outline. In order to retain the logic of the outline Part Two of the text is divided into the technical methods of producing sculpture rather than being divided into the kinds of media available for producing sculpture. Either organizational division would have caused the same problems, such as duplication of material and bothersome separation in the text of related information. The only solution to these problems is to accept the duplication as beneficial, though not economical, and to read the material related to any given medium in each of the chapters on the technical methods in order to gain the broadest understanding of the medium as possible.

Finally I would like to express my gratitude to my terrific wife Nancy and our two children Todd and Robin for their patience with me during the ordeal of revising *Sculpture.* I also owe a debt of gratitude to the students, professional artists, museums, and galleries that have generously offered their time and works for this publication. Thank you.

Notes to the Students

1. Always be a craftsman.
2. Solve each problem as quickly as possible. In the beginning a variety of experiences will generally be more valuable than ownership of a belabored beginners project.
3. Work on more than one project at a time.
4. If an impasse is reached, put the work out of sight for some time. When again viewed, it may be seen in a new and revealing light.
5. Accept failure as normal. A failure is easier to analyze than a success. Study failures and learn from them. Failure is justified, if it results from an intelligent attempt to solve a particular problem, and is not thoughtlessly repeated.
6. Student works are primarily exercises; therefore, rarely is one so magnificent that it is too wonderful for the student to take a chance on improving it, even at the risk of complete failure.
7. Observe the work of others and learn from them.
8. Care for your tools. Use them as if they are extensions of your body and personality.
9. Sculpture is an arduous discipline. If the labor involved is too strenuous, seek another medium.
10. Be safety-conscious! You may want to live long enough to see someone else make money off of your work.
11. Be conscious of the future of your sculpture. There is nothing happy about a crumbling 11 ton cement sculpture collapsing on a child in a city park.

1
The Essence of Sculpture

1
The Estate

Sculpture, which has been found among the earliest traces of all civilizations, has played an important part in the visual arts of most cultures. At times, as in the Golden Age of Greece, sculpture enjoyed the reputation of being the "Queen of the Arts."

With the revolt from academic restriction in the 19th century, the artist began to experiment with sculpture as he did with painting. He unleased new media and new tools and began to investigate the manipulation of space in a way forgotten since pre-classic times. Because of the odd characteristics of the human animal, every one of his cultures had had its own unique orientaton. The ancient Egyptians oriented their culture around worship of the dead, and believed that the spirit would some day return to claim his long-preserved body. To protect against the eventuality that the body should be destroyed, the Egyptians required of their artists enduring statues and realistic portraits which would be recognized by the spirit when it returned to re-enter the body. It is to be expected, therefore, to find in the tombs of Egypt, many idealized full-length portraits of Egyption royalty(figure 1-1). On the other hand, during the same period, the people of the Mesopotamian valley did not believe in the preservation of the body; they believed instead that, rather than living for the future, it was necessary to live for the present. Their culture was oriented around life and its enjoyment, so their arts reflected this orientation by illustrating lion hunts, conquests, war parties, and the other business of an ancient royalty.

Each of the arts which is orientated to a culture is meaningful and functional within that orientation. The sculpture of the Egyptians would have had little meaning for the Mesopotamians and would probably not have been sculpturally functional for them. By the same token, the Egyptian, in considering the sculpture of Mesopotania, would probably have been blind to the cultural value of the objects, except in monetary terms.

The Reasons for Sculpture

It is evident that when the nature of a culture changes for any reason, there will be a corresponding change in the art forms, if the art forms are to remain significant. Because of the advent of modern weapons, the creation of suits of armor like the one in figure 1-2 is no longer a significant art form. A change in a culture often results in a change for the reason for the creation of works of art. Although it is futile to attempt to separate the reasons for the creation of works of art, we can generalize by saying that there are four primary reasons for the existence of any art form: the physical reasons, the intellectual reasons, the spiritual reasons, and the expressive reasons.

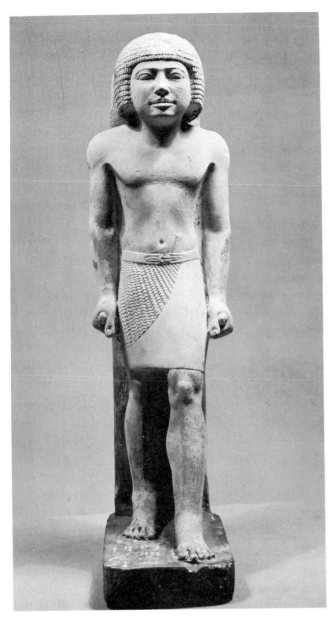

Figure 1-1. *Statuette of Min-nefer,* Egyptian, Late V Dynasty, Limestone, The Cleveland Museum of Art, Purchase from the J. H. Wade Fund.

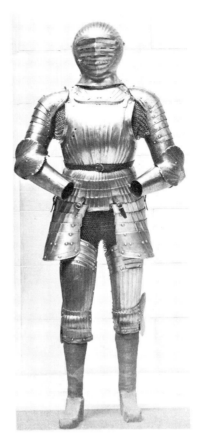

Figure 1-2. *Suit of armor in Maximilian style,* German, 16th century, The Cleveland Museum of Art, Gift of Mr. and Mrs. John L. Severance.

Figure 1-3. Door handles, Don Drumm, American (1935-), commissioned for a private home, cast aluminum.

There are two ways in which sculpture may be desirable for its physical reasons: because of its mechanical properties, such as the sculptured door knobs in figure 1-3 or the doorplate in figure 1-4, or because of its intrinsic properties (superior communication, either symbolically or psychologically). The intellectual reasons for sculpture involve the use of the abstract, perhaps for the purposes of analysis, interpretation, or prediction (figure 1-5). The spiritual reasons are those which deal with the unprovable (areas of beliefs) such as religion or superstition (figures 1-6 and 1-7). The expressive reasons are those which are a result of the emotional nature of man, and may in-

Figure 1-4. Doorplate, Don Drumm, American (1935-), commissioned, cast aluminum.

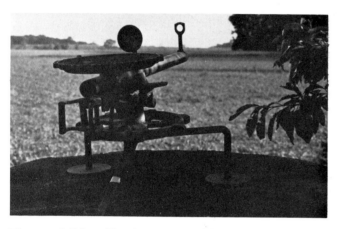

Figure 1-5A. *Final Adult Toy,* found metal, 1972.

Figure 1-5B. *Used Adult Toy,* found metal, 1972.

Figure 1-5C. *Adult Toy* found metal, 1972.

Figure 1-5D. *Adult Toy with Accessories,* aluminum tubing, masonite and cotton, 1972.

Figure 1-5E. Detail figure 1-5D.

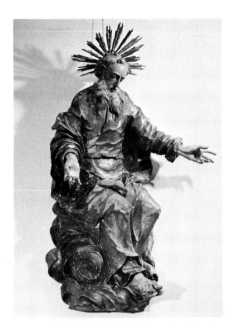

Figure 1-6. *God the Father,* Johann Peter Schwanthaler the Elder (1720-1795), Austrian, painted and gilded wood, The Cleveland Museum of Art, Purchase from the J. H. Wade Fund.

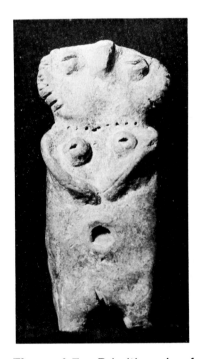

Figure 1-7. Primitive clay female figure.

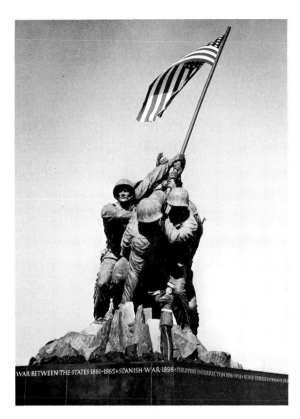

Figure 1-8. *United States Marine Corps War Memorial,* "Marines Raising the American Flag On Iwo Jima," photo by courtesy of National Park Service, U.S. Department of the Interior.

clude fear, pleasure, hate, and patriotism (figure 1-8), to mention only a few.

The course of any art, in aligning itself with the orientation of a culture, is not a matter of happenstance. An art form and its contingent media will only evolve when there is a specific need (the function of the sculpture) and when the art form is contained within the physical, intellectual, and spiritual limits of the culture. A culture may require sculpture as evidence of its maturity or interest in "the cultural aspects of civilization"; it may require sculpture to serve in some form of therapy; or it may utilize sculpture as an advertsing or politicking device. In any case, if the culture has no need of sculpture, none will develop. Although a culture may desire sculpture of a specific nature, the development of that sculpture may be denied or delayed because of the lack of physical means. It would have been difficult for the Egyptians to produce large, permanent, free-standing sculpture if large blocks of some enduring material like stone had not been available. If materials had been available, the Egyptians would still have needed the technology and the paraphernalia to produce the required kind of sculpture. It is obvious that sculpture cannot exist beyond the intellectual level of its culture. If either the concept or hypothesis is not within the realm of a culture, there can be no basis for the production of sculpture within that concept or hypothesis. The development of sculpture is also limited by spiritual concepts. A culture which has a God as a structural basis for the explanation of its existence may evolve sculpture oriented towards the emulation or imitation

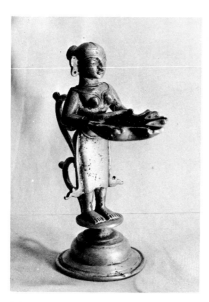

Figure 1-9. *Lamp Bearer,* Delhi, India, cast metal, Collection of H. Hasselschwert.

of that God, but before sculpture can be oriented towards that emulation or imitation, the concept must exist. It is not necessary that the sculptor be convinced of the validity of the concept, but the concept must at least be part of his understanding of his culture.

Sculpture that is oriented to its culture is functional for the culture, in that the individuals within the culture are able to absorb the sculpture into their existence without conscious effort. The spoon is so well sculptured to fit the needs of our culture that only the details of the design of the device are questioned. The basic function is understood without effort by almost everyone. Other cultures, such as those in Africa or China, find the spoon somewhat foreign. When a sculptural form is well understood, that form may have great significance or meaning in relation to the culture. If, on the other hand, the sculpture is at odds with the culture, the sculpture will be meaningless, in which case man, rather than living through the sculpture, will live with the sculpture, perhaps assigning to it some temporary meaning or value. A hitching post in the shape of a boy is of little value to a man without a horse, unless he assigns to the device some quality other than that of its intended function. The post could be placed for decoration, and if antique, some nostalgic value could be attributed to it. The decorative value and the nostalgic value have little significance to the culture except to display a skin of falseness on the culture, or to manifest the desire of the culture to retreat into the past. If the sculpture has no significance for a culture, man will live among such objects until he destroys them as he does old and "useless" buildings, or as did the "lime burners"

of Rome who burned marble sculpture of the expired Greek civilization, in order to make cement.

The motives of the artist are so complex that no single predetermined reason can be given for the production of a work of art, and even then, the reasons for the continued existence of the sculpture may vary with time, geographical location, or numerous other factors. The artist who carves a figure of Christ in order to make a living, produces the sculpture for physical reasons, while the reason for its continued existence may be the spiritual reason of a congregation. The beginner almost invariably produces sculpture for physical reasons: because he is required by assignment to gain experience in the fundamentals of sculpture through the act of producing, and because he has not matured enough or had enough experience with life or with sculptural media to have something of significance to say of life with a sculptural medium. It is not until the creator has had a great deal of experience in life, that through his own growth, maturity, and perhaps curiosity, he will be able to create meaningful works of art, for other than superficial aspects of the reasons for producing sculpture. The artist must have a basis for his creation, even if it is only the seeking of a new expression, new images, clarification of an ideal, a restatement of life, a search for universal truth, a method of communication, or a prediction (the attempt to free from rigid order). These things which the artist feels he must say are frequently answers to problems which have grown out of previous attempts to solve other problems. As the artist creates, new problems—and sometimes a variety of solutions—become obvious. Gradually the artist finds new areas unfolding for his investgation.

Neophyte sculptors are frequently discouraged because they can find nothing "worth producing" or because they have "no ideas" of their own. They lack ideas because they lack knowledge of the historical continuity of the development of three dimensional form and because they have not had enough experience creating within the limits of their media. If the sculptor becomes thoroughly involved with his media, the media itself will suggest problems to be solved, and eventually some solutions to these problems. The artist should avoid the use of popular styles, fads, fashions, or gimmicks. The meaningfulness of sculpture, or any other art form, which relies on fashion for solution—like the silly statue of George Washington in a toga, influenced by a craze emulating the ancient Greeks (figure 1-10), or like the deer in figure 1-11, which is either "cute" or novel—will be short-lived, because the success of the statuary will probably have resulted from their similarity to an accepted vogue rather than from the solution of a sculptural problem.

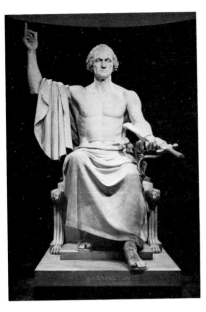

Figure 1-10. *George Washington,* Horatio Greenough, American (1805-1852). Courtesy of the Smithsonian Institute, National Collection of Fine Arts.

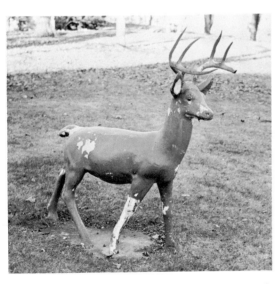

Figure 1-11. Insignificant lawn decoration, Painted Deer, American.

Many artists of the 1960s and 70s reacted to their culture and environment in what appears to be a non traditional manner by utilizing their artistic productiontion as a method of establishing an identity. Large numbers of individuals felt that among other things they had become non-persons in a bureaucratic and statistical morass. One of their methods of establishing identity and self esteem was to glorify their sense of self by proclaiming any overt act as a work of art. These acts might be anything from stepping on a butterfly, or gutting a live chicken before an audience, to putting a tape line down a hallway or painting a white line across Pike's Peak. Audience reaction of any kind served to "prove" the reality and uniqueness of the "artist." In order for the process to continue, the expression had to become progressively more extreme to capture the attention of an audience. Obviously for the sake of greater shock, the artists left the traditional, relatively static realm of the visual arts, and entered the area of the performing arts. The Happening, one variant of the fusion of the visual and performing arts abandoned logical order and evolved around the bizzare and fantastic spontaneous occurance. Some artists entering the drug culture utilized chemically induced imagery as a source of "self expression." These images once again were a source of the bizzare, the astounding, the mind boggling, which would demonstrate unique visions "and help establish the unique identity of the artist."

The roped down park benches, plastic wrapped buildings, invisible gas sculptures, and the tired happenings of the 1960s and 1970s, except for those ecclectics and noncreatives that forever produce those few things that they were taught in their early years, have just about been exhausted as "viable artistic statements." Although these experiments of the artists served a purpose in breaking with tradition, the emptiness of those "works of art" have become obvious.

Our environment has changed considerably since the end of the last war. There probably aren't as many insecure people seeking their "identity" or some sense of self importance, so the artist of the late 1970s seems to be returning to what they wish to be a creative, but more permanent art form.

The Language of Sculpture

There are three traditional languages, one budding contemporary language, and any number of attempts. The three traditional languages, the glyptic, plastic, and linear are reasonably well understood. Contemporary experiments on the other hand may or may not develop into an interpretable form. A considerable number of "experimental sculptures" are products related to art forms other than the pure visual arts and may not develop the body of products or the three dimensional developmental continuity to form a sculptural language.

Some of these experiments deal with the direct control of light, programming of events or event sequences, or even the demonstration of technological feasibility. Surprisingly, except for manipulation and control of pure light, experiments in new languages center around developing technology, not around new concepts. As a result the products emulate the technology and result in a "show and tell," (look at the thing I made) syndrome.

Undoubtedly, new languages of sculptural form will evolve through some of this experimentation, but some discrimination will have to be made between those non-graphic productions which deal with the performing arts or intangible minimal sensory productions which deal primarily in "effect" and those productions which contribute to the understanding of the use of space. Part of the problem which must be faced is the realization that artistic productions which are not graphic are not necessarily Sculpture or may not even belong to the realm of the visual arts.

The series of photographs in figures 1-12A, 1-12B and 1-12C illustrates the elements of sequence which parallels many of the aspects of the performing arts. The progression of apparent activity of the figures add qualities to the sculpture which are not traditional, except that sequence as used in this sculpture is a factor of the elements of time and motion.

The ultimate decision as to the appropriateness of this concept as a sculptural form will inevitably be the responsibility of the community of the artist. If sculptors exploit and expand the concept it may eventually be taken for granted as a traditional language of sculpture.

The language of the sculptor is often determined by the medium that is readily available to him. If a putty-like medium is available, in all probability the plastic langauge will be utilized; if a resistant material such as stone is in ready supply, the language will more likely be glyptic; and if manageable wire is in easy access, the language will be linear—provided that in each case the other materials are less accessible.

If the artist has some exciting exotic (let's say recent technological development which becomes tomorrow's obsolescence) electronic gadgetry at his command and he is an inventive soul, he would more than likely use his gadgetry by including principles of the gadget, the product of the gadget, or the gadget itself in an art form. There is the problem. The product may not be graphic in that its visual concept is revealed within a single plane. Yet it may not be sculptural in that it may be an event belonging to the realm of inorganic theatre, or perhaps be a series of sequential graphic presentations on varying planes. It may be that, as has been the case with new media so many times in the past, the development of significant sculptural form utilizing contemporary scientific and technological phenomenon will not occur until the "revelation" of the obvious and novel capabilities of the New medium has been exhausted. When the artist begins to search for form based on concepts resulting from the properties of the medium, a new or previously unrecognized language of sculpture may be revealed.

Figure 1-12A. *Bernard, Betty and Josh,* Susanne Latham, American (1957-), plaster, metal, fabric.

Figure 1-12B. *Bernard, Betty and Josh,* Susanne Latham, American (1957-), plaster, metal, fabric.

Figure 1-12C. *Bernard, Betty and Josh,* Susanne Latham, American (1957-), plaster, metal, fabric.

Four techniques are utilized in the production of sculpture: manipulation, subtraction, substitution, and addition. Manipulation is considered primarily a technique of the plastic langauge, subtraction a technique of the glyptic language, and substitution and addition techniques of all three languages. Of course these sculptural languages are visual not mechanical languages; therefore, it is not unlikely that stone (which is usually associated with the glyptc language) may be carved in such a way as to become plastic in appearance.

Glyptic Sculpture

The glyptic language is that which emphasizes the material from which the sculpture is being created, whether the material is stone, bronze, or clay. Not only does glyptic sculpture retain the characteristics of the medium, but it usually retains basic geometric qualities of the mass from which it is produced, as in figure 1-13. Frequently, because of the inherent formality of this language, figures created in this manner face forward—static, without twist to the body, as if the body were part of the grain of the medium. This convention, illustrated in figures 1-14 and 1-15 is known as the "law of frontality." Glyptic sculpture retains the tactile, color, and tensile qualities of the material from which it was produced.

Plastic Sculpture

Plastic sculpture is fluid or malleable in nature, because of the fluidity or malleability of the media from which it is produced, or because of the fluidity of the subject with which it deals. Pliable media, like clay or wax, are pushed, modeled, and squeezed until they take on the flowing characteristics of the subject, as in figure 1-16. Plastic media have great immediacy and are autographic and intimate, while glyptic media are resistant, impersonal, and formal. Unlike the rigid figures produced in the glyptic language, plastic sculpture possesses some degree of action or movement.

Linear Sculpture

Although it has ancient origins, linear sculpture is only beginning to mature as a language. Since the advent of gas and electric welding, the artist has been able to assemble wire to enfold space in a line-like substance, like the spider in figure 1-17, resulting in a light, airy, stringy quality which cannot be obtained in either the massiveness of the glyptic or the fluidity of the plastic sculptural languages.

The direct manipulation of light has been a well developed technology in industry for many years. The designers of lenses for instance have a thorough understanding of methods of enlarging, reducing, inverting, reversing, curving, flattening and distorting

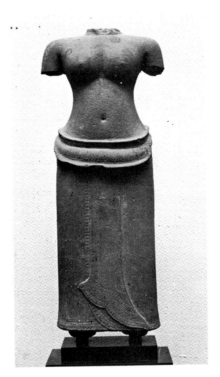

Figure 1-13. *Torso of a Female Deity,* Cambodian, classic Khmer period, about 12th century, The Toledo Museum of Art, Gift of Edward Drummond Libbey.

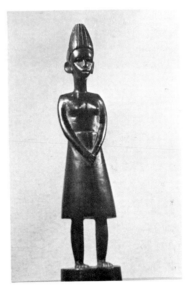

Figure 1-14. Contemporary wood carving, stained black, Tanganyika.

images. Because of the nature of their trade their manipulations of light have been linear and their images have been graphic. The nearest exception to the production of graphic images has been the development of stereo photography yielding the illusion of space. Stereo photography has been used to record the track of moving lights choreographed to use space sculp-

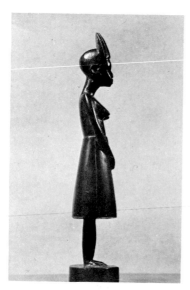

Figure 1-15. Contemporary wood carving, stained black, Tanganyika.

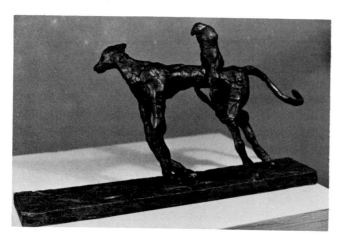

Figure 1-16. *Crow Riders on Dog,* Jaye Bumbaugh, American (1937-), cast bronze. Courtesy Gallery One, Ann Arbor, Michigan.

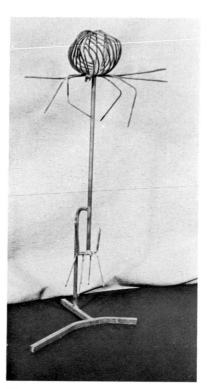

Figure 1-17. *Spider,* welded iron.

turally. The photography served only as a storage mechanism. Although the lens system of the cameras and projector project a graphic image through linear refraction of lights, the image is viewed as occupying space. The lights used to create the photographic images were points of light (colored flashlight bulbs) to make line, and lines of light (flourescent tubes) to make planes. Because the sculptural elements involved by the artists were traditional, the sculptural forms that were most readily produced were traditional. Unfortunately the stereo image can not be reproduced here as an example of the art form.

If the lens designers technology were to be employed in a non-linear manner or perhaps multi-linear manner there is the possibility that form could be established within or even outside of the refractive mass. The image viewed would not appear on the surface of the object. It might appear larger than the mass, an effect similar to looking at a magnifying lens.

Holography (an "exotic") method of manipulating light results in a three dimensional projection of an image in space. Holography may be an avenue to the realization of this new language. For the most part holography has been used only to record images.

The technology and media for the finalization of a sculptural language resulting from the creation of form with transmitted light is available. Acrylic plastic, and glass are excellent stable refractors of light, incandescent, cold cathode (neon), hot cathode (fluorescent), and chemical light sources are plentiful and relatively inexpensive. The only other ingredient necessary to the development to this language is the attention of the artist (figure 1-18).

The "artistic" occurance—the happening—has been in the process of being codified through the use of recorders, computors, and mechanical systems. Some schools of thought include these events in the realm of sculpture. The events may take any form, from a collection of animated ready mades (previously used) objects, which systematically destroys itself, to two individuals thinking the same thought. The artist usually depends on permanitization of the "creation" through the use of photography, recording, or written statements.

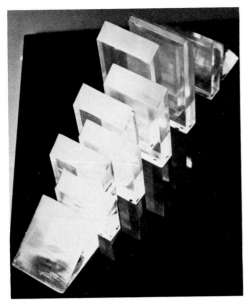

Figure 1-18. *Midnight*, Sue Marie Carroll, American (1957-) acrylic plastic.

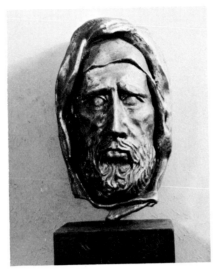

Figure 1-19. *Head*, student work, cast bronze.

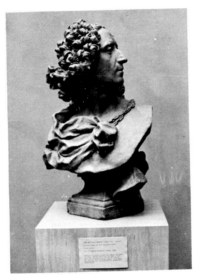

Figure 1-20. *The Painter, Noel Nicolas Coypel*, by Jean Baptiste Lemoyne (1704-1778). French, The Toledo Museum of Art. Gift of Edward Drummond Libbey.

It is not clear at this point whether or not the artistic occurance will prove to be a sculptural language or be relagated to the performing arts.

The Methods of Expression

In each of the languages, the artist is able to utilize five methods of expression: the realistic, the naturalistic, the impressionistic, the expressionistic, and the abstract. In the realistic style, the artist observes, interprets, generalizes, simplifies, rearranges, and elaborates on what he sees in nature. Invariably the finished product is easily recognized as an object typical of its kind, but not as a specific one of a kind. The face on the head in figure 1-19 is a general face, not a particular or specific face, and is therefore, realism.

Naturalistic sculpture results when the artist attempts to eliminate all editorializing in order to imitate an object as faithfully as possible. As in the bust of Coypel (figure 1-20), every detail, no matter how insignificant, is copied, whether that detail is beneficial to the overall sculpture or not. Naturalistic sculpture is of a specific object and, because of its extreme detail, cannot represent but can only mimic. It is this characteristic which makes debatable the validity of naturalism as an art form.

Impressionistic sculpture is that which possesses only a vague visual semblance of a subject, thereby allowing the observer to interpret what he sees (figures 1-21 and 1-22). The image discovered by the observer is not as dependent on the actual shape of the sculpture or on the surface texture, as it is on the way the light and, therefore, the shadows fall on the apparently spontaneous undulations and convolutions of the medium, to give the general impression of the subject. Impressionistic sculpture is not profuse with finished detail, but has hints at detail which facilitate the inclusion of detail by the observer.

Expressionistic sculpture is that which is based on the artist's moods, opinions, and emotions, so that there is inherent or implied emotion, usually related to ideas or movement—and at times to value or subject, as in Barlach's introverted *Singing Man* (figure 1-23).

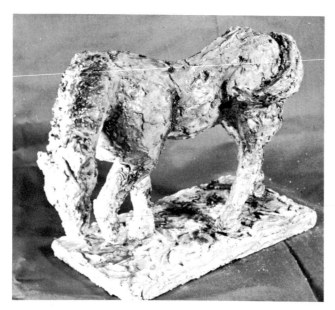

Figure 1-21. *Horse,* student work, plaster.

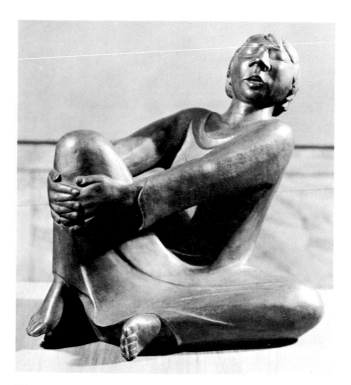

Figure 1-23. *Singing Man,* Ernest Barlach (1870-1938), German, bronze, The Cleveland Museum of Art, Hinman B. Hurlbut Collection.

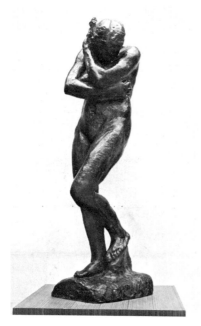

Figure 1-22. *Eve,* Auguste Rodin (1840-1917), French, bronze, The Toledo Museum of Art. Gift of Edward Drummond Libbey.

The Basics

Abstract sculpture, to some degree, includes all sculpture, because the initial conversion from nature to the inanimate is probably the greatest abstraction of all. But technically only that sculpture which has its origin in nature and, like realism, is a result of of interpretation, generalization, simplification, rearrangement, or elaboration to such an extent that the original device, image, or source of inspiration is no

longer recognizable, as in the sculpture by Henry Moore (figure 1-24). More general defintions of abstraction include art which does not have recognizable, visually logical subject matter.

It is entirely possible that to some extent each of the languages could be created in each of the methods of expression, but each language seems to some degree to be suited to particular technical methods. Glypticism, for instance, is better suited to realism than naturalism, because in an attempt to capture detail in naturalism, the quality of the material (necessary to glypticism) would be lost. It is also probable that no sculpture is one pure method of expression. It is obvious for instance, that even the illusionistic naturalism is greatly abstracted from nature.

The Components

There are three components of sculpture: form, content, and subject matter. All three of these components are dependent on and related to each other, but since the emphasis put on the component is to some extent culturally controlled, the components are not equal in importance. Form is the order or unity which comes from the use of the elements of sculpture (shape, value, space, line, time, texture, and color), and is the result of physical manipulation of the elements—and the relationships caused by that manipulaton.

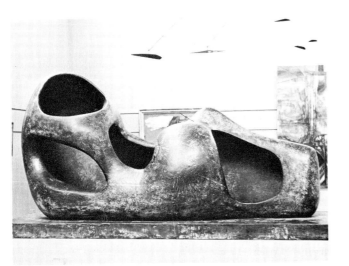

Figure 1-24. *Reclining Figure,* Henry Moore, (1898-), English, The Toledo Museum of Art. Gift of Edward Drummond Libbey.

Form

The achievement of form through the use of the elements is not difficult to understand, if seen in light of the following example. Any individual could purchase several hundred pounds of electronic parts from an electronics supply house and have only that, several hundred pounds of wire, plastic, sheet metal, and so on. An electronics engineer might be able to assemble several dozen different devices, from door bells to television sets from the parts. These electronic machines would be equal to *more than the sum of their parts.* This is the effect the artist strives for when utilizing the elements and principles of order to achieve form.

Content and Subject Matter

Content, the source of which is form, is the meaning or significance of a work of art which manifests itself in aesthetic experience. Subject matter is the theme or story that is represented in a work, and is the only component independent of the others, but when subject matter is used independently of the other components, the result will not be an art form. Subject matter which reflects material things is object-oriented, while subject matter which is concerned with the abstract is concept-oriented.

The Elements

Shape

If it were necessary to arrange the elements of sculpture in order of importance, shape would probably be the first in place. Shape is a generally measurable area, enclosed by contour—caused by line, contrasting color, texture, or value. In sculpture, except for surface embellishment, visible shape usually depends on the position of the viewer and the direction of the source of illumination. Movement around the sculpture results

in the change of the appearance of various shapes within the sculpture because the contours of many of the shapes are simply the edges of curved surfaces which appear or disappear as the viewer changes positions. The same is true of the shapes formed by illumination: as the light source changes direction (as the sun changes its position), the shapes formed by shadows change (figures 1-25, 1-26 and 1-27).

Figure 1-25. Light source from the left.

Figure 1-26. Light source from the center.

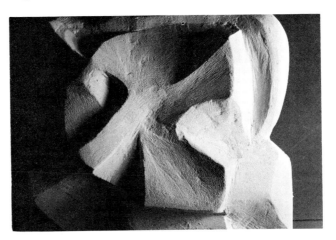

Figure 1-27. Light source from the right.

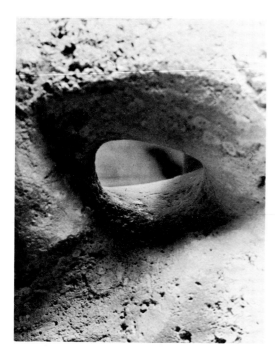

Figure 1-28. Void in stone.

It is not necessary for the shapes to be of solid material. An opening surrounded by finite material, such as a hole in a block of stone, forms an area known as a void, which, like tangible material, can have shape (figure 1-28). When the implied enclosure of space is the goal of the artist, as in much linear sculpture, the defining material is subordinate to the dominative void. On the other hand, the mass of most glyptic sculpture is dominant, and resultant voids, if any, are subordinate.

The void, when considered as a tangible, or definable space, has served a strange function in the recent development of sculpture. It has been used to free the artist on the reliance on mass, which to some ways of thinking was the soul (the inner force) of the sculpture. The void was used to punch through the mass, to let light penetrate and to reveal the "inside" of the mass. The void was also used to carry the cross contours into the inside of the form. In this case, the void became more than simply a hole shot through the mass, the void is given shape integrating the interior of the mass with the exterior shape.

Shape within a piece of sculpture is capable of creating the emotional structure of the sculpture. Shape, as it is formed through three dimensions, blocks the passage of light, creating shadow-value patterns, which if small, frequent, and angular, will appear excited (figure 1-29); or if the patterns are large, and curvilinear, will appear calm (figure 1-30A and 1-30B). Careful manipulation of shape can give an appearance to sculpture, often desired, know as monumentality

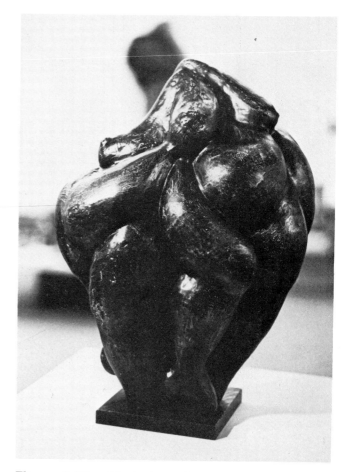

Figure 1-29. Student sculpture.

(figure 1-31). An object is monumental when it appears to be larger than life size, or when it can be produced in any size without visually disturbing effects. The most effective size of a piece of sculpture is generally dictated by its detail, textural effects, or shape character.

Value

Value is the elements which permits most sculpture to be visually understood. Value is that quality of light (of any hue) which ranges from light to dark, and which results from the absorbtion or reflection of light by a surface. Rather than depending only on pigmentation for value range, as in the graphic arts, the sculptor also depends on the presence or absence of light—the lighted surface or the shadowed surface —to establish form (figures 1-32, 1-33 and 1-34).

Shadow is so important to the sculptor that frequently the shape and texture of the sculpture are distorted to make the shadow on the surface of a sculpture visually effective. It should be noted that for the

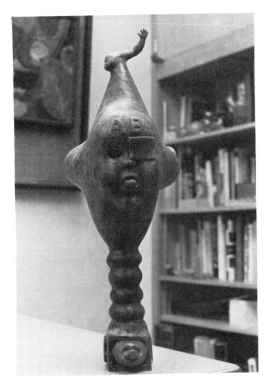

Figure 1-30A. *Defiant Youth,* John McNaughton, American (1943-), wax to be cast in bronze. Collection of Ball State University.

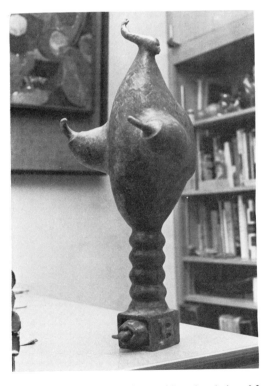

Figure 1-30B. *Defiant Youth,* John McNaughton, American (1943-), wax to be cast in bronze. Collection of Ball State University.

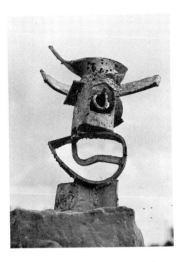

Figure 1-31. Cast aluminum bronze monument 5 inches high.

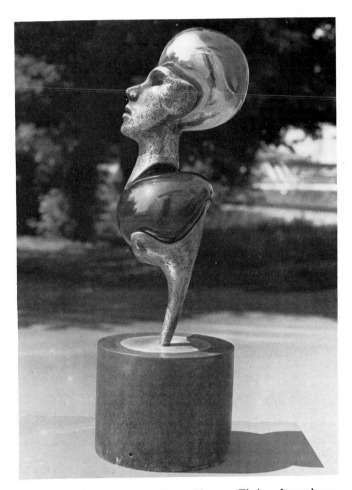

Figure 1-32. *Cerebellum,* Karen Fiely, American (1952-), cast aluminum and blown glass.

Figure 1-33. Student sculpture.

most part in sculptural media, it is value which describes all of the other elements except time.

Space

The differentiating element between the two-dimensional and three-dimensional arts is space. The illusion of space which is achieved in the graphic arts is not a manipulatable device, but instead is a trick of the eye or mind, resulting from the manipulation of the other elements; therefore, space cannot be considered to be one of the elements of graphics. In the three-dimensional arts, however, space is one of the usable devices of the art. The illusion resulting from the use of perspective in graphic art can be used in relief sculpture to distort natural space in such a way as to lend the appearance of greater depth than actually exsits in the sculpture. Because pure space has no visual qualities, a medium is required to demonstrate its existence and to delineate the boundaries of the space which the sculptor desires to utilize.

Line

Except for intaglio relief, such as that of the ancient Egyptians (figure 2-11), there was little purely linear sculpture until the advent of welded metal and the

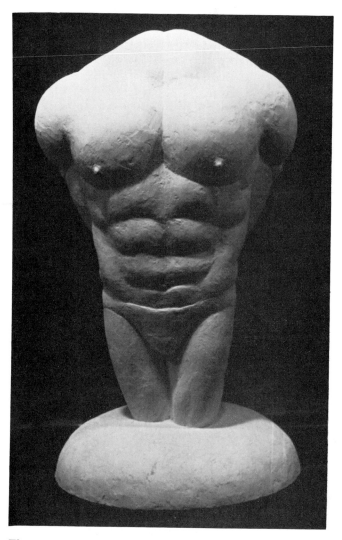

Figure 1-34. *Body Builders Pear*, Otto G. Ocvirk, American (1922-), plaster.

common use of wire. Now, as illustrated in figures 1-35, 1-36 and 1-37, linear sculpture is becoming commonplace.

Unlike the line of graphic media—which is easily produced and, therefore, highly autographic—sculptural line is difficult to produce and tends to be highly formal (figure 1-38). This is especially true when the line is dependent on the intersection of planes as it is in figure 1-33. Cross contours, as in figure 1-37; textural limits, or the linear quality of wire, as in figure 1-38 (monotonous because of its consistent thickness). Line quality can be controlled to a great extent when it is carved in soft clay, but this approaches drawing and tends to become two-dimensional. It wasn't until the technique of shaping wire through forging and welding became prevalent that, by modifying the wire, the sculptor was able to establish significant expressive quality in a three-dimensional linear medium.

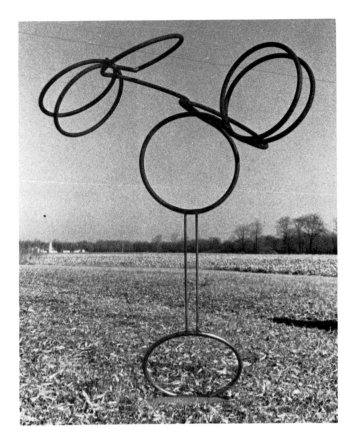

Figure 1-35. Thin wall steel tubing.

Figure 1-37. Student work, wire screen.

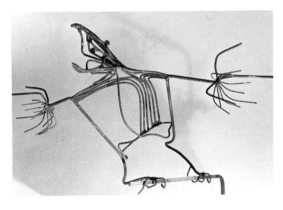

Figure 1-36. *The Politician,* welded iron wire.

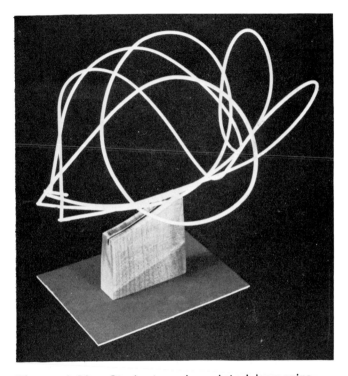

Figure 1-38. Student work, painted iron wire.

Line has the ability to create movement and direction across surface and around the bulk of a piece of sculpture. Because "line" does not actually exist in nature and is, in reality, an invention of the artist, the word "edge" (a more defining but less inclusive term) is often used, particularly in relation to mass, plane, or contour.

Time

Time is probably the least understood of all the elements. It has two sources: one in the nature of the viewer, the other in the nature of the sculpture. Time resulting from the nature of the viewer is almost completely beyond the control of the artist, and is the amount of time that the viewer uses to observe areas of the sculpture, or the time it takes to move around a piece of sculpture in an effort to study the entire composition. The artist, in causing a work to be interesting, may thereby cause the viewer to utilize more time in the study of the work, but the artist is not able to significantly control the amount of time involved (figure 1-39).

The source of time resulting from the nature of the sculpture is subject to a great deal of control by the artist. This is the time required by the object to complete mobility within itself. Such sculpture is designed so that physical change takes place mechanically (figures 1-40 and 1-41).

Figure 1-39. Both objects have similar profiles (contours), but the left sculptural object requires more time for visual inspection than the graphic right object.

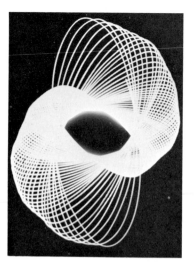

Figure 1-41. Track made by mechanical movement of a mobile.

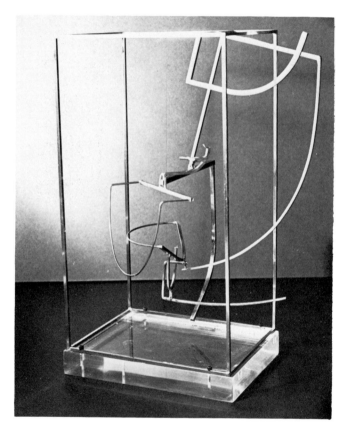

Figure 1-40. *Swingendingenthingen II,* balancing sculpture, nickel plated brass and stainless steel.

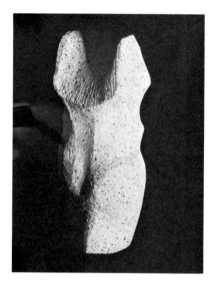

Figure 1-42. Texture resulting from mica flakes in cement aggregate.

Except for random change, the total time required for all of the changes to take place is designed into the sculpture by the artist. Spring motors or electrically driven figures are devices that depend on the artist's utilization of the element of time.

Texture

Texture is that tactile quality of a surface which affects both the sense of touch and the sense of sight. There are two primary sources of texture in sculpture: that which is indigenous to the medium (figure 1-42) and that which the artist produces on the surface of the sculpture in addition to, or in spite of, the natural texture of the material (figures 1-43, 1-44, and 1-45).

In sculpture all textures are actual except those resulting from color or value patterns which are part of the pigmentation of the medium, such as the grain in stone or wood (figures 1-46 and 1-47).

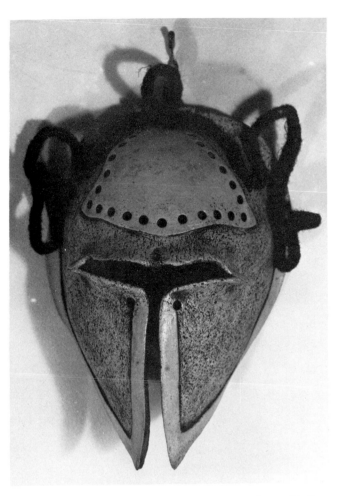

Figure 1-45. Mechanical texture and texture resulting from form.

Figure 1-43. *Protected #1,* Mary Ann Zotto-Beltz, American (1940-), ceramic and fibermack. Courtesy Gallery One, Ann Arbor, Michigan.

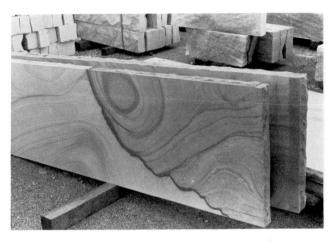

Figure 1-46. Indigenous texture resulting from grain in Crabapple Orchard Sandstone.

In order to make a work effective, the artist sometimes simulates textures by copying from other surfaces such as skin or hair (figure 1-20), or he may create abstract textures (figures 1-48 and 1-49) by re-organizing or simplyfying other textures.

Color

Color is as natural to sculpture as it is to the graphic arts, but the manipulation and control of color, for the most part, differs greatly between the two media. While some wood and metal sculpture is painted and ceramic sculpture can be glazed in every hue of the rainbow (figures 1-50, and 1-51), the color of most sculpture is a direct result of the use of its medium.

Figure 1-44. Texture resulting from form in cast aluminum.

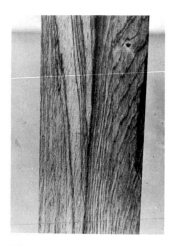

Figure 1-47. Indigenous texture resulting from grain in rosewood.

Figure 1-49. *Hill with Stream,* Judith Greavu, American, (1941-), stoneware and porcelain with coloring oxides.

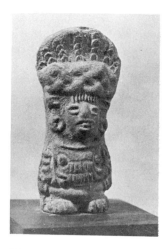

Figure 1-48. Abstract texture used to indicate hair. Pre-Columbian primitive figure, volcanic stone.

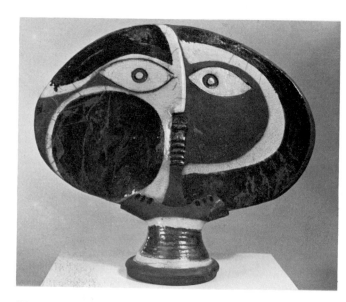

Figure 1-50. Ceramic sculpture, Doug Delind, American, (1947-), Courtesy Gallery One, Ann Arbor, Michigan.

Woods, stones, clays, and metals are found having colors ranging from white through gray to black, and include reds, purples, blues, greens, yellows, and oranges. The natural color of a medium is usually preferred to applied color, because color that is applied to a surface tends to hide the innate qualities of the grain (along with some of the detail), which contribute to the desirability of the medium, and because the spacial effect resulting from the proximity of dissimilar colors often come into conflict with the actual space involved in the sculpture, causing visual confusion. By painting a shadowed area white and a lighted area black, an illusion can be created which would reverse normal visual space.

The Principles of Order

In order to distill meaning from form, the artist regiments his elements in such a way that some under-standable organization, or some order, is achieved. In his arranging, he utilizes the Principles of Order: he considers balance, harmony, variety, economy, proportion, and movement, each in relation to the other.

Balance

Balance is used in two ways—in relation to weight or gravity, and in relation to the other principles of Order and the elements. Gravitational balance can be divided into two pure types: radial balance and asymmetrical balance.

There are, of course, various mixtures and degrees of the two e.g., monosymmetrical balance and approximate symmetry. Pure radial balance exists only in a perfect sphere. No matter which way a plane passes

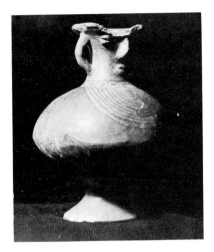

Figure 1-51. Painted primitive jug, ceramic clay.

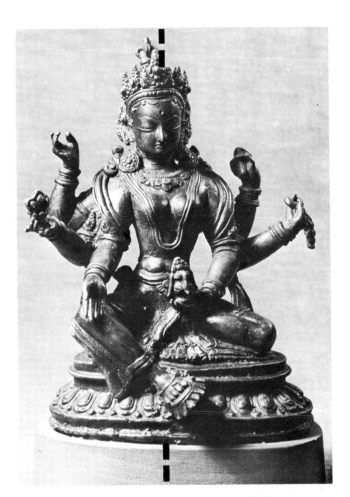

Figure 1-53. *Tara*, Nepal, India, 20th century, cast metal. Collection of H. Hasselschwert.

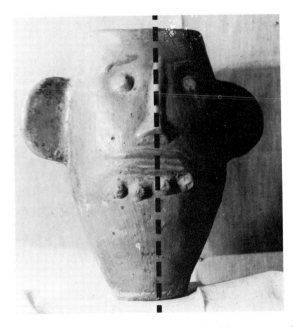

Figure 1-52. Bisymmetry, primitive ceramic clay jug.

through the sphere, so long as the plane passes through the center, the resulting divisions on each side of the plane will be identical, measurably balanced. Asymmetrical balance is a "personal" balance which depends on "unlikes" of equal importance, as in the mobile shown in figure 2-8. There will generally be agreement between individuals, but because of physiological and psychological differences, no two individuals will see alike; therefore, what one individual interprets as satisfactory balance may be interpreted as imbalance by some other person. Asymmetrical balance seldom has a definite fulcrum or dividing line. Monosymmetry is a mixture of radial and asymmetrical balance; it has only one dividing axis (usually vertical), with opposite sides equal (figure 1-52). Approxi-

mate symmetry, on the other hand, utilizes a general dividing line, with opposite sides similar but not identical (figure 1-53).

Balance in relation to the Principles of Order and the elements depends on psychological tensions which are sensed by the observer between the elements and harmony, variety, economy, movement, and proportion. Like asymmetrical balance, it is "personal," and depends on the sensitivity and personality of the observer.

As the artist has a small degree of control over the observer through the use of these tensions, he can cause the beholder to sense anger, excitement, melancholia, sadness, and so on. By using great economy and harmony, the artist can create a still, simple, dignified sculpture (figure 1-54); or by using much movement and great variety, he can create violently florid sculpture (figure 1-55).

Harmony

The presence of tensions in the organization of the sculpture results in characteristics known as harmony and variety. Harmony is the result of the use of ele-

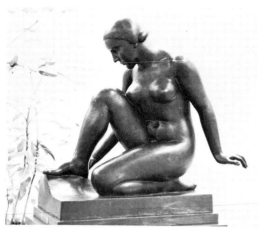

Figure 1-54. *Seated Nude,* Aristide Maillol, (1861-1944), French, The Toledo Museum of Art. Gift of Edward Drummond Libbey.

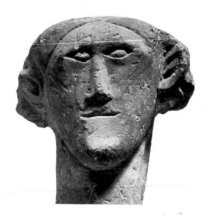

Figure 1-56. *Celtic Head,* about 3rd century, England, The Cleveland Museum of Art. Gift of Dr. and Mrs. Jacob Hirsch.

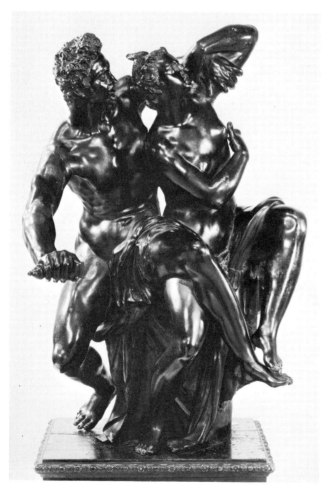

Figure 1-55. *Sextus Tarquinius Threatening Lucrece,* Hubert Gerhard, German, The Cleveland Museum of Art. Purchase from the J. H. Wade Fund.

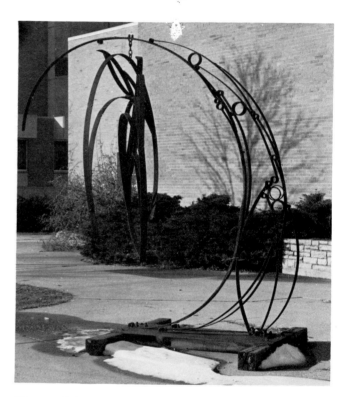

Figure 1-57. *Spring II,* Mark Vance, American (1947-), welded steel.

ments in such a way that there is conformity among the parts (figure 1-56).

If similarity (repetition) is utilized in a manner which can be predicted (having a uniform procedure similar to a musical beat), the compostion has rhythm (figure 1-57).

Rhythm which can be easily and entirely predicted becomes monotonous. Harmony relieved of this tend-

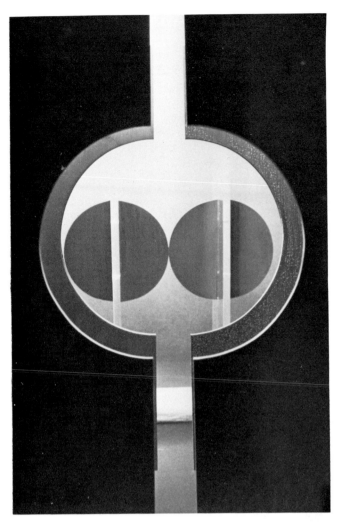

Figure 1-58. Harmony through rhythm, acrylic plastic and magnesium.

Figure 1-59. Harmony, acrylic plastic and magnesium.

ency toward monotony by change (variety) is shown in figures 1-58 and 1-59. Rhythms which are dull can be made interesting by selectively emphasizing parts of the rhythm in such a way as to complicate the beat-forming rhythms within the rhythm (figure 1-60). When some part of a rhythm is emphasized in such a way as to surprise the viewer, the rhythm is said to be syncopated.

Variety

Variety is dissimilarity of parts and is achieved by utilizing parts of contrasting or opposing natures (figure 1-61), or by elaborating on parts until their complexity competes, or contrasts, with other more simple parts. The artist's point of balance between harmony and variety determines, to a great extent, the dynamic or static quality of a piece of sculpture. Variety carried to extremes becomes chaos!

Economy

A work of art can become far too complex to allow the reason for its existence to be evident. The artist finds that it is necessary to eliminate or sacrifice material or detail of lesser importance, in order that the composition not be obscured in a mass of irrelevant material. Great economy results in abstraction. The purpose of economy is to achieve the maximum effect with the simplest design, like the beautifully simple *Water Buffalo* in figure 1-62.

Movement

There are two kinds of movement found in sculpture, that which is implied within the object (figure 1-63) and real motion (figures 1-41, and 2-6). Implied movement tends to draw the various parts of the composition together—the greater the similarity and proximity between the parts, the greater the tension, and

Figure 1-60. Rhythms formed with rhythms, thin walled steel tubing.

Figure 1-61. Variety through dissimilarity of parts.

Figure 1-62. *Water Buffalo,* lamp, India, glazed ceramic clay.

Figure 1-63. *Design Problem #1,* student work, wood.

the more rapid or direct the motion. Real motion, on the other hand, as was discussed under the element "time," describes the totality of the sculpture rather than the surface movement.

Proportion

Proportion is part-to-part relationships in terms of size. It, like asymmetrical balance, requires judgment, and is therefore a personal matter. When proportion is concerned with the relationship of the parts to the total sculpture, or the total sculpture to its surroundings, it is then known as "scale."

2
The Concepts of Sculptural Entity

Sculpture-in-the-Round

There are two concepts of sculptural entity: sculpture-in-the-round (free-standing sculpture), as in Figure 2-1, and relief sculpture (figure 2-2). Sculpture that has been manipulated on at least four sides is known as sculpture-in-the-round, and can be achieved in four ways: monolithic totality, totality through volume (by planes or lines), totality through multiple units (two or more similar or dissimilar units), and totality through real or implied motion.

Totality through Monolithic Mass

Monolithic totality is a solid (dense) unit, usually —though not always—a geometric mass, such as a quarried stone, a block of wood, or even a solid block of bronze.

Totality through Volume

Totality through volume occurs either as a construction of planes such as welded sheet steel sculpture illustrated in figure 2-3 or as in a suit of armor formed of curved sheets of metal (figure 1-2), or as a construction of line, as in the structure of a wire bird cage, in which the surface is not continuous, but is still spacially limiting.

Totality through Multiple Units

Totality through multiple units can easily be compared to a bunch of grapes, the overall cluster being composed of small units (figure 2-4); or totality through multiple units can be compared to the total human body, which is composed of a series of connected cylinders, cones, spheres, and so on. Each unit may have a specific shape; the unit and its shape is subordinate to the overall structure.

Totality through Real or Implied Motion

Totality through real or implied motion is dependent on the movement, or indicated (potential) movement, of a filament of the sculpture through space—in such a way that the moving filament utilizes greater area than the same filament occupies when standing still. A child's top while spinning does not occupy greater space than when it is standing still, nor does its movement result in a change of shape, but the same is not true of a fan blade. The blade has one shape and occupies a given amount of space when motionless, but as a totality, it occupies greater space and has a different shape while it is spinning. This principle is used in mobiles, as in figure 2-6, when many possible movements are designed for the filaments. The wires and attached plates, which are the filaments, occupy greater space—both visually and physically—when they are in motion (figure 2-7) than

Figure 2-1. Student sculpture.

Figure 2-2. Growth plate, cast aluminum.

when they are at rest (figure 2-8). This motion does not have to be accomplished to create the image of the probable limits of the totality; it need only be implied by line, shape, or one of the other elements.

Relief Sculpture

Totality is not achieved in relief sculpture in the same way that it is in sculpture-in-the-round. Because relief sculpture is shallow manipulation on one plane, it is viewed only from the front; it is usually obvious that the surface does not continue behind the relief, but instead flows onto or into the background or supporting surface. Unlike sculpture-in-the-round, relief form defies definition as a pure sculptural totality; in that the object is modeled from a surface, deep space is not involved. Renoir's *Judgment of Paris* (figure 2-9), illustrates that only minor convolutions or undulations in a surface are needed to give the illusion of mass or volume.

Intaglio

There are two kinds of relief sculpture: intaglio relief and cameo relief. Intaglio relief is divided into two styles: the first is a simple line recessed into the surface of the material—in effect, a contour drawing —as in figure 2-10, the second kind of intaglio relief is a depression recessed into the surface of the medium permitting the background to stand high and leaving the design concave (bowl-like) in the surface, as in figure 2-11.

Cameo Relief

Cameo relief is the exact reverse of intaglio. Rather than cutting the design away, or incising a drawn line into a surface, the modeled object is left standing out, hill-like, from the surface, (figure 2-12 and 2-13). Occasionally the entire background is not carved away to the full depth of the figures, but the figures still stand out from their immediate surroundings. Because of the highly restricting nature of relief sculpture and because of the lack of definable mass, relief sculpture is often held akin to two-dimensional design, in which the artist relies on shadows, rather than pigment, for value relationship.

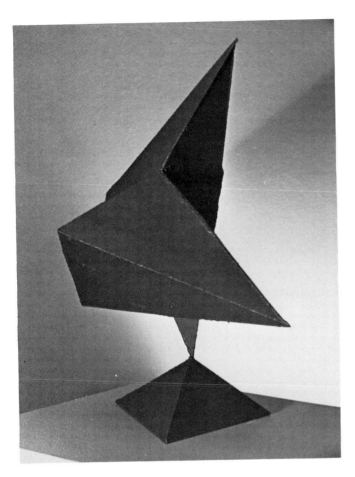

Figure 2-3. Student sculpture.

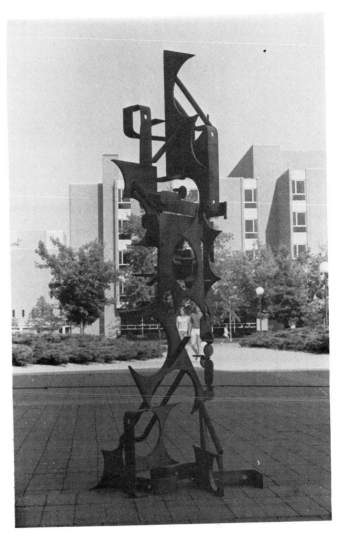

Figure 2-4. *Welded Steel Tower,* Steve Simcox, American (1952-), welded steel.

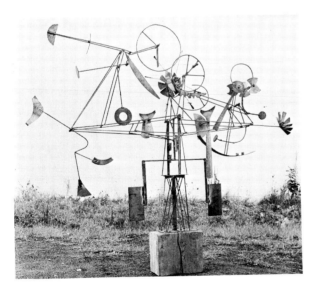

Figure 2-5. *Dingle-Dangle,* Don Drumm, American (1935-), moving sculpture with noise attachments, welded steel.

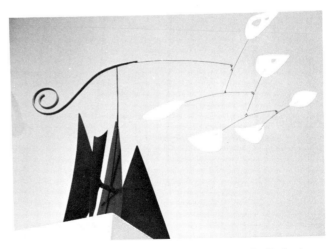

Figure 2-6. *White Loops and Red Spiral on Black,* stabile-mobile, Alexander Calder, American (1898-), The Cleveland Museum of Art, Gift of the Halle Bros. Co.

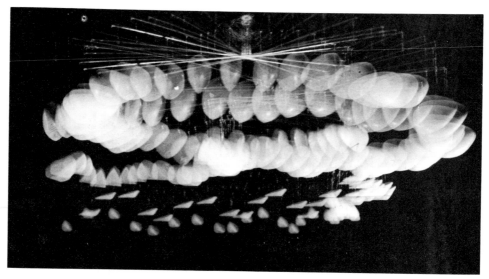

Figure 2-7

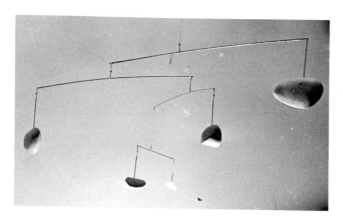

Figure 2-8

Figure 2-10. Detail of a support column, Don Drumm, American, (1935-), from a stairwell in a private home, plaster.

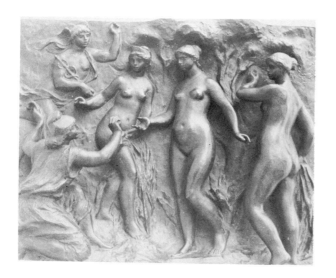

Figure 2-9. *Judgment of Paris,* Pierre Auguste Renoir, French, 20th century, bronze, The Cleveland Museum of Art. Purchase from the J. H. Wade Fund.

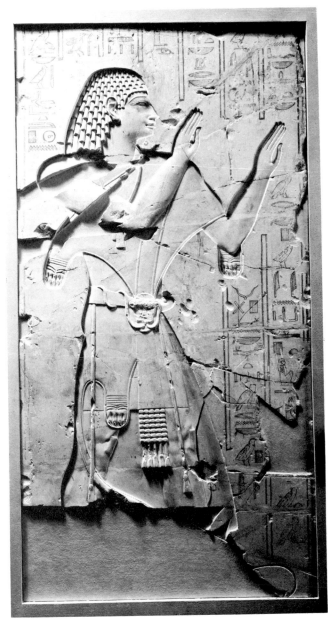

Figure 2-11. *Nobleman in Sacerdotal Vestments, Adoring,* Egyptian, Early XXVI Dynasty, The Cleveland Museum of Art. Gift of the Hanna Fund.

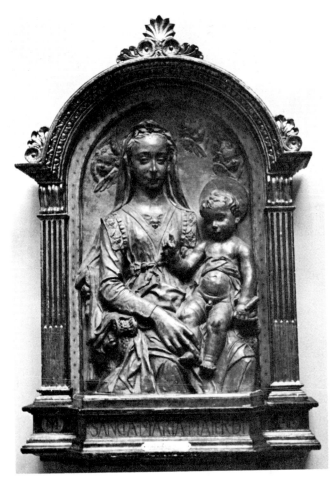

Figure 2-12. *Madonna and Child,* Antonio Rossellino, Italian (1472-1478), The Toledo Museum of Art. Gift of Edward Drummond Libbey.

Figure 2-13. *Socioenamorphic Anti-Congruity,* welded 14 gauge mild hot rolled steel.

3

The Artist, the Product and Its Dissemination

The Artist

Artists have three directions in which they can concentrate their drive to become successful. They can become managers of art, manufacturers of art, or inventors of art. The art industry like every other industry has work forces in each of those areas.

The managers are the taste makers, they create a need for the products and they make consumers. In the everyday business world of art, the educators, museum operators, gallery directors, and critics educate, promote art, and mold public opinion. They prime the pump. They make the consumer consume by teaching what is supposed to be good, showing where it can be obtained, (advertising which works would be sound financial investments), and setting up the reasons for making a buy.

Successful managers usually sacrifice their own work (if they ever were practicing artists) for the sake of the business of the art world. This aspect of the arts can be exhilarating or dull depending on whether one only minds the business, or pursues the business. There are enough "public figures" involved in art exhibiting and collecting, that fast moving gallery owners, museum directors, and critics can find themselves moving in the fashionable "moneyed circle" that establishes itself in every city of any size. Art managers that are engaged in lecturing, conventioneering, or working with charitable exercises (when involved with the media) usually aren't lacking in the social contacts which makes that business exciting. In all probability most managers don't get rich playing this interesting but ulcer inducing business.

On the other hand educators whose primary goal is teaching, gallery operators that are primarily stock clerks, and critics that write their reviews second hand may not find a great deal of excitement in the art industry.

The vast majority of artists are manufacturers (suppliers) of art. They are the most functional among us, because they produce the product which is needed by the largest art buying public. That public is the art market. The artist's problem is to produce forms which satisfy the desires of the public for beauty, strangeness, or whatever is in vogue at the time, without copying what has gone on before and without creating too far ahead of the public. The artist needs to create a different familiarity, so to speak. The artist must walk that narrow area between "more of the same old stuff" and "what's that supposed to be?" The simplest route for the artist is to become a "craftsman." The craftsman works with relatively well understood forms and depends on highly sophisticated and sensitive design and ornamentation of surfaces to satisfy his clientele. The buying public is vastly more

receptive to magnificently textured, colored and intricately patterned objects, than it is to an incomprehensible although perhaps ingenious shape.

Naturally the public taste varies unpredictably and the artist that expects to supply the public must be versatile enough to sense the desire of the buying public. Few artists like chasing the market. Most would rather produce "their own thing" in their own time.

It would seem that the goal of the artist would be to create his own art, and not manage the industry, or operate an art factory. The idea that an artist should be an inventor has spun off an odd byproduct. The continual drive for invention in art has established a predictory "art fantasy fiction" similar to literature's science fiction. The romanticized inventive artist, the artist in search of different media, different forms, different images, different concepts, is the main character of art fantasy fiction. This artist is typical of the research and development personnel of every industry. The creative artist discovers, examines and displays that which he believes to be unique art. In many ways this artist has the most difficult working situation of all, because the product, being unique, is far in advance of the active market. Even if the art form had a market, it probably wouldn't have a compatible environment. This means that the artist must depend on financial support from sources other than the sale of the product, and is more likely to sell a personal image than the work. Oddly enough there has been a lot of "big" money around to support the research artist with an impressive "image." The federal government, industry, institutions, and civic groups have been supportive of the research artist who has learned grantsmanship, the successful method of manipulating the bureaucratic paper game. This process is so difficult that many institutions have established offices to help write and process grants. It is encouraging that once the artist masters grantsmanship and secures the first grant, others follow more easily. The individuals that haunt the power groups, and the social cliques, follow the cocktail circuit, and cozy up to jurors of shows or buyers, are known as "sharks." "Sharks" among the research artists occasionally resort to "shockers" to promote themselves. They may advocate wrapping the earth in tinfoil, or digging a tunnel to the moon as a serious work of art in the hopes of attaining some attention. These gimmicks as obvious as they are, occasionally are effective. So much so that there will inevitably be an intent "following" among art students.

It is obvious that the artist that seeks outside financial help in the form of grants is going to spend considerable time and effort on public reactions, and bureaucratic red tape, but financial aid gained by that route has an important byproduct. Exposure! If an artist expects support of any kind, the artist's product must be brought to the attention of the people that can do the artist some good. Since the taste of the buying public is twenty-five to fifty years behind the development of the creative artist and not much help, the artist needs to be brought to the attention of the tastemakers, the critics, and the speculators (the buyers that follow the "wisdom" of the tastemakers and buy for profit rather than preference). Institutions that extend grants often publicize the products of their grantees providing exposure that the artist could otherwise not afford.

If the artist anticipates a place in history, exposure is critical. Possibly the works of the world's greatest artists have rotted in attics or basements simply because they were never "discovered." Unfortunately discovery may not be good for the artist. Recently "discovered" research artists often find themselves trapped into becoming manufacturers by attempting to fulfill the demand of their public for the product which became the artist's trademark or style.

Where to Work and How to Survive

The arts manager has little problem with his working facilities, because there are existing institutions such as schools, corporate facilities, parks, museums, public halls, publishing houses whose very existence forms working facilities. The security of a manager's position may range from the high degree of stability of the tenured educator, to the risky, free-wheeling and independent, no-fringe benefit artist's representative.

The art manufacturer has a reasonably-solvable facilities problem. Most artists' work style lends itself to a complete but limited studio requirement. The stone carver, the plastics fabricator, or the welder can equip and maintain a studio in a small building or garage with a minimum of tools. Large works may require rental of special equipment or extra space, but the sculptor can operate on a satisfactory basis without owning a warehouse and a factory. In many states, tools and equipment are taxable (every year and forever) so that acquiring a well-equipped studio may be expensive just to own. Many areas have zoning permits, and license requirements, safety restrictions, and other regulatory procedures which may not only become a burden, but, as has happened in recent years, may close studios, or prevent the use of many kinds of equipment. Gas and electric welders, ceramic kilns, foundry equipment, and others have been the subject of harrassment because of their potential danger or otherwise supposedly undesirable effects on the environment.

Artists have discovered that it is generally safer to remain quiet and inconspicuous in urban areas by maintaining small, lightly equipped studios. Inconspicuousness may not be enough. Considerable care should be exercised in the loction of a studio because of the taxing structure of some states. In one eastern state for instance the artist would be required to pay city income tax, county income tax, state income tax, personal property tax (on every tool, piece of equipments, furniture, books, art works owned, art works being constructed, and any inventory), inspection permits for commercial establishments, city vendors license, state vendors license, license for maintenance of welding equipment (issued by the fire department), and liability insurance for business. In addition, there are the federal taxes to which most artists are subject.

The research artist has the greatest studio problem of all, yet perhaps the most easily solved. Unlike the manufacturing artist who can concentrate on one of two media, the research artist deals with a wide variety of concepts, with differing technological requirements of equipment and materials. Few independent artists have the financial backing to create a laboratory complete enough to include the equipment necessary to indulge in comprehensive experimentation in every recent technological development. A studio of this nature would not only be a complete electronics, physics, and chemistry laboratory with machine shop capabilities, it would also have to contain sophisticated complete industrial and commercial systems such as computers, remote control systems, television, holographic systems and so on. New equipment could be added to that environment faster than the artist could become familiar with the operation of the equipment. The taxes, maintenance, and utilities of a studio such as this is beyond discussion.

These studios do exist in the forms of institutions though and they have been the solution for the sculptor for many years. Most larger universities have facilities dealing with areas in the sciences, machine shops, or industrial arts areas with shop equipment, computers, radio and television facilities, and an administration which is interested in interdisciplinary studies and visibility to the extent that the inter-departmental cooperation is encouraged.

In reality the university situation is not always conducive to rapid creative growth and experimentation in the arts. In return for financial security, and usually some studio facilities, the artist teacher may become mired in the business of academia. The artist teacher may find that studio time is preempted by academic and professional accountability, public relation, organizational committees, student mollification, and even fund raising responsibilities. In addition, the well intentioned requirements of business-

oriented administrations occasionally twist the efforts of the research artist toward the quick and flashy product in order for the artist (and the university) to acquire visibility. The apparently easy studio solution offered by the educational institution may in the long run be destructive to significant creative development. Nevertheless, some of the finest works of art that have been produced during the last three decades have come from educational institution environments.

Possibly the best of all solutions to the working situation for the research artist is the long term renewable grant in conjunction with benificent corporations. In these cases, the artist has no studio investment, no utilities payments, no inventory, minor taxing problems, and generally superb exposure. Unfortunately these situations are rare and there may be no permanent fringe benefits with this type of an arrangement.

There are three basic approaches to financial survivorship for the professional artist. The first and most difficult for the artist is to devote all the entire working time to product development, exhibition, and dissemination. These artists begin by exhibiting in every possible show, working every possible outlet, from county or art fairs to major national shows. They travel the art fair circuit which may be a little carnival in atmosphere, but many artists derive more income from the art fair route than all other sources of income combined. Some sculptors concentrate on exhibitions and competitions for their market. They frequently make contact with architects, urban renewal leagues, restoration directors and so on, in search of fertile contacts. A larger number of artists and craftsmen are supporting themselves and their crafts by this approach than is generally realized. There are probably more successful full time professional artists in this country now than ever before in American history.

The second approach is the most common one. The artist generally acquires an art related job, such as draftsman to an architect, interior decorator, greeting card designer, art teacher, or book designer. The advantages to this approach lie primarily in the fact that the artist remains in contact with creative people, their attitudes, and recent developments of concepts, technology, and media. The disadvantages being the loss of studio time and the "brain drain" that the artist suffers in giving away ideas while solving the problems of others.

The third approach requires that the artist work at an unrelated job (often menial) which will not sap the creative energy. Supposedly such jobs as night watchmen, or parking lot attendant will supply a bare subsistence without expending exhausting effort and will permit time for solitude and hopefully concentration. This approach while providing the necessities

of existance may be somewhat desensitizing in that it isolates the artist from the mainstream of creative activity.

Whichever approach is taken, there will be little time to extensively promote the sale of the artist's work. The artist's usual pattern is to make contact with various galleries across the country hoping that the galleries will be able to promote the work. Artists' representatives are now taking the place of the galleries in that they take the work to the buyer rather than expecting the buyer to come to the work. The representatives usually do not have galleries, or stock the artist's work. Instead they or their assistants contact known buyers of art (corporations, collectors, speculators, museums, etc.), and attempt to sell specific works by using standard business techniques. Recent indications are that a good representative will generally be more successful at selling an artist's work than the artist will be.

Many artists are reluctant to place their works in galleries or in the hands of representatives because of the high mark up that these businesses charge. But artists have to expect to pay for sales service, whether exhibiting in a gallery or selling through a representative. If the entire cost of operating a marketing system including salaries, rent, utilities, advertising, mailing, shipping, insurance, and office supplies must come from the sales of unique works of art which are not produced economically in bulk, then it must be expected that the mark up on each piece must be quite high in order for the marketing system to survive. The only option for the artist using one of these marketing systems is to determine the required selling price and add to that price the percentage required by the gallery or representative.

2
The Technical
Methods

Introduction to the Technical Methods

The availability of a medium and the desirability of its qualities lead to the development of a philosophy which attempts to interrelate the medium and man's culture. Consequently, a philosophic controversy has existed over the appropriateness, validity, or superiority of the subtractive technique as opposed to the manipulative technique. These two methods evolved because of the abundance of both stone (a resistant, somewhat permanent material) and clay (a plastic, fragile material). The controversy itself is of little consequence, as the quality of a work of art depends only partially on the kind of technique or method involved in the production of the art form. The only note of importance here is that the controversy emphasized the relation of a medium to the methods to which it is best suited and demonstrates that, as far as man is concerned, all media are not equally suited, psychologically or physiologically, to every technique. Stone is hardly a material that can be squeezed into shape by hand; instead, it must be chipped or carved laboriously and slowly to its proper form; therefore, stone does not lend itself to immediate, spontaneous expression. Clay, on the other hand, is highly autographic and fluid, to such an extent that it responds easily to the touch. It would seem, then, that clay would be suited to an emotional, spontaneous process instead of to a pondering, intellectual, incubation-like process. Naturally, some media are versatile and, like clay, can be exploited in more than one technique.

There are four primary technical methods of producing three-dimensional objects: manipulation, subtraction, addition, and substitution, each of which is discussed in following chapters. It must be noted that much sculpture is produced by combinations of the four technical methods, some of which are included in the text.

Because they require a fairly advanced technology, the techniques of addition (build up) and substitution (casting) occur later in history than manipulation and subtraction. Both of these complex techniques were used in imitation of the simpler techniques, until a point was reached at which the integrity of the techniques became subverted.

The additive technique is often used as a substitute for carved stone or as a pattern for casting; in each, the natural qualities of the additive medium are destroyed in imitating a cast or poured material. The finished product usually looks like a cheap copy or worse.

The manipulative technique suffers the same illness that affects the additive technique. When a manipulative medium such as clay is reproduced by being cast (perhaps in bronze, for purposes of preservation), the result is a secondhand bronze imitation of a clay model. If clay is modeled to suit the nature of flowing metal, the clay medium is perverted, and the result is a bronze imitation of a clay imitation of cast bronze. Fortunately, since the translation from one material to another is difficult, and the differences "seem" slight, we have been able to accept the technique of substitution in spite of these disadvantages.

4
Manipulation (Modeling)

The manipulative technique known as modeling requires a medium which is pliable or can be made pliable during the period in which it is being modeled. It must be able to maintain its shape and support most of its own weight. Manipulative media in common use today include clay, wax, plastic, and metal. Media which are highly plastic require the use of armatures to support the bulk of the material. Armature material can also be used as core material to displace a large bulk of the medium—for reasons of economy, in the case of an expensive medium, or to save weight.

Armatures

Armature material used in the manipulative technique include soft aluminum clothesline wire, heavy lead-coated electrical wire, heavy galvanized iron wire, copper pipe, galvanized iron pipe, iron rods, wood lath (for trellised armatures), and expanded metal such as plaster lath (for large relief sculpture). Clay sculpture which is to be fired can be modeled over a core of tightly bundled and tied excelsior, cloth, or paper. Because clay shrinks as it dries and as it is fired, the armature should be compressible enough to allow the clay to shrink without cracking; it should also be combustible so that the armature material will burn away during the firing process.

Additional armature materials available for other techniques include metal screen, styrofoam, inflatable materials such as balloons or preshaped sheet plastic bags, and combinations of any of these materials.

Armature material which is corrosive or can be destroyed by the media should be shellacked or lacquered to prevent direct contact with the media. Iron should be shellacked to prevent rusting, and styrofoam should be treated with an impervious coating if it is to be covered with solvent plastics.

Wire armatures are bent to shape to form the "bone structure" of the sculpture, then fastened to a temporary base, such as a thick slab of wood (figure 4-1). If the medium is especially soft as some clays are, it may be necessary to wire small blocks of wood to the armature to prevent the wire from pulling through the clay, allowing the clay to drop off of the armature.

Copper or iron pipe armature can be threaded and fitted together in almost and desired form (figure 4-2). Copper tubing is easily soldered, and the soft grade can be bent to shape without the application of heat. The hard grade of copper tubing requires heating in the area of the desired bend before the pipe can be readily bent. Joints to be soldered should be first cleaned with sandpaper, then coated with a soldering paste such as "Nokorode." Solder (the common wire variety without a flux core) will then flow around

Figure 4-1

Figure 4-2

Figure 4-3

Figure 4-4

the heated joint by capillary action, forming a firm bond when cool. Heat can applied with large soldering irons, but a far more efficient tool is a Bernz-a-Matic®-type torch.

Iron pipe, iron rods, and heavy iron wire can be welded and bent to shape with the application of heat, as in the case of the hard copper tubing. Galvanized iron pipe is not safe to weld under normal conditions, as the zinc fumes given off as a white gas during the welding process are quite toxic. Symptoms of zinc poisoning are dizziness, severe headache, sore eyes, and nausea; in general, symptoms closely resemble those of the flu. Mild cases seldom last more than 24 hours.

Large armatures can be constructed of wood framing, over which wood lath or plaster lath is nailed to form a surface for the medium. Wood lath is often used for huge ceramic relief sculpture.

Soft armature materials such as excelsior, paper, or cloth can be bundled and tied with string or wire (figures 4-3, 4-4, and 4-5) and, if necessary, treated with a waterproofer to form a core for a medium. Because of the flexible nature of these armatures, they are primarily used for small sculpture.

, Expanded metals are quite flexible and can be shaped, cut, and joined easily. Because of these characteristics the metal can be cut into patterns or shapes, formed three-dimensionally, and wired together with black iron wire to create a shell, the same shape and almost the same size as the finished sculpture (figures 4-6 and 4-7). All that remains is to isolate the arma-

Figure 4-5

Figure 4-6

ture and apply the medium. Expanded metal is so controllable that it is considered normal to design the armature so that only one-quarter inch of medium need be applied to complete the sculpture.

Styrofoam is available in logs of almost any size. The common blocks (2″ × 24″ × 96″ [50.8 cm × 60.96 cm × 243.84 cm] and 4″ × 18″ × 120″ [10.16 cm × 45.72 cm × 304.8 cm] are available in many lumber yards as insulation or flotation material for dock construction. It is easily cut with a grapefruit knife (figure 4-8), hacksaw blade, saw, router bit (figure 4-9), or hot wire (figure 4-10), and can be joined with stiff wire, wooden pins, some contact cements, collodion, or styrofoam cement. Glue which dissolves or softens styrofoam should be avoided.

Inflatable materials such as balloons or plastic bags shaped by the thermowelding process can also be used for armatures, but the machinery for welding plastic is not readily available—which makes the extensive use of plastic somewhat impractical for this purpose. Inflated balloons are simply joined with tape, string, or contact cement, and then covered with the desired medium.

Most armature materials can be combined. Probably the most used combination is wire and plaster-soaked burlap or cheese cloth, as in Figures 4-12 to 4-15. Iron rod or pipe is also frequently used with expanded metal.

It is vital that the armature be properly formed, as the armature is the foundation around which the sculpture is constructed. Proportions and directions of movement must be absolutely correct in the armature, or the sculpture will not be correctly proportioned or shaped. In some cases, parts of the medium can be removed to reveal the armature so that it can be adjusted, but this kind of wasted time and effort

Figure 4-7

Figure 4-8

Figure 4-9

Figure 4-10

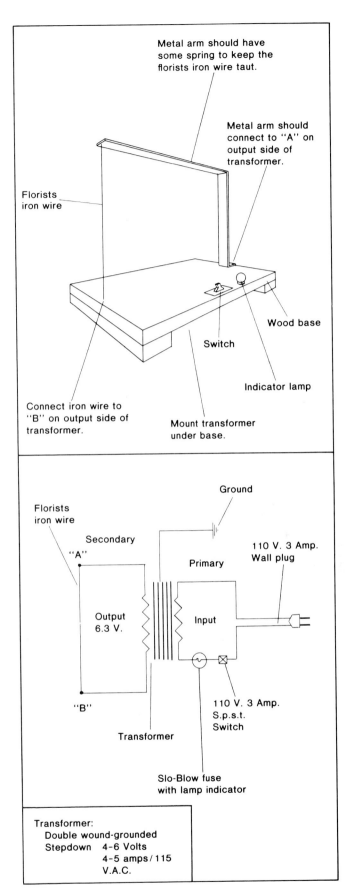

Metal arm should have some spring to keep the florists iron wire taut.

Metal arm should connect to "A" on output side of transformer.

Florists iron wire

Switch

Wood base

Indicator lamp

Connect iron wire to "B" on output side of transformer.

Mount transformer under base.

Ground

Florists iron wire

Secondary

"A"

Primary

110 V. 3 Amp. Wall plug

Output 6.3 V.

Input

110 V. 3 Amp. S.p.s.t. Switch

"B"

Transformer

Slo-Blow fuse with lamp indicator

Transformer:
 Double wound-grounded
 Stepdown 4-6 Volts
 4-5 amps / 115
 V.A.C.

Figure 4-11

Figure 4-12

Figure 4-13

Figure 4-14

Figure 4-15

can be eliminated by correct armature design. It is also important to consider the armature as a core around which the medium is to be wrapped. Space must therefore be provided for the medium all around each part of the armature, as well as where one part of the armature nears another; otherwise, parts of the sculpture will be buried in the medium (Figure 4-16).

Clay

Water-base modeling clay can be obtained pre-mixed, wet, and ready to use, but clay purchased this way is very expensive. It is usually purchased in a dry air-floated powder state, and is prepared by sifting the powder into water, and permitting it to soak (slake) until the water is absorbed into the clay and a thick, putty-like consistency is obtained. If the clay is to be used for ceramics, it is sifted into water until a thick but fluid slip is formed, allowed to age a day or so, and then is mixed with a power mixer if possible (blunged). Excess water is removed by evaporation or by pouring the slip onto dry absorbent plaster slabs known as bats. Once the clay has dried to a proper plasticity, it is stored in crocks, garbage cans, plastic bags, or other nonabsorbent, airtight containers in order to preserve its moisture content until it is used. The water in clay may have a tendency to settle, so it may be necessary to turn the clay occasionally to prevent the bottom from becoming mucky and the top from getting too hard. If the clay stiffens too much to be used, additional water can be added to soften it. If clay is required in large quantities, it should be prepared mechanically, in a filter press, a pug mill, a muller, or a bread dough mixer (figure 4-19).

Water-base clay is inexpensive, can be washed away with water, is responsive to tools, and many of these clays can be used as a ceramic body. They have some disadvantages: all are not suited to modeling, in that they may be too coarse, too gummy, or too slimy; they require preparation and constant care; and may tend to crack, warp, or shrink as they harden. Water-base clay hardens if not deliberately kept wet while being worked.

Oil-base clays (plasteline, plastecine, and plastilina) are modeling media which use nondrying oils such as glycerine, lanolin or even plastic, instead of water to make the clay or talc mass plastic. They are purchased ready to use, and though sometimes stiff, readily become plastic and responsive with normal handling or the application of slight heat. Because oil-base clays are nonhardening, they do not require special care, nor do they shrink or crack. Except for inferior grades, they are very expensive, and have the disadvantageous property of being a little staining, so that it may be

Figure 4-16. If sufficient space is not provided between the arm and the leg, the arm will become buried in the process of building up the leg.

Figure 4-17. *Jack-in-a-Box*, David L. Cayton, American, (1940-　　), ceramic stoneware.

Figure 4-18. *Sea Shell Head Sculpture,* Philip Borden, American, (1943-). Courtesy Gallery One, Ann Arbor, Michigan.

Figure 4-19

necessary to use a solvent to remove the oil from the tools and hands. Oil-base clays cannot be used for ceramic sculpture.

Masses of clay are wadded, squeezed, pounded, and molded until the effect required is achieved. If the sculpture is a bulky one and no armature is required, large pieces of clay can be joined by pounding them together with a block of wood or a clay mallet. If water-base clay sticks to tools, it is too wet and should be left to stiffen. If the clay is too hard, it can be sprayed lightly with water over a period of time until it becomes plastic enough to model. The manner of forming the sculpture depends somewhat on the design being created. A thin, fragile sculpture will collapse under the impact of a block or mallet, so modeling tools or fingers may have to be used; fingers or small tools will have little effect on a massive, bulky gob of clay, so large blocks of wood should be used to drive the clay into shape. The sculptor must avoid over-use of tools, especially small wood clay tools, as these may cause a tendency toward pickiness of detail and overworking of surfaces, while at the same time the basic sculptural form is neglected. In any

event, the tool utilized should reflect the medium chosen and should be suitable to the overall design.

Neither water-base nor oil-base clays are suitable for permanent sculpture, because they are too easily damaged; such sculptures are therefore often converted to a permanent material. Both types of clay can be cast in permanent media (a substitution process), such as plaster or bronze, but only water-base clay can be fired into a ceramic material. Clay which is to be fired must have special handling. It must be clean, especially free of plaster which will cause spalling (large pits) and possibly cracks (figure 4-22). It must also be wedged in order to free it of air pockets which would allow for the entrapment of steam during the firing process and possibly cause the sculpture to explode.

Wedging serves two purposes: it not only breaks down and eliminates air pockets, but it also distributes the moisture evenly through the mass of clay. Probably the easiest way to wedge is to cut a ball or mass of clay in half on a taut wire (figure 4-23), and slam one-half of the ball down on top of the other half, which has been thrown onto a solid surface, such as

Figure 4-20. Student project, clay.

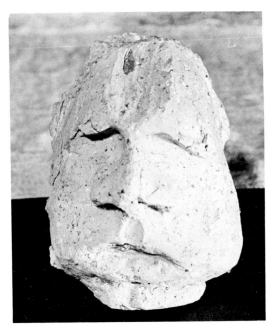

Figure 4-22. Damage resulting from limestone and plaster in a ceramic clay body.

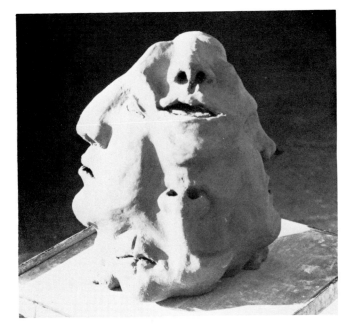

Figure 4-21. Student project, clay.

Figure 4-23

a marble slab, or a heavy table covered with canvas (figure 4-24). This action is repeated until, when cut on the wire, the clay mass appears to be free of trapped air pockets (figure 4-25).

Crushed brick or prefired clay crumbs, known as grog, are often added to the clay in percentages up to 50% to prevent cracking of the clay body from contraction during drying or firing, and to add interesting texture and color to the clay body. Too much grog will cause the body to lose strength. It may be necessary to experiment with each clay body in order to create a satisfactory recipe. Grogs are frequently added during the wedging process, although they can also be blunged into the clay mass during its preparation.

Although common earthenware clays may appear blue, yellow, gray, tan, or red in their natural state, most fire to a red color due to their high iron content. The fired color of a clay body can be varied either by changing the firing time and temperature or by the addition of colorants, usually metallic oxides. Iron oxides produce reds, uranium oxides produce yellow, chrome oxides produce green, cobalt produces blue, copper produces black, and manganese dioxide produces tan through black. Usually, if the fired color of the clay body is white or tan, 4%-5% (by weight) of an oxide will prove effective in obtaining strong color; if the basic clay fires red, a much higher percentage of the coloring oxide will be required. Excessive use of a strong coloring oxide, such as cobalt oxide, may cause undesirable textural or color effects. Often a clay will contain soluble substances which form a powdery

Figure 4-24

Figure 4-25

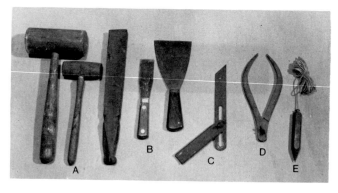

Figure 4-26

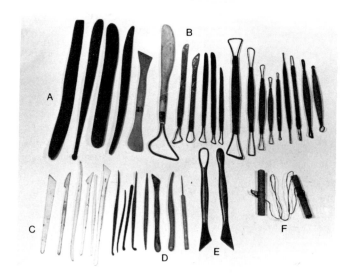

Figure 4-27

white scum on fired ware, destroying their color to some extent. This scum can be eliminated by the addition of 1%-2% barium carbonate (by weight) to the clay body while blunging.

Clay sculpture which is to be preserved by firing must also have special handling. After the clay becomes leather hard (stiff enough to be handled, but soft enough to be marked or carved easily), all rigid material used as an armature must be removed and the object hollowed out, so that the walls of the sculpture are an even thickness—from 1/2" to 1½" thick, depending on the overall size of the sculpture. Uneven walls may cause cracking. If the object cannot be hollowed from the bottom, it may be necessary to cut the model into sections with a saw (a-sciotté) made of twisted strands of 24-gauge wire. An old wire wound guitar string will work satisfactorily. The inside clay is then carved out, and the shell is put together again—after the edges are scored and coated with a thin layer of slip. Slip is a thin paste of water and clay from which the sculpture is made.

It is important that the sculpture be thoroughly dry before firing is attempted. Drying should occur slowly and may take many weeks in the case of large pieces. Rapid, uneven drying will cause uneven contraction of the clay and result in cracking. It may be necessary to

protect the sculpture from air currents with a cloth cover. The dried object, called "greenware," should be smoked (gently heated to drive off water remaining in the clay), to prevent the formation of steam in the clay during firing, which could result in the destruction of the object. Usually earthenware sculpture is fired to Cone 06 (about 1840° F., at a temperature rise of 68° F. per hour), but the temperature can be varied in order to attain a desired color, or degree of porosity or hardness. If additional color or textural variation is desired, the fired object, known as "bisque ware" or "bisquet," can be coated with a glaze and fired a second time. It is imperative that the glaze and the clay body be compatible at the temperature range at which the sculpture is to be fired, or the glaze may flake off (shiver) or crack (craze). If the glaze and clay body are highly incompatible, the body may crack during the cooling process because of the great difference between the rates of contraction of the glaze and the body.

Figure 4-28

Figure 4-30

Figure 4-29

Figure 4-31

Tools Required

a. Clay mallets and pounding stick of lignum vitae (figure 4-26A)
b. Spatulas (figure 4-26B)
c. "T" bevel or square (figure 4-26C)
d. Dividers (figure 4-26D)
e. Plumb bob (figure 4-26E)
f. Assorted large clay modeling tools of lignum vitae (figure 4-27A)
g. Medium-sized wood modeling tools (figure 4-27B)
h. Plastic modelng tools (figure 4-27C)
i. Modeling tools for details and a needle (Figure 4-27D)
j. A-sciotté (figure 4-27E)
k. Stainless steel modeling tools (figure 4-27E)

Modeling in Clay

1. Prepare the clay if necessary. Water-base clay may need to be sifted, slaked, blunged, dried, and wedged before it can be used (pages 41 and 42).

Figure 4-32

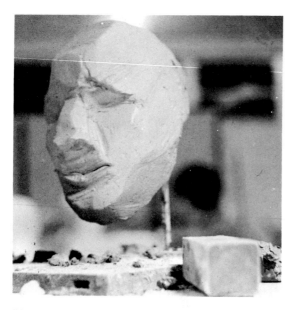

Figure 4-33

Figure 4-36

Figure 4-34

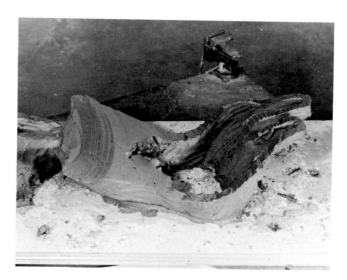

Figure 4-37

Figure 4-35

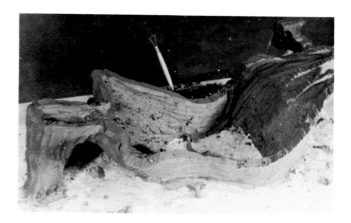

Figure 4-38

Figure 4-39

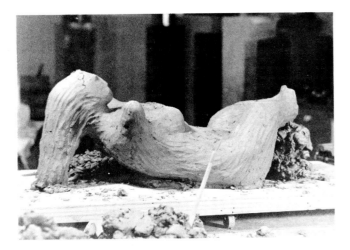

Figure 4-40

2. Prepare the armature if one is needed (figure 4-28).
3. Apply the mass of clay to the armature in small pieces (figure 4-29), or pound small lumps of clay together to the rough form desired (figures 4-30 and 4-31).
4. Shape the clay with a mallet, modeling tools, or the hands by striking, pressing, pushing, or squeezing (figures 4-32, 4-33, 4-34 and 4-35).
5. Water may be sprayed onto the water-base clay if it tends to dry out. Between work sessions, wrap water-base clay with wet cloth and cover with sheet plastic to prevent the clay from drying out.
6. If the sculpture is to be fired, it must be hollowed and the armature removed if there is one (figures 4-36, 4-37, 4-38, 4-39 and 4-40).
7. If the sculpture is to be cast, refer to the applicable substitution technique in chapter 6.

Wax

Small wax sculpture is usually constructed in solid wax, while large wax sculpture is modeled over an armature constructed of wire or, when the wax is to be cast in metal, over a core of investment. Waxes for modeling can be obtained from the commercial sources or compounded of common materials (page 271). Modeling waxes often require some adjustment of composition in order to be suitable to the season of the year. Small quantities of paraffin can be melted into the wax to stiffen it for warm weather, Vasoline and 30 wt. non-detergent motor oil can be used to soften the wax for winter. If the wax will not stick to itself a small amount of resin can be melted into the wax batch.

We tend to think of waxes as being similar to parafin or candle wax, but some of the most interesting of the waxes available to the artist through foundry and pattern supply houses are so hard that they can be machined. Very little use has been made of these waxes so a great deal of experimentation with them is yet to come. Waxes are quite often translucent and cause some visual difficulty during modeling. Colorants, such as English vermilion or red or green stearate compounds, can be added to make the wax opaque, so long as they do not leave a residue in the mold when the wax is melted out (especially if the wax is to be cast in metal).

Tools Required
a. Alcohol lamp or Bunsen burner (figure 4-41A)
b. Various metal tool shapes to be heated and used to model the surface of the wax (figure 4-41B)

Wax Modeling
1. A suitable wax is compounded in a double boiler. Recipes for waxes are listed on page 271.
2. The molten wax (heated to just a little above its melting point) is poured onto sheets of wet formica, wet plywood, wet paper, or best of all wet plaster bats (figure 4-42). If the wax sticks, the sheets are too dry or the wax is too hot. Re-wet the areas before each succeeding pour.
3. If the wax form will be too large to stand by itself an armature should be constructed and fastened to a solid base. If the wax is to be modeled over an investment armature, refer to the discussion on investments on page 134.
4. Strips of warm wax formed into balls are wrapped around the armature or core, to build the necessary bulk. Wax can be melted and brushed over

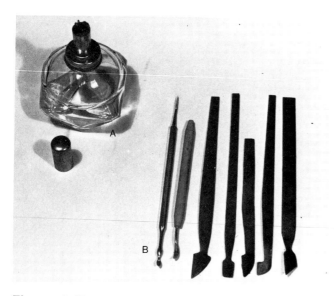

Figure 4-41

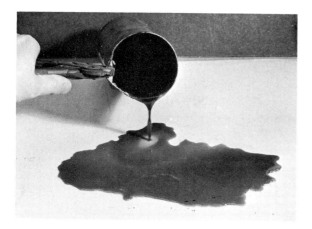

Figure 4-42

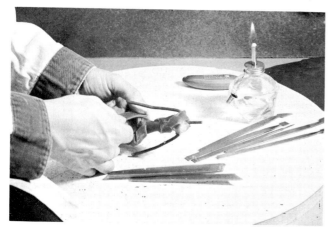

Figure 4-43

a core to build a uniform thickness as is required for casting purposes (figure 4-43).

5. Some waxes can be modeled direct while they are warm, and they will remain pliable as long as they are being handled. If they become too soft they can be dipped in cold water to stiffen them, or in the winter when they tend to become brittle they can be modeled under a heat lamp which will keep them pliable.

6. Metal tools, heated with an alcohol lamp or Bunsen burner, can be used to model the surface of the wax (figure 4-44).

7. Textural effects can be obtained by pressing, scrapping or rubbing textured materials or objects into the surface of the wax. Pouring molten wax into cold water will cause highly textured, convoluted masses of wax (figure 4-45).

8. Wax sculpture must be protected from concussion, abrasion, heat, and cold. Because of the almost certain loss or damage of waxes, most wax sculpture is prepared for the substitution process and cast in metal or plastic.

Plastic

Because the development of plastics has reached the state of the art where the medium can be "custom tailored" to the requirements of a designer, there can be no current comprehensive listing of available materials and their characteristics, that will not be obsolete before it is published. Products of the plastic industry are publicized in the trade magazines and the annuals (such as Modern Plastics). Although directed towards industry, the information packed periodicals keep the artist informed of the products in development and their characteristics.

There are two basic categories of plastic of interest to the sculptor. Thermoplastic materials soften on application of heat and harden when they are cooled. Thermosetting plastics, on the other hand, are fluids that become permanently rigid through the application of heat or the heat of a chemical reaction.

Thermosetting plastics have been mixed with clay or clay like fillers and a coloring agent in order to manufacture a modeling medium similar to plasteline or plastecine. The plastics, usually epoxy or polyesters, permanently harden the manipulatable body. The hardened body can then be finished with most painting systems, if the proper primers are used. These bodies cannot be rejuvinated for reuse and they will not withstand heat over 350°F. (176.7°C.). Epoxy bonded modeling clays are expensive, roughly fifteen

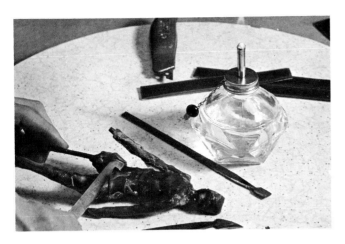

Figure 4-44

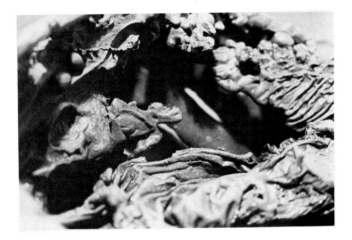

Figure 4-45

to twenty-five times more expensive than equal quantities of dry water base clay, they are difficult to locate, and they may present a serious health hazard. Allergic reactions may prove fatal to some individuals. Normal safety precautions require the use of eye protection, skin protection, and thorough ventilation. Foundry and industrial school suppliers have stocked these clays but they are being used with less frequency with the disclosure of their toxicity. Actually, the solvent in the mixtures rather than the epoxy may present the health hazard, because the hardened epoxy is almost totally chemically inert.

A similar material though faster curing is sold in discount houses as plumber's puddy. It hardens rather quickly and is very expensive. There are other plastic based media which are very interesting such as the water activated phenolic binders. These materials are designed for high speed mass production so their curing times are often too fast (short period of plasticity) for the artist.

Polyester and epoxy resins commonly used by sculptors in the creation of glass fibre reinforced forms. Although there is considerable hands on manipulation of the medium the nature of the form is usually a result of substitution rather than manipulation. Instructions for the use of glass fibre reinforced resins can be found on pages 120 to 123.

Polyesters and Epoxies

1. Construct an armature which occupies the bulk of the sculpture. If the armature can be designed using clay or wax, for a core, the core can be removed from the finished sculpture, leaving a hollow shell, and reducing the weight of the sculpture considerably.
2. Make a test batch of resin to determine the proper quantities of aggregate, pigment, fillers, and hardening agent. Record the batch quantities.
3. Using the batch records for reference, dry mix the aggregate, fillers, and pigment in sufficient quantity to complete the form.
4. Mix a small quantity of the resin, dry mixed ingredients, and hardner in the proper ratio as indicated by the batch records. Do not mix the batch rapidly or violently. The mix should be stirred slowly for a couple minutes before it is used. Manufacturer's directions should be followed regarding hardening agents, curing time, suitable aggregates, etc. WARNING: Do not reverse the ratio of hardner to resin as a violent chemical reaction may take place.
5. Apply the small batch of resin and repeat steps 4 and 5 as required.
6. If raw resin is used, mix the resin with its appropriate hardening agent. In most cases, raw resin must be reinforced with some material like fiberglass mat.
7. Apply the resin with plastic, wood, or metal spatulas, in the case of aggregates, and with brush or roller for raw resins.
8. Many aggregates cure with an unpleasant glossy surface, which will hide the texture and color of the aggregate. This gloss can be removed by sanding, light grinding, or sand blasting.
9. The surface of the plastic can be modified by filing, grinding, and cutting, but chiseling should be avoided because aggregates may cause brittleness or otherwise be unpredictable, when subjected to heavy impact from sharp tools.

Safety Precautions

1. Work only in areas with adequate ventilation. Forced air may be necessary to remove both vapor and solid particulants.

Plastic	Small Slip			Flame color	Odor	Burning Rate		
	hard	soft	tough			slow	fast	none
Polystyrene	X			Yellow with black smoke black lumps	natural gas	X		
ABS		X	X	Yellow with black smoke black lumps	natural gas and rubber			
Acrylic	X			Blue with yellow tip	fruit	X		
Nylon			X	Blue with yellow tip drips	burned wool	X		
Polypropylene			X	Blue yellow tip, drips and burns	sweet	X		
Polyethylene			X	Blue with yellow tips drips and burns	wax		X	
Polycarbonate			X	decomposes				

Figure 4-46. Flame test identification of common thermoplastics.

2. Use adequate eye protection. Recent medical information has revealed that a common hardner of polyester resin will irrevocably destroy the tissue of the eye. If this catalyst contacts the eyes, it must be washed away within four seconds or it begins tissue disintegration which cannot be stopped.

3. Respirators should be worn when working with plastics. Cannister types (which remove toxic fumes) should be used when working with liquids although filter types can be used when grinding or sanding solids.

4. Avoid skin contact.

5. Do not taste or swallow. Do not store or wash plastics around food.

6. Treat fluid plastics and components as poisons, and keep them locked away from children.

7. Do not work fluid plastics around heat or open flames.

8. Do not smoke when working plastics.

9. If the plastic flames or vaporizes for any reason, do not breathe the smoke. Some burning plastics release cyanide which can kill in as few as 20 seconds.

10. Powdered metals (especially lead) are often mixed with resins and must be handled as poisons.

11. Do not reverse mixing proportions of resins and hardners as an explosion may result.

Thermoplastic materials which are available in sheet, rods, tubes, granules, powders, etc., have been the subject of much experimentation by the sculptor. Styrenes (polystyrenes and ABS plastics) can be modeled by the direct application of heat and pressure. The heat can be supplied by soldering irons, heat guns, infrared lamps, hot plates and aso on. Common plastic bottles may provide an inexpensive source of plastic for experimentation though not all will be one of the styrenes.

Some thermoplastics can be welded by melting the plastic together with a clean soldering iron, or shaped and heated metal rod. This capability along with their elasticity while heated lead to some very unusual visual effects.

Many thermoplastics such as the styrenes, acrylics, nylons, phenoxys, polyethylenes and polysulfones, become pliable when heated. While hot they can be bent, twisted, and stretched and will retain their new shape on cooling. Some of these plastics have a memory and creep slightly when cool. Butyrate, for instance, valued for its ease of forming while hot and for its transparency, will return to its original shape when reheated. It has a problem which restricts its use for precision shapes, it tends to return slightly to its original shape even when it is cool.

Figure 4-47. Di-Acro plastic press Model #18, O'Neil-Irwin Mfg. Co., Lake City, Minn.

Thermoplastic sheet stock can be manipulated easily by fastening the sheets in a rigid frame and applying heat. The sheets can then be manipulated by direct pressure. The surface of the sheet is affected texturally, non-autographically, but the sheet itself will be responsive and will take a print when blown, drawn, stamped, or pressed into a mold. If the sheet stock is to be manipulated with hand pressure, soft cotton gloves should be worn to prevent burns on the hands and damage to the plastic surface. Large flat sheets of plastic can be heated locally and manipulated in small areas. Larger regular shapes can be blown by applying air pressure to the heated sheet or drawn into a mold by the use of a vacuum.

Tools Required
a. A rigid frame
b. A heat lamp, hot plate, heat gun, or oven
c. Vacuum cleaner and hoses
d. Pressure or vacuum forming press, if available (figures 4-47 and 4-48)

Direct Modeling Plastic
1. Select or construct a rigid clamp-type frame.
2. Clamp the plastic into the frame (figures 4-49, 4-50, and 4-51).
3. Heat the plastic in an oven, with heat lamps, or over a hot plate, being certain that the plastic does not sag and touch a hot surface (figure 4-52).

Various kinds of plastic require different treatment. The easiest types to use, styrenes, butyrate, and ABS's, will generally respond to being heated to 225°F. (107.2°C.) in an oven with the door slightly open. Acetates, which are also readily available, require a higher temperature and longer "soaking" time. Thick sheets over 1/8″ (3.175 mm) of any of the plastics are difficult to form.

4. Remove the heat and manipulate the plastic (figure 4-53).
5. Remove the plastic from the frame and trim as required (figure 4-54).
6. Formed shapes should be kept away from heat, as most of this type of plastic has a "memory" and will return to its original shape when heated.

Vacuum Forming Plastic
1. Drill or pierce the outer edge of the plastic sheet with a hot wire if necessary. Do not try to punch the sheet with a sharp tool. Most frames require perforation of the plastic to match pins in the frame which prevent the sheet from stretching away from the frame.
2. Fasten the sheet plastic in a frame (figures 4-47 and 4-48).
3. Heat the plastic until it relaxes and sags.
4. Place the model on the plenum.
5. Quickly place the frame holding the plastic over the plenum.
6. Turn on the vacuum until the plastic is cool.
7. Remove the plastic sheet from the frame and trim as necessary.

Pressure Forming Plastic
1. Fasten the sheet plastic in a frame (figures 4-47 and 4-48).
2. Heat the plastic until it relaxes and sags.
3. Quickly place the frame holding the plastic over the plenum.
4. Place the model over the soft plastic sheet.
5. Turn on the pressure to swell the plastic against the model until the plastic is cool.
6. Remove the plastic shape and trim as necessary. Considerable care should be taken to seal the frame to the plenum. Air leaks will decrease the efficiency of the vacuum or pressure former to the point of uselessness. If it is discovered that the plastic will not draw into some areas of the model, the model may have to be vented in order to let the air out of trapped areas.

Machining Plastics
Most plastics can be shaped by machining if they are cut at relatively high surface speeds, with a light constant cut, at slow feed speed, and cooled, usually

Figure 4-48. Formicator, couresty Idea Development, Inc., Newark, Delaware.

Figure 4-49

Figure 4-50

Figure 4-51

Figure 4-52

Figure 4-53

Figure 4-54

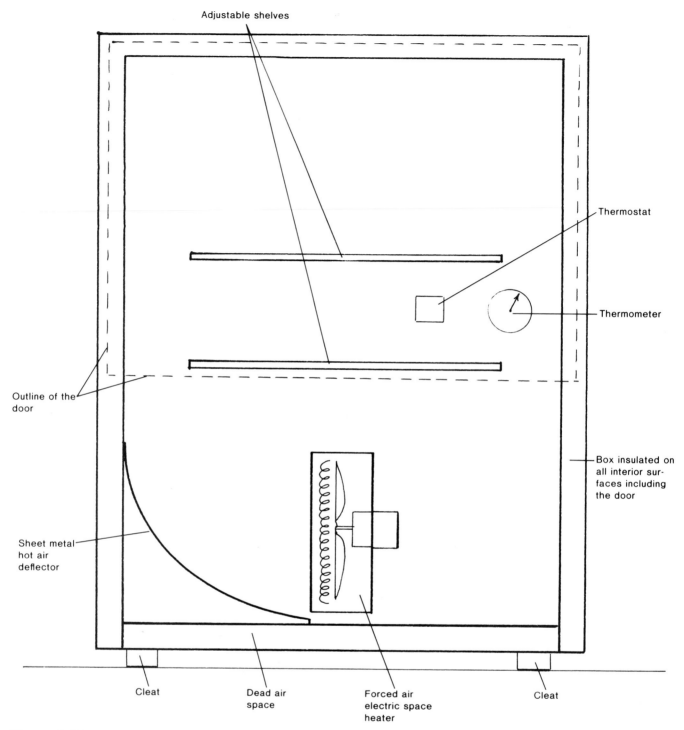

Adjustable shelves

Thermostat

Thermometer

Outline of the door

Box insulated on all interior surfaces including the door

Sheet metal hot air deflector

Cleat

Dead air space

Forced air electric space heater

Cleat

Figure 4-55

Plastic	Turn-ing SFPM	Depth of cut	Feed rate inches per RPM	Sawing SFPM	Blade type	Feed RPM	Impact shaping Blanking Shearing Punching Max. thickness	Drilling RPM	Drilling Feed FPR
Polyethylene Polypropylene TFE Fluorocarbon butyrate	450′	.005″	0.1″	15000-18000	carbide tipped or hollow ground	8′-10′	.25″	2,500	.015″-.030″
Hi impact styrene certain acrylics	500′	0.05″	0.1″	15000	carbide tipped or hollow ground	10′-12′	.048″	2,500	.005″ .010″
Acetal Nylon Polycarbonate	500′-700′	.02″	0.1″	15000-18000	*		.125″	2,500	.005″ .015″
Acrylics	700′	.05″	.02″	8000-12000	*	10′-25′	.125″ preheat	2,500	.005″ .010″
Polystyrene	100′-200′	.01″	.02″	3000-5000	hollow ground with coolant		NO	5,000	.005″

*For additional technical information see Figure 7-113 page 212.

Figure 4-56. Approximate machining speeds for thermoplastics.

with liquid coolants (figure 4-56). It is also important that the cutting tools be very sharp and have adequate tool design and chip clearance. The greatest problem with machining plastics comes with distortion and softening of the work because of heat build up. Machined acrylic shapes should be annealed before being joined by cementing.

Annealing Acrylic Plastic

Heat transfer in acrylic plastic is slow enough that severe internal stresses caused by uneven expansion and contraction can cause crazing, cracking or even shattering. These stresses can be minimized by evenly heating and then slowly cooling the plastic, a process known as annealing. Forced hot air which gives a fairly even heat is used to bring the plastic up to temperature. A simple insulated box with an electric space heater, a fan and a thermostat can anneal small plastic shapes (figure 4-55). Caution should be exercised when annealing heat formed shapes at temperatures near or over 180° F. (82.2° C.) because many plastics will distort at these temperatures and may begin to return to their original shape if the plastic has memory.

Thickest section in inches	Hours of heat up, heat soak and cool down				
	200°F.	190°F.	180°F.	170°F.	160°F.
0-.15	4	6	8	18	24
.15-.5	4.5	6.5	8.5	18.5	24
.5-.75	5	7	9	19	24
.75-1.5	6	8	10	21	24

Figure 4-57. Heating and cooling cycle for annealing acrylic plastic.

Parts to be annealed should be placed in the cold annealing oven and slowly brought up to heat. At the end of the indicated chart time, which includes the heat soak, the temperature should be decreased at the same rate, taking the same amount of time to cool as it did to heat (figure 4-57). Motorized timers and thermostats can be obtained to automize the annealing cycle. These annealing times are only recommended as conditions vary between annealing ovens and plastics.

Stresses in acrylic plastic can be seen as colored patterns if viewed through polarized lenses. These color

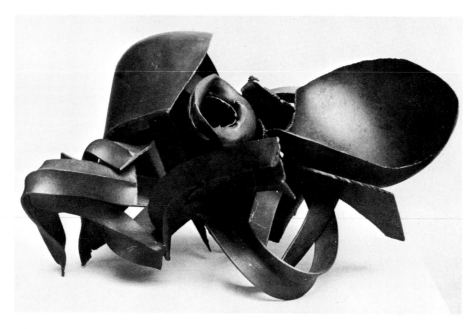

Figure 4-58 *L'Avaleur,* Robert Muller, Swiss, 20th century, welded iron, Contemporary. Collection of the Cleveland Museum of Art.

bands can be identified by bending or flexing a sheet while observing it through the lens. The color bands will change as the stresses change. Annealed plastic will have a minimum of the colored bands which will indicate that the stresses have been removed.

Polyvinyl Latex (modeling paste)

1. Construct a rigid armature which will also serve as a core, and which will have a coarse texture, such as window screen or plaster lath. If the sculpture is to be bulky, form the core to within 1/8″ (3.175 mm) or 1/4″ (6.35 mm) of the finished surface, in order to reduce the amount of material needed, and to reduce weight.
2. Remove a small quantity of the putty-like material from the container (enough for about 15 minutes' work) and apply to the plastic in thin layers, with metal, plastic, or wood tools. Thick applications tend to become crumbly. Areas requiring thick sections should be built up slowly in thin layers, allowing adequate time between applications for thorough hardening.
3. The surface of this material can be modified by filing, grinding, drilling, cutting, and sanding, if excess heat is avoided.

Metal

Any metal which is malleable can be manipulated sculpturally. Thin sheets of the metal are hammered to shape over sandbags, anvils, stakes, or prepared wood or metal forms. Mild steel, brass, copper, silver, gold, lead, and some of their alloys are metals commonly hammered or forged by the artist. Lead, the softest metal and not as subject to hardening as other metals, is probably the simplest to form, while copper and silver are probably the metals most often used by the artist.

The hardening that results from hammer blows on copper and silver and many other metals is serious enough to cause cracking, splitting, and crumbling of the metal if it is not annealed. The annealing process differs between metals, but essentially the metal is heated to a point where its crystalling structure undergoes a change, usually around red heat. The metal is usually heated in a reducing atmosphere to prevent oxidation, then allowed to cool slowly, or is quenched in a liquid depending on the metal.

Mild steel can be shaped cold, but because of its resistance, forming is frequently accomplished while the metal is red hot from a forge. Hard coppers are also often heated for forming, but some brasses and silver tend to become very brittle at temperature ranges near cherry red. At such temperatures, the slightest blow may cause the metal to crumble.

Because most manipulated metal also involves fabrication, greater detail regarding the qualities of various metals will be found on pages 177 through 182.

Figure 4-59 *War Machine,* John McNaughton, American, (1943-), sheet copper assemblage.

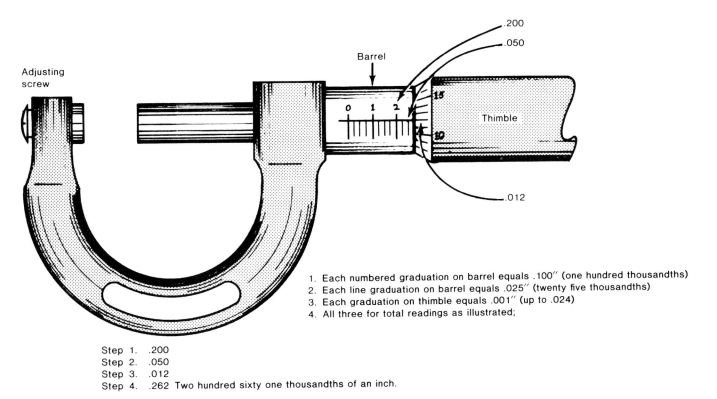

Adjusting screw

Barrel

.200

.050

.012

Thimble

1. Each numbered graduation on barrel equals .100″ (one hundred thousandths)
2. Each line graduation on barrel equals .025″ (twenty five thousandths)
3. Each graduation on thimble equals .001″ (up to .024)
4. All three for total readings as illustrated;

Step 1. .200
Step 2. .050
Step 3. .012
Step 4. .262 Two hundred sixty one thousandths of an inch.

Figure 4-60. How to Read a Micrometer.

A common metal available to the sculptor, but willingly overlooked, is light gauge sheet iron (figure 4-59). This metal, readily available from heating and air conditioning shops and junk yards, is mild steel, generally 16 gauge or thinner and frequently coated with zinc (galvanized) or tin (tinplate) (figure 4-60 and 4-61). It is seemingly difficult to work, but actually is reasonably easy to work if its disadvantages are taken into consideration. The metal will work harden from impact and bending, it will shrink if heated to red heat and slowly cooled, and it rusts.

Gauge number	American or Brown & Sharpe	Birmingham	American Steel & Wire	British Imperial Wire
	Wire & Sheet	Wire	Sheet	Wire
3	0.2294	0.259	0.2437	0.2520
4	0.2043	0.238	0.2253	0.2320
5	0.1819	0.220	0.2070	0.2120
6	0.1620	0.203	0.2010	0.1920
7	0.1443	0.180	0.1770	0.1760
8	0.1285	0.1620	0.1970	0.1600
9	0.1144	0.148	0.194	0.144
10	0.1019	0.134	0.1350	0.1280
11	0.0907	0.120	0.1205	0.1160
12	0.0808	0.109	0.1055	0.1040
13	0.0720	0.045	0.0915	0.0920
14	0.0641	0.0830	0.0800	0.0800
15	0.0571	0.072	0.0720	0.0720
16	0.0508	0.065	0.0625	0.0640
17	0.0453	0.058	0.0540	0.0560
18	0.0403	0.049	0.0475	0.0480
19	0.0359	0.042	0.0410	0.0400
20	0.0320	0.035	0.0348	0.0360
21	0.0285	0.032	0.0317	0.0320
22	0.0253	0.028	0.0286	0.0280
23	0.0226	0.025	0.0258	0.0240
24	0.0201	0.022	0.0230	0.0220
25	0.0179	0.020	0.0204	0.0200
26	0.0159	0.018	0.0181	0.0180
27	0.0142	0.016	0.0143	0.0164
28	0.0126	0.014	0.0162	0.0148
29	0.0113	0.013	0.0150	0.0136
30	0.0100	0.012	0.0140	0.0124
31	0.0089	0.010	0.0132	0.0116
32	0.0080	0.009	0.0128	0.0108

Figure 4-61. Useful wire and sheet metal gauges

There are two approaches to using thin gauge sheet metal. The artist can design forms around preshaped sections cut from existing pressed or stamped merchandise (auto bodies, appliances, furnance air ducts, and industrial scrap). Or the forms can be created from new flat stock which can be purchased from suppliers.

The first problem the sculptor will encounter with new sheet stock will be in materials handling. Although a 4' x 10' (1.22 m. × 3.048 m.) 14-gauge sheet of mild steel will weigh only 125 pounds (56700 g), it will be difficult to handle because it will be quite limp and slippery. Vice grips, "C" clamps, or sheet-metal vice grips can be used to grip the sheet so that it can be handled (figure 462A, and 462B).

Although the edges of full size new sheet stock are seldom sharp (the corners are sharp) there is enough weight to a full sheet of metal to sever a foot or hand if the sheet is dropped on it on edge from considerable height. It is important that every precaution should be taken to keep everyone out of the way of material which is being lifted off the ground. Sheet metal which has been sheared will have a very nasty sharp burred edge which will inflict a ragged, painful, usually dirty cut.

The second problem which will confront the sculptor will probably be cutting. Common sheet metal, except for stainless steel, in 16 gauge or thinner, can be cut with hand tools such as airplane snips, tin snips, hand nibblers, and the like (figure 4-63A and 4-63B). Heavier gauges can be cut with portable electric reciprocating saws (jig, sabre, do-all, etc.) (figure 8-33) if the proper blade is used (figure 8-34). Cutting with the reciprocation saw is slow and tedious and in the case of some metals, like stainless steel, just plain hard work. These saws will permit scroll cutting with a very thin kerf (slot left by the blade) and will not damage metal around the area of cut, but the cut line may wander on long continuous cuts. The blades usually leave a sharp burr on all cut edges. (Safety precautions page 257).

Special metal and slitting blades can be purchased to fit the common table saw. These blades grind their way through sheet metal fairly rapidly. They only cut on a straight line, throw off a lot of heat and sparks which are a fire hazard, and are quite brittle. These blades should never be used without a guard, which protects the operator in the event that the blade shatters while running at full speed.

Figure 4-62A

Figure 4-62B

Figure 4-63A

Figure 4-63B

More sophisticated and faster cutting tools are available in the form of portable electric shears and punches. The shears (figure 4-64 and 4-65) work quite rapidly and are generally available for stock up to 11 gauge (mild steel). They will cut a reasonably straight line, and can cut fairly small diameter circles, but they have a tendency to stretch some of the metal on one side of the line of cut. These shears are considerably cheaper than the punch or nibbler type of cutter.

The nibbler may be either air or electrically operated and uses a punch and anvil to punch out small sections of metal (figure 4-66). When the nibbler is moved continuously in a line the nibbler eats out a slot (from 1/8" [3.175 mm] to 1/2" [12.7 mm] wide) which separates the shape desired from the sheet. Nibblers capable of cutting plate 3/8" (9.525 mm) thick are not uncommon. The nibbler operates at about one fourth the cutting speed of the shear, but unlike the shear, it does not damage the metal around the area of the cut. The nibbler can also cut smaller diameter circles, from the center of sheet metal, than the shear can cut. The nibbler has the interesting capability of chewing areas away from a desired shape, as opposed to cutting a slot around the shape.

Most nibblers require that the line of cut be oiled either manually or with a built-in oiler. Dry operation will damage the very expensive punch and anvil. The spacing between the guide plates must also be adjusted to the thickness of the metal as recommended by the manufacturer of the machine. The nibbler is in some ways a delicate machine and may not be abused.

The small pieces of metal punched out by the nibbler are usually ejected into the work area. These planchets (as well as the edge of the line of cut) have sharp edges and are very slippery. They should be cleaned from the work area immediately after cutting.

There are versions of the shear and nibbler which are not readily portable and are available in machine shops, sheet metal shops, industrial arts facilities, fabricating plants, and so on. The Beverly shear and Pecto shear (figure 4-78) are hand and foot operated cutting machines. They are simple to operate, cut in straight lines and usually handle 16 gauge and lighter stock. There are shears available that will cut up to 1/2" (12.7 mm) plate.

As a last resort, the metals, with a few exceptions, can be cut with a gas or electric torch (see pages 204-205). Torch cutting is expensive, leaves a rather poor edge, and causes warping of the metal.

The third problem that faces the metal sculptor is that of forming. Simple shapes, bends, and curves, can be formed on breaks (figure 4-67) and rolls (figure 4-68 and 4-69). Light weight brakes and rolls that are capable of forming stock 16 gauge or thinner are

fairly common, but machines for bending or rolling thicker stock are extremely hard to locate, and impossible for the average sculptor to purchase. The "Iron Worker" a "C" shaped machine designed to cut, punch, bend, and even roll compound curves can occasionally be located in fabricating shops, but otherwise for heavier gauge metals or complex forms, such as recurving compound curves, the sculptor must turn to traditional hand working methods.

It may be easier to obtain shapes from scrap yards by cutting away a shape approximating the desired shape, and modifying the found piece if necessary, than performing the tedious forging processes necessary to raise compound curves. Stamped shapes have built in stresses (they want to spring back to their original flat shape) and they will be a little work hardened from their initial stamping. A tightly stamped crown (compound curve) commonly found on the rear fender of an automobile, for instance, may spring slightly open when it is cut away from the rest of the fender. The work hardening and spring-back can be removed by heating the metal to a bright salmon pink (1600° F. [871.1° C.], a little above bright red). On cooling the metal will be dead soft and its stresses, therefore its shape, will be normalized. The shape which will be shrunken slightly can be altered by selective hammering. A large variety of auto body working tools for this purpose are available at auto supply stores and discount houses (figure 4-70).

The area to be shaped should be backed up with a dolly three to four times the weight of the hammer. The steel is then hammered "around" the edge of the dolly to bring the metal forward or to sink the area. Hammers with small striking areas like a pick (figure 4-70A) will rapidly stretch and harden small pockets of metal leaving interesting textures but will make raising large areas difficult. Large flat headed hammers (only the center is flat) will tend to squeeze the metal (rather than punch it) to stretch it (figure 4-70B).

There are two techniques that are used with the body tools. The "hammer on" technique is striking the metal where it is backed up by a dolly. The hammer strikes the metal and rebounds. The dolly also bounces away. The dolly should not return to strike the metal. If the dolly returns to strike the back of the metal it will raise the area. The hammer on technique is used, for the most part, to flatten an area or to bring an area to a smooth surface.

The "hammer off" technique calls for striking the metal adjacent to the dolly. The dolly may "bounce back" from the hammer blow but unlike the "hammer on" technique it may also restrike the back side of the metal. The hammer should strike within 1/4" (6.35 mm) of the dolly which should be of the high crowned variety (figure 4-71).

Figure 4-64

Figure 4-65

Figure 4-66

Figure 4-67

Figure 4-68

Figure 4-69

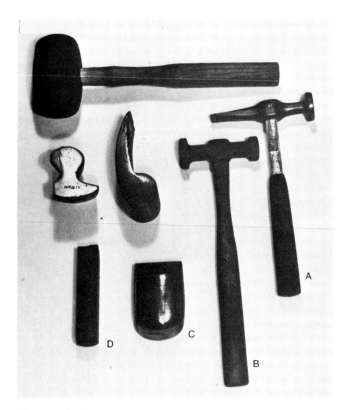

Figure 4-70

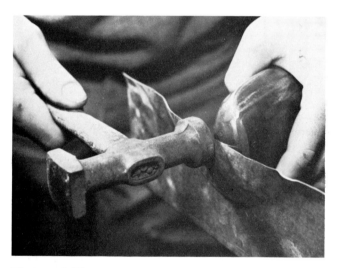

Figure 4-71

The hammer off technique is used for raising areas or forming simple or compound curved shapes.

Eventually the metal will work harden, resist additional shaping without cracking, and will become quite springy. This condition can be removed by annealing the metal.

Work hardened mild steel can be softened (annealed) by using heat, commonly an oxyaceylene torch with a large heating flame (rather than a welding flame) to bring the metal to an all over salmon pink.

The metal will expand appreciably on heating and on cooling will shrink to smaller than its original size. A slightly raised area (a bulge) hammered in the sheet may shrink to flat on cooling. Shrinkage can be minimized or localized if desired by quickly quenching the hot metal with a water soaked rag. The metal must still be hot enough to boil off the water for the quenching to be effective. Great care must be exercised to prevent severe burns from the steam generated during quenching.

Manipulating sheet metal this way requires a great deal of patience and expertise. If a raised section in a flat sheet is heated red and shrunk by slow cooling, stresses may be set up in the surrounding metal that may cause the sheet to buckle or pucker. The stresses can be relieved by reheating with less quenching in the case of buckling or in the use of hammer on technique in the event of puckering from excess shrinkage. When shrinkage is removed by using the hammer on technique, light widely spaced hammer blows are struck against light dolly pressure around the area of stress.

Flanges, folds, and edging, are fairly easy to form. A flat bucking bar (figure 4-70) is used like a dolly and repeatedly moved along the line of bend while the metal is hammered and bent in a hammers on technique (figures 4-72 and 4-73). On flat stock the metal should be bent on a break (metal folder) if possible. If a break is not available, the metal can be clamped between steel bars or hard wood rails and then bent by folding with a stiff straight edge. Once a fold is established, the straight edge should be struck in place with a heavy hammer to set the bend. The edge of the fold can be sharpened (a smaller radius) by hammering a bucking bar along the face of the edge while it is still clamped between the bars. Bucking bars used in the preceding operations should have rounded edges to prevent sharp dents from appearing in the metal.

Hard wood or heavy metal patterns can be used for forming mild sheet metal up to 16 gauge. Soft wood can be used for patterns for up to 18 gauge and tin plate. Bucking bars may still be required to retain the original plane of the metal while forming the metal over the edge of the pattern (figure 4-72). Of course dollies should be used in the place of flat bucking bars when the edge is to be made on curved stock.

Sheet metal machinery such as metal stretchers, shrinkers, rollers, edgers, punches, and so on can make the progress quicker and easier. Any Tinner, heating and air conditioner shop, and most schools with industrial arts type courses have this type of equipment. For a good many years highly satisfactory, but obsolete, sheet metal equipment has been available on the used machinery market, at very reasonable prices.

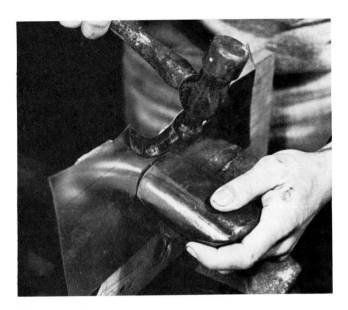

Figure 4-72

Figure 4-74A

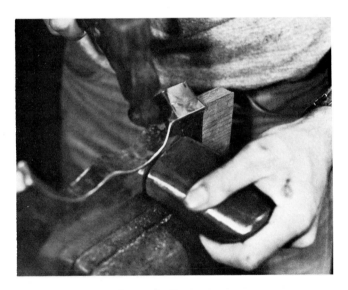

Figure 4-73

Much of the product of the small shops is being mass produced or is available in plastic (gutters and down-spouts, etc.) so the small lightweight equipment often resides unused in the basements of old hardware stores, plumbing shops, and even junk yards.

Complex sheet metal sculptural shapes may require fabrication of a series of formed shapes. The bits and pieces can be gas or electric welded, brazed, soldered, or even fastened with mechanical fasteners, like rivets, bolts, or held in place temporarily with cleco fasteners which act like rivets, but can be removed instantly (figures 4-74A and 4-74B). If the units are to be welded the welds should be treated in the same way that the metal is treated for annealing and shrinking.

Figure 4-74B

The units should be tack welded about every 6″ (152.4 mm) along the weld line, and the tack quenched with water immediately. After the units are tack welded the remainder of the bead can be run about 3″ (76.2 mm) at a time with immediate quenching after each 3″ (76.2 mm). Once the weld is complete the bead can be reheated to bright red and hammered flat or recessed so that the surface can be ground flat. The hammered surface will be stretched so that it may require some shrinkage to prevent the work from buckling. Experience only will dictate how much shrinkage and quenching will be necessary to prevent distortion of the work.

Joining techniques are described in the chapter on Addition (pages 182-205). Finishing techniques for metal can be found on pages 205-209.

Tools Required

a. Forge (figure 4-75)
b. Anvil with stakes (figure 4-76)
c. A sand bed
d. A heating and cutting torch (figures 7-86 and 7-87)
e. Tongs (figure 4-77A)
f. Blacksmith's hammers (figure 4-77C)
g. Cutting tools (figures 4-78, 4-36A, 4-36B, and 8-33)
h. Stakes (figure 4-79)

Modeling Metal

1. Anneal the metal if necessary. Silver should be heated to a dull red and quenched in water or a pickle (a cleaning agent). Yellow or green gold should be heated to a cherry red, and then either quenched or allowed to cool slowly. Copper should be annealed in a muffle furnace (a reverberatory furnace), as quickly as possible; over-annealing will burn the copper yellow, causing it to become granular and extremely brittle. The best way to anneal copper is to heat it in iron pots while introducing steam. Steam should isolate the copper from the air until it has cooled to below 250° F. (121.1° C.), or it should be dipped into cold water until it is cool.
2. Cut the sheet to the desired shape with metal saws, chisels, tin snips, a metal shear, or (except for nonferrous metals) a cutting torch.
3. Heat the metal for forming if necessary.
4. Place the metal over the appropriate sandbag, anvil, or stake, and hammer with light blows, working out from the center in a circular direction around the center (figure 4-80). Blows should overlap, and the process should be repeated until the form which is desired is procured or until annealing is required.
5. If necessary, the metal is annealed and step 4 is repeated.

Repoussé

For copper or silver repoussé (a relief form which is worked from behind the face of the sculpture), the sheet should be faced with a resilient pad of pitch or wax—rather then sandbags, which will not hold the metal firmly enough.

1. Heat the sheet metal and press it onto a deep pad of warm pitch or wax (recipe on page 271).
2. Allow the metal to cool completely.
3. Use punches to depress the sheet metal into the pitch where the sculpture is to appear *raised,* working from the shallowest to the deepest area (figure 4-81). Remember that the relief will be seen from the face which is embedded in the pitch, so areas which are depressed with a punch will appear raised from the front.
4. Remove the repoussé for annealing if required, by warming the metal slightly and prying the metal loose from one corner.
5. Anneal and readhere the metal for additional forming.
6. The repoussé should be removed from the pitch, cleaned, and readhered, face up, on the pitch for final forming and chasing of the surface with textured punches.

Other Media

It is of course possible to manipulate materials which are only temporarily plastic, such as some plastics, cement, plaster, and glass. Most of these materials are difficult to control because of their lack of strength, lack of adhesion, or lack of direct control of hardening time while in the plastic state. Sculptural use of these materials is therefore frequently involved in more than a single technical method.

There is also a problem, unique to glass and some plastic, that requires a concept different than that of opaque sculpture. Clear glass denies its bulk, in that it is transparent. Differing from most sculpture, the glass object does not create shadows which define its exterior shape; instead, its visual interpretation depends on refraction and reflection of light through the mass—neither defining the surface nor defining the interior of the mass itself (figure 4-82).

Like most other new or little-used media, glass has primarily been used in imitation of other media (especially ceramics), which involve visual concepts suitable for opaque materials. The greatest asset of glass, transparency, has been used with color or graphic effects rather than for itself. For the most part, the forms produced in glass could, or have been, produced with opaque materials.

Figure 4-75. Johnson gas forge #133, Johnson Gas Appliance, Cedar Rapids, Iowa.

Figure 4-76

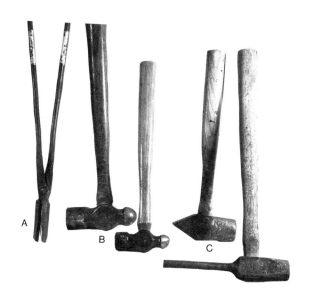

A

B

C

Figure 4-77

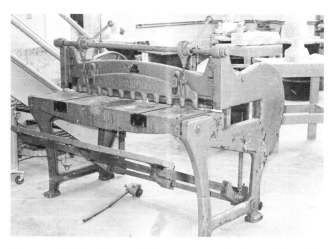

Figure 4-78 Pexto Shear, manufactured by the Peck, Stow, and Wilcox Co.

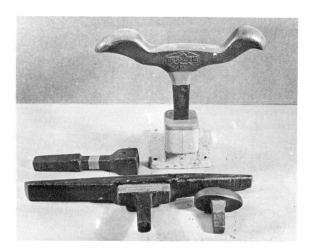

Figure 4-79

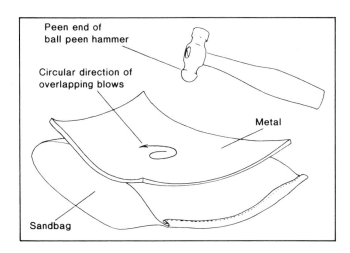

Peen end of ball peen hammer

Circular direction of overlapping blows

Metal

Sandbag

Figure 4-80

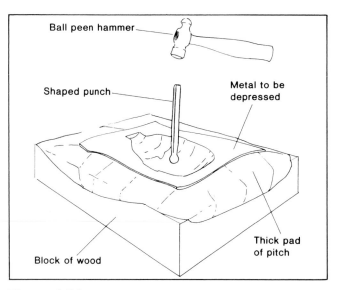

Figure 4-81

Figure 4-82. *I am Yesterday, I Know Tomorrow, Who Then Is He.* Michael Fix, American, (1948–), glass, formica.

5
Subtraction (Carving)

There are three approaches to the subtractive method of obtaining a three-dimensional object from a solid mass: (1) the appropriate contour or profile of the form desired is drawn on each of the faces of the material, then carved through to form a three-dimensional silhouette (figure 5-1); (2) the block is worked from all directions, removing excess material until the desired form emerges (figure 5-2); (3) points of the sculpture which lie on the surface of the block are located, and the block is cut back from these points until the required planes of the sculpture are revealed and subsequently join the other points (figure 5-3). Each method has its advantages, depending on the form, the medium, and the artist.

Common media suitable for carving include wood, stone, cement, plaster, clay, and some plastics.

Wood

Almost any wood can be carved, but preferable woods have a few qualities in common. Choice woods cut clean, without tearing, crushing, or breaking of the fibers; they are devoid of excess rosin or sap; they are hard enough to resist bruising or denting from mild blows of a blunt instrument; and they must dry without rapid deterioration or excessive checking (splitting).

In many parts of this country locating seasoned wood (properly dried) in blocks large enough for carving, has become nearly impossible. Generally trees which are to be seasoned for carving should be cut down after the leaves fall in the autumn. The logs should be cut into lengths 2' (50.8 mm) longer than the lengths desired for carving because 8" (203.2 mm) to 18" (457.2 mm) of the end of each log may be lost to checking.

The bark should then be removed and the ends of the log painted with enamel, tar, shellac, or wax, in order to slow up the loss of water through the end grain. Large logs may need to be split lengthwise to prevent the massive checking evidenced in figure 5-6. The logs should be stored out of the sun and weather and stacked in such a way that there is free circulation of air around them.

The scarcity of dried carving wood has forced carvers to resort to bothersome measures. Sculptors have begun to carve green wood when in the past they would have certainly used other material. In some cases green wood doesn't carve as crisply as well seasoned wood, interestingly enough, as in the case of oak, the green wood carves easier than old wood. Most green wood shrinks and checks disastrously unless it is dried very slowly, or unless the center or the wood mass is removed so that the wood can shrink on itself. Many types of wood have been cut, and

Figure 5-1

Figure 5-2

Figure 5-3

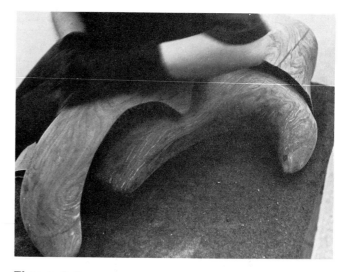

Figure 5-4

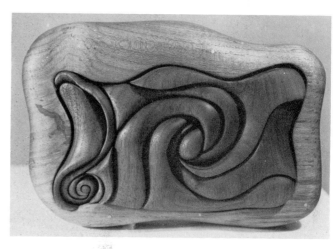

Figure 5-5. *Ten J's and Two Dots,* Peter Wegner and Dominie LeVasseur (German 1943- , American 1953-), Purple heart wood, Courtesy Gallery One, Ann Arbor Michigan.

Figure 5-6

stored in plastic bags where they are kept wet for short periods of time. The wood is removed from the plastic bag for carving sessions at which time it is coated with linseed oil. Unfortunately, linseed oil soaked wood will not accept all finishes. Tung oil can also be used in place of the linseed oil. It will not soak in as far and will harden on the surface of the wood. It can be removed at a later time for any type of finish.

The wood must be stored in the plastic bag until the carving is finished and a finish which will drastic-ally retard drying of the wood is applied to the sculpture.

Fruit woods like apple, cherry, and pear, nut woods like walnut, hickory and oak, and others like birch, maple, teak, rosewood, ebony, lignum vitae, mahogany are all good carving woods (figure 5-7). Common construction lumber like most pine, fir, cedar, and red-wood, which are soft and tend to tear while being cut or which have uneven hardness due to the varying density of the growth rings or deposits of sap, make poor woods to carve. Because they are inexpensive, however, their use is common.

Figure 5-7. Some wood that the sculptor may encounter.

Names	Colors	Comments	Availability	Origin
ACCACIA (See MYRTLE)				
ALANTHIS (TREE OF LIFE, TREE OF HEAVEN)	cream	very weak, punky not available commercially	common	U.S.
ALDER	red pale pinkish brown to white	good working qualities	plentiful	U.S.
AMERICAN HORNBEAM	(see BLUE BIRCH)			
APPLEWOOD	sap-red, heart-brown	good working, checks badly, short lengths common	not plentiful	U.S.
ASH	white to green and black and cream to light brown	tough, elastic, will bend easily if steamed or soaked of the six ashes (BLACK, MOUN-TAIN, BLUE, BLUEBERRY, BRUSH, and WHITE), the BLACK ASH is probably the weakest and most brittle	plentiful	U.S.
ASPEN (see POPLAR, POPPLE)				
AVODIRE	white to gold			
BALSAWOOD (LIMEWOOD)	tan-brown	extremely light and soft, sands & saws easily, glues well, hard to carve because it tears and rips	plentiful (expensive)	Equadore
BASSWOOD (LINDENWOOD, LINWOOD)	cream to white	carves well, machines easily, glues well, even close grain	plentiful	U.S.
BEBEERU (see GREENHART)				
BEECH (SWEET BLACK & CHERRY BIRCH)	white-tan brown	splits easily, carves easily, hard fine grain, slightly hard	plentiful	U.S.
BILBERRY (see MYRTLE)				

Figure 5-7. (Continued)

Names	Colors	Comments	Availability	Origin
BIRCH (SILVER, GRAY & SWAMP)	redish-light brown	hard close grain, splits easily on carving, polishes, stains, & finishes easily and beautifully	plentiful	U.S.
BLACKWOOD	(Biti-East Indies East Indian ROSEWOOD) (Black Mangrove West Indies)			
BOUKAU	(see BIRCH)			
BOX ELDER				
BOX WOOD	yellow-white	tough close grained, heavy, takes a fine polish	plentiful	U.S.
BRIARWOOD				S. Europe N.W. Africa
BUTTERNUT	light brown	easy to carve, similar to walnut but softer	moderately rare	U.S.
CALIFORNIA LAUREL	(see MYRTLE)			
CAMPHORWOOD	brown			
CANARYWOOD	(see TULIP)			
CANOEWOOD	(see TULIP)			
CASCARA BUCKTHORN	(see CHILLAM WOOD)			
CATALPA (BLACK BEAN bean tree)				
CEDAR, PORT OXFORD	yellow-brown	smells like ginger, good machining	available	U.S.
CEDAR, RED AROMATIC	banded red-white	frequent knots, poor carving	plentiful	U.S.
CEDAR, RED WESTERN	dull red		plentiful	U.S.
CHERRY, WILD BLACK	light red, brown	seasons beautifully, great to carve oxidized to dark red if aged without a finish	semi rare	U.S.
CHESTNUT	tan	light coarse grained, remaining available wood is wormy-trees destroyed by blight and remaining wood is found in barn beams, railroad ties and fences	rare	U.S.
CHITTAM WOOD (CASCARA BUCK-THORN SMOKE TREE)	orange			U.S.
COCOBOLO	yellow, brown, red	natural oil, will polish, some people are alergic to this sawdust		
COTTONWOOD	(see POPLAR)			

Figure 5-7. (Continued)

Names	Colors	Comments	Availability	Origin
CRAB APPLE	pink-brown		abundant	U.S.
CROCUS WOOD	(see GRENADILLA)			
CYPRESS	yellowish-brown,		plentiful	U.S.
DOGWOOD	yellow-brown	hard tough	available	U.S.
EBONY	brown	hard, heavy, durable, monotenous grain, takes fine polish	scarce	Asia, Africa
ELM	brown	very hard, tough, slightly stringy	available	U.S.
ELM, RED	light red	very tough	rare	U.S.
EUCALYPTUS, AUSTRALIAN	(see IRON BARK)			
FIR	light to deep yellow, ages gray	poor carving, good construction lumber	plentiful	U.S.
GREENHART (BEBEERU)	olive to black	very flexible, some people alergic to this wood		S. America
GRENADILLA (CROCUSWOOD)	black			
GUM (HAZELWOOD, SWEET, and RED)	heart-redish brown, sap-pink white, bluish	light grain, soft, fair carving, not strong, stains easily and is used to immitate walnut and mahogany, machines well	plentiful	U.S.
HACKBERRY	light yellow	similar to elm		U.S.
HAZELWOOD	(see GUM)			
HEMLOCK	white to yellow	poor carving, machines well	plentiful	U.S.
HICKORY	light cream	tough, durable, stringy	getting scarce	U.S.
HINOKE	pale yellow			
HOLLY	white, ages dark	difficult to glue	scarce	U.S.
HORSE CHESTNUT				
IRONBARK	(see AUSTRALIAN EUCALYPTUS)			Australia
IRONWOOD	cream to redish	name given to a great many species of very hard coarse grained wood, usually heavy, seldom available in large sizes		U.S.
JUNIPER (AROMATIC CEDAR)				
KENTUCKY COFFEE TREE		wood similar to LOCUST	rare	U.S.

Figure 5-7. (Continued)

Name	Colors	Comments	Availability	Origin
KINGWOOD (VIOLET WOOD)	violet			Brazil
KOA	gold brown with dark streaks	carves well, fine grain, machines well		Hawaii
LANCAWOOD	(see LEMON WOOD)			
LANCEWOOD	pink to red brown			
LAUREL, CALIFORNIA	(see MYRTLE)			
LEMONWOOD	pale yellow	very fine grain, tough, springy		
LIGNUM VITAE	yellow-orange-brown	heaviest of woods, beautiful color variation, often tight curly grain, contains natural oil which will polish the wood		
LIMBA	yellow-light brown			
LIMEWOOD	(see BALSA WOOD)			
LINDEN	(see BASS WOOD)			
LOCUST, HONEY	brown	exceedingly hard and durable, good for outdoor use	becoming scarce	U.S.
MADRONE (MANZANITA, MADRONA)	light red brown, white	shrub, difficult to season, warps and checks, polishes well (glass smooth)		U.S.
MAGNOLIA	cream, greenish cast, dark streaks	carves well, machines well	available in small pieces	U.S.
MAHOGANY, AFRICAN	red brown	easy to machine and carve, fairly fine grain, white wood is punky and does not carve well	available	
MAHOGANY, HONDURAS	red brown (deep color)	true mahogany, carves and machines very well, tight grain, polishes beautifully	available	Honduras
MAPLE, HARD	cream, red brown	light firm close grain, machines well, very hard to carve	plentiful	U.S.
MAPLE, SOFT	cream, red brown	soft easily broken, not the best to carve, rots quickly in damp areas	plentiful	U.S.
MARNUT	violet to brown			
MAZANITA	(see MADRONE)			
MESQUITE	brown	durable, hard, usually only small pieces available, heavy		U.S.
MONKEY BALL	(see OSAGE ORANGE)			
MONKEY POD	brown			Brazil

Figure 5-7. (Continued)

Name	Colors	Comments	Availability	Origin
MONKEY WART	(see MYRTLE)			
MULBERRY		durable	available	U.S.
MYRTLE (BILBERRY, TRAILING PERIWINKLE, MONEY WART, PEPPER WOOD, ACACIA, CALIFORNIA LAUREL)	yellow, brown, red, gray, black, silver	good to machine	rare	U.S.
OAK, WHITE	light brown to silver gray	new oak is easy to work, ages to be very hard and difficult to impossible to carve, strong, heavy, durable, beautiful silvery grain when quartersawed, machines well	available	U.S.
OAK BLACK	light brown	not as durable as white oak, no silvery grain when quarter sawed	available	U.S.
OHIO BUCKEYE			rare	U.S.
OSAGE ORANGE (MONKEY BALL TREE)	green yellow, orange	seasons badly, splits, porous, large grain, gnarled, once used as hedgerows	scarce	U.S.
PAKUAK, VERMILLION	brown violet, red with dark stripes	easy to carve		
PALDAO	red-brown			
PARTRIDGEWOOD	purple-brown	hard mottled		W. Indies
PAU FRTTO	purple-brown	similar to rosewood		
PEAR	pink cream		scarce	U.S.
PECAN	red brown, dark streaks		available	U.S.
PEPPERWOOD	(see MYRTLE)			
PERNAMBUCO	bright red			
PEROBA	rose-yellow			
PERSIMMON	brown black, white sapwood	cures poorly, hard fine grain		U.S.
PHEASANT WOOD	(see PARTRIDGE WOOD)			
PINE, SUGAR, WHITE	white, tan brown	irregular grain often soft with hard resinous areas, clear areas good machining	available	U.S.
POPLAR, COTTONWOOD (POPPLE, ASPEN)	yellow	not strong, flexible (used in baskets, strawberry boxes, etc.)	plentiful	U.S.
POPLAR, YELLOW (TULIP, WHITE WOOD, CANARY WOOD, CANOE WOOD)	yellow-white slightly greenish	light, soft, carves well, machines excellently, glues well, excellent for painting, staining, and finishing, holds dimensions (does not absorb moisture from the air)	available	U.S.

Figure 5-7. (Continued)

Name	Colors	Comments	Availability	Origin
PRIMA VERA	yellow white			
PURPLEHEART AMARANTH	deep purple (banded)	machines well, strong durable, elastic		Tropic Americas
RAMIN	gold			
REDWOOD	red	poor carving, fibers tear, surface soft, not strong, light, will polish	plentiful	U.S.
ROSEWOOD, African BENGE BUBINGA	 tan, black stripe red, purple stripe	 hard, beautiful grain, natural oil, polishes well hard, beautiful grain, natural oil, polishes well		
ROSEWOOD, Brazilian	dark brown to violet streaks			
ROSEWOOD East Indian (BITI)	dark purple to black, streaks red, yellow			
SABICU	pink red			U.S.
SANDALWOOD	yellowish	compact close grain, machines and carves well, spicey aroma		India, Australia
SAPELE	dark red-brown			
SASSAFRAS	soft yellow	aromatic		U.S.
SATINWOOD	yellow to brown with satin lustre	very hard		E. India
SHEDULA	yellow gray			
SMOKE TREE	(see CHITTAM)			
SPRUCE, SITKA	brown	light, soft, greatest strength for weight, good machining, regular grain	available	U.S.
SUMAC	yellow-orange-green	easy to carve, small sections only, Poison Sumac usually a shrub, occasionally a small tree, is very poisonous and should not be handled		
SYCAMORE (LONDON PLANE TREE, BUTTON WOOD, BUTTON BALL TREE)	red, brown, light brown	difficult to season, splits, does not split after seasoned, easy to carve, tight even grain	available	U.S.
TAMARRACK, LARCH		extinct in some areas because of insect damage, found in old railroad ties		U.S.
TEAK	yellow-brown	hard, durable		E. India
TULIPWOOD	(see POPLAR)			

Figure 5-7. (Continued)

Name	Colors	Comments	Availability	Origin
WALNUT, AMERICAN	brown to purple-brown, cream sap wood	seasons poorly without special treatment, carves beautifully, machines very well, wide range of grain patterns	becoming scarce	U.S.
WALNUT, CIRCASSIAN	tawny brown			
WALNUT, CLARO	dark brown with streaks, black, tan			
WALNUT, FRENCH	gray brown			
WALNUT, SOUTH AMERICAN	dark brown to purple brown			
WENGE	purple brown			
WHITEWOOD	(see TULIP POPLAR)			
WILLOW	light brown	not strong, light grain, supple	plentiful	U.S.
YELLOW WOOD (KENTUCKY YELLOW WOOD, GOPHER WOOD)				U.S.
YEW	red brown	heavy, hard, finely figured grain	rare	U.S. Canada
ZEBRAWOOD		any of several striped woods, usually tropical in origin		

Laminations of boards of the same or different kinds of wood are frequently used when suitable blocks of wood are not available (figures 5-9 and 5-10). Varying the colors of the lamination leads to intriguing (figure 5-11), but sometimes melodramatic color effects in the finished sculpture.

Wood to be laminated should be cut to length and glued up immediately so that the boards will not warp. The boards should be matched so that the grain runs in the same directions, marked and numbered for cutting, cut, then placed in the proper order and position for laminating (figure 5-13).

A heavy film of glue should be spread on both common surfaces of a pair of boards to be joined and the pair pressed together, the next pair spread, etc., etc. The glue can be spread with a piece of cardboard to help speed up the process.

The work must proceed rapidly to prevent the glue from drying off before the block can be clamped up. The block should be clamped in a pattern that will force a little glue out from the center (figure 5-8). The block should not be clamped tightly enough to squeeze out most of the glue or the bond will be weak.

Commercially prepared wood is usually kiln dried, and checking is minimized provided the wood is stored in a place which has an even temperature and humidity, or is coated with a sealer until it is used and finished. Checking should be considered a normal action of wood and the sculptor should allow for it and make use of it. If necessary, fillers or beeswax mixed with the appropriate color oil paint can be used to pack the checks. Packing these checks may prevent the wood from chipping along the edge of the cracks encountered during carving. Frequently, in time, checks in wood will close. If a hard filler, such as plastic wood, or plaster, is used in the cracks, the wood may be forced to split in other places when the original checks swell closed.

All wood has grain, although some grain is not obvious. The grain of the wood should be respected: cuts tangent to growth rings result in broad grain (figure 5-12); cuts at right angles to growth rings give narrow grain (figure 5-11); cuts against the grain cause the tool to dive or dig into the wood. Only cuts across the grain or with the grain permit the sculptor to maintain total control over the medium.

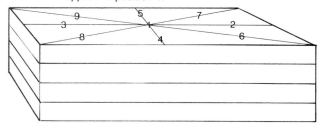

The first clamp should be applied in position 1.

Figure 5-8. Typical clamping sequence.

Figure 5-11

Figure 5-9

Figure 5-10

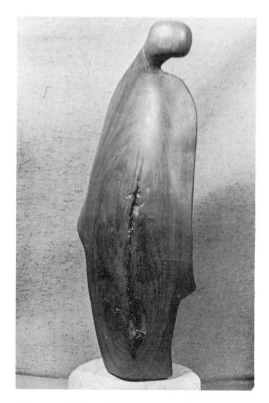

Figure 5-12. *Flapper*, walnut.

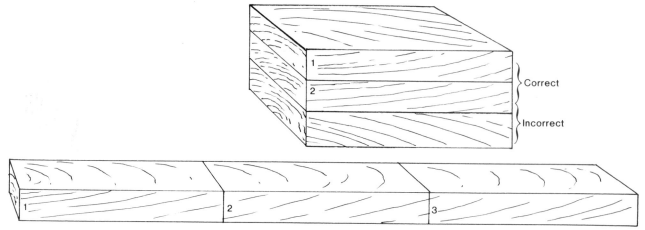

Figure 5-13. Proper method of stacking laminates

Although the vast majority of wood sculptures are carved with traditional tools like adzes and wood chisels, the advent of powerful, reasonably inexpensive pneumatic and electric tools has encouraged the grinding or sanding of sculptural forms from wood. Electric and gasoline chain saws can also be used to shape large masses of wood.

Tools Required

a. Sharpening stone (figure 5-14A)
b. Mallet, preferably of lignum vitae wood (figure 5-14B)
c. Gouges, (figure 5-14C, 5-14D, and 5-14E)
d. Flat chisels (figure 5-14F)
e. Skew chisel (figure 5-14G)
f. Parting or "V" chisel (figure 5-14H)
g. Sharpening slips (figure 5-14I)
h. Bent chisel (figure 5-14J)
i. Spoon chisel (figure 5-14K)
j. Bench lag bolt (figure 5-14L)
k. An assortment of rifflers and rasps (pages 247 to 249)

Additional tools for carving wood include air hammer (with an assortment of suitable chisels), bucksaw (figure 5-16B), handsaw (figure 5-16A), coping saw (figure 5-16C), band saw, hand adzes (figure 5-15A), foot adzes (figure 5-15B), and wedges and sledge (figure 5-15C).

Tool Care

Some newly purchased wood carving tools require only honing for use, more commonly though, new tools require some shaping and sharpening as well as honing. More often than not the run of the mill carving tool is only a blank requiring a great deal of preparation before it can be used to cut wood. Wood chisels should be made from high grade steel that is heat tempered so that the tool will hold an edge. The tool is first ground to shape on a fine wheel, by holding the tool at a right angle to the wheel (figure 5-17). Care must be exercised while grinding the tool to prevent overheating and burning the tool. If the metal changes color (turns blue) it has already burned, lost its temper, has become soft, and although it still can be sharpened it will not hold its edge. The tool should be cooled every few seconds by dipping it in water. Hollow grind the blade next, using the circumference of the wheel to bevel the tool (figure 5-18).

The tool should be held against the wheel very lightly and then only for an instant. Before any amount of heat build up occurs the tool should be inserted in cool water to cool. Beveling can then continue. The edge of the tool will become thin and heat up very rapidly. For this reason the urge to grind continu-

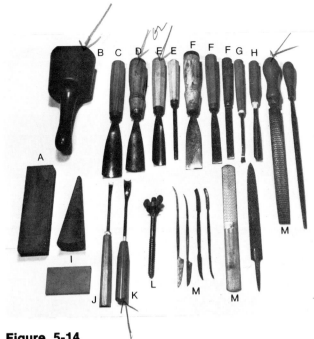

Figure 5-14

Figure 5-15

Figure 5-16

Figure 5-17. The wheel guard has been removed for photographic clarity only.

Figure 5-19

Figure 5-18. The wheel guard has been removed for purposes of photographic clarity.

ously should be ignored. Modern electric bench grinders are quite a problem to the tool sharpener. The grinding wheel turns far too fast, and produces too much heat. Actually the old fashioned large diameter treadle operated whet stones are vastly superior to the bench grinder. The speed of the whet stone was slow enough to permit a thin film of water to flow over the stone to wash away grit that would knick the blade and to cool the blade while being ground. Dripping water over a high speed electrical wheel would be a hazard.

The tool may be finished on the coarse side of a combination stone. The bevel is pressed against the stone and pushed forward (figure 5-19). To sharpen the stone quickly considerable pressure must be exerted against the blade while it is being pushed forward. It should not be pulled back while resting on the stone. Pulling the blade across the stone tends to fold a wire edge up on the blade and draws the blade over tiny grains of stone which scar and groove the bevel of the blade. The groves on the beveled sur-

face result in a rough saw tooth blade edge. When the blade is moved forward the tiny chips of stone are forced up over the edge rather than under the edge. The sharpening motion should continue until the edge of the blade appears to be the right shape and sharp with no flat spots. The face of the bevel should appear to be perfectly flat.

If even pressure is not applied while it is being shaped or sharpened the chisel face will appear to be curved or the edge of the blade will not retain the proper angle to the length of the blade.

Once the blade is rough shaped and sharpened it should be finish sharpened on the fine side of a hard combination stone and then a hard stone. The same routine is used to establish a fine edge except that care must be exercised to keep the surface of the stone clean. A dirty stone will ruin the edge of the blade.

A soft stone (washita or soft arkansas) cuts rapidly but leaves a saw tooth edge almost as rough as the grain of the stone. A hard fine stone (a hard arkansas or India stone) cuts very slowly but leave a super fine edge.

When the blade has acquired a razor sharp edge it is turned upside down and drawn or pulled backward over the thumbnail. If the blade has a burr or wire edge a small scraping of the nail will roll up under the blade edge. The wire edge may be removed by placing the tool flat bevel up on the hard stone and drawing the tool away from the edge once or twice.

Some carvers prefer to leave the wire edge on the tool because it tends to break the chip of wood, causing it to curl away from the chisel. An extremely sharp chisel without the wire edge will often sink deep and lodge in the wood.

Blades which are to be used for detail carving may need to be honed. Leather blocks or straps (from drive belting) are fastened to a bench and the blade is

pulled repeatedly under pressure over the leather away from the edge. A soapy lather applied to the leather will aid the honing. Honing will yield a razor sharp edge.

Curved gouges are sharpened the same way as flat chisels except that the blade is rotated evenly from corner to corner as it is pressed forward. The stone will wear in a pattern to fit the gouge, so stones used to sharpen gouges should not be used to sharpen flat chisels. Cone shaped India stones are available to sharpen gouges but they are slow and tedious in use and will not give as fine an edge as a hard arkansas stone.

The wire edge on a gouge can be removed with an arkansas slip by passing the slip along the edge several times. The slip should rest flat along the inside of the gouge parallel to the length of the blade, and should not be rocked over the edge of the blade.

Flat blades with a bevel on both faces should be sharpened as a flat chisel except that the faces should be ground alternately. Press forward on one face, return the blade and press forward on the opposite face.

Although some wood will sharpen chisels, most woods dull the blades. Balsa wood which is a soft wood, contains mineral deposits which nick thin edges. If the blade is sharpened often on a hard stone while it is being used it may be kept constantly sharp. If the blade is used too long without honing, it will become ragged and require finish sharpening, as well as honing before it will render satisfactory service. Generally speaking, if the blade is given a few good licks on a hard stone after every 5 or 10 minutes of carving, the blade will stay keen.

There are conflicting theories regarding the use of lubricants (oil, kerosene, water, spit, etc.) versus no lubricants on the stone during sharpening. Proponents of the lubricant theory claim that the oil floats the ground metal and the stone particles away from the blade, preventing gouging and scoring. The proponents also claim that an unlubricated stone will eventually load up with metal particles, ruining the stone.

Proponents of the no lubricant theory claim that stone particles floating in oil scratch just as badly as unlubricated particles. Any stone lubricated or unlubricated must eventually be cleaned and flattened. The stones can be scrubbed in soapy water with a very stiff brush to remove trapped metal particals. If a stone needs to be leveled because the center is depressed, it can be rubbed on another stone and they will flatten each other.

Metal tools should be oiled lightly with a nondrying oil such as Hope's #9 gun oil. Three-in-one type oil should not be used as the oil eventually evaporates and the tools will rust.

Wood Carving

Seasoned Wood
1. Fill the checks with beeswax.
2. Remove large unwanted areas of wood by sawing (figure 5-20), splitting (figure 5-21), and cutting away with an adz or a large gouge.
3. Lock the wood to a bench in a wood vise, with a large bench screw or with clamps and a bench stop (figure 5-20). If none of these is satisfactory, the wood can be placed on bags of sand or in a barrel filled with sand.
4. Gouges are used to rough out the shape. The tools are pushed by hand or struck with a wood mallet (figure 5-24). In order to prevent fatigue, air hammers with special chisels can be used. Start the tool into the wood at a 45° angle, but don't take too big a bite, and don't cut against the grain, as this may cause the tool to dive into the wood and jam. If the tool jams, do not strike the side of the tool or pry up on the handle or blade; instead, lift the wood by holding the chisel blade in such a way that the wood hangs down, then strike down on the wood to drive the wood off of the chisel. Do not lever with the tool, as this will probably break the edge, if not the whole end, of the tool (figure 8-14C).

 If the tool cannot be removed by this method, or the wood is too heavy to be lifted, the chisel can be cut free by cutting the wood away from the jammed tool with a flat chisel.

 Remove long strips of wood rather than chunks (figure 5-25).
5. Use small gouges to clarify the form and simplify the emerging shapes. Change gouges to suit the area being carved.
6. Use flat chisels to clean up textures left by gouges, if desirable, and to sharpen contours or edges (figures 5-26 and 5-27).
7. Rasp and sand areas which are to be free of tool marks (figure 8-38A and 8-38C).

Finishing
Wood which is to be polished will require some care in its surface preparation. The wood should be filed until its surface attains its proper configuration, at which time it can be scraped with thin pieces of spring steel (scrapers) or freshly broken pieces of glass. The scraper is held perpendicular to the surface of the wood and pulled toward the operator with the grain of the wood. If the scraper is operated properly it will peel off a very fine curl of material. The wood will have a slightly glossy surface. The wood should be sanded next. (Information on sandpaper can be found on page 261).

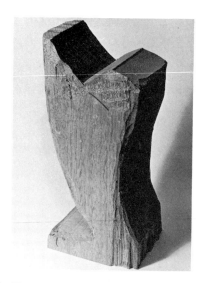

Figure 5-20

Figure 5-22

Figure 5-21

Figure 5-23

Figure 5-24

Figure 5-27

Figure 5-25

Figure 5-28

Figure 5-26

If the wood has been properly scraped the coarsest paper needed may be 360 grit. If the wood is slightly rough it may be necessary to use a coarser grit perhaps 120 grit to start sanding. The sanding should progress toward finer and finer grit (120, 240, 320 or 360, 400, and finally for a polish 600).

Some woods such as rosewood, lignum vitae, teak, and ebony have natural oils or waxes and do not need an artificial sealer or finish, other than polishing with a soft cloth. Other woods, however, require a protective coat, which prevents moisture intake, the collection of dirt, and perhaps enhances the color of the wood. It may also be desirable to tint the wood.

The sculptor has four options for finishing: wood can be left natural color and raw, it can be covered with an opaque paint, it may be tinted overall or in selective areas, and it can be coated with any one of many transparent sealing agents (waxes, oils, lacquer, etc.).

One of the best and simplest clear finishes consists of several rubbings of tung oil. Tung oil brings out the grain color of the wood without danger of yellowing or gumming. It tends to darken the wood giving a slightly wet look. Probably the most common oil finish has been the linseed oil treatment. Two or three brushed and rubbed layers of boiled linseed oil will provide a satisfactorily protective finish. Linseed oil has a tendency to yellow with time and must be oiled frequently. There are many commercial preparations sold for maintenance of furniture which will give satisfactory finishes on sculpture. Most paste waxes and some shoe polish can be used as directed for the product. Liquid Gold® will produce a soft wet look on unvarnished and unlacquered wood. Lacquer can be sprayed on and rubbed with steel wool to give satin finishes. Polyurethane, spar varnishes, and most lacquers produce a plastic like glossy surface that is highly unsatisfactory on most sculpture. The wood can also be treated with commercially prepared stains, bleaches, artists' oil or acrylic polymer paints and gesso. A variety of home brew recipes for finishing wood can be found on page 261.)

Unwanted paint can be removed by mixing a paste of wallpaper paste and lye, which is painted on and then cleaned off of the wood with water or turpentine after the paint has become sufficiently soft. This material should be used as a last resort as it is slightly destructive of the wood, and the solution is caustic and can cause severe burns if it comes into contact with any part of the body.

Stone

Rock can be divided into three classifications: sedimentary rock (sandstone and limestone), metamorphic rock (marble, serpentine, steatite or soap-stone, and slate), and igneous rock (granite, gabbros, and basalts). Sedimentary rock is stone formed from layers of sand, gravel, and shell deposits, which have been under pressure, and have become cemented together. Metamorphic rock is sedimentary rock that has been subjected to great heat and pressure until it has fused. Igneous rock is a solidified mass which at one time was fluid, perhaps through the heat of volcanic action. It is the hardest of the three classifications of rock to carve, but it is among the most durable, and takes an excellent polish. In most cases, the favored rock of the sculptor is metamorphic rock, usually marble—which, like limestone of the sedimentary class is fairly easy to carve, but the durability of which is questionable. Softer metamorphic rock—like some steatite—can be carved with a penknife and scratched with a fingernail. These rocks are not at all durable and frequently have a greasy or soapy feeling, from which they get their common name, soapstone. Sedimentary rocks are often visibly layered or stratified. These stratifications are known as bedding planes. When carving stratified rocks, it is advantageous to keep the bedding planes in their natural positions; otherwise, when utilized out-of-doors, the stone may weather rapidly and decay.

In northern climates rain water seeping into vertically oriented bedding planes may freeze in cold weather, wedging the stone apart.

Igneous and metamorphic rock and many limestones, which do not have these stratifications, and, therefore, do not have natural bedding planes, are known as "freestones."

Domestic carving stone includes marble in various colors and various textures; alabaster in many colors and from very soft to quite hard (and excellent to rotten); limestone primarily gray to cream to brown, coarse to fine grain, soft to moderately hard, and excellent to rotten carving; sandstone in reds, purple, brown, and yellows, crumbly to too hard to carve; slate gray and black primarily in thin sections and poor carving but good grinding and sanding; and soapstone, blue black, green black, and dark gray, good carving.

These materials are not available in every part of the country, but they are common enough building materials that they can be obtained through supplier or contractors, stone yards, builder suppliers, and so on. Of course there are a large variety of other kinds of stone to be found lying all over the country, in

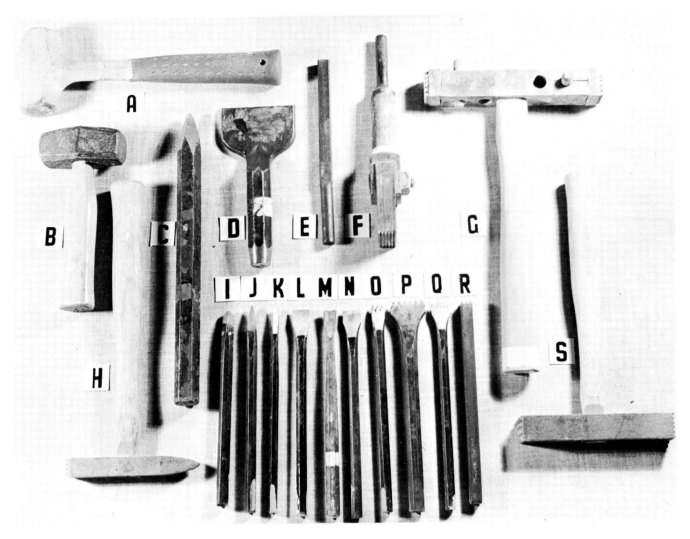

Figure 5-29

stream beds, road cuts, barrow pits, and the like. Some are carvable, most are too difficult to be worth the time. Oddly enough the most attractive stone found in a free state will be igneous and too hard to carve.

Decorative stone such as feather stone a light porous soft volcanic glass, or brecia a loosely glued assemblage of sea shells having the texture of breakfast cereal, are often very easy to shape. They are soft enough to be destroyed by very light pressure, so although they may present a fast inexpensive medium, they should not be considered a permanent material.

Most stones being carved, ground, or sanded throw off large quantities of stone dust. Some of this dust is dangerous to breathe, none of it will do the lungs any good. It has become obvious in the last few years that sculptors engaged in shaping stone must wear respirators for their health's sake.

Tools Required

a. Carvers hammers (figures 5-29A and 5-29B)
b. A large point (figure 5-29C)
c. Pitching tool or "bullset" (figure 5-29D)
d. A tool blank to be forged to special shapes (figure 5-29E)
e. Machine tooth chisel (figure 5-29F)
f. Universal bush hammer (figure 5-29G)
g. Combination pick and bush hammer (figure 5-29H)
h. Small point (figures 5-29I and 5-29J)
i. Flat chisel, fine (figure 5-29)
j. Flat chisel, broad (figure 5-29L)
k. Roundel or gouge (figure 5-29M)
l. Flat-toothed chisel (figure 5-29N)
m. Toothed chisels (figures 5-29O, 5-29P and 5-29Q)
n. Nine-point bush chisel (figure 5-29R)
o. Square bush hammer (figure 5-29S)
p. Feathers (figure 5-30A)
q. Plugs (figure 5-30B)
r. Rifflers (figure 5-14M)

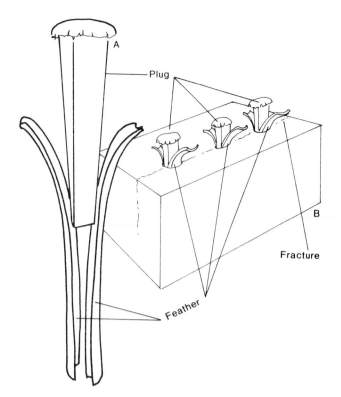

Figure 5-30

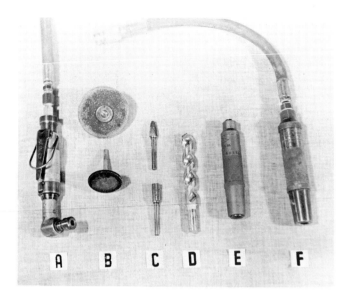

Figure 5-31

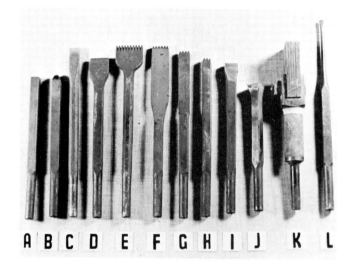

Figure 5-32

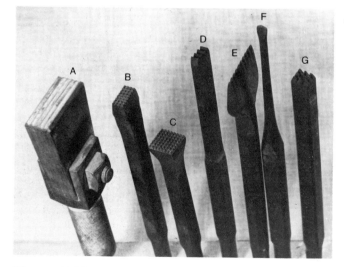

Figure 5-33

Power Tools
a. Pneumatic grinder (figure 5-31A)
b. Grinding wheels (figure 5-31B)
c. Grinding burrs (figure 5-31C)
d. Carbide-tipped drill (to be used in an electric drill) (figure 5-31D)
e. One-half inch straight line pneumatic hammer (figure 5-31E)
f. Three-quarter inch straight line pneumatic hammer, with attached hose and snap-on fitting (figure 5-31F)
g. Tool blank (figure 5-32A)
h. Point (figure 5-32B)
i. Machine chisel (figure 5-32C)
j. Cleanup chisel (figure 5-22D)
k. Marble tooth chisel (figures 5-22E and 5-33E)
l. Ripper (figure 5-32F)
m. Frosting chisel, large point (figures 5-32G and 5-33D)
n. Nine-point chisel (figures 5-32H and 5-33G)
o. Frosting tool, small point (figures 5-32I and 5-33B)
p. Frosting tool, fine point (figures 5-32J and 5-33C)
q. Machine bush chisel (figures 5-32K and 5-33A)
r. Carvers or plug drill (figures 5-32L and 5-33F)

Other Tools

Carborundum slips, Wet or Dry sandpaper, stone wedges, feathers, plugs, grub saw (a two-man saw which uses sand or shot instead of teeth), rifflers, rasps, and a sledge hammer.

Stone tools are usually purchased preshaped, tempered, and sharpened, but on occasion must be forged by the sculptor. The end of the tool blank is placed in the red coals (mixed coke and charcoal) of a forge until the tool is cherry red, at which time it is hammered to shape. The tool is then replaced in the fire; when the tip is cherry red ($1650°$-$1700°$ F.), it is removed from the fire and dipped one-half inch into a cold brine solution of 2 oz. rock salt to 11 gallons of water, for six seconds. The tool is then quickly rubbed on fine sandpaper in order to reveal the temper. If the temper is correct for granite, the tip colors will be white, to gold, to bronze, to purple, to blue. This banding should extend only three-quarters of an inch from the tip of the tool. When the tool has cooled to this temper, it is quickly dipped into the brine to hold the temper. Marble tools should be hardened to a bluish purple and quenched in cold water rather than brine.

Stone Carving

1. Determine the bedding of the stone. If the bottom is not flat, it must be carved flat.
2. Split away excess stone with plugs and feathers. The line of the split is marked, and pilot holes are drilled with a carvers or plug drill. Larger holes following the pilot holes are then drilled with a carbide drill. Feathers are inserted in the holes with the divisions between the feathers parallel to the line of the split; feathers are then lightly greased, and wedged into place with the plugs. The plugs are then struck lightly in order. The impact against the plugs is increased until the sound of the stone goes "dead" end the stone splits.

 The stone can also be split by drilling a series of holes along the break line (figure 5-35), then chiseling between the holes to open the stone (figure 5-36). It may be necessary to pound tapered wedges into the holes to help put a strain on the block along the break line.

 The most common way of splitting small stone (up to 18′ [457.2 mm] thick) is through the use of the bullset and a heavy hammer (grip the stone hammer near the head as in figure 5-34 to prevent injury to the chisel hand). The tool is used as described in step three except that the cut line is marked all around the stone, but not 1″ (25.4 mm) from the edge. The bullset is then struck along the cut line. When the stone is heard to loose its ring, the sound goes dead, the stone will split

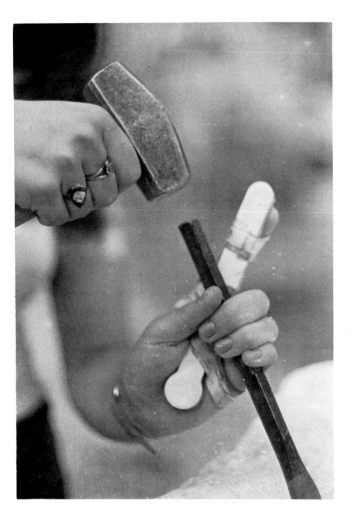

Figure 5-34. Improper care or use of tools may result in severe injury.

Figure 5-35

Figure 5-36

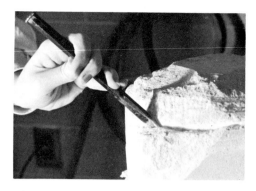

Figure 5-38

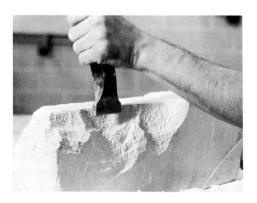

Figure 5-37

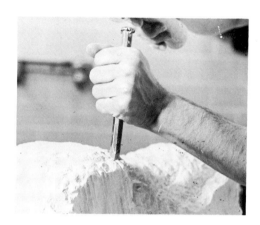

Figure 5-39

on the next blow or so. Soft stone usually requires a great deal more effort to break than hard stone since the soft stone will crush rather than transmit the impact of the hammer blow. On thin stock a hand set (similar but thinner and wider than a bullset) will split the stone with less crushing of the edge. The hand set is usually used to remove excess material from along the edge of a block of stone.

3. The pitcher is then used to remove the remaining large amounts of excess stone, by placing it at right angles to the surface and parallel to the edge of the stone, about 1″ (25.4 mm) back from the edge. The pitcher—or bullset, as it is sometimes called—is then struck with a heavy hammer, causing large spalls to break off (figure 5-37). The pitcher should be struck repeatedly as it is moved sideways back and forth along a line parallel to the edge. Pitchers can be used as long as there are flat areas on the stone.

If the surface is too coarse to utilize the pitcher, a groove, known as a "chase," about 1″ (25.4 mm) wide should be carved along the edge of the

Figure 5-40

stone with a point, in order to give the pitcher some place to grip (figure 5-38).

4. A heavy point is used to rough out the basic form. This tool is held at a 40°–60° angle to the surface of the stone, depending on the hardness of the material. It is then struck repeatedly, until a piece of stone spalls off (figures 5-39 and 5-40). Stone chisels do not cut the stone. The point of the chisel concentrates the impact of the hammer

blow in a small area crushing (bruising) the crystaline structure of the stone. The point is then wedged by succeeding blows into the powdered area forcing a flake (spall) up and off of the stone. If the tool dives and sticks, the angle is too steep, and the point will break off. If the angle is too shallow, the tool will not chip; it will slip instead. Most carving of the sculpture, with either hand or power tools, should be done with the point, however low grade alabaster and other soft stones may be shattered by heavy blows on a point. They can better be carved with a tooth chisel.

5. The form is refined with the light point, used in the same manner as the heavy point.

6. Further leveling and texturing is managed with the tooth chisel (claw tool) (figure 5-41). The claw or tooth chisel will not spall off large pieces of stone—it tends, rather, to grind and powder the surface—but it does leave furrow-like lines (figure 5-42). The tooth chisel does not bruise the stone as deeply as a point.

7. Frosting tools (bushing hammers) may be used to break away the shallowly bruised surface left by the tooth chisels. Bruising left by the point is usually too deep to be cleaned away by bushing hammers. The bushing hammer also levels the furrows left by the tooth chisel (figure 5-43).

8. Flat chisels are used where smooth surfaces or sharp angles and edges are desired as in figure 5-44. Flat chisels can be used to remove the furrows and irregularities left by previously used tools (figure 5-45). The flat chisel hardly bruises the stone so that rasping or filing will be sufficient to clean up the surface of the stone for sanding.

9. Rough surfaces of soft rock, like marble and limestone can be cut and smoothed at this time by rasps and rifflers (figure 5-46). These tools are not hard enough to be used on most igneous rocks. Power sanders (preferably pneumatic) are often used to speed up surface preparation for polishing. Ordinary electric hand drills with flexible sanding discs will be more than satisfactory for most stones. High speed air grinders with small diameter flexible sanding discs are preferable in that the stone can be sanded wet (never wet sand with electric tools). Wet sanding lengthens the life of the tools and sanding discs and keeps down dangerous stone dust. Electric sanders usually won't endure stone dust too long. Which ever tool is used the operator must wear safety goggles and a respirator. If high capacity sand blasting equipment is available the stone can be shaped or textured by sandblasting. A jet of air containing

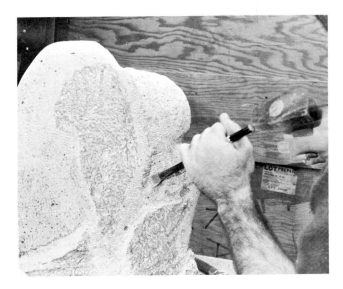

Figure 5-41

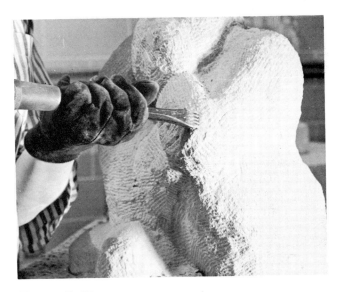

Figure 5-42

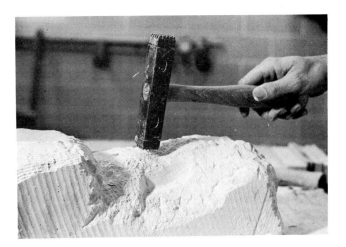

Figure 5-43

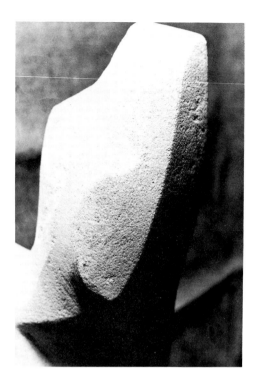

Figure 5-44

Figure 5-45

abrasive particles is directed at the stone. The sand in the air stream hammers away the surface of the stone. The stone can be masked so that a pattern can be cut into the stone. The masking material, rubber, thick cloth, etc., will absorb the impact of the abrasive particles. (See page 265 for additional information on sand blasting.)

10. The stone is finished and polished by rubbing with succeedingly finer grades of wet or dry sandpaper, and then washed and rubbed with cloth. The normal order of grit starting with the most coarse would be 80, 120, 240, 360, 400, and 600,

Figure 5-46

the finest grit. A difference of 20 grit would not be significant. A 320, 340, or 360 grit paper would be close enough to give similar results. Wet sanding is most satisfactorily performed in a tub or sink under a stream of water. The water washes stone residue out of the sandpaper, prolonging its life and preventing the surface of the stone from being scratched by trash imbedded in the sand paper. Many kinds of stone will not profit from sanding with grits finer than 400. Limestone of the coarse variety is far coarser than 360 grit paper and will not polish past that point. Many sandstones when sanded past 120 grit crumble off and gouge the surface of the stone.

If a high polish is desired the stone can be rubbed down with putty powder paste after sanding and then washed and rubbed down with a cloth. A traditional finishing sequence for marble follows:

a. rub with fine emery stone; wash and rub with cloth;

b. rub with coarse sandstone; wash and rub with cloth;

c. rub with fine sandstone; wash and rub with cloth;

d. rub with pumice stone; wash and rub with cloth;

e. rub with an English hone; wash and rub with cloth;

f. rub with putty powder and powdered oxalic acid on a damp rag; wash and rub with cloth.

Finished stone sculpture should be sealed to prevent the intake of moisture and to keep the stone clean. Commercial preparations for sealing cement, terazzo floors, or tombstones, will work very well if the manufacturers directions are followed. Less expensive and also slightly less satis-

factory paste waxes can also be used. Although waxes sometimes cause yellowing the stone. Some types of stone can be dyed to yield very nice colors. Iron stains are among the easiest to use and the most effective.

Cement

Portland cement ranges from dark gray to white in color, and it hardens when mixed with water. These cements acquire strength with age, and require water in order to complete the tempering cycle. For this reason, cement sculpture should be kept damp, if not wet, for 28 days from the time that the cement is poured, at which time the cement will have reached its greatest strength. Cements which are mixed only with water are known as neat cements; those mixed with fine filler, such as sand, are known as mortars; and those mixed with various-sized fillers, like sand and gravel, are known as concrete.

Stable materials, such as marble chips, brick dust, iron filings, perlite, zonalite, terrazzo chips, ground glass, pebbles, sand, and so on, can be added to cement in amounts up to 50% by volume to vary weight and create interesting textures and colors. Organic materials should not be mixed with cement. The dry ingredients should be thoroughly mixed, then cool water folded in, to make a paste with the consistency of thick mud. Additional water or cement can be added to adjust the thickness of the matrix as required. The common problem of surface cracking (figure 5-47) can to a great extent be eliminated by mixing an extremely thick mixture and tamping rather then pouring the matrix into a container.

Special pigments (mortar colors) can be added to the aggregate to color the cement. Manufacturers' directions must be carefully followed, as misuse of the pigments can destroy the binding qualities of the cement.

Plaster

There have been a great many commercial plaster mixtures available to the artist. Of special interest to the sculptor were Number 1 White Casting Plaster, Number 1 White Molding Plaster, Art Plaster, and Plaster of Paris. All of these preparations were high quality plasters with various purpose additives which controlled hardening time, dimensional stability, water absorption, toolability, and so on. During the energy crisis of the 1970's fuel used to heat the kiln to turn gypsum into plaster became expensive and in short supply. Some companies curtailed the production of some types of plaster which were in low demand and instead produced a general purpose plaster. Various companies producd similar plaster under different

Figure 5-47

names. (White Art Plaster of one company might be the same as Molding and Casting Plaster of another company). Most of the art plasters will give satisfactory results following minor variations in mixes and periods of plasticity, except for plaster used to make molds for slip casting. General purpose plasters generally do not give satisfactory service for slip casting molds if they are to be given hard service.

Construction grade plasters are less expensive and more readily available than art plasters but they are of low grade, may be too soft, greyish, full of sand-like particles, and may have too little adhesion to be useable.

Small quantities of plaster are usually mixed by hand, larger batches should be mixed by power equipment. For quantities of less than 50 pounds a 1/4 to 1/2 horsepower electrically driven motor turning a 3″ (76.2 mm) blade with a 25° pitch at 1750 RPM will prove satisfactory. The propeller should be a couple of inches from the bottom of the bucket, off center and turned to force the slurry down. The propeller shaft should not be perpendicular to the surface of the slurry, but should be angled about 75° from the surface. Round bottom buckets such as the ones used in vertical bread dough mixers are preferable to flat bottom containers.

Small batches of plaster should be mixed by hand, by slowly sifting the powder through the fingers into a pan of still cool water (figures 5-48, 5-49 and 5-50), until the plaster rises slightly above the water level (figure 5-51). If the plaster is dumped into the water too rapidly the bottom of the mass will become slimy, preventing the further rapid absorption of water, causing the plaster to float. An island will then be formed which will prevent the water from being absorbed by new plaster added to the mix. The resulting mixture will be too thin, yielding a soft, porous, slow-hardening plaster. If too much plaster is added to the

water, the result will be a rapid-setting, lumpy, dense, hard plaster.

One hundred pounds (45.36 kg.) of plaster requires about two and one quarter (2¼) gallons (8.5163 liters) of water to create a mass of plaster at its greatest density and its smallest pore size. Any additional water tends to float the crystals apart leaving a softer more porous plaster.

Two and one quarter (2¼) gallons (8.5163 liters) of water in 100 pounds (45.36 kg) of plaster is not enough water to yield a sufficiently fluid mixture. A more acceptable recipe for a workable plaster slurry is a range of sixty (60) 27.216 kg) to eighty (80) pounds (36.288 kg) of water to 100 pounds (45.36 kg) of plaster (7.2 gallons [27.25 liters] to 9.6 gallons [36.34 liters] of water).

After all of the plaster has darkened slightly from being moistened, the mix should be allowed to soak for one to three minutes. During this time water displaces the air which surrounds each plaster particle, floating the grains apart and reducing grain friction. The water also begins to take the plaster into solution. The plaster slurry should be then mixed (figure 5-52) for two to three minutes. Theoretically this mixing not only eliminates irregular density layers and removes any lumps, but it also supersaturates the water with plaster. Minute gypsum crystals on which a mass of gypsum crystals grow, precipitate out of the solution. These crystals interlock during rapid random growth, eventually forming a mass shot through with microscopic pores.

At this point the hardening action is accelerated. Neither water nor plaster should be added to the matrix after mixing has started. Aggregates which are damp can be added at this time, but, if possible, aggregate materials should be mixed with the dry plaster. Plaster aggregates usually harden rapidly, in some cases in less than 4 minutes after mixing is started.

If a period of longer fluidity or plasticity is desired, retarders can be added or the plaster can be mixed with ice water. Accelerators or hot water will speed up the hardening time of the plaster mix. Recipes for accelerators and retarders will be found on page 274.

Normal plaster will harden in 15-20 minutes. Most of the strength of the plaster is established by the time the plaster becomes warm (heat of crystallization), but a little additional strength is gained during the following 24 hours. Many of the same aggregate materials used in cement can be used in plaster, and in increased amounts, if desired. Tests should be made to check for setting time and hardness. Some aggregates may destroy the setting ability of the plaster; others, such as a mixture of ground glass and iron filings, may slow the setting time slightly and make the aggregate too hard to be worked with ordinary tools.

Figure 5-48

Figure 5-49

Figure 5-50

Figure 5-51

Figure 5-52

Specially compounded dry pigments, usually in amounts of less than 10%, can be added to the water to color the plaster. Ordinary tempera paint and large amounts of dry tempera pigment are not satisfactory, because in certain cases they destroy the hardness of the plaster or because the plaster may bleach away the color.

Plaster mixes which contain aggregates which absorb water must have enough water so that the water absorbed by the aggregate will not deprive the plaster of the water that it requires for crystallization. Plasters deprived of water will become grey, extremely hard and glossy, and will harden rapidly.

Finishing

Cements have greater resistance to weather than plasters, but if either is to be utilized out of doors, some protective coating must be applied to the sculpture to prevent the porous bodies from absorbing dirt, and to prevent intake of water, which will destroy plaster and can rot cement. In freezing temperatures, absorbed water will freeze, expand, and fracture plaster and cement or, at the least, cause spalling. Plaster will have reasonable suvivability if it is thoroughly dried, sealed and coated with several layers of paint, then kept out of wet environments. Linseed oil will serve as a satisfactory sealer. Damaged surfaces must be repaired immediately to maintain the integrity of the plaster. Directions and recipes for finishing plaster and cement are given on pages 163 and 164.

Plaster and Cement Carving

1. Dry mix the ingredients, then mix the matrix.
2. Pour or tamp the fluid matrix into a waterproof container such as a plastic-lined cardboard box or a shellacked wooden box. Shake or tamp the matrix while the box is being filled in order to release air bubbles.
3. When the matrix stiffens enough to be handled without damage (2-8 hours for cement, 10-20 minutes for plaster), remove the box and carve the rough form with any suitable tool such as a spoon,

knife, hacksaw blade, pick, chisel, or wood tool. Rasps, saws, and similar tools which will become clogged by the muggy medium should be avoided.
4. Permit the roughed form to harden and dry to a point where it can be worked with rasps, files, and eventually sandpaper. Cement requires 1-10 days to reach this state, but care must be taken to keep it from drying too rapidly, or it will lose its strength and crack or crumble. Special tools are available to work wet plaster, but it will usually take a week or more for plaster to dry enough to be rasped with an ordinary rasp. Do not force cement or plaster to dry with heat, as cracking may result.

Clay

Clay which is to be carved is prepared in the same manner as clay which is to be modeled (pages 41 to 44). It is preferable, though, that clay which is to be carved be of a little stiffer consistency than modeled clay. Wire and wood tools are used to expose form and to complete detail instead of the pounding block or the hands. Some care must be taken that the clay carving does not become a study of detail rather than a sculptural unit. Normally this danger is avoided by combining the manipulative technique with the subtractive technique when dealing with clay.

Tools Required

a. Clay mallet (figure 5-53A)
b. Wire modeling tools (figure 5-53B)
c. Wood modeling tools (figure 5-53C)
d. A spatula (figure 5-53D)
e. A-sciotté, a saw made of twisted strands of wire (figure 5-53E)

Tool Care

All tools should be cleaned and dried after use. Iron or steel tools should be rubbed with an oily cloth before storage.

Clay Carving

1. Wedge ceramic clay to eliminate air bubbles (figures 4-23, 4-24, and 4-25).
2. Pound the clay into a large mass with the mallet (figure 5-54). If the clay sculpture will require an armature (pages 36-41), the clay should be pounded around this support.
3. Allow the clay to stiffen if necessary.
4. Cut away excess clay with the a-sciotté by drawing the wire back and forth across and through the clay (figure 5-55).
5. Refine the form with the wire tools. Use as large a tool as possible at all times (figures 5-56, 5-57 and 5-58).

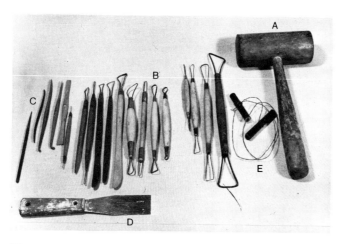

Figure 5-53

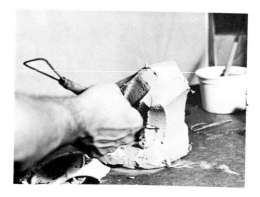

Figure 5-56

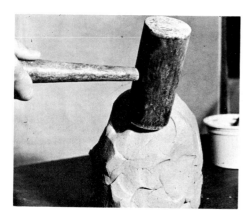

Figure 5-54

Figure 5-57

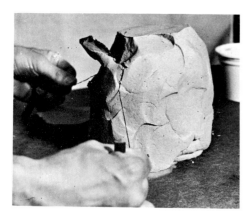

Figure 5-55

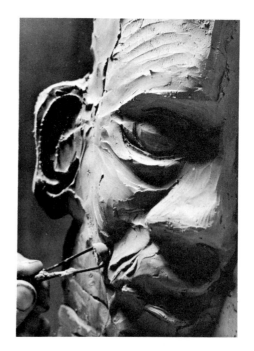

Figure 5-58

Figure 5-59

Figure 5-60

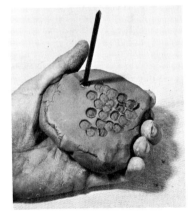

Figure 5-61

Figure 5-62

6. Scrapers and stamps may be used to create texture (figure 5-59). The scrapers are drawn across the surface in order to leave marks, not to remove marks (figure 5-60). Do not utilize the scraper to smooth or slick surfaces. Stamps are objects with textures on their surfaces that can be transferred to the clay by pressing the object against the clay (figure 5-61). Tools, wire screen, bolts, screws, coins, and so on can be used as stamps.

7. Hollow and allow the sculpture to dry slowly, out of drafts (figure 5-62). It may be necessary to cover the sculpture with a box of some kind to slow the drying time. It is important that the walls of the sculpture be of consistent thickness (between one-half of an inch and one inch), or the walls may crack during the firing process.

8. If the sculpture is to be cast in plaster, it should be prepared for casting as indicated in chapter 7, and not hollowed.

9. If it is necessary to preserve the sculpture in its plastic state for any length of time, a wet cloth should be draped over the clay, and it should then be covered with sheet plastic.

Plastic

Except for the foams and acrylics which are often carved with power tools, few plastics are being carved at this time, in spite of what was a promising start. The problem with these otherwise interesting materials is the ever increasing health hazard which they are presenting. Because of this the instructions for working these materials are only a brief outline. More detailed information can be found in the chapters on Manipulation, pages 49 to 56 and Addition, pages 210 to 215. If plastics are to be carved it would be prudent to wear respirators and have adequate ventilation at all times, as indicated in the safety precautions on pages 49 to 50.

Among those plastic materials that are available for carving, the most suitable are some of the acrylics, the phenolics, the polyesters, and the epoxies. Although frequently used in their "neat" state, filler materials are often added to the plastic to form aggregates. These fillers substantially decrease the cost of the medium, as well as add bulk, strength, resistance to warping and shrinkage, and color; they also cause opacity. Aggregate plastics purchased from commercial sources are usually more "pure" than studio-made aggregates, and are a great deal more expensive.

If the block is to be prepared from liquid state by the sculptor, care should be exercised in selection of the plastic, and the manufacturer's directions should be followed to-the-letter. Only certain polyesters and expoxies can be cast easily into blocks over 3″ thick without serious warping, shrinking, and cracking problems. For large masses of plastic, the commercial resins sold for use with glass fibers will give the fewest problems. It may even be necessary to build large masses by pouring the plastic in layers. Acrylics are highly susceptible to these faults; therefore, this type of plastic mass should be obtained from commercial sources if possible.

Acrylics, polyesters, and epoxies are fairly easy to work with ordinary tools. Objects can be rough-shaped by sawing with wood or metal saws. A straight saw having 8-10 teeth per inch, with very little set, is best suited to this work. The saw should be held straight, without twist, or the plastic may crack. These plastics can be drilled to remove material by using a heated wire, or with an ordinary twist drill for metal—but which has been reground for drilling brass. The cutting edge of the drill should be ground flat instead of angled, in order to produce a scraping edge instead of a cutting edge. A slow-turning drill is preferred, but high-speed drills can be used if the hole is lubricated with water or kerosene to prevent burning of the plastic. Never drill cold plastic. The material should always be warmed to at least 70° F. before drilling is attempted. Probably most of the final cutting of the plastic will be done with files. Flats, half-rounds, and rat-tail files will be most useful, so long as they have not been dulled or gummed from filing on metal or other materials. Files should be cleaned frequently with a wire brush. Scrapers can be used to remove material or to texture the surface of the plastic. Scrapers should be held at a 45° angle to the work and pulled toward the operator. Hacksaw blades, old files, knives, or tool steel blanks can be ground to shapes or textures desired. The wire burr which is left from shaping and sharpening the scraper blade should be removed before use. Shaping tools and grinding wheels that can be used in the chuck or collet of an electric drill or flexible shaft can be used to cut in tight spots. Sanding disks can also be used in these chucks to cut away or smooth larger areas.

Common phenolics are more difficult to work than acrylics, polyesters, or epoxies. Probably the only really useful carving tools for most phenolics are sanding disks, grinding tools, or carbide bits in flexible shafts. Phenolics should be cast in their approximate shape and size, and finished with a minimum of grinding. They can be polished with #400 waterproof sandpaper.

Polystyrene, which has been foamed (styrofoam) can be easily carved with the simplest of devices, knives, files, sandpaper, hot soldering irons, hot wire, or even heated metal tools. Because of the extreme softness of this plastic, it is usually carved for armatures (page 38) or to be cast in metal (page 153).

The styrene foam which is easily located in lumber yards and suppliers of building and insulating material is manufactured in two types. The easiest type to carve consists of a mass of hollow cells similar to soap bubbles (figure 5-63). This foam comes in various densities—the greater the density, the smaller the cell, and the finer the surface. The low density foam will have large cells and leave a ragged surface. The low density foam is usually the least expensive foam and the easiest to carve, but is not satisfactory for casting.

The other type of styrofoam available is the closed cell form and it resembles pressed popped popcorn (figure 5-64). This form will give a very smooth surface if it is cut with a hot wire, but is liable to tear if sawed, rasped, or sanded. The closed cell foam is a terrific medium to use as a core if the form is to be surfaced (laminated or veniered) with wood or some other material. Generally waterbased contact cement will effect a strong permanent bond with the foam. Open celled foam does not laminate as satisfactorily because not enough foam surface comes into intimate contact with the surfacing material to allow a firm grip.

Another foam which is very common is polyurethane (rigid and flexible). Rigid urethane foam carves very well though generally not quite as crisply as styrofoam. Some of the rigid urethanes are a little rubbery and make carving a chore. The flexible urethanes can be cut with a razor blade or a scissors, but are spongy and will stretch and roll under most carving conditions. Urethanes should not be cut with a hot wire or disposed of by burning as they may release deadly fumes.

Both styrenes and urethanes are available in the pre-foam stage and can be obtained in two part mixes, or in pressurized cans. This convenience makes it possible to "form-in-place" a mass of foam in a pre-shaped container. Foam-in-place plastics are available in

Figure 5-63

Figure 5-64

hobby stores, marine suppliers, and auto repair parts stores.

Foams which are carved and surfaced with a rigid medium such as polyester resin, epoxy resin, or plaster, will often prove unsatisfactory unless the surface is reinforced. Foam is sensitive to atmospheric pressure, and temperature change, and so it expands and contracts like a balloon. This expansion will crack up to 3/8″ (9.525 mm) thickness of plaster, and 1/8″ (3.175 mm) thickness or either of the resins. The problem can be solved by carving out the center of large masses of foam or reinforcing the surface material by adding thickness in the case of plaster or adding reinforcing cloth to the resin.

Tools Required
a. Wood saws (figure 5-65A)
b. Hacksaws (figure 5-65B)
c. Coping saw (figure 5-65C)
d. Files (figure 5-65D)
e. Flexible shaft (figure 5-65E)
f. Electric drill (figure 5-65F)
g. Drills (twist) (figure 5-65G)

h. Drill (spade) (figure 5-65H)
i. Electric soldering iron (figure 5-65I)
j. Sanding disks (figure 5-66A)
k. Wire brush (figure 5-66B)
l. Wire wheel (figure 5-66C)
m. Buffing wheels and compounds (figure 5-66D)
n. Hot wire (figure 4-11)
o. Jewelry saw (figure 5-65F)

Carving Plastic
1. Obtain, or pour and cure, a block of plastic.
2. Draw the design on the appropriate faces of the block with a grease pencil or scratch it in with a metal scribe.
3. Saw excess material away.
4. Use files, sanders, shaping tools, and grinders to complete the shaping of the sculpture (figures 5-67, 5-68, 5-69, 5-70).
5. If desired, the sculpture can be sanded or textured by scraping the surface with a scraper, by impressing hot stamps into the plastic, by brushing with a wire wheel, or by sand blasting (figure 7-111).

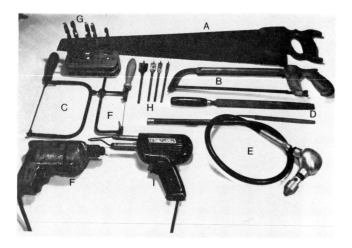

Figure 5-65

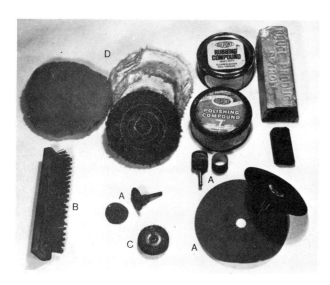

Figure 5-66

6. Foamed polystyrene and urethane materials cannot be polished, but acrylic plastics can be polished in accordance with the directions on page 215. Polyesters, epoxies, and phenolics can be polished by sanding wet with #400 wet or dry sandpaper and buffing with a wool bonnet using first rubbing compound, then white polishing compound.

Figure 5-67

Other Media

Bone and ivory are other materials which can be utilized for the subtractive technique, but are not extensively used in our culture because of some natural limitations (figure 5-71). Both bone and ivory are easily obtained, though limited in size, and are readily shaped through the use of hand or power tools, incorporating cutting, grinding, or shaping bits. Both materials tend to yellow, warp, and check with age. Even though these media are easily carved, they still have considerable strength; as a result, highly intricate and delicate carving can be achieved.

Figure 5-68

Figure 5-69

Figure 5-70

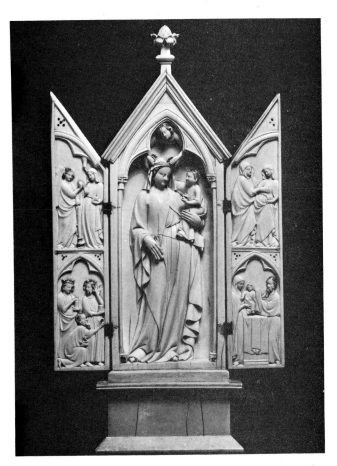

Figure 5-71. *Madonna and Child,* ivory triptych, French, 14th century, The Cleveland Museum of Art. Purchase from the J. H. Wade Fund.

6
Substitution (Casting)

Substitution is the process of casting in a medium the shape or imprint of another mass. The technique has traditionally been an imitative device, in which copies of a model have been the goal of the foundryman. The contemporary artist has been utilizing the tecnique as a method of creating a shell from which the sculpture is created. The casting is treated as the beginning of the sculpture, not as the final goal of the artist.

There are four kinds of molds normally used in casting processes: waste molds, piece molds, flexible molds, and sand molds. The waste mold is a unique mold; it produces only one cast and is eventually destroyed in order to remove the cast. It is the most accurate mold type for the student, but frequently causes trouble during the process of removing the mold from the cast. The piece mold is similar to the waste mold except that it is usually divided into a greater number of sections; as a result, the mold can be removed from the cast in pieces in such a way as to save the mold for reuse. Piece molds are subject to some surface blemishes and distortion due to shrinkage and warping of the mold sections and because of the flashing marks left by the seams between the mold sections (figure 6-2). Some distortion also stems from the fact that piece molds can seldom be reassembled in exactly the same position. Regardless of these disadvantages, piece molds are probably the best for all-around use.

Flexible molds may be molds which are elastic enough that they can be removed from fairly complex master (model) shapes without damage to the mold or the model. Flexible molds are subject to excess distortion and shrinkage, and have other disadvanages due to their chemical make-up. Sand molds are, in a sense, waste molds, because they are used only once, but they are similar to piece molds in the way in which they are assembled. Because of the nature of the sand, these molds are limited in complexity and, for all practical purposes, limited as to the casting medium.

Molds are constructed of many materials. Waste molds are usually constructed of plaster-based mixtures, sulphur, sometimes hard waxes and occasionally resins. Piece molds are constructed of plaster, cement, metal, wood, waxes, fiberglass, and others. Flexible molds are made from natural rubber, glue (gelatin), and plastics. Sand molds are formed from mixtures of earth materials, including various grades of sand, loam, and clay, and sometimes artificial binders.

Models for plaster molds are usually made in modeling clay; occasionally models of plaster, plastics, metal, and wood are used. Models used in sand molds are formed from any hard dry material; wood, plaster, or metal are used most commonly. If the cast is to be

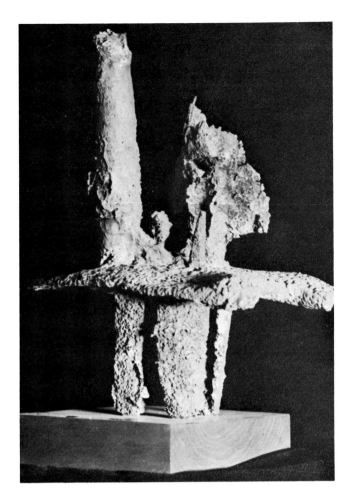

Figure 6-1. *Altar to Another God,* cast aluminum.

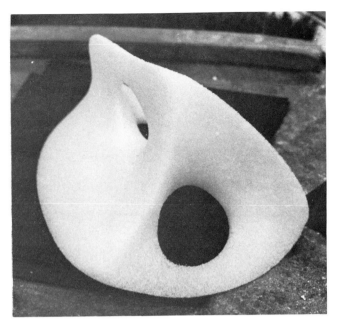

Figure 6-3

Figure 6-4

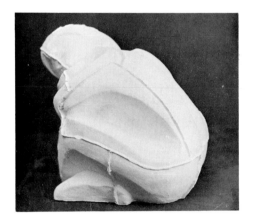

Figure 6-2

Figure 6-5

in molten metal over 800° F., volatile materials—which pass off in small volumes of gas and little ash—may be used as models or parts of models by simply imbedding these materials in investments or in sand, and then either burning out the model before pouring the metal, or pouring the molten metal directly onto the model in such a way that the heat of the metal burns away the model.

Not all volatile materials are safe to burn out this way. Styrofoam can be burned out directly (figure 6-3), waxes on the other hand may explode if hot metals come in contact with them.

The kind of mold which should be constructed for a casting depends on the nature of the model, the accuracy required of the cast, the number of casts required, and the media to be used for the cast.

Substitution (Casting) 99

Figure 6-6

Figure 6-7

Plaster

Waste Mold

1. Divide the model into the fewest number of divisions which will allow removal of the model without damage to the mold. Sometimes a clay model can be completely dug out of a waste mold, in which case the model need not be divided at all (figure 6-4).

2. Press shim stock (brass or aluminum .008″ [.2032 mm] thick) or flexible strips of stiff plastic into the model along the division lines (figure 6-5). The shims must overlap tightly, and the top edges of the shims must be trimmed evenly (figure 6-6).

3. Add plaster to water that has been heavily tinted with liquid bluing; a thick plaster mixture is required.

4. Snap a thin (1/8″ [3.175 mm]) blue plaster warning coat onto the model by dipping the fingers into the plaster and snapping the fingers at the model with some force (figures 6-7 and 6-8). It is a great deal of help if the hand is thrown forward and the fingers snapped at the same time to drive the plaster forward with some force. The plaster must come into positive contact with the model in order to produce a sharp impression. Take care that no bubbles of air are trapped under the warning coat, especially in corners and crevices. The blue warning coat of plaster serves to indicate the proximity to the mold surface to the cast surface if it is necessary to chip the cast from the mold.

5. After the model is covered with a layer of blue plaster, carefully scrape all of the edges, not the surfaces, of the shims clean of plaster (figure 6-9).

6. A thick batch of white plaster is then mixed and snapped on the blue warning coat, in order to strengthen the blue coat. Air pockets must still be avoided at this stage. This thin coat must be strengthened by Step 8 within an hour or so to

Figure 6-8

Figure 6-9

Figure 6-10

prevent the coat from cracking and falling off (figure 6-10). Expansion or contraction of the clay model from drying or picking up moisture will destroy the thin shell.

7. Clean the edges of the shims. Do not clean the surfaces of the shims.

Figure 6-11

Figure 6-12

Figure 6-13

Figure 6-14

Figure 6-15

Figure 6-16

8. Apply additional plaster with a spatula or similar tool to cover the entire mold to a thickness of about 1″ (25.4 mm) or thicker, except for the shim lines which must remain exposed (figure 6-11).

9. Scrape the shims clean.

10. After the plaster hardens, break the mold and the model from the base by striking the board sharply with a hammer, then remove the mold by tapping along the line of shims with a blunt chisel, alternately from one side of the mold to the other on the same shim line, until the mold begins to separate (figures 6-11, 6-12, and 6-13).

11. When the mold opens a crack, rock the pieces of the mold gently and work the mold until it separates from the model. If additional force is required to start the model to open, use a thick chisel along the shim line (figures 6-14 and 6-15).

12. Remove the shims and any parts of the model which may have remained in the mold. Wash the mold clean with water and a soft brush. Overwashing will destroy detail and cause the surface of the mold to go soft.

13. Apply the proper mold separator to the mold (figure 6-16). Probably the most common separator for plaster cast in plaster is a good grade of neutral or potassium soap. Soaps react with plaster

Figure 6-17

Figure 6-18

Figure 6-19

producing calcium stearate which is insoluable in water. This protects the mold from erosion and prevents the slurry from adhering to the mold. A heavy layer of suds should be brushed repeatedly over the face of the mold between quick rinses of cold water. Too little soap will cause hard spots on the cast or disasterous adhesion of the mold to the cast. Too much soap will produce excessive calcium stearate which will be deposited on the cast. Alkaline soaps should not be used as they will produce sodium sulphate, a soluable which will cause efflorescence.

14. Assemble the mold and bind it with wire (figure 6-39), heavy rubber bands cut from inner tubes (figure 6-40), metal spring clamps or burlap strips soaked in plaster (figure 6-17).

15. If the cast is to be in plaster or cement soak the mold in cold water, then prop the mold, opening up, in a container such as a bucket, waste basket or wooden box, packed with paper excelsion, or some other packing material. If the mold has not dried out after soaping, or if other casting media are used the mold will not require soaking.

16. Mix the plaster according to the directions on pages 89 to 91, if it is to be the casting medium.

17. Vibrate or shake the mold while it is being poured full of the casting material, to release trapped air which will float to the top of the mix in the form of bubbles. (figure 6-18). If plaster is poured down the side of the mold a hard spot will be produced on the cast.

18. Set the casting aside where it will not be subject to shock or vibration until after the cast has hardened.

19. Remove the bindings from the mold.

20. Progressing from the weakest area of the casting to the strongest, usually from the top to the bottom, chisel the mold away from the cast. The layer of blue plaster next to the surface of the cast will indicate that the cast is about to be revealed and that great care must be taken that the surface of the cast is not scarred by an impatient sculptor, or that the cast is not broken by rough handling. Weak areas of the cast should be supported so that the shock of chipping does not fracture the cast (figure 6-19).

Piece Mold

The area requiring the greatest attention in a piece mold is the undercut—a place on a model which, because of its shape, restricts removal of the mold. If for instance, a bottle shape is being cast, the mold which shapes the inside of the bottle will be too large to be taken out of the mouth of the bottle; in such a cast, the neck and lip would be called an undercut. It would be necessary to divide the mold in such a way that the mold could be removed in sections, eliminating the restricting effect of the undercut.

Soft Model

1. Divide the model into as few, and as simple, sections as possible—presenting no undercuts (figure 6-4).

2. Press shim stock into the model along the dividing lines (figure 6-5). Registration of the mold will be aided if the shim line of each section contains a sharp "S" curve or if a shim is folded into a

Figure 6-20

Figure 6-21

Figure 6-22

"V" shape (figure 6-20). Shims must lap tightly, and edges should be evenly trimmed (figure 6-6).

3. Mix a thick plaster (page 89) and slap a layer onto the model to build up the mold. Though not necessary, a warning coat of blue plaster is often useful. Care must be exercised to avoid trapping air on the face of the model and within the first half-inch of the thickness of the mold.

4. Clean the edges of the shims.

5. Apply additional layers of plaster with a spatula or similar tool to an all-over thickness of 1" or thicker for larger molds. If the mold consists of many sections, loops of wire may be embedded in the plaster of each section before the plaster hardens, to be used in tying the mold together again (figure 6-25).

6. Clean the edges of the shims.

7. Number the sections of the mold, in order to avoid confusion during reassembly of the mold.

8. Use a thick chisel along the shim lines to loosen the mold (figures 6-12 and 6-13). Remove the mold from the model, and wash the mold clean. Overwashing should be avoided. If difficulty is encountered in removing sections of the mold, a blast of compressed air—between model and mold—may break the mild vacuum which forms when sections of the mold are lifted from the model.

Hard Model

1. Treat the model with a separator to prevent the plaster of the mold from clinging to the model (figure 6-21). For wood or stone models, use two coats of shellac cut with alcohol, and a final coat of stearine dissolved in kerosene. For plaster models, use green soap or commercial mold soap, well lathered on the surface of the sculpture; rinse in cold water. It may be necessary to treat the model several times before a satisfactory surface is procured. For metal models, use a light coating of motor oil, 3-in-1 Oil, or a kerosene-stearine solution.

2. Mark the model into sections which will eliminate all undercuts.

3. Build a clay wall ¼" (6.35 mm) to ½" (12.7 mm) thick, and about 1" (25.4 mm) high along the dividing lines to isolate one section of the mold (figure 6-22). These walls should have dimples pressed into them with a marble or similar device, to aid in keying the sections for reassembly. It may be necessary to lay the model on its side, and to make the mold sections one side at a time. If the mold is made one side at a time, the lines dividing the halves should be the division lines for the retaining shells referred to in Step 8. Avoid making the isolated sections too large, or it will be difficult to fill the section with plaster (figure 6-23).

4. Warm stearine-kerosene solution or oil is then painted in the isolated area if required.

5. Pour plaster inside of the clay walls and vibrate or puddle the plaster with a stick to release trapped air (figure 6-24). A sharp rap on the stand supporting the mold may release bubbles from the surface of the model.

6. Embed a wire loop ½" into the plaster, to aid in reassembly of the mold (figure 6-25).

7. After the plaster sets, remove the clay wall and soap the edges of the plaster where the new mold

Figure 6-23

Figure 6-24

Figure 6-25

Figure 6-26

Figure 6-27

Figure 6-28

sections will come into contact with the completed section (figure 6-26). If a retaining shell is required (see Step 8), the surface of the section, which should be smooth, should also be soaped.

8. Repeat the above steps until the mold is completed (figures 6-27, 6-28, 6-29 and 6-30). If a great number of sections are involved, it may be necessary to build a retaining shell to hold mold sections in place during reassembly and casting.

Retaining Shell

1. Complete Steps 1-8 for "Piece Mold (Hard Shell)," but do not dimple the clay retaining walls. Be certain to place the model on its side and to divide the mold sections into two groups (dividing the model in half) (figure 6-31).

2. Apply a heavy coat of stearine-kerosene solution to the outside faces of the mold sections. Mold soap may also be used.

3. Place clay plugs over the wire loops so that the loops do not become embedded in the plaster of the retaining shell, and to provide an opening in the retaining shell so that the mold sections can be held in place (figure 6-32). The clay plugs should stand high enough to protrude through the plaster which is applied to make the retaining shell.

4. Apply a thick coat of plaster to form one half of the shell (figure 6-33).

Figure 6-29

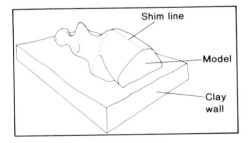

Figure 6-30

Figure 6-31

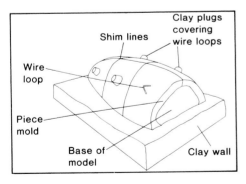

Figure 6-32

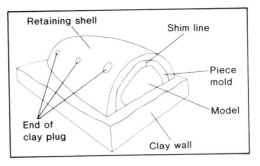

Figure 6-33

5. Turn the mold over, remove the clay walls if any were used, and apply mold separator to the edge of the completed retaining shell which will come into contact with the fresh plaster of the second half of the shell.

6. Repeat Step 4, to form the second half of the retaining shell.

7. Remove the retaining shells, and clean the clay from the holes left by the clay plugs (figure 6-34).

8. Remove the mold sections from the model.

9. Replace the mold sections in their proper places in the retaining shell (figure 6-35). Mold sections can be held in place by tying wire to the loops on the mold sections, then passing the wire through the corresponding hole in the shell, where it is twisted around a stick placed across the hole (figure 6-36).

10. Join and bind the retaining shell containing the mold sections in preparation for casting (figure 6-37).

Solid Cast

1. Faces and edges of the sections of the mold are treated with the proper mold separator (pages 101 to 102).

2. The mold is assembled and held together with wire (figures 6-38 and 6-39), heavy rubber bands cut from inner tubes (figure 6-40), or metal springs.

3. If necessary, fill the seams with clay on the outside of the mold to prevent the casting medium from leaking out of the mold (figure 6-41).

4. Soak the mold with water if it has dried out after application of the separator.

5. Fill the mold; take care to avoid trapping air in the mold during the pour. Rock and vibrate the mold to facilitate the release of air and to force the medium into undercuts. Level the bottom of the cast by drawing a flat stick across the bottom of the mold (figure 6-42).

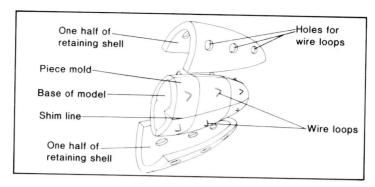

Figure 6-34

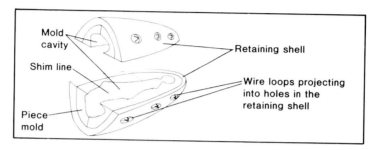

Figure 6-35

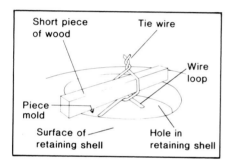

Figure 6-36

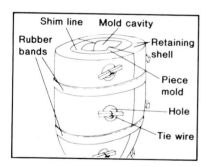

Figure 6-37

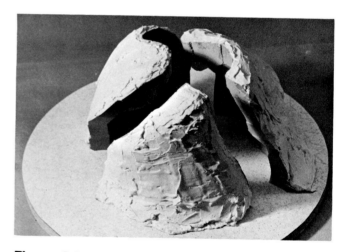

Figure 6-38

6. After the cast has hardened, remove the sections of the mold from the cast and retreat the mold with separator in preparation for the next cast. It may be necessary to rap the mold sections or blast with compressed air to release them from the cast.

Hollow Cast

1. Complete Steps 1-4 for "Piece Mold (Solid Cast)."
2. Pour semi-thick plaster into the mold until it is about half-filled (figure 6-43).
3. Roll the mold in such a way as to coat all of the surfaces on the inside of the mold, especially those of the undercuts, if there are any (figure 6-44).

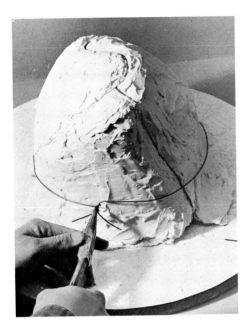

Figure 6-39

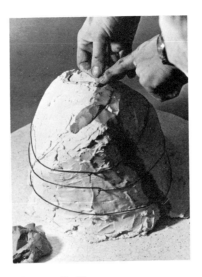

Figure 6-41

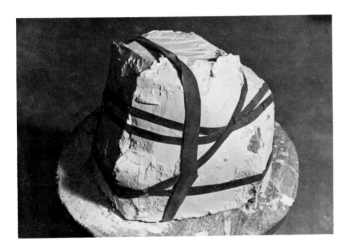

Figure 6-40

Figure 6-42

4. Pour the plaster out of the mold (figure 6-45).
5. Reinforce the inside of the wet plaster cast with fibrous materials such as burlap, straw, or cloth, by pressing the materials gently onto the wet plaster (figure 6-46). Do not force the reinforcing materials through the plaster, or they will show on the surface of the cast. If additional reinforcing is necessary allow the first coating to harden before adding a second coating.
6. Repeat Steps 2, 3, and 4 until the desired wall thickness is achieved.
7. Remove the mold, and treat it with a separator in preparation for the next casting.

Figure 6-43

Figure 6-44

Figure 6-45

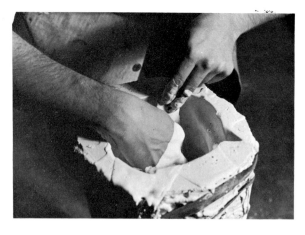

Figure 6-46

Flexible Molds

Flexible molds, being somewhat elastic, permit the casting of complex pieces which have some mild undercutting without resorting to the use of molds constructed of many sections. There is a variety of flexible molding compounds available to the sculptor. Gelatin, probably the most common and least expensive, yields accurate casts and can be reused. Zinc Sulfate or Carbolic acid may be added to the gelatin to preserve it. The major problem with gelatin is that it is subject to shrinkage, warpage, and surface softening if it is subjected to heat.

Latex is a popular, highly flexible molding compound that is readily available from hobby suppliers in the summer. Latex is damaged by cold and is not shipped in northern climates in the winter. Latex molds are accurate, elastic, reasonably strong, and economical even though the rubber cannot be remelted for reuse. The molds will withstand heat up to 250° F. (121° C.), but may be subject to some warping and shrinkage if it is cured by evaporation alone. Its stability can be enhanced by curing the latex with heat (up to 250° F. [121° C.]).

Vinyl compounds in various formulations and sold under various trade names are, in general, accurate with controllable shrinkage to no shrinkage, usually cannot be remelted for reuse, will withstand greater heat then gelatin molds, are impervious to and in some case, requires a lot of heat to cure, and have become so expensive that their use is prohibitive for other than production work.

Gelatin Mold

1. Embed the bottom half of the model in a layer of clay (figure 6-47).
2. Roll a 1/2″ (12.7 mm) sheet of soft clay on a damp cloth with a rolling pin.
3. Cut strips of clay and press them over the model forming a 1/2″ (12.7 mm) layer of clay over the model.
4. Make pouring funnels of tin, plastic or wood and press them into the 1/2″ (12.7 mm) layer of clay covering the model. These funnels should be placed on the highest points of the model (figure 6-48).
5. Build a 1″ (25.4 mm) wall around the model with clay, wood strips, or some other stiff material.
6. Press dimples in the clay base at several locations around the model then cover the entire unit with a layer of plaster at least 1′ (25.4 mm) thick (figure 6-49).

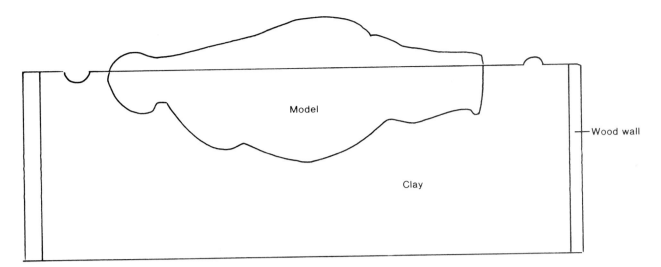

Figure 6-47

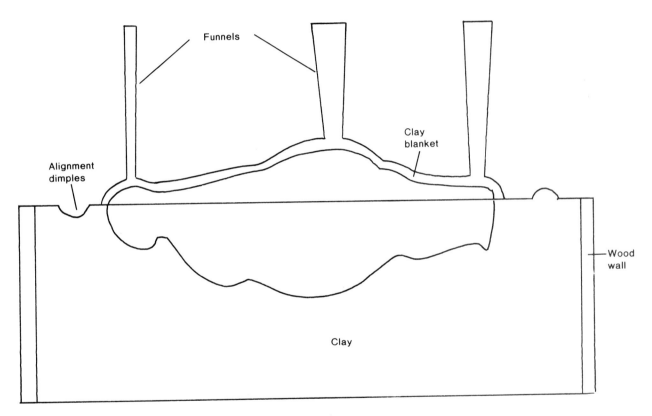

Figure 6-48

7. Remove the retaining walls.
8. Remove the mother mold and clean clay residue from the inner surface of the plaster.
9. Remove the 1/2″ (12.7 mm) layer of clay covering the model.
10. Treat the model with the proper separator if required (pages 101 and 272).
11. Replace the mother mold over the model, aligning it with the alignment marks (step 7).

12. Prepare the gelatin and pour the gelatin into the funnel at the highest point of the model (figure 6-48). The gelatin will flow into the cavity left when the 1/2″ (12.7 mm) layer of clay was removed from the mold. When the gelatin appears in the other funnels the mold will be full. If the gelatin stops flowing through one funnel the pour should continue through the other funnels.

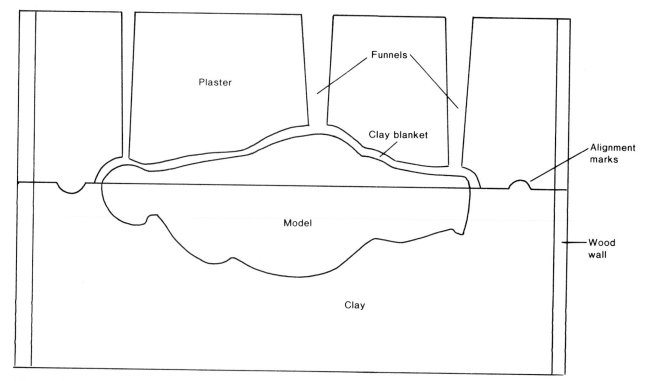

Figure 6-49

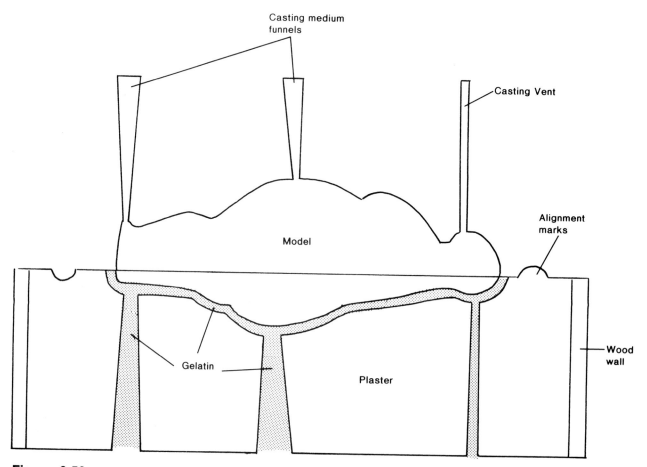

Figure 6-50

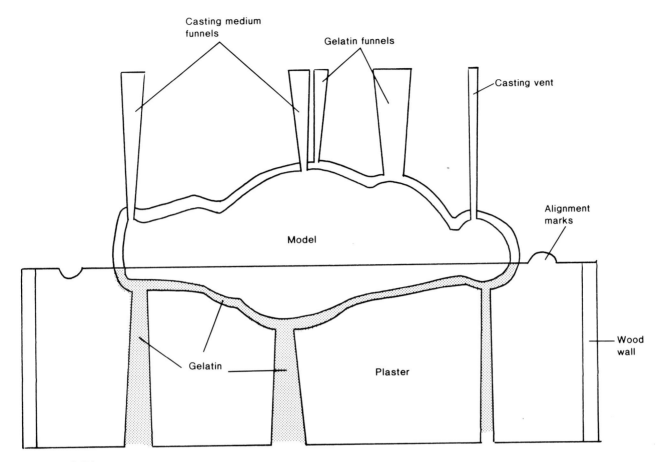

Figure 6-51

13. After the gelatin has hardened, remove the model, gelatin, and mother mold intact from its bed of clay and invert the entire unit (figure 6-50).

14. Repeat steps 2, 3, and 4.

15. Make two sets of pouring funnels. One set for pouring the gelatin and one set for pouring the casting medium. Insert one set of funnels through the 1/2" (12.7 mm) layer of clay at the highest points of the model (figure 6-50). The casting medium will be poured here. Insert the second set of funnels into the 1/2" (12.7 mm) layer of clay at the highest points possible. The gelatin will be poured through these funnels (figure 6-51).

16. Cover the unit with a layer of plaster at least 1" (25.4 mm) thick (figure 6-52).

17. Remove the retaining walls, the plaster mother mold and the 1/2" (12.7 mm) layer of clay covering the model.

18. Clean the mother mold of any clay residue, treat the model and the gelatin flange with the proper separator if required and replace the mother mold over the model aligning it with the registration keys.

19. Prepare the gelatin and pour the molding compound into the funnel for gelatin.

20. After the gelatin has hardened, separate the mother molds, remove the model, treat the gelatin with a separator if required and clear the casting pouring funnels of foreign matter.

21. Bind the mother molds and secure the mold in a container (figure 6-53).

22. Pour the casting medium through the casting medium funnels. Rock or vibrate the container containing the molds to float out entrapped air.

23. After the cast has hardened, remove the bindings, open the mold, remove the cast and, if desired, repeat steps 20, 21, 22, and 23 for additional casts.

Latex Mold

1. Fasten the model to a base with at least 1" of free space around the model for flange space.

2. Spray or brush the model with shellac thinned with alcohol (figure 6-54).

3. Brush on the first layer of latex (the brush should be stored in soapy water) (figure 6-55).

4. Apply folded cheesecloth saturated with latex, as a registration flange (figures 6-56 and 6-57).

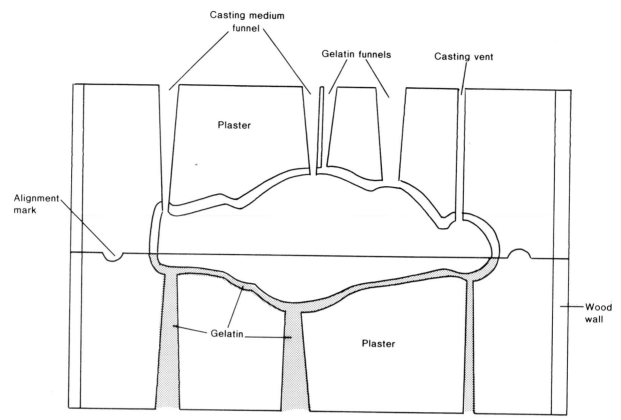

Figure 6-52

5. Undercuts and deep holes must be reinforced with a paste of latex filler, applied in layers 1/16" thick. This paste can be obtained commercially or made from liquid latex and a filler such as talc or sawdust.

6. Allow the latex to dry until a color change takes place.

7. Repeat 4 or 5 layers, until the required thickness is achieved.

8. The mold is dry when the latex snaps back after being pulled with the fingernail, even so, the mold should cure 48 hours before it is removed from the model.

9. Cut the mold with a razor blade along the registration flange and remove it from the model (figure 6-58). If the mold will stretch enough to remove the mold from the model without damage, it need not be cut, and the casting process will be considerably simplified.

10. If the mold is large and tends to sag, a two-piece plaster shell can be built around the latex mold before it is removed from the model (figure 6-60) see "Piece Mold (with Retaining Shell)."

11. Rinse the mold with soapy water before casting.

12. Assemble the mold and fasten it along the registration flange (figure 6-59). If the mold has a plaster shell, the mold should not be removed from the shell if possible. The shell containing the mold can be held together with wire, rubber bands, metal spring clamps, and so on.

13. Fill the mold in the usual manner, avoiding trapping air and air bubbles.

14. Open the mold and remove the cast. If the mold is to be stored, it should be cleaned and dusted with talc.

Cement

Cement and its aggregates should be mixed dry; see directions for mixing cement on page 60. If aggregates are used in the casting, the surface of the dried cast should be rasped, filed, or ground to remove the scum in order to reveal the color and texture of the aggregate. If the cast is not overly complex, the mold can be removed from the cast shortly after the matrix has hardened, and a fine hard spray of water can be directed against the cast to cut the surface scum. This treatment will impart a coarse texture to the cast, and may undersiably soften detail and round edges.

Plaster molds should be treated with two coats of shellac thinned with alcohol, plus a coating of motor oil; or with a heavy application of a solution of mut-

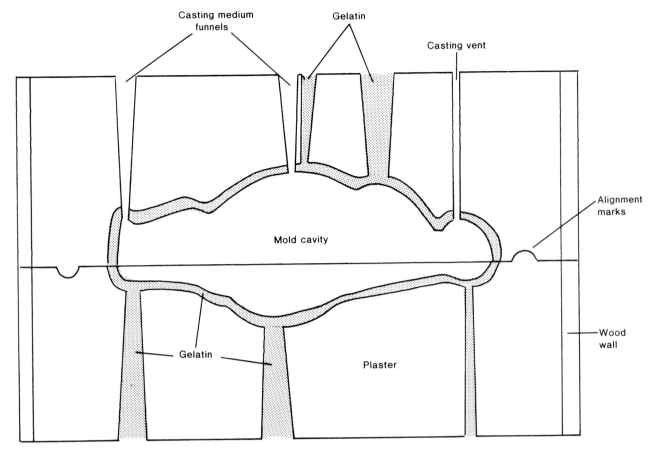

Figure 6-53

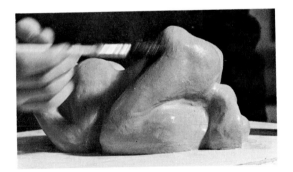

Figure 6-54

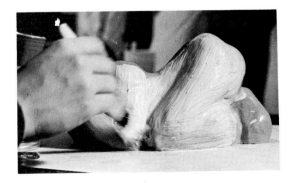

Figure 6-55

Figure 6-56

Figure 6-57

Figure 6-58

Figure 6-59

Figure 6-60

Figure 6-61. Student sculpture, cast cement.

ton tallow and kerosene; or by soaking the mold in a mixture of linseed oil and beeswax for two days, then washing with kerosene—and brushing, immediately before casting, with a thin mix of stearic acid dissolved in kerosene.

Cement cast should not be removed from plaster molds for several days and should be kept soaking wet for the first three days, and damp for the next 25 days to prevent the cement from cracking or crumbling. The cast may be removed for special treatment, but the surface should not be allowed to dry for at least a week. Cement casts should be removed from flexible molds as soon as possible, as the lime in the cement will affect the molds. Latex molds should be treated with green soap as a separator, gelatin molds should be coated with grease (figure 6-64).

Pouring the Cement Cast (Piece Mold)

1. Soak the plaster mold in water.
2. Apply the separator.
3. Assemble the mold.
4. Pour or tamp cement into the mold.
5. Vibrate, shake, rock, and puddle the mix (if fluid) to release air. Once the cement begins to stiffen, it must not be disturbed until it has become hard.

6. Keep the mold soaking wet for three days.

7. Remove the cast from the mold for finishing, but keep the cast wet for about 25 more days.

Pouring the Cement Cast (Waste Mold)

1. Plaster molds should be soaked in water before the mold separator is applied and immediately before casting if it has dried out.

2. Treat the mold with the proper separator.

3. Remove excess water with a soft cloth or with blasts of air.

4. Assemble the mold (page 106).

5. Slowly pour the cement into the mold, without splashing. If the mix is too stiff to pour, it must be tamped carefully so that all of the air will be forced out of the cast.

6. If the mix is fluid, shake, vibrate, or rock the mold in order that undercuts fill with cement. Do not disturb the cement after it has begun to harden, or the cast will become fractured.

7. Level the bottom of the cast by drawing a flat stick across the bottom of the mold.

Sand or Clay Relief Molds

Clay and sand molds for relief sculpture are simple to construct and are in extensive use. Clay or damp sand (containing a little clay to serve as a binder) is modeled in a box with a retaining wall about 1½" (3.81 cm) higher than the level of the clay or sand (figure 6-62). After the model is completed in intaglio or cameo relief, a medium, commonly plaster or cement (metal is discussed on page 154), is allowed to flow slowly over the surface of the model until the box is filled (figures 6-63 and 6-65). After the cast has hardened, the completed relief can be lifted away and additional casts can be made. In the cast of a clay mold, a blast of compressed air may help separate the clay mold from the cast, without the damage that might otherwise occur. It must be remembered that, as in other molding systems, the cast will be in reverse of the mold. If the cast is required in the same pattern as the mold, it will be necessary to make a cast of the original casting, using the first cast as a mold.

Clay

Clay castings can be created either through the use of a slip (fluid clay) poured into a mold, or through the use of a plastic clay packed into a mold. In either case, an absorbent mold is needed to remove excess water from the clay to make it stiff enough to be self-supporting.

Figure 6-62

Figure 6-63

Figure 6-64

Figure 6-65

Tools Required

Assorted wood and wire modeling tools (Figure 6-66.)

Slip Casting

1. Construct a plaster piece mold (page 102). Do not use mold separator on the surfaces of the mold, as this will prevent the mold from drawing water from the clay.
2. Allow the mold to dry 3-14 days, depending on the thickness of the mold and the temperature and humidity of the room.
3. Assemble the mold. If the mold is bone-dry, it should be dusted with talcum powder to prevent clay from sticking to the face of the mold (figures 6-40, 6-41).
4. Prepare the slip (pages 41 to 44).
 a. Slake the clay for an hour or more.
 b. Blunge the slip.
 c. If there is danger of foreign material—twigs, pebbles, nails, or leaves—in the slip, the slip should be passed through a 60-mesh screen.
 d. Allow the slip to age a day or two, then decant excess water which comes to the top.
 e. Blunge the slip to remove air before pouring the cast.
5. Fill the mold with slip, and allow it to stand until a ¼" (6.35 mm) to ½" (12.7 mm) wall is deposited on the face of the mold. When the surface level of the slip falls, slip should be added to maintain the proper level (Figure 6-67).
6. Pour the remaining slip out of the mold (figure 6-68).
7. Trim the bottom of the mold with a wire tool (Figure 6-69).
8. Allow the cast to remain in the mold until it shrinks away from the mold (figure 6-70).
9. Remove the mold by turning it so that the cast rests on its base; remove the topmost mold sections first.

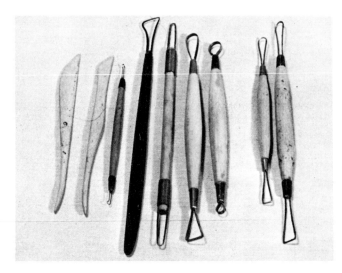

Figure 6-66

10. Trim the seams with a wire tool. Use some of the trimmings from the seams to fill small air holes or irrgular spots. Wood modeling tools can be used to sharpen detail or to make corrections where necessary, if the tools are not over-used.
11. The process can be repeated until the mold is too wet to absorb water, at which time clay will no longer be deposited on the mold wall. If additional casts are required, the mold must first be dried.
12. Dry and prepare the cast for firing (pages 43-44).

Casting with Plastic Clay

1. Construct a piece mold (page 102). Do not use a mold sparator on the faces of the mold.
2. Allow the mold to dry for a day or more, depending on the thickness of the mold, the temperature, and the humidity of the area.
3. The mold should not be bone-dry. If it becomes too dry, dampen it with a sponge or spray with a light mist of water.
4. Small balls of plastic clay are pressed firmly onto the face of the mold in such a way that they blend together to form the wall of the cast. Separate sections of the mold can be packed before they are joined to the rest of the mold, but care must be taken to form a ridge of clay around the edges of the mold section so that the clay walls can be easily joined at the seams between the mold sections (figure 6-11).
5. After the walls are built up (between ¼" [6.35 mm] to ½" [12.7 mm]) and the clay has stiffened, the cast can be placed on its base and the mold removed.
6. The mold should be trimmed with wire tools and irregularities repaired with wood modeling tools.

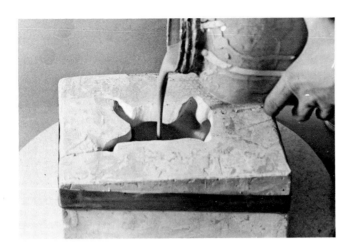

Figure 6-67

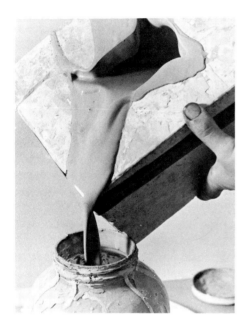

Figure 6-68

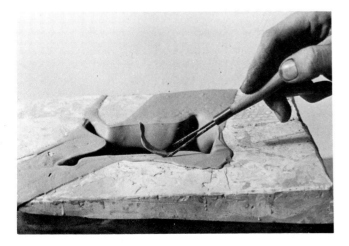

Figure 6-69

Figure 6-70

Figure 6-71

7. Allow the cast to dry; prepare the cast for firing (pages 43-44).

Plastic

Plastics that are fluid can be cast in several techniques. The two most common noncommercial being open face and open mold casting. Industrially plastics are commonly cast by sprayed open face reinforced mold, die casting (injection molding), and rotary casting.

Open face castings are shallow relief molds that are simply filled or coated with one or more layers of plastic and reinforcing agents, if they are needed. Industrial applications include spraying the plastics on large forms and usually some form of pressure from matching molds or phneumatic bags.

Open mold castings are high volume molds that use gravity to provide pressure for filling the mold and to provide an accurate "print." Industrial use of open

mold casting is limited because it is slow and expensive. The addition of high pressure injection and automatic machinery to open and close the mold (known as dies) results in a process known as die casting.

Rotary casting is a variation of open mold casting in which a small quantity of casting medium is slushed around the face of the mold and allowed to harden in place. Rotary casting usually uses metal molds which are injected (or hand loaded in the case of solid casting material) with a small quantity of plastic which is automatically dispersed on the surface of the mold as the mold is spun by the rotary casting machine. Rotary casters often use powdered plastics which are fused by heat when the molds are spun in heat chambers. The products are almost always hollow casts. Talk or soapstone is used to keep the plastic from sticking to the metal molds. Products typical of rotary casting include milk bottles, water and gasoline containers, heating and cooling ducts for automobiles, campers and so on.

The plastic most easily obtained for casting are the polyesters, polyurethanes, epoxies, and the acrylics. All three can be cast neat, but they each have problems.

Polyester resins are the easiest casting resins to use, the least expensive, and by far the greatest immediate health hazard of the three resins (see safety precautions on page 49). Polyesters are not as transparent as the acrylics but they can be obtained from as clear as glass to opaque. They are not as strong or as adhesive as the epoxies, but their strength can be increased by the addition of fillers. They also have an annoying shrinkage of about 7% except in rare cases of extended hardening times where shrinkage has been measured as high as 25%. Like all other organic plastics the resin is gradually degraded by prolonged exposure to sunlight even though they may contain ultraviolet filters. Polyesters are less affected by sunlight than the epoxies.

Polyester casting resins are available through sculpture suppliers and plastic supply houses. General purpose resins typical of those found in the discount houses are not really suited to casting large masses. They are usually tinted yellowish, pinkish, or bluish and are not attractive when cast in their neat state.

Thick casting of the resin may create great amounts of heat which will cause unequal expansion and may crack the cast. This problem can be minimized by pouring the cast in layers of one inch (25.4 mm) or less with a minimum of catalyst. Various castings resins will require different amounts of hardener.

Very large castings may require as little catalyst as .05% by weight. Smaller casts in cool conditions may require as much as 2% by weight. CAUTION: this catalyst ls usually MEK peroxide an explosive and blinding chemical (page 50) and great care should

be exercised in its use. Large casts may require the addition of a flexibilizer. Flexibilizers reduce the brittleness of the casts and in some cases may leave the surfaces a little rubbery. The thicker the cast, the higher the temperature, the lower the humidity, the less the hardener required. Casting should not be attempted at temperatures below 70° F. (21.1° C.). Seventy-seven degrss farenheit (21.1° C.) is considered a good ambient temperature.

Chances of success in pouring large masses are enhanced by mixing the resins and catalyst for as slow a cure as is practical. Curing periods of a week or more are normal except with some polyester resins which react unfavorably to extended curing times and shrink excessively.

Casts which harden but remain tacky can be cured out by applying gentle heat over a long period of time. An annealing box (figure 4-55) like the one used for acrylic plastic sheet can be used to cure polyester but the temperatures should be kept in the 90° F. (32.2 C°.) to 125° F. (51.7° C.) range. Under more primitive conditions widely spaced heat lamps can be used to provide the temperature needed.

Epoxy resins are expensive, vary greatly in their ability to transmit light, can be obtained from transparent to opaque, oxidize yellow and turn dull if exposed to sunlight for extended periods. The epoxies are so strong and adhesive that they can be used with a wide range of fillers in a wide range of ratios without degrading effects. It shrinks much less than polyesters (only up to ½%) so that expoxies are fine casting materials for reproducing strong precision shapes. Epoxies also are machinable and work a little like wood.

Acrylic resins are expensive, not readily available but produce the clearest most transparent castings (superior to glass) of any of the resins. The acrylics also have fascinating light transmission properties. These plastics are good insulators, they do not conduct heat well, as a result they are subject to critical expansion and contraction. Large acrylic masses must be annealed to relieve them of acquired stresses.

Pint and quart sized quantities of acrylic plastic are available in hobby stores as clear casting resin, or as embedding plastics. They are designed to be cast in sections of 1″ (25.4 mm) or less but can be used for thicker masses.

Casting large masses of acrylic resin requires equipment and involves expense and technology not generally available to the beginning sculptor. The molds containing the casting medium must be vacuumed to de-air the resin, then placed in a high pressure chamber and treated by slowly cycling the temperature and pressure from ambient room temperature and pressure to around 230° F. (110° C.) at 80 psi to (5.6246 kg

per sq. cm.) to 100 PSI (7.0308 kg per sq. in.) and then back to room temperature and pressure. A program which may require a number of days or weeks depending on the size of the mass.

Acrylic resin may be mixed with the same aggregates and colorants as the polyesters and epoxies. They can also be colored by dyeing after the cast has cured. The sculpture should be immersed in the dye (ordinary fabric dyes) and boiled until the desired tint is acquired. It is impractical to dye large acrylic forms because of the danger of expansion cracking from the heat of the boiling water.

Thick masses of acrylic plastic are subject to accumulated stress from sunlight induced localized expansion, impact from tooling, or surface chilling, and must be annealed to relieve the casting of the stresses which may cause it to crack or shatter. Annealing is affected by slowly cycling the temperature of the sculpture in a heat chamber to a maximum of about 230° F. (110° C.) and then back to room temperature. Interestingly enough the stresses can be made visible by observing the cast through a polarized filter. The areas of stress will appear as brightly colored bands or patterns.

Fillers and Colorants

The appearance of plastic castings is often enhanced by the addition of fillers and pigments to the casting media. Useable fillers include glass fibers, glass solids, hollow glass spheres (micro-balloons) silica flour (thixotropic agent), fiborous talc, cellulose fiber (nut shells, ground corn cobs), sical fibre, chopped paper, crepe paper, wood bark, soybean meal, ground feathers, mica, clay, perlite, cork, and the most popular-metal powders. Most fillers tend to settle or float out of suspension so various amounts of a thixotropic agent (a filler or stiffener) must be added to increase the viscosity of the fluid. Air floated silica flour of microscopic particle size are common fillers as were asbestos fibers. CAUTION! Never use asbestos fibers in the studio. Asbestos is a proven carcenogen.

Some special effects can be obtained by using water soluble fillers which can be dissolved out of the plastic mass after it has cured.

Many kinds of pigments can be used in the casting resins. Generally the pigment should be easily dispersed throughout the casting medium, should be non-reacting, and should be fade resistant. Color effects can be created ranging from transparent tints to opaque, matt through bright, and flat through pearlescent or metallic. Metal particles suspended in the resin may be exposed to corrode and produce natural patinas. Gaudy multiple color effects (similar to those seen in Mercurochrome) can be produced with special colorants. Except for very small quantities of resin,

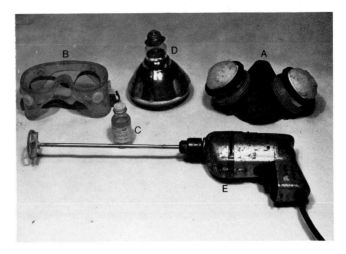

Figure 6-72

mixing should be accomplished with power equipment. An electric hand drill or a drill press can be utilized if a low vortexing mixing blade is used and the speed kept below that which causes the entire batch to spin. The vortex of a spinning mass will draw air into the mix. In gallon (3.785 liters) size batch three minutes of mixing should be sufficient.

Tools and Materials Required
a. Respirator (canister type) (figure 6-72A).
b. Safety goggles (figure 6-72B).
c. Disposable plastic gloves
d. Stirring sticks
e. Disposable containers
f. Filler materials
g. Separators (mold release) (figure 6-72C)
h. Infrared lamps (figure 6-72D)
i. Electric drill and mixing blade (figure 6-72E)

Casting Polyester and Epoxy Resin
1. Prepare the mold. Thin molds will allow easy heat transfer in the case of very large castings.
2. Coat the mold surface with the appropriate separator. Open face molds can be rinsed with polyvinyl alcohol, coated with very thin shellac (1 part 2-pound cut shellac and 1 part shellac alcohol), and polished with 2 coats of paste wax or liquid floor wax. Silicon spray parting agents and plastic parting agents can also be used.
3. Machine mix the resin, catalyst, and aggregates in the appropriate amounts.
4. Fill the mold. Large pours should be poured in layers of less than 1″ (25.4 mm) thickness. Where practical, vacuum should be used to remove entrained air. On nonporous or sealed molds a simple masonite board with a hole to fit the hose of a tank type vacuum cleaner can be connected to the suction side of the vacuum cleaner, then sealed

over the mold opening. This will provide ample low pressure to de-air the resin. Warning! The vacuum cleaner must be of the explosion proof sealed motor type to prevent the danger of igniting explosive fumes coming from the resins.

5. The cast should be allowed to cure. If during the early stages of the cure there is excessive release of heat (exothermic reaction) the mold should be cooled with air or cool water.

6. If the exothermic reaction stops and the surface of the resin remains tacky, it can be placed in a heat chamber to complete curing.

7. When the cast has cured, remove the mold and finish the sculpture.

Fiberglass

One of the most popular plastic systems of the late 1960s and early 1970s consisted of glass fiber reinforced resins, commonly called fiberglass. The toxicity, difficulty of handling, unpredictability in curing due to weather related gross humidity and temperature variations, and physical problems such as embrittlement and oxidation which occurs on aging, have diminished considerably the popularity of fiber glass as a workable medium. Epoxies or their vapors alone can cause severe allergic reactions in some individuals.

Both epoxy and polyester resins are used to bond the glass fiber. Epoxies are stronger, more impervious to solvents and considerably more expensive than polyesters. Polyesters are more common, have finishing problems, do not grip as well, but are considerably cheaper than epoxies. Polyesters also have the disadvantage of attacking styrenes if they come into contact with them as a surfacing material. Isolation materials such as latex paint or thin films of acrylic paint or plaster will prevent the resins from dissolving the foam. Most but not all epoxies can be used directly on the foam.

The techniques for using polyester and epoxies are nearly identical. The only difference commonly encountered would be in the choice of polyester resin types. Polyester resins are available in bonding (laminating) coats and finishing coats (often called boat resins). Bonding resins are compounded so that they resist hardening as long as they are exposed to the air. Their usefulness lies in their tacky quality. Fiberglass fabrics have so much "spring" that they do not want to lie tightly to a high crowned surface or fold tightly against a 90° corner or edge. The tack of a bond coat will act a little like a contact cement and hold the glass fibers in place until additional laminating coats or finishing coats can be applied. The finishing resin contains a wax like material which floats to the top of the applied resin, shutting off the air and allowing the resin to cure. The wax like material that floats to the surface of the resin will reduce the bonding qualities of the resin, weakening the laminate. It will also prevent finishing materials from adhering satisfactorily. The wax like material can be superficially removed with lacquer thinner or acetone, but should be sanded to remove all traces of the wax. Any residue on the surface of the polyester resin may cause a paint defect known as fish eye which is the result of the paint drawing away, leaving a bare spot on the surface.

Bonding resins can be cured by physically excluding air. Common techniques include rubbing a layer of plastic film, such as Saran Wrap or plastic from garbage bags on to the tacky resin. If temperatures are over 80° F. (26.7° C.) and the humidity is reasonably low, the resin may eventually cure. Other covers such as paint have been tried with various degrees of success.

Even though finishing resins are a sticky mess to work with, they can be used neat, as a base for many painting systems. The secret is to mix the resin with the catalyst properly, then apply the resin in small areas with a brush or a plastic scraper. Immediately after applying the resin, heat the surface gently with a heat gun, hair drier, or heat lamp (no higher than 170° F. [76.7° C.]), then brush out the resin. The resin will thin, spread, and penetrate quite easily. On cooling slightly, the resin will stay in its place without running or bagging, but it will flow, leveling out into a glassy surface. Overheating will cause the resin to bubble and thicken into a gummy mess called roping. On large smooth surfaces a plastic squeegee will work better than a brush.

A gel coat is a resin compounded for laminating in molds and is similar in use to finishing resin in that it is the exposed surface of the laminate. The gel coat which can be obtained in a variety of colors and which contain a thickening agent is placed against a mold surface to form a resin wall. Glass fibers are then laminated to the gel coat. The gel coat is flexible, may contain color, and often contains an ultra violet filtering agent. This thick layer of plastic prevents the glass fibers from showing up on the surface of the cast.

Epoxy and polyester resins are hardened by chemical action which is accelerated by the action of a catalyst (or hardener). Various hardeners are used in varying quantities dependent on the kind of resin, the temperature, the humidity, and so on. There are epoxies readily available that can be used at temperatures as low as 50° F. (10° C.) but most resins cannot be used at temperatures below 70° F. (21.1° C.). As a general rule varying the amount of hardener will not compensate for low temperature or high humidity which retards or prevents curing of the resin. Most

polyester resins are catalized with very small quantities of Methyl Ethyl Keyton Peroxide (MEK) (1% to 2%). MEK is a highly dangerous chemical that will not only destroy eye tissue on contact with a continuous and irreversable reaction, but it is also explosive. It should also be noted that incorrect proportions of the mix, such as reversing the proportions of catalyst to resin may result in a violent chemical reaction, and at times (as in the case of phenol/phosphoric acid) explode violently.

Epoxies, unlike polyesters, are usually compounded so that the agents to be mixed are mixed in ratios of 1:1 or 2:1, and they are in no way as dangerous as the polyesters. They do have the problem of being toxic over a long period of time if the uncured resins comes in direct contact with the body.

Epoxies are available in hobby supply outlets and are identified by their various curing times. The fast curing resins have a working time of about five minutes and a curing time of fifteen minutes. The longest curing times are about twenty-four hours with a three to five hour working time. Fast hardening resins are usually weaker and less flexible than the slow hardening varieties.

Unfortunately many suppliers did not restock after the petrochemical shortages which occurred in the mid 1970s so many plastics and resins which had been stocked in previous years are no longer shelf items. Slow moving items have become difficult and expensive to obtain. In some cases probably to keep costs down and to eliminate slow moving inventory manufacturers have had to alter the characteristics of their materials. In at least one case finishing and gel coat resins are no longer needed to seal the bonding (laminating) resin because the bonding resin has been compounded to harden in the presence of air.

Fiberglass laminating fabrics are available in closed and open weave cloth, in many weights from 3/4 ounce (21.26 g) sailcloth used by modelers for the construction of radio controlled boats and airplanes to 10 ounce per square yard fabric used in the lamination of full scale automobile bodies and boat hulls. The fabric also comes in veil, woven roving, matt veil (figure 6-73), which has been difficult to obtain, is a very thin continuous filament material that looks like old angel hair used on Christmas trees, or the glass filter material used in furnaces. Woven roving has a coarse weave of unspun strands of glass. Matt is a felt like pad that is built up from chopped strands of glass up to two and one half inches long.

Veil is the most responsive of the fabrics, in that it will stay where it is placed. It is used to lay up a thin tight layer of glass against a mold surface. Unlike woven fabrics it will sand down smoothly without leaving a waffle pattern on the surface of the fiberglass. Glass cloth is next in responsiveness. It is slightly springly. Roving and matt are both difficult to hold in place. They both tend to spring loose from curved surfaces and almost never form a tight 90° angle. Contact cement and staples can be used to hold the roving and matt in place when necessary. Matt is miserable to work with because the glass strands are loose and short enough to pull out of the fabric while it is being brushed or rolled. Everything that comes in contact with the messy matt or tools will end up covered with prickly hairy strands of skin irritating glass. The glass strands are very sharp and can cause irritating skin rashes with considerable discomfort. It is advisable to avoid the use of matt except in cases where the matt is pressed rather than brushed or rolled. Matt saturated resin will not develop its full strength unless it is hardened under pressure. Sheets of matt can be pressed between oiled and weighted metal sheets.

Epoxy residue can be removed from tools and the body by washing with soap and water or alcohol before the resin cures. Polyester resins can be removed with thinner or acetone.

There are several interesting techniques which can be used to form glass smooth surfaces and tight laminations of glass fabrics. One approach is to make a shape (plug) and cover the plug with the appropriate resin filled glass fabric. A balloon is then inflated and pressed over the plug and then allowed to deflate in such a way that the rubber stretches back over the plug and fiberglass. The rubber shrinks evenly on the plug, pressing the laminations tightly together and forming a smooth surface. Unfortunately the rubber will not reach undercuts or deep recesses. The technique will also work in a mold, but not as well, as it is difficult to maintain pressure on the inflated balloon long enough for the resin to cure. Sharp edges on the mold are more than likely to cut the rubber in a mold than on a plug.

Large flat sheets of fiberglass laminate can be made by laying up layers of glass cloth and resin on a sheet of waxed aluminum or some other smooth surface to which the resin will not adhere. The cloth should be rolled into the resin and the excess resin squeegeed off with a plastic squeegee. If a very light glass sheet is desired, excess resin may be lifted from the sheet by rolling a roll of toilet paper over the surface of the sticky resin. As soon as the toilet paper is saturated with resin the messy top layers of paper should be stripped off in the trash and the process continued until all of the excess resin is removed from the sheet. This process will work with any of the laminating techniques.

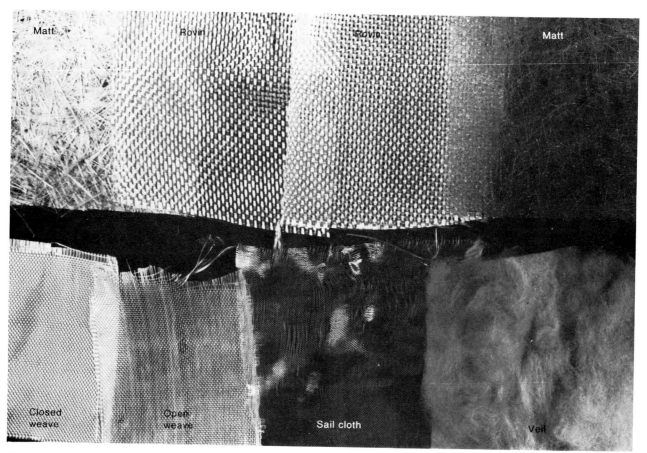

Figure 6-73

Tools Required

a. Squeegee (figure 6-74A)
b. Rollers (figure 6-74B)
c. Nonsoluble and non-waxy disposable containers and brushes
d. Disposable mixing sticks
e. Scissors or tin snips (figure 6-74C)
f. Staple gun (figure 6-74D)
g. Heat lamp (figure 6-74E)
h. toilet paper rolls (figure 6-74F)
i. Silicon spray or other separators
j. Polyvinyl alcohol (figure 6-74G)
k. Paste wax (figure 6-74H)
l. Balloons (figure 6-74I)
m. Finned roller (figure 6-75)
n. Cleaning solution (figure 6-74J)

Figure 6-74

Laminating over a Plug

1. Shape the plug and fasten to a handle or stand.
2. Apply a separator to the plug.
3. Apply the resin and glass fabric in layers.
4. Inflate a large balloon and press over the plug while the balloon deflates. Surgical rubber sheeting can be used in the place of balloons on some plugs.

5. Tie the balloon in place.
6. Clean residue from the tools.
7. After the resin has cured remove the balloon and laminate from the plug.
8. Repeat steps 2 through 6 to form multiples of the same shape.

Figure 6-75

Laminating over an Armature

1. Construct an armature. Styrofoam is an ideal armature material but it must be sealed from polyester resins. Latex paint or thin plaster will prevent the polyester resin from dissolving the foam.
2. Mix a small quantity of bonding resin and coat the armature.
3. Roll the glass fabric into the resin with a finned roller.
4. Allow the resin to tack. Roll the fabric whenever necessary to prevent the fabric from raising and forming a bubble.
5. Dispose of the container and mix fresh resin.
6. Roll or brush on a second lamination of cloth and resin.
7. The roller should be used to press the glass firmly into the resin. It will press out bubbles of air and squeeze the resin through the weave of the fabric. Bubbles which form in the laminate as a result of the laminations lifting will cause finishing problems, especially if final sanding breaks through the weave of the glass cloth.
8. Remove excess resin with a plastic squeegee. Roll a roll of toilet paper over the laminate to pick up excess resin.
9. Laminate lay up should be continued by repeating steps 5 through 7 until the required thickness is achieved.
10. Colors can be mixed with the resin at every step. If a little color is added in each layer, a slightly "deep" translucent effect can be developed.
11. The final coats should be finishing resin. They should be applied after the last laminate and they are used to impart the desired surface and color. The resin is best applied in small areas with a brush or squeegee and then heated with a heat gun, hair drier, or heat lamp (not over 170° F. [76.7° C.]) to cause the resin to spread and level.
12. If a styrofoam armature was used the foam can be dissolved out of the fiberglass laminate with lacquer thinner or other solvents. This step must be executed out of doors and away from any kind of spark or flame. After the foam is dissolved, the shell should be soaked or scrubbed with water and Bon Ami and aired for twelve hours. All traces of the solvents must be removed to prevent them from attacking the fiberglass.
13. Fiberglass can be finished by sanding, polishing, and buffing as in the case of plastics, or they can be sanded, primed, and painted with most painting systems.

Metals

Molten metals can be cast in molds of many materials including salt, ashes, loam, clay, sulphur, metals, ceramics, and plaster. Industrial processes use sand for huge coating and short production runs, metal molds (die casting) for large production runs of thin moderately complex castings, and ceramics for short or long production runs of small but highly accurate forms of any complexity.

The three most useful materials to the sculptor are blended sands, plaster mixes, and bonded ceramics. A casting system has developed around each of the materials.

Plaster mixtures are used as investments in the lost wax method of casting, in which a wax model is buried in plaster, melted out, and replaced with molten metal or plastic.

Bonded ceramics, known as the ceramic shell process, consists of coating a wax pattern with a ceramic refractory cover, melting out the wax, then pouring metal in place of the wax.

Sand casting is the process of pouring a casting medium in an impression left in the sand by a pattern. Traditionally, the pattern was removed intact from the sand (which was a piece mold), but bonded sands and volatile pattern media now permit the entrapment of the pattern in the sand. The pattern can be dissolved with solvents, or vaporized with heat in a system known as the "lost pattern" of "full mold" process.

The quality of casts produced by these systems are roughly comparable (dependent primarily on the quality of the molding material and the skill of the foundryman). The casting system selected should be a matter of suitability of the system with respect to the problem, the metal being used, and the capabilities of the foundry.

Casting Metals

There are innumerable metals and their alloys suitable for casting. They are roughly divided into ferrous (iron) and non-ferrous (all the others) based alloys. The only ferrous based metal suited to the "do it yourself" founder is cast iron. Even that isn't too practical. The non-ferrous casting alloys that are in common use are the pot metals, the light alloys, copper based alloys, and the precious metals.

Pot metals are low temperature melting alloys (below 650° F. [343.3° C.]), are held in low esteem by artists, are relatively weak, do not patina well (they may throw off powdery white corrosion), and most of all they are dirt cheap compared to other metals. These alloys are used in the manufacture of toys, automotive sub assemblies (grills, dashboards, etc.) machinery cases (fuel pump and carburetor castings), etc. They are used because they can be die cast in very thin sections with beautifully highly detailed smooth surfaces, and can be painted or plated attractively and easily. Old printing shops often have large amounts of obsolete type metal (one form of pot metal) for sale cheap. Pot metals are unappreciated materials, their greatest assets are their availability, and easy and unique finishing capability.

The light weight metals of interest are aluminum and magnesium. They are similar in their appearance and casting nature except that magnesium has a nasty tendency of burning furiously. Aluminum is more difficult to finish but is far more stable than magnesium which corrodes rapidly and uncontrollably in adverse conditions (page 179). Aluminum is a favored casting medium for the sculptor because it is inexpensive. It weighs about 1/3 the weight of bronze and costs about 1/2 as much per pound, so that an equal mass of aluminum would cost in the neighborhood of 1/6 as much as bronze. Aluminum is also easy to locate as scrap, is easy to melt and pour, and some alloys can be repaired by soldering or welding.

The most common copper based alloys include red and yellow brass, phosphor bronze, naval bronze, gun metal, silicon bronze, aluminum bronze, lead bronze, statuary bronze, and bell bronze. Each of the alloys has its peculiar casting qualities most of which are of no interest to the sculptor. The favorite copper based casting alloys for the sculptor are statuary bronze, Everdur, bell bronze, 85-5-5-5, and white bronze. They are generally melted and poured at over 2000° F. (1093.3° C.), are heavy, expensive and except for white bronze (White Tombasil*) which may be similar to chrome in color, will patina easily and attractively.

*Trademark H. Kramer Co., 1315-59 W. 21st, Chicago, IL.

The precious metals are beyond the budget of the average beginning sculptor unless the product is miniscule. The three "big time" metals are gold, silver, and platinum, all three of which have superior casting qualities. The cost of gold will often range around 380 times greater than that of bronze for the same mass. A seventy dollar ($70) bronze cast would cost around twenty-six thousand six hundred dollars ($26,600.00) in gold.

Choosing a casting alloy is much simpler than it would seem. Ingot metal is sold in alloys compounded to equal standards established by the Society of American Engineers. Alloys are compounded for job application, castability, strength, machineability, and molding process, among other things. For instance SAE Standard #34, Type 2 alloy was used to cast automobile pistons, air cooled cylinder heads for aircraft and piston sleeves for diesel engines. It could be cast in permanent or sand molds. SAE Standard #35, type 1 alloy is a general purpose casting alloy. It can be cast in mixed thick and thin sections but is not particularly strong.

It is advisable to use an alloy which can be welded or soldered in the event that a cast might require some filling or other repair. If scrap metal is to be used, a rough guide to the suitability of the metal would be the manner in which it was formed. Extruded aluminum, tubes, boat trim, railings, etc., contain large amounts of silicon which give the metal a wide temperature range of plasticity. The metal stays mushy and does not flow easily. It will therefore require greater pressure (hydrostatic pressure from the height of the pouring head) to get a print equal to that of a more fluid alloy. Scrap metal which was casting in thick sections like air cooled heads of aircraft or automobile engines, cylinder blocks, and so on, will usually be very fluid when melted and will flow and print well. Cast metal objects which were cast in thin sections were probably die cast and could be any number of alloys from pot metal to zinc to aluminum to magnesium and they are not worth the risk unless the base metal is known. Large aluminum forgings such as airplane propellers, connecting rods and forged pistons will usually cast well but they can be improved by mixing them with an equal amount of a general casting alloy. Airplane propellers seem to make brighter, stronger and more easily finished sculpture than industrial standard SAE 319.

It usually doesn't pay to cast with scrap bronze or brass. There are too many problems associated with mixing unknown alloys, especially when one or two pounds of the wrong metal can curdle 200 pounds (90.72 Kg.) of expensive metal, rendering it useless except for sale as scrap.

There are also other serious problems associated with the use of scrap metal. Frequently undesirable foreign materials are cast in place in manufactured articles. Automobile pistons for instance may have a steel band cast into the piston. On melting the piston the steel is released into the melt and the aluminum is contaminated with iron. Even worse, some scrap items may be inherently dangerous to melt. Used bronze valves will occasionally explode violently, throwing molten metal out into the air, because of water or air trapped on the inside of the valve. The red brass known as bronze and called eight five three fives (85-5-5-5) and Everdur are probably cast by more sculptors than all of the other copper based alloys together. These two alloys are not compatable and should not be melted in the same crucible. Alloy 85-5-5-5 is a red brass composed of 85% copper, 5% tin, 5% lead, and 5% zinc. It machines well, casts well, has good finishing qualities, and can be welded and silver soldered. Everdur is a silicon bronze having about 96% copper, 3% silicon, and 1% manganese. It is significantly more fluid than 85-5-5-5, casts cleaner, welds beautifully, but does not patina as well, and is much more expensive than red brass.

White bronzes have not been as exploited as a casting medium as they should be. They cast better than either 85-5-5-5 or everdur and have a finish similar to soft chrome.

Grey iron can be melted in most furnaces that will melt bronze. Pig iron, the iron produced in a cupola from iron and limestone, melts at about 2100° F. (1148.9° C.) and wrought iron melts at around 2800° F. (1537.8° C.) Iron castings are cheap, heavy, brittle, usually crude, are touchy to weld for repairs or patching, and hard to finish. They also require bothersome maintenance because they rust rapidly.

Until recently the cupola furnace which uses coke and forced air for heat was the common method of melting metal. Environmental problems and the scarcity of coke in many areas have made the cupola less popular than it was. Some founders are solving this problem by using #2 crude oil to melt cast iron.

Designing A Pour

After the molds are prepared and are ready to be poured, the layout of the pouring floor must be designed for ease and safety. The pour in the floor layout is dependent on the facilities in the foundry, but there is also a common sense order that should be followed. The area around the furnace should be clear enough so the crucible can be lifted out of the furnace, set in a pouring shank, then lifted and moved to the pouring area. The arrangement of the flasks to be poured depend on the manner of transporting the crucible (figures 6-76, 6-77, and 6-78). If the crucible is carried by a crane the flasks should be arranged in a row directly below the line of travel of the crane. Traveling bridge cranes with trolleys (figure 6-79) have access to the entire area beneath the rails on which the bridge travels so the pour can be designed in any number of ways. Generally it is easiest to align the flask in rows parallel to the bridge so that the crucible is moved from flask to flask by moving only the trolley and not the entire bridge. The bridge with all of its weight need only be moved from row to row. Jib cranes are very limited in floor accessibility (figure 6-80). The flasks are usually arranged around the supporting post in a semi-circle unless the jib is equipped with a trolley. In this case the flasks can be arranged in any pattern within the segment of a circle of accessibility of the crane.

If portable engine cranes are used the layout of the flasks becomes critically important (figure 6-81). The portable engine crane is a highly versatile, relatively inexpensive, easy to build and easy to use lifting device, but it has its problems. This crane requires a fairly smooth concrete floor (macadam should never be used in a foundry) and ample area in which to maneuver. The legs on the crane can cause problems if the spread is not great enough to straddle sand boxes, flasks, burn outs or furnaces, or if the boom is not long enough to reach deep into a pouring area. Because of their limitations the flasks in a pour using a portable engine crane are arranged in a segment of a circle so that the crane can be located in one general area and simply turned from flask to flask, rather than traveling down rows. Some engine cranes do not have swiveling front casters and are not satisfactory for this type of work unless they are converted.

The flask must also be arranged in such a way that they do not interfere with the pouring shank in each succeeding pour. The arrangement should allow a free continuous sweep of the pouring floor without backing up or crossing over unpoured flasks. It is also usually preferable to arrange the flasks in an order of ascending heights. The shortest flasks being poured first. It is safer to keep the crucible near the floor while it is in its fullest state. The layout should also prevent the crucible from being positioned over a flask (full or empty) while a pour is being made. A full mold may smoke sufficiently to obscure the pour of another flask, and the crucible may drop scale or other junk into the pouring basin of an empty flask, ruining its cast.

Pours being made in a common bed of sand should be designed so that the pouring basins to be poured first (in front) should be the lowest. The pours made across the front of the bed, then worked back in rows. If the highest pouring basins are filled first and there is a miss-pour, or a break out, metal will flow to

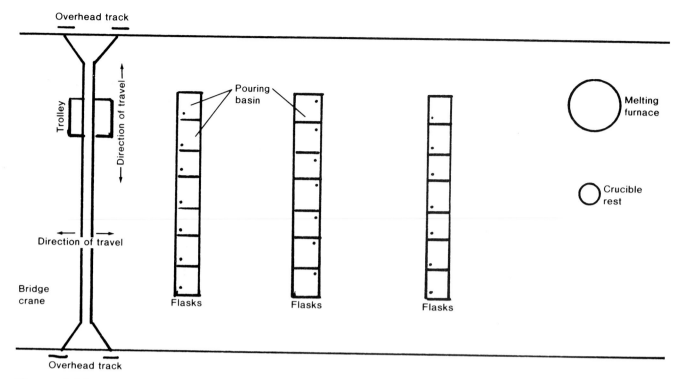

Figure 6-76. Pouring floor arrangement for Bridge Crane.

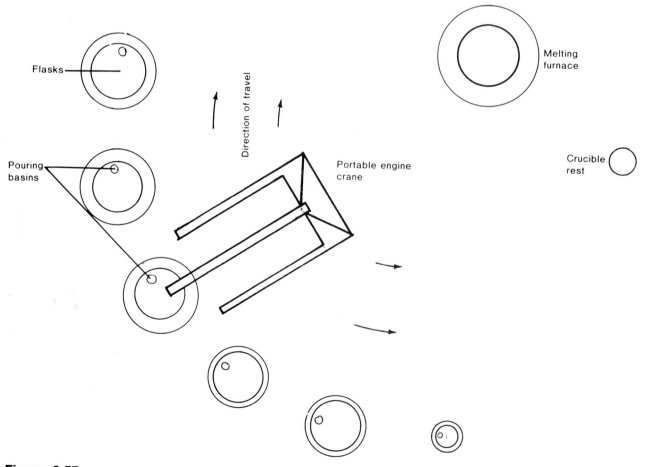

Figure 6-77

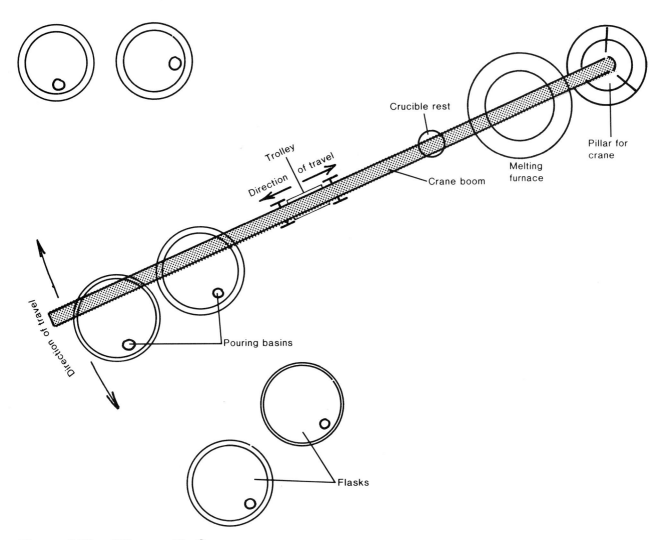

Figure 6-78. Pillar or Jib Crane.

Figure 6-79

Figure 6-80

Figure 6-81

lower points of the sand bed, perhaps blocking pouring basins or only partially filling other molds. The only save in a situation of this kind would be to dump metal at a faster rate than usual in hopes of filling the lower flask before the metal freezes off in the sprue.

Considerable care must be taken to see that every flask can be poured safely, without interference, and without trapping or boxing anyone into a dangerous area or situation. The only way to guarantee the practability of safety of a pouring layout is to make a dry run of the pour with an empty or a dummy crucible and the entire pouring team.

The pouring team may consist of three to four people. One person will operate the crane, one will dead man the pouring shank (steady the shank), founder, who will tilt the crucible, and one person who will skim or hold back trash on the surface of the crucible during the pour. Other chores are divided between the members depending on the layout of the foundry. A typical team operation follows: The crane operator moves the crucible and never leaves the crane. The skimmer will open and close the furnace, skim the metal, open the pouring basins if they have been covered to keep out trash, and pull sprue and vent formers and other miscellaneous tasks that may be required as each succeeding pour is made. The dead man may assist in lifting the crucible from the furnace, transferring it to the pouring shank, degassing and fluxing the metal, and steadying the pouring shank while it is being rotated to make a pour. The founder usually captains the small pouring operation. Responsibility for the safety and success rests on the leadership of the founder because the founder calls all directions to the crane operator (no other orders should con-

fuse the movements of the crane and the crucible) and every other member of the team.He also charges the crucible, lifts the melt, locks the crucible in the pouring shank, positions the crucible for the pour, tilts the crucible to fill the flask, and determines when the flask will take no more metal. The founder is also responsible for the actions of the pouring team during emergency situations and should establish orderly procedures to be followed for each contingency. Problems which could occur during a pour might include dropping a loaded melt (figure 6-82), cracking the bottom out of a crucible, a blow out of a flask, dropping metal onto the floor or throwing it into the air, mispouring and setting fire to shop furniture (wood boxes). The pouring team frequently has a properly suited safety man standing by in the event that some additional help or substitution is required. Apprentices to the team frequently relieve members of the team who become the safety man.

One area of the pouring floor (out of the traffic pattern) should be set aside for pouring ingots. Metal left in the crucible, except for a shallow boot in the bottom, should be poured into ingot molds (15 to 20 lbs. [6.804 Kg. to 9.072 Kg.] for aluminum and 20 to 30 lbs. [9.072 Kg. to 13.608 Kg.] for bronze). The boot is left in the crucible to facilitate heat transfer at the beginning of the heat. If a large amount of metal is left in the crucible the metal will expand on reheating and may rupture the crucible. When the pour is finished the crucible should be returned to the ingot area, or some other protected area, placed on a crucible rest and the area blocked off for safety sake.

Making a Pour

The furnace should be preheated to about 450° F. (232.2° C.), turned off and the crucible placed inside of the furnace to pre-heat (the opening in the furnace lid should be covered), the pouring floor laid out, and a dry run tried out. When the crucible has heat soaked sufficiently it should be lifted from the furnace and a double thickness of water soaked corrugated cardboard should be placed on the crucible rest in the bottom of the furnace. The crucible should be immediately returned to the furnace and the furnace ignited. Ideally, careful timing will bring the metal to pouring temperature shortly after the layout of the pouring floor is complete. The metal should be brought to temperature as quickly as is safe and practical and poured as soon as possible. On reaching heat the crucible is lifted from the furnace and placed in a pouring ring on a crucible rest while it is degassed, skimmed, and fluxed (dependent on the kind of metal being melted). It is then lifted, locked in the pouring shank, and moved to the flasks to be poured.

When the crucible is empty it is returned to the furnace to be placed on wet cardboard again and additional metal melted, or the excess metal is poured into ingots and the crucible returned to the crucible rest in the ingot area and blocked off to prevent accidents. The furnace is kept closed at all times except to insert or remove the crucible or to light the fire. A typical pouring sequence follows:

Typical pouring sequence for 240 lbs. (108.86 kg) of bronze or 60 lbs. (27.22 kg) of aluminum

15 min. 1. Preheat the furnace
20 min. 2. Pre-heat the crucible in the furnace

1½ to 3 hrs.
Sand Cast
 Design the pouring layout
 Lay out the pouring floor
 Make a dry run
 Pack lost pattern sand molds

1½ to 3 hrs.
Investment Cast
 Design the pouring layout and make a dry run
 Open burn out and remove investment flasks
 Lay out the pouring floor
 Pack the investments in sand
 Make a dry run

Bronze 2½ hrs.

3. put flux in crucible

4. load pre-heated metal

5. lift crucible and insert wet cardboard replace crucible

6. Light furnace

7. add metal as needed

8. reach melt temperature

9. open furnace and lift out melt

10. place on crucible rest and skim

11. flux, lift and lock the crucible in the pouring shank

12. pour flasks and ingots

13. unlock shank and lower the crucible to the crucible rest and lower the pouring shank to the floor

14. block off the areas of heat for safety

Aluminum 1½ hrs.

3. load pre-heated metal

4. lift crucible and insert wet cardboard, replace crucible

5. light furnace

6. add metal as needed

7. attain melt temperature

8. open furnace, degass, and skim and lift out melt

9. place and the crucible rest and skim

10. lift and lock the crucible in the pouring shank

11. pour the flanks and ingots

12. Unlock the shank and lower the crucible to the crucible rest and the pouring shank to the floor.

13. Block off the areas of heat for safety.

Allow bronze to cool for 24 hours before removal and 1 to 2 hours for aluminum

Figure 6-82

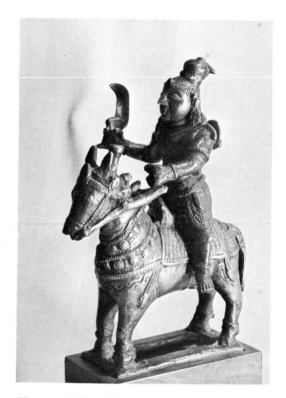

Figure 6-83. *Toy Warrior on a Horse* (originally on wheels), cast bronze and copper, Delhi area, India. Collection of H. Hasselschwert.

Figure 6-84. *Rama,* South India, mid 19th century, cast bronze. Collection of H. Hasselschwert.

Melting Aluminum

A mild steel, cast iron, graphite, or silicon carbide crucible can be charged with the aluminum when the crucible is placed in the furnace to start the melt. The fire at the mouth of the crucible furnace should reach several inches beyond the opening in the lid and should be slightly yellowish green (green if the furnace has been used to melt bronze). If the flame does not show above the lid some of the metal will burn and be ruined. The heat should be brought up as quickly as the equipment will safely allow. Additional metal should be preheated by placing it around the

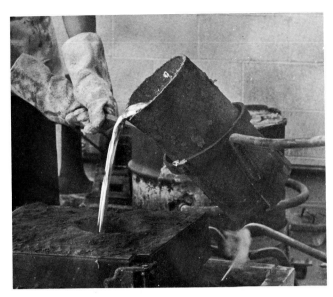

Figure 6-85. Pouring aluminum from a home-made mild steel pipe casing melting pot.

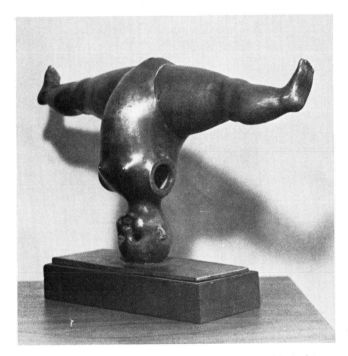

Figure 6-86. Baby Bank, John McNaughton, American, (1943-) cast bronze.

opening on the lid of the furnace. As the aluminum melts down, pre-heated metal should be lowered gently into the melt. The melt should not be stirred, mixed or otherwise disturbed to prevent it from picking up air and other harmful gasses. Many aluminum alloys begin to melt at 800° F. (426.7° C.) and can be poured between 1100° F. (593.3° C.) and 1500° F. (815.6° C.). General purpose casting alloy #319 for instance should be heated to about 1200° F. (648.9°

C.) and allowed to cool back while it is being skimmed to around 1100° F. (593.3° C.). At this temperature the slightest red glow will be visible if the surface of the metal is viewed through a 1/8″ (3.175 mm) hole in the bottom of a can. (Founders more often make a fist and, using it like a telescope, place it against the eye and make a small opening through which to view the metal).

As the metal reaches the pouring temperature it will become very fluid and may begin to spin violently in the crucible, throwing metal out into the bottom of the furnace. The fire should be reduced immediately if there is any tendency for the metal to spin. If the aluminum is to be degassed, it should be degassed below 1250° F. (676.7° C.). In many foundries it is degassed before it is lifted from the furnace to take advantage of the hoods which remove dangerous fumes from the furnace. After the melt is degassed it should be skimmed and poured immediately. Tools which are immersed in the melt should always be pre-heated to prevent sweat, which forms on the tools, from turning to steam and exploding metal out of the crucible.

Melting Bronze

Bronze is loaded into the pre-heated furnace and graphite or silicon carbide crucible in the same manner as aluminum, except that an agent which floats to the top of the melt isolating it from the air, is placed in the bottom of the crucible before the metal is loaded. Excellent commercial fluxes or covers are available, but there seems to be a lot of mythology concerning the proper gas covers. Preferences run from baby food jars to green coke bottles, to a mysterious "brown bottle." Glass, often used by the back yard founder, will work but it makes a terrible mess in the crucible, gradually decreases the capacity of the crucible, and is definitely inferior to the covers used in industry.

The flame of the furnace should be adjusted to extend out of the opening in the lid and should appear to be green. The melt should be brought to temperature as quickly as is practical. Pre-heated metal should be lowered gently into the melt. Cold metal may cause violent eruptions (kick backs) in the melt. If scrap metal is to be used care should be exercised to eliminate closed containers such as pipes plugged at both ends, valves, or expansion chambers, or an explosion of some magnitude is sure to result.

When the melt is up to temperature (2450° F. [1343.3° C.] for 85-5-5-5) the furnace should be shut down and the crucible lifted out of the furnace. The metal should be skimmed and flux deoxidized immediately before the pour. Some foundrymen that use glass as a cover break a small opening in the surface

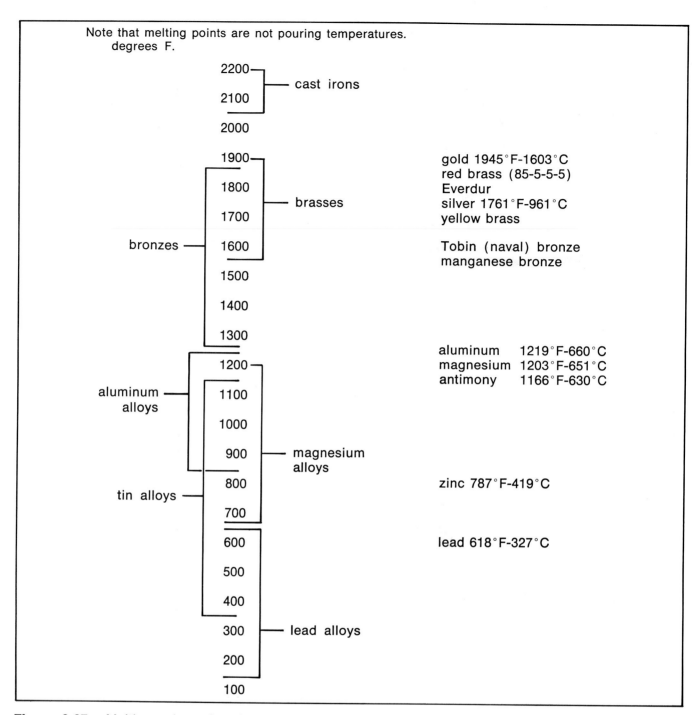

Note that melting points are not pouring temperatures.
degrees F.

2200 — cast irons
2100
2000

1900 — gold 1945°F-1603°C
 red brass (85-5-5-5)
1800 Everdur
 silver 1761°F-961°C
1700 yellow brass

bronzes — 1600 Tobin (naval) bronze
 manganese bronze
brasses

1500
1400
1300

1200 aluminum 1219°F-660°C
 magnesium 1203°F-651°C
aluminum 1100 antimony 1166°F-630°C
alloys
1000
 magnesium
900 alloys

tin alloys — 800 zinc 787°F-419°C
700

600 lead 618°F-327°C
500
400
300 — lead alloys
200
100

Figure 6-87. Melting points of useful casting metals.

of the glass through which they make the pour. Others use a flat tool and flip the glass layer out of the crucible to prevent it from sagging down the inside and coating the walls of the crucible during the pour.

Melting Pot Metals

Pot metals melt at a wide range of temperatures below 600° F. (315.6° C.). They can be melted on gasoline plumbers' stoves, natural or bottled gas stoves, and even electric hot plates in simple iron pots. They can be so easily melted that they are especially dangerous because casters tend to overlook common sense safety rules. The melting containers must be stable (not tippy as are many lead melting pots) and have an adequate handle or pouring device. Molten pot metal will splatter if water or damp tools or ladles are placed in the melt. The metals are usually silvery in color and do not change color when they cool.

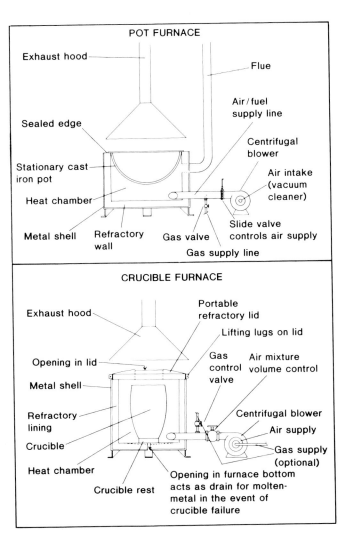

POT FURNACE

Exhaust hood

Flue

Air/fuel supply line

Centrifugal blower

Sealed edge

Air intake (vacuum cleaner)

Stationary cast iron pot

Heat chamber

Metal shell

Refractory wall

Gas valve

Slide valve controls air supply

Gas supply line

CRUCIBLE FURNACE

Exhaust hood

Portable refractory lid

Lifting lugs on lid

Opening in lid

Gas control valve

Air mixture volume control

Metal shell

Centrifugal blower

Refractory lining

Air supply

Crucible

Gas supply (optional)

Heat chamber

Opening in furnace bottom acts as drain for molten-metal in the event of crucible failure

Crucible rest

Figure 6-88

Lighting the Furnace

The centrifugal furnace illustrated in figure 6-88 is started by first checking that all valves are turned off and that power and fuel are available. The fan is started or the drafts opened on the exhaust hood, the furnace opened and a burning oily rag fastened on a wire is placed against the nozzle. A heavy oil such as 40 wt. motor oil should be used so that it can be easily extinguished and will not blow out by the draft in the furnace. Start the blower motor, but do not open the air supply valve. The gas valve should be opened slightly and the flame ignited with the burning rag. A soft yellow lazy but large flame should appear in the furnace. Open the air valve until the flame begins to roar. Use the oily rag to bring the flame back to the nozzle if necessary. If the flame is adjusted properly it will stay at the nozzle and the rag can be removed. If the flame is too small the gas should be increased slightly and the air increased in that order. If the flame is too rich (excess gas) it will drift away from the nozzle, spin around the

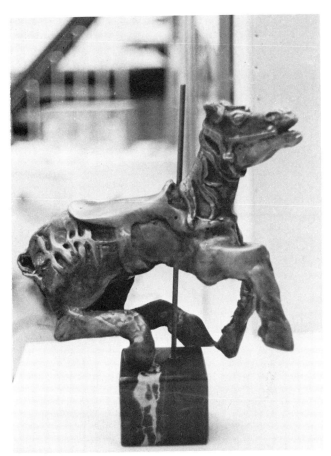

Figure 6-89. Cast bronze, student sculpture.

furnace and finally go out. If the flame is too lean (not enough gas) it will draw back into the nozzle, possibly pop and go out. When the flame is adjusted properly to bring the furnace to pre-heat it will burn with a roar, cling to the edge of the nozzle, and show a slight yellow licking feather at the end of the flame. When the flame is adjusted to bring the metal up to temperature, it will burn with a loud roar, cling to the nozzle, leave a ring of flame around the crucible and stand green above the opening of the lid. The flame will require constant attention as it will change as the ambient temperature of the furnace changes.

To shut the furnace down, turn off the gas valve and shut off the air supply valve and the blower in that order.

Many furnaces have safety equipment that will shut the system down if the flame goes out, or if the fuel feed, or power fails. These systems often have a pilot light that is lighted to trigger the system and ignite the flame. Once the safety system "sees" the flame it permits fuel to flow and power to the system. If the flame goes out, the system no longer senses the light (or sometimes heat) and turns off the fuel and power. Manufacturer's directions for the operation of these systems should be consulted for their proper operation.

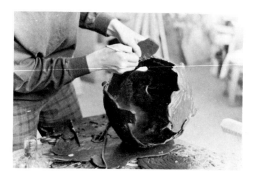

Figure 6-90

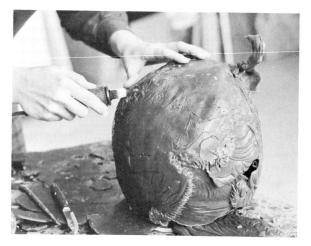

Figure 6-92

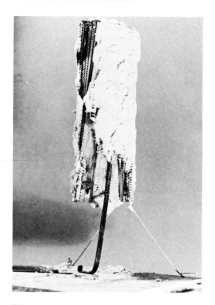

Figure 6-91

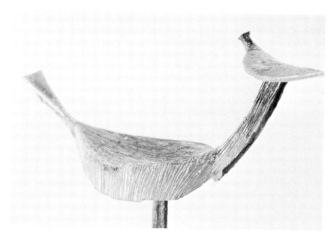

Figure 6-93

Lost Wax in Plaster Investment

1. Form the model in sheet or solid wax, or build it up on a core made up of investment (figure 6-90).

Construct the core around a wire armature, if necessary, building to within 1/8″ of the finished size. (figure 6-91). Recipes for various investments are listed on page 273. In each recipe, mix the crushed dry ingredients before sifting the powder into the water. Luto (investment which has been previously used in the casting process, then crushed) should be screened free of lumps before it is added to the other ingredients.

When using commercial investments such as Non-Ferrous Investment #1 or PVI 10, be certain that the manufacturers' directions are followed exactly. Investments, for the most part, are mixed in the same manner as plaster (page 89), but because investment mixes tend to set quite rapidly, the slurry should be mixed with a power mixer and, if possible, de-aired with vacuum equipment.

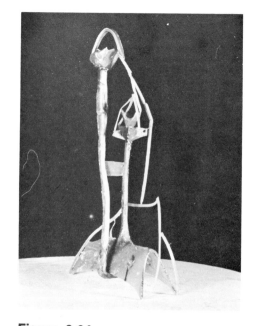

Figure 6-94

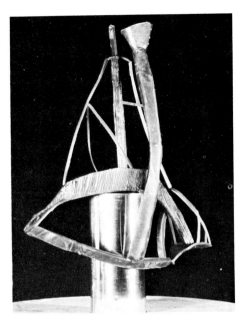

Figure 6-95

Figure 6-97

Figure 6-96

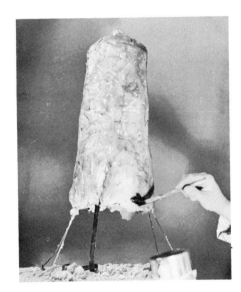

Figure 6-98

2. Press warm lumps or strips of wax onto the core in a uniform thickness of about 3/16" (4.763 mm). This wax can also be applied by dipping the core into molten wax, or by brushing the wax onto the core with a paint brush (figure 6-98).

3. Modify the surface of the wax with any suitable tool. Heated metal can be pressed onto the wax to create textures, or to form planes or lines (figures 6-92 and 6-93). Use sharp implements to scrape or cut the wax surface.

4. Construct a sprue and gating system, the purpose of which will be to funnel the molten metal into the flask and to allow the gasses to escape (figures 6-94, 6-95, 6-96, and 6-97).

Fasten a stiff wax rod (hollow or solid) to a working board. Fashion a pouring basin by waxing over a paper or plastic cup which has been fitted over the sprue and against the board. The wax must seal the cup tightly to both the sprue and the board (figure 6-105).

Bend a small section of the sprue to form a runner, or attach wax rods to form runners. Attach a short small diameter wax rod to the wax model to serve as an ingate and attach the ingate to the runner in such a way as to suspend the model. Support the model from below with anything handy until a sturdy venting system of small diameter hard wax rods can be constructed from the model to the board. Add additional runners and ingates as necessary to insure a steady undisturbed flow of metal from the sprue, through the model and up out of the vents. The runners should be attached to the sprues leading up at a sharp angle so that the metal must flow upward into the sculpture. It should be noted that the sprue tree under

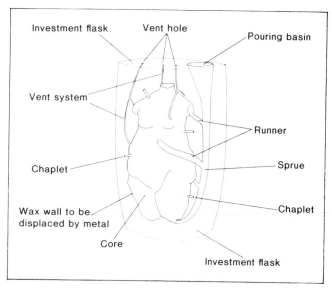

Investment flask — Vent hole — Pouring basin
Vent system
Runner
Chaplet — Sprue
Wax wall to be displaced by metal — Chaplet
Core
Investment flask

Figure 6-99

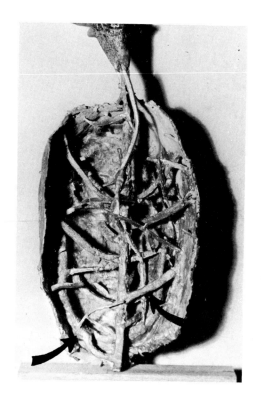

Figure 6-100

construction is upside down and the runners and vents must be oriented towards the working board which is "up."

The size of the sprue and runners depends on the mass and kind of metal being poured. Light metals such as aluminum and magnesium require larger diameter sprues and runners and higher pouring head than heavy metals such as bronze or iron. The base of the pouring basin should be at least 8″ (20.32 cm) above the nearest point of the model for small aluminum pieces (less than 5 lbs. [2.268 kg]) and at least 11″ (27.94 cm) for larger pieces. The sprues should be no less than 1½″ (3.81 cm) in diameter. Heavy metals can be poured with as little as a 4″ (10.16 cm) head for small pieces and a 6″ (15.24 cm) head for larger ones. The sprues should be no less than ½″ (1.27 cm) in diameter and 1¼″ (3.175 cm) respectively. The general rule for determining the diameter of the runners is that the sum of the cross sectional areas of all of the runners should be equal to or slightly less than the cross sectional area of the sprue.

Risers have traditionally been placed in the gating system to store enough extra molten metal so that when the cast begins to cool and shrink, hot metal will flow down from the riser filling the gap left as a result of the shrinking action (figure 6-138).

There is reason today to question the value of the riser in the prevention of shrinkage problems in art casting unless the metal in the riser is kept hot through the use of insulating sleeves or thermo-reactors installed in the risers.

The risers are a definite value in floating off trash since the risers are placed above the flow of the metal. If the risers are of sufficient size to work

Figure 6-101

as a trash trap they may cause problems by shrinking metal out of the sculpture. This problem can be minimized by "choking" (narrowing) the riser adjacent to the sculpture. The risers frequently work best when they are vented.

Sections of the cast which have been lost can be repaired by brazing the area closed with plugs or welding rod made of the same or similar metal as the cast (figure 6-101). In some cases special weld-

Figure 6-102

Figure 6-103

Figure 6-104

ing techniques must be used as not all alloy can be brazed.

5. Attach vents, consisting of ¼″ (6.35 mm) strips of wax, to the model in such a way that there will be no pockets of air trapped in undercuts, which may block the metal, or cause eruptions of the fluid metal as a result of the sudden violent expansion of the trapped air (figures 6-94, 6-95, and 6-99). Enough of a venting system must be constructed so that the back pressure of escaping gas is never great enough to restrict the flow of the metal; otherwise, the metal may freeze before the mold is filled.

6. Insert metal pins (chaplets or core pins) through the wax into the core to prevent the core from shifting when the wax is melted out of the mold (figures 6-102 and 6-122). The pins should be made of a metal with a higher melting point than the pouring point of the metal used for the cast, and should be long enough so that the pins will be firmly embedded in both the core and the mold. Nails or mild steel welding rod will prove satisfactory. A swelling of wax can be made around the base of the core pin so that when the core pin is removed from the cast, the raised lip of metal formed by the wax can be peened over the hole left by the removal of the core pin.

7. Obtain or construct a container large enough to hold the model with its attached gate and risers, plus 2″ (50.8 mm) of clearance all the way around, 2″ (50.8 mm) below the model, and even with the top of the pouring basin on the gating system. If the container does not have a bottom, fasten the container to a firm base with clay (figure 6-

Figure 6-105

Figure 6-106

103). Metal or stiff plastic sheets can be coiled and taped to any size desired, if cardboard or plastic containers are not available (figure 6-104). Flasks over 8″ (203.2 mm) in diameter are best poured in containers made of sheet metal typical of that used for furnace and air condition duct work. The container will be useful to contain the

flask and sand packing while the cast is being poured. For this reason the metal wrap forming the container wall should overlap by about 1/3 the circumference of the container.

8. Form a cylinder of plaster lath which will clear the container wall by about 1″ (25.4 mm) and insert it into the container. This mesh will reinforce the plaster when the container is removed or burned away, and it will hold the model in place until the investment has hardened (figure 6-105).

9. Suspend the model in the container by wires fastened to the core pins and the plaster lath, so that the model will not float or shift when the investment is poured under and around the model. The model should clear the bottom of the container by about 3″ (76.2 mm). If the welding rods are used as chaplets, they can be passed completely through the model (unless it has a solid core) and be fastened directly to the plaster lath. Large models are difficult to suspend in this manner. Instead the bottom should be removed from the container, if it has one, and the model inverted and rested on the pouring basin. The wax pouring basin should be sealed to the base and additional vents to wax from the form to the base can be used to stiffen the wax mass. The model should still be tied in the lath to prevent the wax from floating when the investment is poured into the container.

10. It is preferable to mix enough investment to fill the container in one pour. Large flasks will undoubtedly require more than one. If more than one pour is needed, a sufficient quantity of dry investment should be premixed so that the content of the investment will not vary from layer to layer. The pours should be made as rapidly as possible in order to get a good bond between the layers. A poor bond may result in separation of the layers causing serious flashing on the cast, or worse failure of the flask (figure 6-106). Flashing is the formation of a web of metal projecting out from the surface of the cast.

11. Fill the container while vibrating or rocking it gently to release trapped air and to make positive contact with the surface of the model. Vacuum equipment should be used to exhaust trapped air if possible. The investment should not close the vents or the pouring basin.

12. The containers should be left on the flask until it is positioned in the burn out at which time it should be removed. If the flask must be held for some time before burn out, it should be removed from the container and wrapped tightly in plastic to prevent the loss of moisture from the flask.

Figure 6-107

Figure 6-109

Figure 6-108

13. The burn out should be started within eight hours after the investment has hardened, unless the flask was stored in plastic. Place the flask in a burnout oven or a kiln, which can be a simple fire brick box (figures 6-107, 6-108, 6-109, and 6-110). If the wax is to be saved, invert the flask over a trough constructed to catch and drain the wax out of the kiln (figure 6-107). If the wax is not to be saved, it can be burned off with the flask right side up, in pouring position. Traditionally the wax has been saved by inverting the flask over a steam bath and catching the wax in a layer of water, but this has proven to be a false economy in most cases. Even though the flask can be burned off pouring side up when it is still filled with wax, burning the flask out inverted seems to be easier and requires less time and heat to complete the burn out.

14. Smoke the flask with a low heat for a couple of hours for a small flask, and 5 to 8 hours for flasks over 100 pounds (45.36 Kg.). Wax should start to melt out of the inverted flasks and burn.

15. After smoking the flask bring the heat up so that the wax is burning off rapidly the ambient temperature in the burnout may be as high as 1200° F. (648.9° C.) but the flask should not be much higher than 500° F. (260° C.) on its surface. Control the temperature so that the flask holds surface temperature of about 500° F. (260° C.) until the wax can no longer be seen burning off at the mouth of the pouring basin or vent holes. If a layer of black soot can be seen on the flask continue the burn out. When the soot has disappeared the burnout should be shut down and closed tightly to prevent cold air drafts from warping or cracking the hot flasks. A burnout containing 6 flasks each weighing 250 to 300 pounds (113.4 to 136.09 Kg.) may take as many as 84 hours to get a clean burn out and 24 hours to cool to pouring temperature.

16. When the flask is cool enough to handle with gloves, remove it from the kiln and embed it in dry sand for pouring (figures 6-101). Prevent sand from entering the gating system. If the flasks are large, the metal containers can be wrapped around them to promote easy handling. If the flasks must be inverted for pouring wrapping the containers around the flasks will prevent damage

Figure 6-110

Figure 6-111

Figure 6-112

to the flasks from the handling equipment. The containers can be loosened slightly and sand packed between the container wall and the flask to embed the flask with a minimum of space and sand.

17. If there is danger of the metal flowing out of the side or bottom of the flask because of a break in the flask or because of separation, ram damp sand tightly around the flask and make the pour immediately.

18. Pour the molten metal directly into the pouring basin in a steady stream, as rapidly as possible, with no splashing (figure 6-116). At no time should the metal disappear down the sprue faster than it is poured from the crucible. The pour should not be stopped until the mold is filled, except for reasons of safety or because of obvious failure of the flask; otherwise, the cast will have a series of disconnected layers of metal (figure 6-119), or sections of the cast may be blocked by frozen metal.

19. Allow the flask to cool, several hours for a small bronze cast, overnight for a large bronze. Aluminum pours can be opened in a couple of hours in almost any cast produced in the sculpture studio. Small aluminum pours can be opened in a half hour or so.

Figure 6-113

Figure 6-114

20. Remove the investment with picks (figure 6-120), knives, light hammers (figure 6-121), pointed wires, and similar tools (figure 6-122). Save the investment for luto. The light scum on the surface of the cast can be blown off with air or washed away with water. Stubborn residue can be brushed with a wire brush (preferably stainless steel or brass) or sand blasted with a cleaning particle such as ground corn cobs.

21. Clean the casting. The castings can be cleaned by dipping them in the appropriate cleaning solution (page 279) or by sand blasting as in step 20.

22. Vents, runners, gates, and sprues can be cut off with bolt cutters, hacksaws, power saws, or even bandsaws (figure 6-123).

Figure 6-115

Figure 6-116

Figure 6-118

Figure 6-119

Figure 6-117

Figure 6-120

Figure 6-121

Figure 6-122

Figure 6-123

Lost Wax in Ceramic Shell Casting

1. Construct the model in a material which will either melt or burn out clean; the traditional medium is wax.
2. Add a gating system with risers and vents. Some shell processes do not require vents, since the shell material is porous enough to allow the air to pass out of the shell through the walls.
3. Dip the model in acetone to remove any trace of grease from the surface.
4. Wash the wax model with an alcohol-shellac solution and allow it to dry (figure 6-124).
5. Dip the model in a freshly stirred slurry (a suspension of silicon refractory flour and a binder-like hydrolyzed ethyl silicate) to form an even covering. If cracks are found, wash the slurry from the model with water, and repeat the dipping action until an even coat is achieved (figure 6-125).
6. Coat the slurry with stucco (an air-floated refractory grog) by blowing the stucco over the wet slurry (figure 6-126).
7. Repeat the coating until a ¼" (6.35 mm) wall, or larger, is built up.
8. Invert the shell and insert it in an oven preheated to the melting temperature of the wax. The shell must be brought to heat quickly to prevent the expansion of the wax from cracking the shell. Infrared lamps can be used effectively.
9. Fire the shell for 4 hours at 1300° F. (704.4°C.) to burn out the residue.
10. Pack the shell in sand preheated at 500° F. (260° C.) to prevent thermal shock and the hydraulic force of the heated metal from rupturing the shell. The sand can be worked tightly around the shell by vibrating the container in which the sand and shell are placed.
11. Pour the metal into the still-hot shell.
12. The shell can be removed from the casting with a hot chemical bath, but if this commercial service is not available it can be broken loose with hand tools, wire brushes, or sandblasting equipment.

Lost Wax in Piece Mold

1. Attach a wax gating and venting system to the model (figure 6-127).
2. Treat the model with mold separator (page 272).
3. Make a piece mold of the model, using investment instead of plaster. Do not coat the piece mold with mold separator. When the mold is removed from the model, the venting and gating system should break away from the model and remain buried within the piece mold. Clean the faces of the mold.

Figure 6-124

Figure 6-125

Figure 6-126

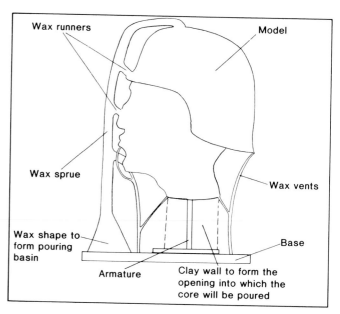

Figure 6-127

4. Coat the inside faces of the piece mold with an even layer of wax between 3/16" (4.763 mm) and 1/4" (6.35 mm) thick, depending on the size of the cast (figure 6-128).

5. Assemble the piece mold, and wrap wire around the outside of the mold to hold it together. When the mold is assembled, these wax layers should be joined at the edges of the mold sections with wax, in order to form a continuous wax layer over the face of the mold.

6. Drill holes through the investment and the wax, and insert chaplets, so that the chaplets will bind the core which is yet to be poured, to the shell of the mold (figure 6-129).

7. Soak the piece mold in water.

8. Place the mold in a container as in Steps 8 and 9 (page 138).

9. Mix and pour an investment into the container, around and under the mold, and fill the cavity in the mold which will become the core of the piece mold. Do not cover the pouring basin or the vents of the gating system.

10. Remove the container, burn out the mold, bury it in sand, and make the pour (Steps 13-22, pages 139-143).

Sand Casting

Sand casting is an inexpensive method of producing castings in many kinds of metal from lead to iron. Full mold, lost pattern, and chemically bonded techniques will allow highly complex unique shapes to be cast on a one per model basis.

Pattern casting in sand on the other hand is useful for production of a large number of casts from the

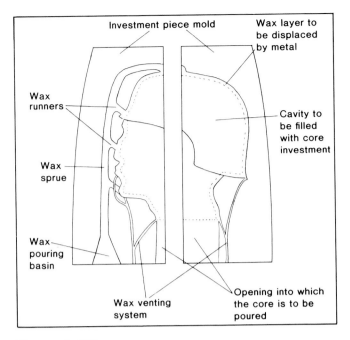

Figure 6-128

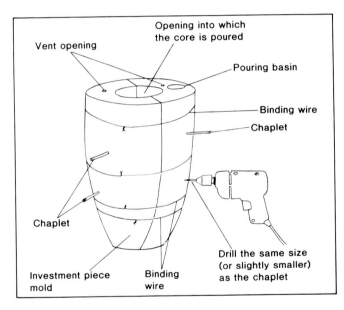

Figure 6-129

same pattern (in the thousands), but is limited to relatively simple shapes with little or no undercutting. Although highly complex undercut hollow shapes are commonplace in industry the process is fussy enough and time consuming to the extent that it is of limited use to the sculptor.

Chemically Bonded Sand

Chemically bonded sands were developed to simplify and speed up the casting process and to achieve greater mold strength to minimize mold damage during handling and pouring. It differs from older tra-

ditional casting sands in that the chemically bonded sands use chemicals which become adhesive and cure hard (as hard as soft brick) through chemical action without the use of heat other than room temperature. Bonded sands which use organic materials such as molasses or starch has been used for many years, but these sands require expensive equipment in the form of ovens, and take a considerable amount of time to produce satisfactory large molds.

Chemically bonded sands (cold-set, or no-bake as they are often called) are manufactured using many different chemicals as a base. The common bonders are based on phenolics, ureas, sodium silicate, and oils, have varying requirements for mixing, periods of fluidity, periods of plasticity, and curing times. The phenolics, ureas and oil use "mix in" additives to harden the binder in the sand. Sodium silicate requires that carbon dioxide is "gassed" into the sand through pierced tubes which are pressed into the sand, or with a cup of some sort which is pressed against the surface of the sand. The sodium silicate/carbon dioxide process (known as the CO^2 process) is superior to the other no bake process for the production of hand modeled reliefs because small sections of the relief can be hardened as they are finished. Because the binder can be hardened on demand, the setting time of the whole mass of sand does not become a problem as it does with the other processes.

The self hardening binders, on the other hand, are superior for forming massive volumes of sand as they harden in any thickness. These resins also have a predictable "set" time which requires that the sculptor complete packing before the sand hardens. Some binders attack foam models if the setting time is extended so control of the setting time is desirable. Some common binders harden in as little as three minutes to facilitate speed on the production line. Setting time this short is seldom of use to the sculptor as it will not allow sufficient manipulation of the sand before it hardens. Chemical binders used by the sculptor are usually compounded to give about twenty minutes of working time before they lose their fluidity.

Bonded sands are also useful to the sculptor because the sand hardens into a hard but carvable mass. The sculptor can ram a rough mold in bonded sand, open the mold, remove the model, and then carve, texture, polish, or otherwise finish the inside of the mold before casting (figures 6-130, 6-131, and 6-132).

The artist can also line the face of the mold with a resilient blanket, such as foam carpet underlayment, then fill the cavity with sand to make a core (figure 6-133). On a spherical form, each half of the mold is packed to form a core half, then the halves glued together with core paste.

The underlayment is removed from the mold, the core is replaced in the mold, and supported by chap-

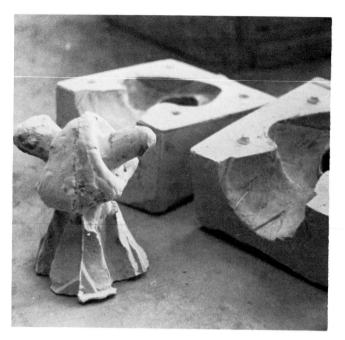

Figure 6-130

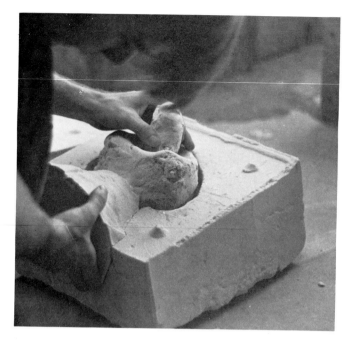

Figure 6-132

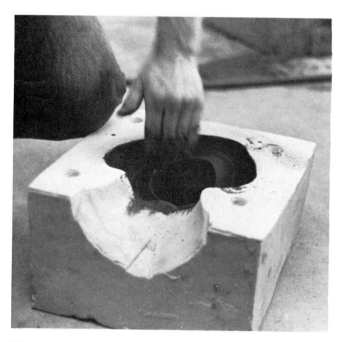

Figure 6-131

ally bonded sand, burned out at 350° F. (176° C.) and cast in metal in the same fashion as plaster investment casting.

Typically Mixing Procedures for Phenolic No Bake Bonded Sand

1. Place 100 lbs (45.36 Kg.) of calcium free dry sand in a mixer or muller. Lake or beach sand can be used if the shell content is low. White quartz sand (banding sand) is the easiest to use though expensive.
2. Weight out 2 lbs. (9072 g) resin.
3. Weigh out .2 lbs. (907.2 g) 80° Baume phosphoric acid. Avoid handling the acid or the mixed resin.
4. Add the acid to the sand and mix for three minutes.
5. Add the resin to the sand mixture and mix for three minutes. Avoid breathing the fumes given off.
6. Remove the sand from the mixer and ram the mold. This mixture will be fluid enough that jogging or gentle vibrating will pack the mold satisfactorily.
7. Clean the mixer in soapy water before the resin sets.

Sand Casting Tools

a. Snap flask drag (figure 6-135); with cope (figure 6-136); and assembled snap flask (figure 6-137)
b. Crucibles (figures 6-139A, B and C)
c. Pouring shank, 2-man (figure 6-139D)
d. Pouring shank, 1-man (figure 6-139E)
e. Bent handle crucible tongs (figure 6-139F)
f. Straight handle crucible tongs (figure 6-139G)
g. Hook for lifting lid (figure 6-139H)

lets. The core is placed on the drag, weighted, and the metal poured.

Chemically bonded sand is so simple to use that cardboard boxes can be substituted for wooden or metal flasks in the lost pattern or full mold process. These cardboard rammed flask should be stripped of their cardboard and packed in sand for pouring (figure 6-134). Wax patterns can be embedded in chemic-

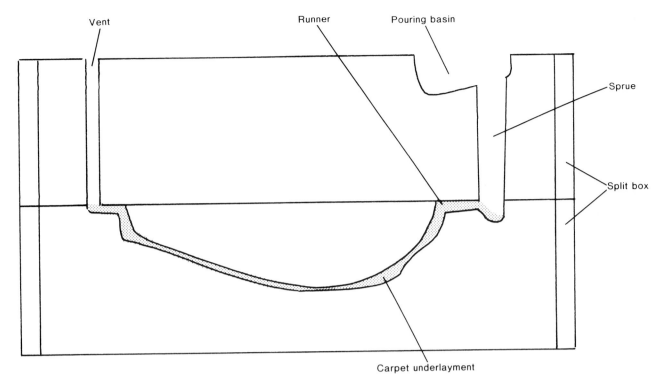

Figure 6-133

Figure 6-134

Figure 6-135

h. Pyrometer (figure 6-139I)
i. Molder's brush (figure 6-140A)
j. Venting wires (figures 6-140B)
k. Runner tool (figure 6-140C)
l. Set of bench lifters (figure 6-140D)
m. Square trowel (figure 6-140E)
n. Tapered trowel (figure 6-140F)
o. Mouth spray can (figure 6-140G)
p. Gating tools and spoon (figure 6-140H)
q. Slick and oval spoon (figure 6-140I)

r. Gate cutter and spoon (figure 6-140J)
s. "T" draw screw (figure 6-140K)
t. Bulb sponge (figure 6-140L)
u. Hook to lift hot castings (figure 6-140M)
v. Sprue or riser pins (figure 6-141A)
w. Rammers (figure 6-141B)
x. Bench rammer with peen (figure 6-141C)
y. Ingot pattern (figure 6-141D)
z. Riddle (figure 6-142C)

Figure 6-136

Figure 6-137

Other Tools

Tools that are required for maintaining the condition of the sand, but are not illustrated, are a square shovel, a rake, and a sprinkling can. Additional tools which will be valuable for sand casting include a molder's bellows (figure 6-143B) and a laddle for dipping small amounts of metal from the crucible for small pours (figure 6-143A).

Casting a Pattern

1. The model, if wood, plaster, cement, or porous metal, is given two coats of shellac diluted with alcohol, then dusted with parting (a commercial parting compound). The parting is kept in a cloth bag which is simply shaken over the pattern to deposit a light film of the white dust.
2. Mark the model to determine the divisions which will present no undercutting.

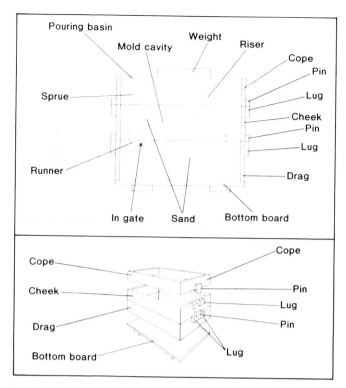

Figure 6-138

Figure 6-139

3. Ram the bottom half of the flask (drag) full of sand (figures 6-143 and 6-144), and draw a straight edge across the top of the drag to produce a level surface (figure 6-145). The sand should be just damp enough to lump together when squeezed in the hand and to leave a crisp edge when the lump is broken in half.
4. Hollow an area a little larger than the model in the sand (Figure 6-146), then riddle (shake sand through a screen high above the flask) sand into the hollow (figure 6-147).

Figure 6-140

Figure 6-141

Figure 6-142

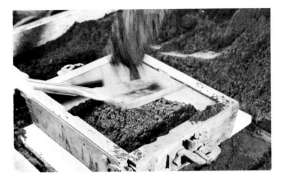

Figure 6-143

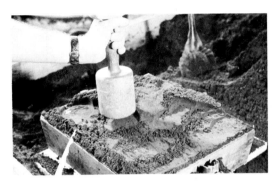

Figure 6-144

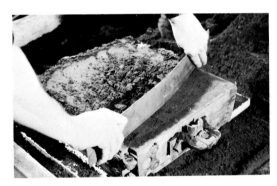

Figure 6-145

Figure 6-146

Figure 6-147

Figure 6-148

Figure 6-149

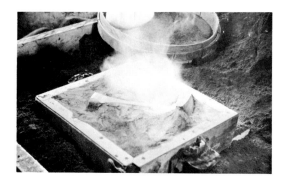

Figure 6-150

Forms which are too complex to "take a print" when they are pressed into sand should be split along the dividing line established in step 2 and attached to a match plate and the process completed as indicated in "Casting a Pattern on a Match Plate" (page 151).

5. Press the model into the sand to form one-half of the mold (figure 6-148). Ram all of the surrounding sand level (figure 6-149).

6. Sprinkle parting over the sand and model (figure 6-150).

7. Fit the top of the flask (cope) over the drag so that the cope is held in alignment by the pins which fit in the lugs (figure 6-151).

8. Insert a gate pin into the sand of the drag. This pin must stand higher than the top of the cope.

9. Riddle and ram sand into the cope until the cope is filled. Carve a pouring basin in the sand around the gate pin (figure 6-152).

10. Strike the gate pin a light blow on the side and lift it out with a slight twisting motion.

11. Lift the cope from the drag (figure 6-153).

12. Tap the model to loosen it, then remove it from the sand (figure 6-154). On large patterns, screw the "T" draw screw into the pattern, rap on the screw lightly from side to side, then lift the pattern out by the "T" handle.

13. Carve a groove (runner) in the sand to carry the molten metal to the cavity caused by the removal of the model (figure 6-155). Blow loose sand from the drag with a bellows.

14. If the sand becomes too dry at any point, spray a fine mist of water on the sand with an atomizer or the mouth spray can.

15. If a smooth surface is desired, spray a mixture of graphite and molasses on the mold surface, and dry it with a torch or in an oven. Molds for steel or iron should be sprayed with a mixture of powdered silica, molasses, and water.

16. Replace the cope on the drag (figure 6-155). Weight the sand with heavy slabs of metal to prevent the sand from floating on top of the heavy molten metal.

17. Pour the molten metal into the pouring basin as smoothly and quickly as is practiced.

18. Shake or vibrate the sand from the model after the casting has cooled enough to be handled. Commercial castings are often sandblasted to clean the surfaces that may have a great deal of scale.

Models which have undercuts or are hollow require additional steps. Cores can be made by making a plaster mold of the model, packing the mold with sand that has been mixed with boiled linseed oil (page 274), all of which is then baked at 450° F. (232.2° C.)

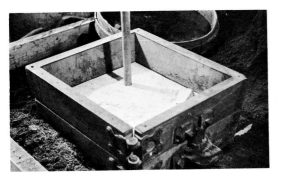

Figure 6-151

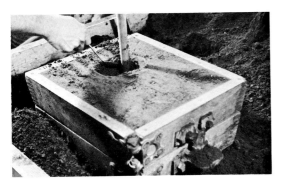

Figure 6-152

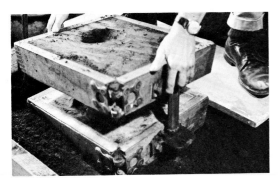

Figure 6-153

Figure 6-154

Figure 6-155

Figure 6-156

to harden the core. After the hardened core is removed from the mold, a layer of the surface of the core is filed away, in a thickness equal to the desired thickness of the cast—between 1/8″ (3.175 mm and 3/16″ (4.763 mm, depending on the size of the model. Cores are held in place with chaplets (figure 6-156). Undercuts can be handled by building up removable sections of sand in a manner similar to piece molding. Sand used for these removable sections should be mixed with a solution of gelatinized starch, dextrin and molasses (page 274), so that the sections will become hard enough to handle after drying a short time. During construction, the sections should be isolated from the other sand with parting; cores and removable sectons may absorb moisture from the surrounding sand and lose strength, if left in place too long, resulting in casting failures. Pours should be made as quickly as possible after the mold is assembled.

Casting a Pattern on a Match Plate

1. The model is constructed from a material (usually wood) which has been assembled from two pieces and plugged together with dowel pins (figure 6-157A). The lamination line would be designed to separate the form so that each half can be cast without undercuts, unless complexed sand sections are anticipated.

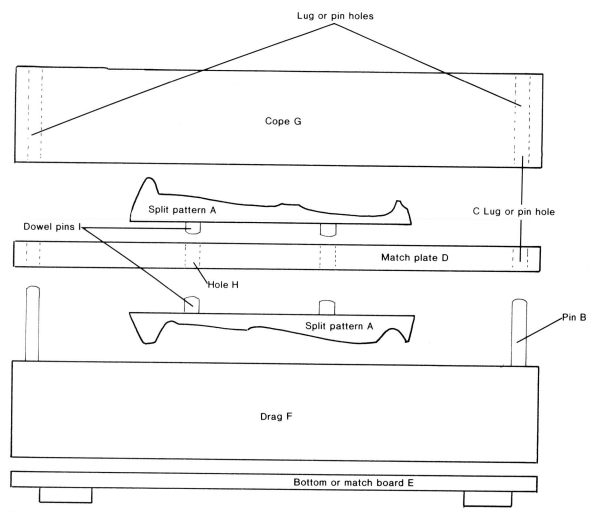

Figure 6-157

2. Holes matching the spacing of the dowel pins in the model are drilled in a board or metal plate which has been keyed to fit between a cope and drag (figure 6-157H and I). The plate (match plate) is usually cut or drilled so that the pins and lugs of the cope and drag will engage the match plate automatically registering the position of the match plate and therefore the position of the pattern (figure 6-157B and C).

3. The match plate is placed on a match board, and the bottom half of the pattern plugged into the dowel holes.

4. Invert the drag and place it over the match plate engaging the pins or lugs. A dummy pin may have to be used to assure registration.

5. Ram the drag full of sand, and draw a straight edge across the top of the drag to produce a level surface.

6. Place a bottom board on top of the drag, and grasping top and bottom boards turn the unit over.

7. Remove the molding board which is now on top, rap the match plate lightly, and lift the match plate and pattern off of the sand. If the pattern sticks in the sand, screw a "T" draw screw (figure 6-140K) into the pattern, rap it lightly on the side of the screw and lift the pattern straight out of the sand.

8. Remove the pattern from the match plate and plug the top half of the pattern into the holds on the opposite side of the match plate that the bottom half of the pattern was on. Be careful to have the pattern in the proper alignment as it can be reversed if there is no core to interefre.

9. Place the match plate on a match board and place the cope, right side up, over the match plate, engaging the pins and lugs. Use dummy pins or lugs if necessary. Insert risers, sprue formers or whatever else is necessary in the cope half of the flask at this time.

10. Ram sand in the cope until it is full of sand.

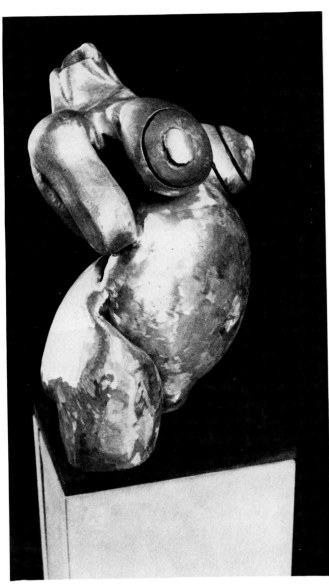

Figure 6-158. *Modern Fertility Goddess,* Sally Hobbib, American, welded and cast aluminum and acrylic plastic.

11. Place a bottom board over the cope and turn over the entire unit. Remove the match board which is now on top and remove the match plate and pattern.
12. Using hand tools cut runners and a gating system in the sand on the drag. The runners must meet the hole formed by the sprue former in the cope (figure 6-138).
13. Carefully lift the cope, turn it over, and place it over the drag aligning the pattern (right end to right end) and lower the cope into the drage, engaging the pins and lugs.
14. Carve a pouring basin around the sprue former and remove the sprue former (figure 6-138).
15. Pour the metal.

Sand Casting by Direct Displacement

Dry materials or objects which are able to vaporize such as ping-pong balls, corrugated cardboard, balloons, straw, or styroform*, can be shaped and assembled in any desired manner, embedded in sand, and cast direct (figure 6-158). The molten metal vaporizes the material, and the gasses formed pass into the sand, allowing the metal to fill the cavity just formed. Urethane foams should not be used in this process.

In many instances the materials used in lost pattern casting do not burn out entirely, a characteristic which endeared the process to many sculptors in the 1950s. Cardboard, wood and many plastics burn out incompletely, yielding spontaneous fragmented, decaying appearing forms which the sculptor often used in assemblages. Such casings are usually accompanied with much smoke, splattering, and no little hazard to the founder.

When pouring light metals like aluminum or magnesium the pouring basin which is carved around the sprue former should be at least 12″ (304.8 mm) above the top of the model, and should be at least 1 3/8″ (34.925 mm) in diameter. Shorter sprues may be used on heavier metals. Metals with a melting point below 800° F. (426.7° C.) are difficult to use in the lost pattern or full mold process.

1. Riddle a layer of sand into a box.
2. Pack the bottom of the model with sand, and place the model in the bottom of the box, bottom down (figure 6-159).
3. Place the sprue former adjacent to the model or attach a styrofoam runner to the model and rest the sprue former on the runner (figure 6-160).
4. Riddle and ram sand over the model, filling the box (figure 6-161).
5. Rap and remove the sprue former.
6. If the casting is large, repeatedly drive a thin wire through the sand to help vent excess gas which may be formed. If it is found that trash collects at the top of the casts leaving a swirled or wrinkled surface, a riser should be placed at the top of the model while it is being packed in the sand. The riser can be a wooden dowel that is pulled out of the sand at the same time that the sprue former is pulled, immediately before the pour. If the model is massive a sharpened welding rod can be passed down the riser hole to pierce the model (if it is made out of foam) to facilitate venting.

*Casting in this manner was patented by Harold F. Shroyer in April of 1953, and eventually licensed to the Full Mold Process Co., Lathrop Village, Mich.

Figure 6-159

Figure 6-160

Figure 6-161

7. Weight the top of the sand, then pour the metal. Metal poured directly over embedded materials must have enough heat to vaporize the volatile pattern. Molten lead does not have sufficient heat to vaporize materials commonly used for direct casting, whereas molten iron, given time, will displace most volatile materials. There is some danger inherent in the use of these materials, as it is possible that violent expansion of the gasses of the materials may blow the molten metal back out of the sand.

Sand Casting (Direct Carving)

Sand which has a good binder can be carved to form original one-time molds. Bulky casts attained through this process are usually excessively heavy, so the process is primarily restricted to relief sculpture. If an inch or so of thickness of metal is not prohibitive, an open-face casting can be executed, but open-face castings are heavy, expensive (because of the waste metal), and they do not always receive a good impression on the casting. Closed-face casting on the other hand, gives fine impressions on the cast, is lighter than open-face casting, and is therefore less expensive. Closed-face castings are more time consuming and more difficult to produce than open-face castings, however.

Sand Casting (Direct Carving, Open Face)

1. Riddle and ram sand into a box.
2. Strike off the sand to form a level surface.
3. Carve the appropriate design in the sand, in reverse. High points on the desired cast must be deep points in the carved sand. Lettering and similar devices must be carved in the sand to read backwards.
4. Pour molten metal into the design.

Sand Casting (Direct Carving, Closed Face)

1. Riddle and ram sand in a drag (figure 6-162).
2. Strike off the sand (form a level surface) (Figure 6-163).
3. Carve the design in the sand in reverse (figures 6-164, 165). Include a gate and runner (figure 6-165).
4. Riddle and ram sand in a cope, and strike it off.
5. Cut a sprue hole in the cope sand with a sprue cutter or a piece of thin wall pipe (figure 6-166), so that the sprue hole will be directly above the gate carved in the sand of the drag when the cope is placed on the drag.

Figure 6-162

Figure 6-163

Figure 6-164

6. Place the cope on the drag (figure 6-167).
7. Carve a pouring basin, being careful not to allow sand to fall into the sprue hole (figure 6-168). If necessary, the cope can be removed for this operation, or for cleaning out sand that may have fallen into the hole.
8. Weight the sand in the cope, and make the pour.
9. Allow the cast to cool before removing the sand from the casting.

Finishing Metal Castings

After the cast has cooled, the investment or sand is cleaned away (figures 6-169, 6-170, and 6-171). Sand hardened with chemical binders should be discarded. Plaster investment may be saved for luto. The gating system may be cut away with bolt cutters, hack saws, band saws, or a beverly shears. A stub of about 1/8″ (3.175 mm) should be allowed to stand above the casting when the vents, risers, and gates are cut away. The 1/8″ (3.175 mm) protrusions can be filed down or worked flush with the surface by chasing, whichever is preferable. Chasing is the act of lightly striking the metal with a hammer and a punch like tool (figures 6-173 and 6-175).

Flashing can be cut off with a chisel (figure 6-174), then ground or filed down to the surface to within 1/32″ (.79375 mm), then blended in with files and chased with textured punches (figure 6-175).

The chaplets should be pulled or drilled out of the metal, the holes tapped (figure 6-172), and a threaded wire of metal similar to the cast (a vent perhaps) screwed into place, cut off, and chased. If a nipple of metal remains around the chaplet hole the metal can be chased into the hole with a smoothly rounded punch and the hole closed without resorting to threaded pins. The chaplet holes or other flaws can be repaired in most metals by fitting sections of scrap metal from the pour into the flawed area and soldering or welding the patch in place. Large damaged areas or lost sections can be replaced by casting a patch to match the damage then soldering the patch into the cast. Irregular holes should be cleaned up to facilitate fitting a patch. Frequently large hollow shapes or complicated large shapes are easier to cast in sections than to cast in one piece. In these cases the sections of the cast are fitted and welded into a single unit after the pour. It is preferable to cast all of the section of the cast from a single melt.

The metal should be cleaned with compressed air blasts, wire brushes, (brass or stainless steel for copper based metal), sand blasting or acid cleaners (bright dip) as indicated on pages 278 to 279.

Figure 6-165

Figure 6-168

Figure 6-166

Figure 6-169

Figure 6-167

Figure 6-170

Figure 6-171

Figure 6-173

Figure 6-172

Figure 6-174

Figure 6-175

Fault		Probable causes			
Cold shut	two streams of metal fail to blend in the mold	low sprue	pouring system blocked	poor venting	temperature too low
Shrinkage cracks	depressions on the surface or tears in the metal	sections too thick	poor gating and venting of thick sections	poor metal	temperature too high
Gas pockets	smooth holes on or under the surface	wet sand junk in the sand	poor metal possible contamination during the melt	bad pouring technique	temperature too high
Misrun	cast not filled out	wet sand poor venting	low sprue insufficient gating area	slow pour gassy metal	temperature too low
Finning or flashing	webs of metal perpendicular to the surface	wet sand poor venting	low permeability sand vents blocked	shallow sand over part of the mold	temperature too high
Surface inclusion	rippled or wrinkled surface with carbon traces	common in full mold and lost pattern	insufficient riser area to draw off pattern residue		

Sections of aluminum 1/4-inch thick or less are good casting thicknesses. Heavier sections tend to develop structure problems. Plaster molds insulate the metal, slowing the freeze up, therefore allowing the metal to crystalize. Crystalline metal is brittle, weak and usually presents finishing problems.

Figure 6-176. Casting faults: Aluminum in sand

Fault		Probable causes			
Cold shut	two streams of the metal fail to blend in the mold	sprue heighth too low	pouring system blocked	poor venting	
Burning into the sand	metal erodes the sand surface	sand too coarse too dry	poor quality metal	temperature too high	
Wormy surface	rough metal at in-gates gates broken	not enough gating area	poor metal	temperature too high	
Shrinkage cracks	depressions on the surface or tears in the metal	alternating thick and thin sections	poor gating especially too thick sections	temperature too high or too low	
Gas pockets	holes near or under the surface of the cast usually smooth	wet sand	poor metal (possible contamination during the melt)	temperature too high	
Misrun	partially filled mold	sprue height too low gates too small or blocked	vents blocked poor metal slow pour	temperature too low	
Finning or flashing	webs of metal usually perpendicular to surface	wet sand uneven ramming poor packing	low permeability of the sand sand not weighted over cast	temperature too high	

Figure 6-177. Casting faults: Bronze in sand

7
Addition (Buildup)

Figure 7-1. *Giraffe,* student work, built-up plaster.

Because the additive method of producing sculpture can have the advantages of freedom from structural limitations, manipulative intimacy, and comparative rapidity of execution, the technique is probably the one most used today. In general, the sculptor may utilize materials which are temporarily fluid at least in part. In the case of plaster, cement, and certain plastics, the medium is fluid until chemical action or evaporation causes the materials to become rigid. Welded, brazed, or soldered meals, on the other hand, require the use of heat to soften the material to a point suitable for manipulation, after which the metal again freezes. Media, like wood and certain plastics, are rigid rather than fluid during the creative process, and may be joined through the use of rivets, screws, nails, glue, or even lock joints; they are legitimate media of the additive technique.

Plaster and Cement

Neither plaster nor cement have enongh innate strength to retain a shape or position forced on them while in their fluid state, and it is necessary to devise supporting systems known as armatures (pages 36 to 41) to support these materials. An armature should be strong enough to easily support the full weight of the applied medium without sagging; it should also be rigid enough that it will not flex, vibrate, or sway— thereby causing the material to crack, crumble, or fall off. For small light sculpture, an armature of heavy wire will be adequate. If the sculpture is bulky, a core can be formed by wrapping the wire armature tightly with cheese cloth strips soaked in cement or plaster.

Figure 7-2. *Emu,* student work, built-up plaster.

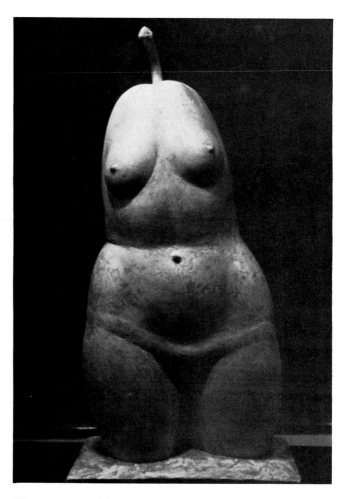

Figure 7-4. *Navel Pear II,* Otto G. Ocvirk, American, (1922-), plaster.

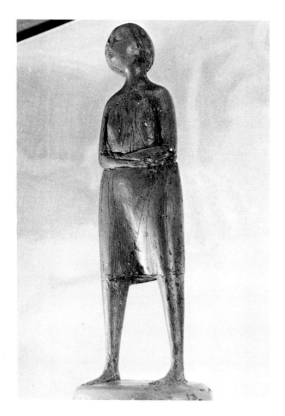

Figure 7-3. *Windblown Figure I,* L. E. Moll, American.

Larger sculpture may require an armature made of iron pipe or welded rods. In such cases, the bulk of the sculpture may be formed by shaping plaster lath to within ¼″ of the desired shape, and wiring this support to the armature.

Styrofoam blocks, fastened together with long wooden or metal pins and glue, and then carved to the desired shape, can be used as an armature (page

38). The face of the styrofoam should be rough so that the medium will have a surface which it can grip. Plaster can be sprayed on larger forms with a spray gun but the spray guns are not necessary (figure 7-5)

Tools Required
a. A small flexible mixing container such as half of a rubber ball, or a plastic bowl (figure 7-6A).
b. Shellac (figure 7-6B).
c. A wire brush for cleaning tools (figure 7-6C).
d. Paint brushes (figure 7-6D).
e. Spatula (figure 7-6E).
f. Sponge (figure 7-6F).
g. Hot wire cutter or small soldering iron, for cutting styrofoam (figures 4-10 and 4-11).
h. A series of plaster knives and rifflers (figure 7-7A).
i. SURFORM® tools (figure 7-7B) Stanley Tools Div. of the ST Works, New Brittian, Conn.
j. Rasps (figure 7-7C).
k. Proportional dividers (figure 7-7D).

Figure 7-5. R-2 Materials spray gun spraying plaster slurry.

Figure 7-6

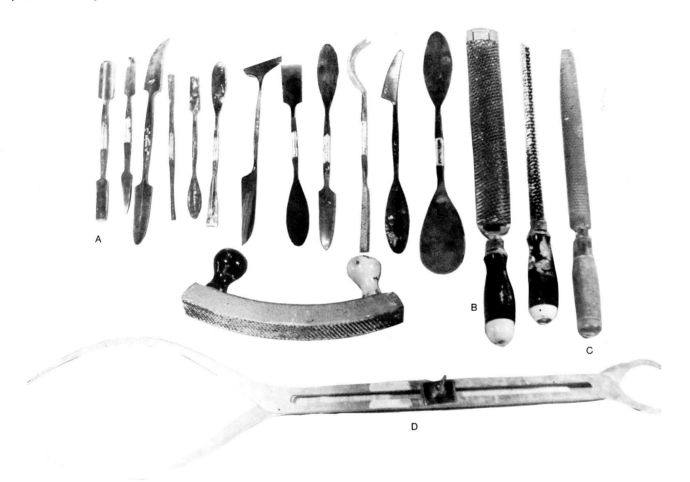

Figure 7-7

Care of Tools

Neither plaster nor cement should be poured down drains. Waste material should be dumped into containers for disposal; rinsing in buckets of water will catch the medium remaining on the hands and in the mixing bowl. Mixing bowls should always be thoroughly cleaned before mixing new batches of medium. Flexible containers can often be peeled off of large masses of hardened material; thin layers will flake away from the sides of the container when it is flexed. Brushes used in shellac can be cleaned with alcohol, even if the shellac has hardened in the brush.

Tools should be cleaned immediately after use, and all metal tools should be dried and oiled to prevent serious rusting. Rifflers, rasps, and SURFORM® tools will work best on plaster which is completely dry; working damp plaster will cause most of these tools to clog, sometimes beyond easy repair. These tools work well on soft aggregate cement, but the harder aggregates—containing high percentages of hard sand or marble chips—will quickly dull them. Clogged tools should be wire-brushed to remove embedded medium, then oiled to prevent rust.

Worn rifflers and rasps can be dipped into liquid epoxy cement, then rolled in carborundum powder or titanium oxide powder of any desired grit, to restore the abrasive character of the tool. The epoxy will cause the grit to adhere to the tool until the grit is worn beyond use, at which time the tool can be recharged by repeating the process.

Plasters and cements should be stored in damp-proof containers, preferably fiber drums with plastic bag liners, which can be sealed. Material which is left exposed will eventually absorb moisture from the air, making the cement or plaster useless.

Built-up Plaster

1. Build the armature and fasten it to a solid base (figure 7-8).
2. Shellac the armature if it can rust.
3. Mix a thick batch of plaster and apply it in thin layers with a spatula (figure 7-9).
4. Mix additional batches and apply them in thin layers with a spatula until the desired form and texture is developed (figures 7-10, 7-11, and 7-12).
5. If the build-up process is delayed for more than eight hours, the sculpture should be thoroughly soaked with water to prevent the old plaster on the sculpture from ruining new plaster by absorbing water from the fresh batch.
6. Use plaster knives, surform rasps, or similar tools to remove overbuilding.
7. Allow the plaster to dry after the desired shape is achieved. If files, rifflers, rasps, or sandpaper are used on wet plaster they will be ruined. Tools

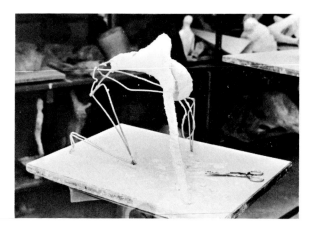

Figure 7-8

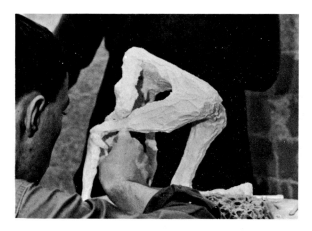

Figure 7-9

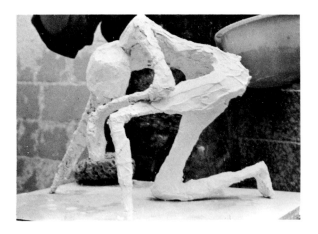

Figure 7-10

clogged by plaster should be cleaned immediately. A wire brush may be necessary if the tool is impacted with plaster.

8. Use rifflers, rasps, files, and, if necessary, sandpaper to refine areas of the sculpture.

Figure 7-11

Figure 7-12

Figure 7-13. *Growth Forms,* concrete, steel, wood and ceramics.

Finishing Plaster

The finishes that can be effected on plaster are almost numberless. Raw plaster, polished plaster, transparent or opaque, water-base or oil-base, metal plating (copper, bronze, gold, silver, and steel), or even plastic or rubber surfacing are a few of the finishes available for the medium (pages 274 and 275). Raw plaster has a dead-white, porous surface that attracts dirt and makes the sculpture hard to see. If the whiteness of the plaster is desirable, the surface can be sealed with a clear plastic or wax to prevent the absorption of dirt. Most often, color is applied to soften the harsh appearance of the plaster and to emphasize the surface qualities of the sculpture. Frequently, although incessantly criticized as being false to the medium, the patina on plaster is made to resemble, or to imitate, other media. Commercially, the most common technique for disguising plaster other

than painting is metal plating. Critics object to this imitation of metal sculpture, but supporters of such processes state that there is no significant difference between the artificial oxidatioin of bronze to eliminate its natural bright and shiny yellow surface and the plating or painting of plaster to eliminate its natural dull and harsh white surface. Either process results in an artificial treatment of a surface to change or eliminate unwanted characteristics of a medium.

Painting Plaster

If the patina to be applied is a paint, the plaster should be sealed with three coats of an appropriate sealer. A mixture of one part artist linseed oil to one part artist rectified turpentine will work well for oil paint. Three coats of 4 pound cut shellac mixed with an equal portion of shellac alcohol will work for a painting system of dry pigment and shellac. Either painting medium or white acrylic paint in two or three coats will provide an adequate base for acrylic paint. Automotive paints such as acrylic lacquer or acrylic enamel should be applied over a base of one coat of shellac to prevent moisture migration, then one coat of the appropriate primer for the paint (pages 207-209).

Cement

Cement is built up in much the same manner as plaster, but more time is required for cement to harden than for plaster. A good recipe for the foundtion or supporting cement is three parts cement to one part lime putty, by volume. Mortars commonly used for surface build-up have a composition approximating one part Portland cement (white or gray) and three parts fine aggregate (plaster sand, marble dust, marble chips, granite chips, or ground glass), by volume. Concrete is difficult to use for the additive method, because concrete mixes contain large particles

of aggregate which resist application in thin layers, especially for a finishing coat. A typical concrete composition is two parts Portland cement, one part perlite (or sand), and one part zonalite (or gravel), by volume. Other recipes are listed on page 275.

Built-up Cement

1. Build a strong armature and fasten it to a solid base. The armature should have a rough surface, such as is provided by plaster lath, so that the cement will have a gripping surface.
2. Paint the armature with shellac if it will rust or otherwise be afffected by the lime or water in the cement.
3. Dry mix the powdered ingredients of the cement, including dry pigments if any are to be used.
4. Add water, a little at a time, and fold it into the powder until a slurry, about the consistency of thick rolled oats, is obtained.
5. Apply the matrix in layers about ½″ thick. Score or roughen the surface of the layers if additional layers of cement are to be applied.
6. Allow the first layers to harden 8-10 hours before applying additional layers.
7. Do not allow the cement to dry, at any time, for at least 20 days. Wet cloths and plastic should be wrapped around the sculpture to prevent premature drying.
8. The surface can be rasped 4-10 hours after application, depending on the aggregate. Eventtually, after two or three days, stone tools can be used to alter the surface. If aggregates such as perlite or zonalite are used, the cement will usually remain soft enough to be worked with ordinary rasps and chisels.
9. It may be necessary to sand or grind the dry surface of the sculpture to remove the scum of the cement, in order to expose the texture of the aggregate (figure 5-47). In some instances, a fine, hard spray of water can be sprayed on the cement which has just hardned, to remove the scum.
10. If coloration is not to be added by the capillary process, the finished sculpture should be washed down with muriatic acid (the commercial preparation for cleaning brick and cement) and then neutralized with water, prior to finishing.

Finishing Cement

Cement should not be treated for the first 28 days except with water. After that period, it can be dried and sealed with commercial cement sealers designed for that purpose. Powdered color can be added to the cement for special effects while it is being mixed. Too much pigment (over 10%), or the wrong kind of pigment, such as tempera pigments, may destroy the

Figure 7-14

cement, or the colorants may be bleached out by the lime in the cement. Commercial colorants, which are safe to use, are available for both cement and plaster.

Cement sculpture which is to be left out-of-doors should be sealed (including the bottom) with three coats of a hot mixture of three parts boiled linseed oil to one part turpentine, by volume. This mixture tends to turn the cement a mellow yellow, and is good for about two years, at which time the treatment should be repeated. Commercial cement floor sealers can also be used—with varying results, depending on the recipe of the cement. Ordinary oil paint can be added to the linseed oil if color is desired on the cement (figure 7-14).

Cement can also be colored by capillary action. After the cement is several days old (preferably much older), it can be immersed in solutions of aniline colors, copper sulfate, iron sulfate, and other metallic colors.

The solutions should be saturated with the coloring agents. If colorants settle out on the bottom of the container they will mark the cement. The sculpture should be lifted off the bottom of the container by placing it on some sort of block or rest.

When the cement has absorbed all of the color that its pores will hold, it becomes somewhat waterproof; if metallic colors are used, the concrete can be buffed and polished to a dull lustre. Upon oxidization, the colors will impart a metallic appearance to the cement.

Clay

The obvious manner in which to build up a bulk for clay sculpture is to press small lumps of clay onto a large firm clay mass in such a way that the form desired is developed. At this point, modeling is utilized to clarify the form. Over-building should be avoided, but if it does occur, large chunks of clay can be torn away from the mass and the build-up process repeated. This method of building clay can present difficulties if the finished work is to be hollowed and fired. Building with small lumps of clay can form air pockets which may cause the sculpture to explode in the kiln; care must be exercised to avoid this.

Coil Construction

Sculpture constructed by the coil method requires that a fairly complete image of the completed sculpture be fixed in the mind of the artist before the build-up is begun, because the overall form is established from the bottom to the top of the sculpture without recourse to other than very minor modification (figures 7-15, 7-16). Surface detail can be changed easily, but in coil sculpture the basic form is comparatively unyielding.

1. Wedge a clay mass (pages 41-43).
2. Form lemon-size balls of clay (figure 7-17).
3. Roll the clay balls on a dampened cloth until long rolls of clay, about 5/8″ (15.86 mm) to 3/4″ (19.05 mm) in diameter, are formed (figure 7-18).
4. Lay the first roll of clay on a base to form the bottom of the sculpture (figure 7-19). If the sculpture is large, webs of clay should be built up across the inside of the sculpture at the same time that the outside walls are being coiled up. If a coil is not long enough, additional lengths can be slipped on.
5. Serrate the coil along the top with a knife or wire tool (figure 7-20), and coat the serrations of the coil with a thick slip. Try to prevent the slip from coating the clay which will be the face of the sculpture, to prevent a slimy or greasy appearance on the surface.
6. Serrate another coil along what will be its bottom, coat the serrations with slip, and lay the coil on top of the first rope of clay (figure 7-21). The form of the sculpture is created by varying the position of the coils as they are placed one on top of the other (figures 7-22, 7-23, and 7-24).

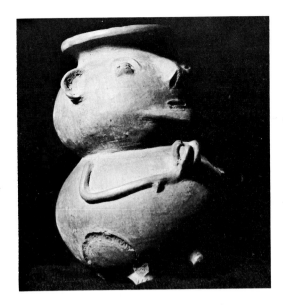

Figure 7-15

Figure 7-16

Figure 7-17

Figure 7-18

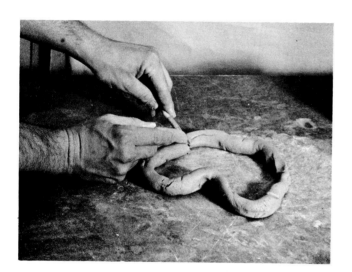

Figure 7-19

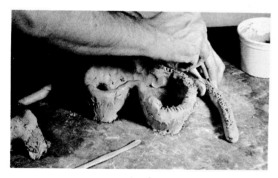

Figure 7-20

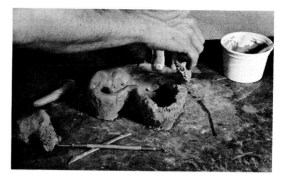

Figure 7-21

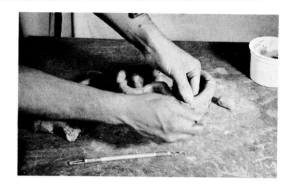

Figure 7-22

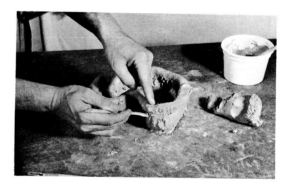

Figure 7-23

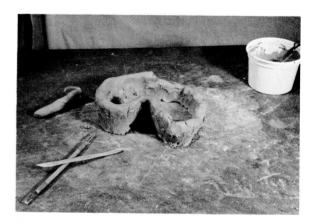

Figure 7-24

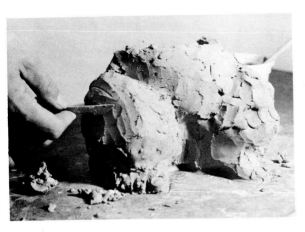

Figure 7-25

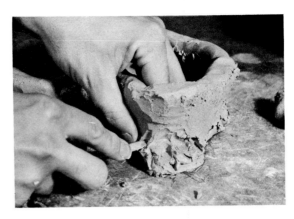

Figure 7-26

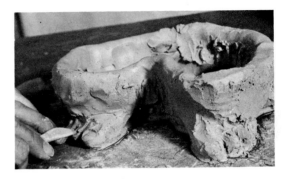

Figure 7-27

7. Continue to build, coil on coil, forming the shape and size desired (figures 7-22, 7-23, and 7-24).

8. Blend and texture the surface of the clay with the fingers or clay tools until the desired visual effect is completed (figure 7-25). Avoid wetting the surface of the clay as a means of smoothing—this usually leads to unpleasant textural characteristics.

9. Allow the clay to dry slowly, then prepare it for firing (pages 43-44).

Because plastic clay will not support great weight it may be necessary to allow the bottom coils to dry and become stiff or leather hard before building the sculpture to its full bulk. If this is the case, the modeling of the lower sections of the sculpture should be pretty well completed before the upper sections are ever formed (figures 7-26 and 7-27). If the clay tends to dry too fast (causing cracking), sheet plastic can be wrapped around it to slow the drying time; in extreme cases, a fine film of water may be blown over the clay before covering it. When the sculpture is completed, it should be allowed to dry as slowly as possible, a procedure which may take weeks.

Figure 7-28

Slab Construction

1. Wedge the clay (pages 41-43).
2. Roll out a slab of clay on a damp cloth using two 3/8″ square sticks as rails for a rolling pin (figure 7-28). Interesting texture can be obtained by varying the kind and coarseness of the cloth on which the clay is rolled.
3. Cut shapes out of the clay with a paring knife or some similar tool (figure 7-29).
4. Serrate the edges of the shapes where they are to be joined (figure 7-30), coat these serrations with slip (figure 7-31), and press the joints together firmly (figure 7-32). If desired, the edges can be blended together with modeling tools (figure 7-33) or with fingers.

Figure 7-29

Figure 7-30

Figure 7-31

Figure 7-32

Figure 7-33

Figure 7-34

5. The slabs can be shaped to some extent before they are joined (figure 7-31). If the clay is too dry, too coarse, or is stretched too far, it may crack (figure 7-34).
6. If the slabs tend to sag, they are too wet and should be permitted to dry a little. If the clay tends to dry too fast, it should be covered with plastic sheets.
7. After the sculpture is completed, dry it as slowly as possible in preparation for firing (pages 43-44).

Wood

The usual joining methods employed when using wood in an additive manner are nailing, screwing, doweling, gluing, and interlocking. Because of the rigidity of the individual blocks of wood, and the interference with the spontaneous creative process caused by the mechanical nature of joining wood, the additive process is usually de-emphasized and carving a subtractive technique predominates. Wood can be shaped by cutting, grinding, or bending, either before or after the build-up process has taken place.

Nailing is an inferior joining device. It does not pull the separate pieces together; it primarily prevents side movement. Friction alone prevents the nail from slipping out of the wood or the wood from the nail. Resin coated nails are available which will hold much tighter than uncoated nails. The resin is heated by friction as the nail is driven and on cooling the resin hardens and acts like cement. Resin coated nails are harder to drive than uncoated nails because of the sticky nature of the resin. If more than one nail is used, at slight angles towards each other (toe nailing), the joint will be significantly stronger—but the pieces of wood will still not be pulled together by the nails. Unless pilot holes are drilled, with a drill slightly smaller than the nail, there is danger that the nail will split the wood.

A screw joint is one in which a threaded pin pulls the pieces of wood together, and prevents side motion as well, though occasionally a single screw will

Figure 7-36. *Wood Construction,* red elm.

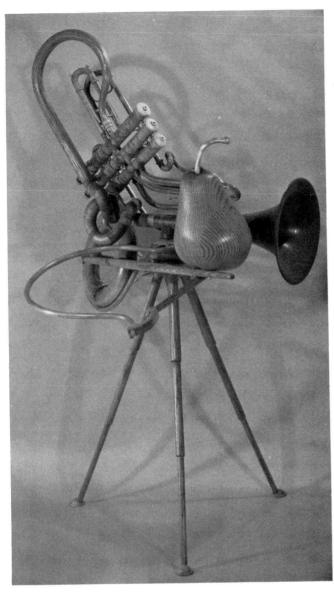

Figure 7-35. *Still Life,* Robert Strini, American, (1942-), Oak and maple, 5 feet high.

allow one of the pieces of wood to rotate off of the screw until it is also glued, doweled, nailed, or otherwise prevented from turning. Screw joints are the strongest and most common mechanical joints used in woodworking. The screw head can usually be countersunk and the resulting hole plunged with a dowel and glue.

Doweling is the process of pinning a joint with a short wooden shaft which is usually glued into a snug hole in the joint. The hole is drilled through one piece of wood into the second piece of wood (through the joint); then the proper size dowel (preferably fluted) is swabbed with glue and driven into the glue-swabbed hole with a wooden mallet. The dowel can be driven below the surface of the wood and a plug inserted to

hide the dowel. When the glue is dry, the dowel and glue will prevent movement of the pieces of wood in any direction. Some sculptural forms utilize the dowel without glue, so that the sculpture can be rearranged at will; as in figures 7-37, 7-38, 7-39, 7-40, 7-41, and 7-42.

Joints in wood that are only glued seldom have great strength. Though the glue might hold, the joint may fail under stress, because the wood adjacent to the glue often breaks away, and a paper-thin layer of it will be found stuck to the glue. For joints where there is neither great stress nor great impact, most ordinary wood glues are adequate. For joints where there may be weight, stress, or impact, screws, dowels, or interlocking joints should be used to bear the brunt of leverage, torque, or sheer forces across the face of the joint. Of the many glues available, animal or hide glues have long been favorites, though some require the use of heat and pressure and have long curing times. Newer glues such as the whiteglues (polyvinyl acetate resin), resorcinals, and epoxies are proving satisfactory, if not vastly superior, to the older glues.

Although some fabricators of wood still prefer traditional glues for wood, industry has for the most part converted to modern glues because of their proven superiority. Traditional wood glues were made from the hides, hooves, and other parts of animal bodies. They required considerable preparation, maintenance, and no little skill in their use. Most old glues are subject to gradual disintegration and are affected by the presence or lack of humidity. They have their advantages in that they do not dull tools.

Figure 7-37

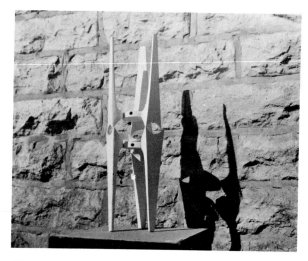

Figure 7-40

Figure 7-38

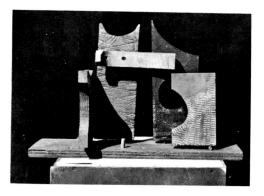

Figure 7-41

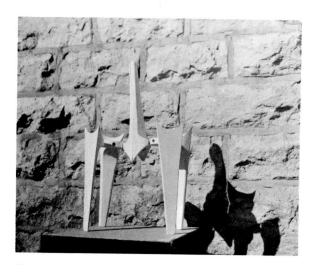

Figure 7-39

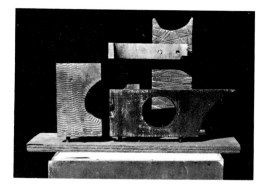

Figure 7-42

Animal glues are obtained in brittle transparent sheets, flakes or as powder. The glue must be soaked in cold water for about 12 hours before use. Water to glue ratios vary according to the application, therefore manufacturer's directions should be followed. The glue itself should be heated (no higher than 145° F. [62.8° C.]) in a clean glue pot. It has a short working time, must be used hot, with a room temperature of over 70° F. (21.1° C.). This glue weakens with

extended pot age or with thinning. Unused glue should be discarded at the end of a day's use.

Casein glue, a glue made from milk, was once a very common household glue. It is no longer quite as common. Casein is obtained in powder form which is mixed in equal parts with water to attain a viscosity of that of milk. A few minutes after the glue is mixed in with the water it should be mixed for about one minute and then it will be ready for use in about twenty minutes. Caseins for the most part, are highly staining, water resistant, reasonably strong, and will work cold (below 70° F. [21.1° C.]). Pot life is considered to be one working day.

Glues known as liquid glues are generally animal glues that are prepared to have a long shelf life and are ready to use. They are roughly comparable to powdered animal glues in strength. They will probably disappear from the market in only a few years because of the abundance of super synthetic glues being pushed on the market.

There are many "white" glues on the market under several trade names, nevertheless they are pretty much the same except that one group of the glues form hard rigid bonds while the other group forms slightly rubbery bonds. Neither is water proof, both stain, and are difficult to sand for finishing. The white glues are very strong, set in about three hours, but should be cured overnight, and resist varnish and many other applied fnishes. They require clamping for a good bond and do not cure properly at temperatures below 70° F. (21.1°C.).

Another glue, popular with professional wood workers is Urea-resin glue. It is a two part glue which is used at room temperatures (70° F. [21.1° C.]), is water resistant, but softens at temperatures over 150° F. (65.6° C.). It also dulls tools slightly, is a little staining, and leaves a tan glue line.

A wide range of epoxies is also available for use if an extremely strong waterproof bond is required. The epoxies are packaged in two part mixes (usually 1:1 or 1:2). They are designed to have varying curing times, typically 5 minutes, 45 minutes, 3 hours and so on. The fast curing epoxies are brittle and weaker than the more flexible slow curing varieties. Epoxies are non-staining, difficult to sand for finishing, resist some finishes (they may prevent polyester resin finishes from hardening), and they soften wth extreme heat.

Industrial hot resin glues packaged as "glue sticks" and used in hot glue runs (figure 7-43) have become available for public use. The gun is electically heated and the glue sticks are pressed through the hot nozzle where the glue becomes liquid and can be squeezed into the joint to be glued. The glue which is principally vinyl plastic will freeze rapidly, form-

Figure 7-43

ing a mildly strong bond which increases its strength with age. Joints glued with this material are almost certain to fail if the material being joined is cold when the glue is applied. If the joint area is warmed with a heat gun or hair drier before application of the glue stick the bond will be strong flexible and water resistant.

One of the most interesting new cements to appear on the open market is the alpha cyanoacrylates (One Drop or instant glue). These cements are generally clear thin, expensive liquids that will bond almost instantly (5 to 30 seconds). Most are compounded to bond non pourous materials but some such as Zap® and Hot Stuff® are compounded to bond pourous materials. These cements are drawn through tight fitting joints by capillary action where they are activated by trace moisture on the surface of the material to be bonded. The cement does not leave a visible bond. Blue Line Hot Stuff® is compounded to leave a blue line in the joint so that the distance the cement has

Common name	Type	Water Resistance	Temperature F.°	Setting Time
Contact Cement	Liquid Neoprene Ready to use	Good		Bonds on contact when dry
Epoxy Cement	2 part Mix to use	Good	70° F. or above	1 min.-10 hrs. Can be accelerated with heat
Household Cement	Liquid vinyl	Good		9-15 min.
Resorcinol	Resin and Catalyist Mix to use	Waterproof	70° F. or above	8-10 hrs. at 70° F. Can be accelerated with heat
Plastic Rubber Cement	Liquid Synthetic Rubber Ready to use	Good		20-40 min.
Silicon Rubber	Liquid Syntheic Rubber Ready to use	Waterproof		20-90 min.
Polystyrene Cement Model Cement (plastic)	Liquid Styrene Ready to use	Good		5-15 min.
Casein Glue	Powder—mix with water	Good		2-4 hrs.
Animal Hide Glue	Liquid animal hide glue Mix with water	Slight, for interior use only	Glue should be heated	45-60 min.
Plastic Resin Glue	Powder-Mix with water	very good	70° F. or above	5-6 hrs. at 70° F. Can be accelerated with heat
White Glue	Liquid Polyvinyl Ready to use	only moderate		20-30 min.
Body Putty	Epoxy and filler Mix to use	Good	Above 70° F.	8-10 hrs. at 70° F.
Model Cement*2 (wood)	Nitro Cellulose Ready to use	Good		10-15 min. 24 hrs. for maximum strength
Eastman 910 DANGER*3, 4	Alpha Cyanoacrylate Ready to use	Good		5 sec. to 2 min.
Hot Stuff*3, 4 ZAP*3, 4	Alpha Cyanoacrylate Ready to use	Good		5 sec. to 2 min.
Glue Stick	Solid Vinyl Heat to use	Good		On cooling

*1 Because variations in humidity will cause wood to expand and contract, it may split when glued to a material which is not flexible. When glued to a soft stone such as limestone, the wood may remain intact, but breaks the stone.
*2 Use for rapid work in areas of only a few inches.

Figure 7-44. Glues and Cements

Metal to Metal	Paper to Paper or Fabrics	Wood to Wood and Plywood*1	Wood for in-water use	Wood-Outdoors	Wood Veneering	Hardboard to Wood	Decorative Plywood panels	Plastic Laminate Wood to Wood	Metal to Wood*1	Metal to Stone	Canvas to Wood	Rubber to Wood or Metal	Leather to Leather or Wood	Flexible Caulk Filler	Plexiglass or Glass to Wood or Styrofoam	Wood to Stone*1	Styrene Plastic to Styrene Plastic
					X	X	X	X	X		X	X	X				
X			x *5						X	X		X				X	
	X										X	X	X				
		X	X	X	X			X			X						
													X	X			
														X			
											X			X			X
		X			X	X	X	X			X						
	X	X			X	X		X			X		X				
		X		X	X	X	X	X			X						
	X	X			X	X		X			X		X				
X														X	X		
	X	X				X				X	X					X	
X																	
X	X	X	X	X	X	X	X	X	X		X	X	X	X			
	X	X				X					X			X		X	

*3 WARNING: This bonding agent will bond skin together instantly and is therefore dangerous around the eyes and mouth. See manufacturer's instructions for use.
*4 Although this agent is suitable for many materials, it is too expensive for many applications. It also has tremendous bonding strength which can be a problem.
*5 When compounded for this purpose.

Addition (Build Up) 173

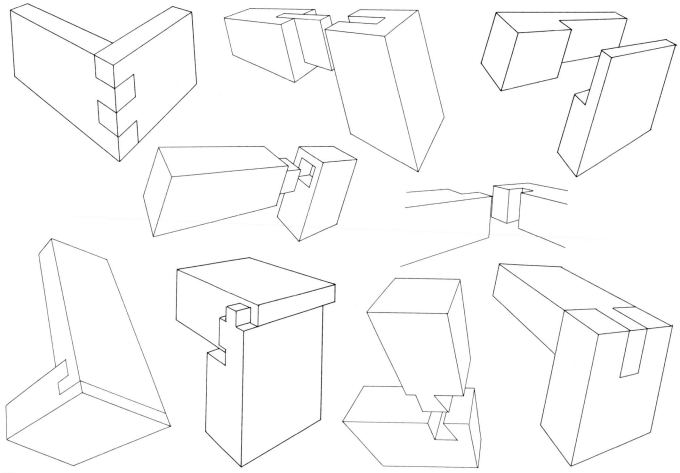

Figure 7-45

traveled in the joint can be detected. If the cement does not "kick off" on application the surface may be too dry and can be dampened (breathe on it) to activate the cement. In cases where pourous materials are being bonded, baking soda can be rubbed into the joint to act as a filler and to activate the cement.

The alpha cyanoacrylates are unusual in that the less cement used the stronger the bond. Also the cement will not stick to itself once it has set so it can not be used to build fillets.

These instant glues are also peculiar in that they will bond human tissue (especially the eyes and mouth) almost instantly. The only real danger to bonding tissue is that enough heat may be generated when the cement "kicks off" to cause severe burns. Tissue which has been bonded will usually release within a couple of days but medical attention should be sought in any but the mildest of cases. Fingernail polish remover or acetone will release most of the brands of the instant glues. Do not use these solvents around the eyes or mouth. CAUTION: If you get instant glue on your fingers, do not rub your eyes or touch your fingers to your lips or tongue, or you may glue your fingers in place. When instant glue "kicks off" it releases

fumes which irritate the eyes and the natural reaction is to rub the eyes.

The instant glues compounded for porous materials are also very useful for hardening the surface of soft wood or for filling holes which must be tapped. The glue can be dropped onto the wood where it will be wicked over and into the surface where it will harden and strengthen the wood. Holes can be filled with thin layers of baking soda or soda and sawdust mixture. When the cement is dropped onto the layer it will "kick off" boil and smoke and the next layer can be packed and kicked. Holes filled this way will be hard enough to drill and tap. Although instant glue is very strong, it is not satisfactory for interlocking joints because it does not have good shear strength.

Interlocking joints are those which are cut in such a way that the pieces fit together like a puzzle. The interweaving of the parts, along with a glue bond, is enough to form strong joints for many purposes. Among these joints are box joints, splined joints, middle and end laps, tee laps, mortise and tenon, open tenon, milled dado box corner, dovetail dado, and lock joints, as illustrated in figure 7-45.

Figure 7-46. *Wing Piece,* Robert Strini, American (1942-), 19′ x 6′ x 4′.

Figure 7-47. *Sheridan Piece,* Robert Strini, American, (1942-), 8′ x 4′ x 4′, cherry, ash, and oak.

Wood Forming

Wood forming belongs to the chapter on manipulation because under some circumstances wood can be made quite plastic. Generally the forming process in wood is an adjunct to either the additive or subtractive process so it is being included in this chapter for convenience. Many species of wood will become flexible after they have been soaked or steamed for a sufficient length of time (figure 7-50). Steaming is not beyond the capability of the average sculptor. A container, such as a length of downspout or an old pipe, is plugged with wood at both ends. A one gallon

(3.785 liter) can or larger, fitted with a cap and a large diameter copper tube, is filled 3/4 full of water and placed over a fire to boil. The copper pipe is inserted through a hole in the wooden plug at one end of the container. The other end of the container must have a small opening to prevent pressure from building up and exploding the system. The plug opposite the boiler should be removed to insert the wood which is to be softened. The container should slant down slightly toward the vent end so that water condensing in the pipe can drain through the vent hole which should be on the bottom of the plug (figure 7-49).

Figure 7-48. Robert Strini, American, (1942-),
5′ x 8′ x 4′, pine, oak, maple, and rosewood.

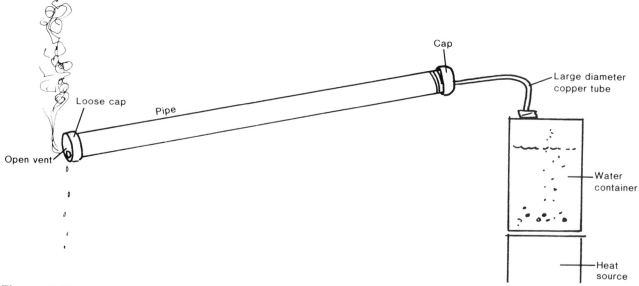

Figure 7-49

Steaming the wood to the desired degree of flexibility may take hours depending on the kind, cross section and the length of the wood and the amount of steam being produced.

When the wood is soft enough, it should be removed from the steam chest, quickly bent to shape, glued as necessary, and clamped overnight. The wood will tend to spring back to its original shape if it is not sufficiently cooled and dried before it is removed from the restraints. Wood can also be treated with urea, urea and formaldehyde, or dimethylol urea to make it highly plastic.

Very thin sheets of wood can be softened by soaking them in a mixture of household ammonia 1 part and water 10 parts. If allowed to soak long enough some wood like balsa can be rolled into small diameter tubes and can be shaped into gentle compound curves. Normal soaking times are about 10 minutes of soak per every 1/32" (.79375 mm) thickness of wood.

Very strong sections can be created by laminating the wood over preformed shapes. The softened sheets are wrapped against the preformed shapes with 2" (50.8 mm) or 3" (76.2 mm) gauze and rubber bands, or strong tape. On drying additional softened sheets are bent and glued over the first sheet. Each lamination should be bound with the gauze until it has hardened. If an area cracks, simply allow the sheet to dry on the form, cut away from the bad section (layer), and patch in new materials.

Best bending ability	American Elm
	White Oak
	Locust
	American Beech
	Yellow Birch
	Red Oak
	Yew
Moderate bending ability	Mahogany (Central American)
	Mahogany (African)
	Hickory
	Ash
	Maple
	Walnut
	Sweet Gum

Most soft woods have poor bending qualities.

Figure 7-50. Bending capability of wood in descending order

Figure 7-51. *Airplane on Rollerskates,* John McNaughton, American, (1943-), sheet copper assemblage.

Metal

The sculptors of this country have been blessed with a variety of easily obtained and worked metals suitable for sculpture fabrication. Most of the copper based metals which are a pleasure to work with have become too expensive for the sculptor to experiment with, therefore, since ferrous metals are still reasonably priced they have been the primary medium for the artist. The ferrous metals except for the stainless varieties suffer from rust, while the lightweight metals which have also become available for use by the artist has been difficult to weld or solder.

Cor-ten[T] (form number ADUSS 88-1788) is a metal much preferred by the sculptor for outdoor art. The name Corten[T] is a trademark of the United States Steel Company referring to a high strength low alloy nickle bearing steel which corrodes to an even dark purplish/red brown color with an extremely even fine grain. This rust layer forms a tight nearly impervious layer that inhibits continued rapid rusting resulting in a reasonably permanent material.

On the initial corrosion of the metal, highly stationary rust particles rapidly erode away making other secondary areas. Eventually (five to ten years) the corrosion is minimized. Generally the acquisition of a rapid even coating is facilitated by exposure to the

elements. The more exposure to the weather the more rapid and even the acquisition of the layer of rust. Cor-tenT should not be used in a salt water atmosphere.

Cor-tenT can be electric welded with welding systems available to most sculptors. Manual arc, inert gas, (MIG or TIG) may be used with mild steel welding rods in the event of single pass welds. The Cor-tenT will mix with the filler metal resulting in a bead with color and corrosion resistance similar to Cor-tenT. For cosmetic purposes or multiple pass welds a nickle bearing (2.5% to 3.5%) electrode should be used. Extremely heavy weld sections of Cor-tenT should be preheated (1/2" [12.7 mm] to 50° F. [10° C.] — 1" [25.4 mm] to 2" [50.8 mm] to 100° F. [37.8° C.]). The metal should not be welded when environmental temperature is below 0° F (−17.8° C.). Weld lines should be ground or sand blasted in order to remove scale which would inhibit uniform coloration.

Fasteners for fabrication methods other than welding are available in Cor-tenT. Nuts, bolts, washers, and rivets, are available from United States Steel. It should be noted that Cor-tenT rivets are a pain in the neck in that they must either be annealed (to 1500° F. [815.6° C.] and then furnace cooled) for sizes smaller than 3/8" (9.525 mm) or they must be driven hot (1900° F. [1037.8° C.] to 2100° F. [1148.9° C.]). These fasteners color and corrode to match the sheet metal.

Finishing Cor-tenT is relatively simple. The metal sheets should be kept clean of grease, paint, oil, and crayon, cement before, during and after construction. Any of these materials will affect even coloration of the metal. Soiled Cor-tenT can be cleaned by pickling, non-metallic sand blasting, or sanding and grinding. The metal should not be stored so that water puddles on the surface, or streaking and uneven coloration will result.

Cor-tenT can be painted if it is ground-sanded, or sand blasted. Welds should be chipped, wire brushed, and washed with a 5% phosphoric acid/water solution, then rinsed with fresh water and dried.

Magnesium*

Magnesium is an exciting metal for the sculptor. It is extremely light which makes it ideal to use with mixed media such as plastic or glass, but even more importantly because it is so light thick sections (sections with obvious substance or mass) may be explored by the artist. Plates up to 3/8" (9.525 mm) thick can be easily cut with a sabre saw and welded without distressing warping. Plates over 1/8" (3.175 mm) can be assembled by edge drilling, taping and bolting. Of course most metals can be assembled in

*See caution on page 179.

the same way except that they have problems not shared by magnesium. Aluminum is another light metal that can be edge bolted like magnesium but aluminum is a gummy fluid-like metal and it clogs saw blades, grinding wheels, drills, and taps and as a result is discouragingly hard on tools. Even worse the alloys of aluminum which are readily available and easy to work are so soft that threads tend to tear out if excessive stress is placed on the bolts. Magnesum has another interesting property: available alloys are stiff for their weight and resist flexing; when forced to bend the metal begins to bend on a large radius and then breaks. If forced to bend in a small radius it breaks almost immediately. If care is taken with some of the alloys the metal can be bent once. Any additional bending or straightening in the same area will result in immediate fracture.

Joining magnesium sheets by welding or brazing is only a little difficult. Once mastered, joining presents few problems. First the metal must be mechanically and chemically cleaned, the joint should not be a tight fit (the edges should be beveled in fact) and the edges area of weld should be coated with a magnesium flux, often a paste. This flux serves two purposes: it cleans the metal and forms a film over the joint to prevent instant corrosion from forming in the molten metal, and it prevents ignition of the metal. A small, slightly fuel-rich flame (reducing flame) is used to preheat the metal along the joint in order to drive off the moisture in the flux, and then to melt the flux into a glass like coating. The flame should not touch the flux until after the flux has become glassy. The tip of the flame should be held about 1/4" (6.35 mm) above the joint and should be directed along the joint at an angle of about 45° from vertical and directed along the joints. A slight bagginess will be noted in the metal beneath the flame at which time a magnesium filler rod (preferably flux coated) should be fed into the bubble of molten magnesium. The molten puddle will be hard to see because it will be covered with a dull gray oxide and because the flux usually flames bright red, obscuring the melt. The torch tip should be rotated in a small circle across the joint and slightly in front of the bubble to keep the melt moving and preventing the metal from melting through. Too much heat will blow the puddle away as soon as it melts or else the bubble will melt back onto the plate thickening it. Excessive heat will also burn the flux away from the joint causing the filler rod to spark and burst into flame. These flames have a tendency to flair and drop, setting fire to anything and everything handy, especially clothing. As soon as the line of weld has cooled, the flux should be flushed from the joint with a wire brush and then washed well with hot water (or whatever the manufacturer of the flux

recommends), because the flux will etch any area that it contacts making that area hard to finish. If the flux is not removed it will continue to corrode, and severely pit the metal. Magnesium plate 1/8" (3.175 mm) thick can be corroded completely through overnight in the worst of conditions.

Part of the pleasure that comes from working with magnesium is the ease with which it can be finished. Weld lines can be worked to a crisp, clean, brilliant surface with hand files, slow turning disc sanders, belt sanders, or even die grinders with a tool steel router bit. Unlike aluminum, which is somewhat similar in color and weight (and much more common), magnesium does not seriously "load up" and destroy finishing tools. Magnesium plates can be finished and polished in the same manner as aluminum (see page 180).

CAUTION CAUTION CAUTION

Although magnesium in sold mass is as safe as most other metals, it is tremendously dangerous in powder or thin film form. In either of the latter forms the metal is highly flammable and even explosive. The powder thrown into the air by a sander can be ignited by a spark, causing an instant devastating explosion (figure 7-52). Magnesium powder on the floor or around the base of a grinder will almost certainly ignite the first time that steel, iron or some other sparking metal is ground on the same grinder. A magnesium fire is nearly impossible to extinguish with ordinary fire fighting materials, in fact, water thrown on a magnesium fire will result in an explosion. It is imperative that all magnesium residue be continuously removed from the workshop while work is in progress. Most of the dust can be swept up with wet saw dust. A vacuum cleaner can be used to remove magnesium dust as long as it is of the sparkless (explosion proof) variety.

Iron

Iron as it is drawn from the blast furnace is used to make either pig iron or steel. Pig iron is heavy, crystalline, brittle and is used to make cast iron castings.

Steel is iron with the impurities removed. It is ductile, malleable and tough. It can be rolled into many forms, including square, flat, octagonal bar, sheets, rolls, and drawn wire.

There are a great many grades of steel available to the fabricator. The most useful grade of steel to the sculptor is mild steel. Mild steel (low carbon steel, machining steel) is a very common and reasonably inexpensive metal for the sculptor. It is obtained in sheet, plate, rods, tubing, and many structural shapes. The sheets (plates of 1/4" [6.35 mm] or thicker and over 8" [203.2 mm] wide) are available in large sizes

Figure 7-52

(4' x 12' [1.2192 m x 3.6576 m) and many thicknesses, (see figure 4-61). It is also available in cold rolled or hot rolled. Cold rolled is slightly tougher than hot rolled sheet of the same gauge. The surface of cold rolled is silvery and often heavily oiled to prevent it from rusting which it will do almost immediately. Hot rolled steel is blue-black because the surface is oxidized during rolling. It is usually not oiled because the preoxidized surface does not rust quite as easily as cold rolled. It can be stored for some time in a dry atmosphere without fear of rusting. Hot rolled sheets are often slightly bowed and usually cannot be spot welded until the black scale is ground from the surface to be welded. Mild steel can be arc, resistance (spot) or gas welded. It can be joined by any of the mechanical fastening systems (rivets, nuts and bolts, interlocking, etc.). The metal is ductile enough to be stamped, forged, shrunk, bent, drilled, sheared, sawed, punched, and so on. Although the degree of hardening is not great enough to be useful for making cutting tools, and does not harden with heat, it will harden from impact. It is so sensitive to impact hardening that sand blasting (or shot peening), or hand hammering will stiffen the metal. Hardened mild steel can be softened (annealed) with heat.

Aluminum

Aluminum is the most common available lightweight metal. It is silvery gray in color when unoxidized and dull powdery gray when corroded. It conducts heat and electricity easily and is unfortunately chemically active. Aluminum available to the sculptor is usually not pure but is alloyed with as many as six other elements, including bismuth, copper, chromium, iron, lead, magnesium, manganese, nickel, silicon, titanium

and zinc. These elements are added to the base metal to control its joining qualities (weldability, etc.), heat treating characteristics, hardness, strength, casting and forging characteristics, and so on. Aluminum alloys are formulated as wrought or cast alloys. Wrought alloys are used for bar, rod, pipe, plate, sheet, tube, wire, and extrusions and stampings. Cast aluminum alloys are formulated to be very fluid, have minimum shrinkage and to have low surface tension to insure a good surface print and filling of a minute recess in the mold. Aluminum casting alloys are generally suitable for green sand, chemically bonded sand, ceramic shell, permanent mold, and investment casting processes.

Even though both wrought and cast aluminum alloys melt between 900° F. (482.2° C.) and 1215° F. (657.2° C.) the wrought alloys are not usually satisfactory for casting. Wrought aluminum alloys used for extruding purposes may contain large amounts of silicon which tends to make the aluminum stiff and sluggish at normal pouring temperatures. Sluggish metal is not fluid enough to fill out a mold unless the metal is overheated or unless some form of pressure can be exerted on the metal in the mold. Overheating the metal will form gray, porous, crystalline casts with severe shrinkage defects. These casts are very difficult to repair because they are often honeycombed with porosity or hollow pockets which cannot be readily welded.

Sheet aluminum (usually a wrought alloy) can be obtained with widely varying characteristics (figure 7-53). Dead soft sheet stock can be worked with tools for wood working and shaped over wood forms with soft faced hammers. High strength alloys are so hard that they are springy and break when bent cold. Some hard grade wrought aluminum alloys, in fact, are stronger than low carbon steel of equal dimensions. All common mechanical joining and fastening systems (rivets, nuts, bolts, etc.) can be utilized with aluminum sheet stock.

Unfortunately because most aluminum alloys are electronically active, they tend to corrode where they come into contact with other metals. Fiber insulators, epoxy barriers, or some other similar separator preventing contact between the different metals will stop destructive corrosion.

Sheet aluminum can be obtained with various surfaces (finishes) including mill, fluted, diamond pattern, square pattern, leather grain and stucco embossed. These finishes may be retained as desired but they may also be polished.

1. Weldable
2. Weldable but not durable, unstable
3. Weldable using special techniques only
4. Not weldable or solderable

Method of Joining

Alloy	Electrode & Flux	Inert Gas	Oxy-Acetylene	Resistance (Spot)	Braze	Solder
EC	1	1	1	3	1	1
1100	1	1	1	2	1	1
2011	4	4	4	3	4	4
2014	3	2	4	4	4	4
2017	3	2	4	4	4	4
2024	3	2	4	4	4	4
3003	1	1	1	2	1	1
3004	1	1	3	2	3	3
5050	1	1	1	2	3	3
6053	1	1	1	1	1	1
6061	1	1	1	1	1	1
6062	1	1	1	1	1	3
6063	1	1	1	1	1	3
7075	3	2	4	3	4	4

Figure 7-53. Wrought aluminum alloy weldability

Aluminum is a slightly sticky metal. It tends to clog files, saws, sand paper, and anything else that cuts or shaves off small particles. It is necessary to use an open coat, non-clogging paper when sanding the metal. Belt and disc sanding belts should be lightly coated with white soap or sanding belt grease to prevent the metal from filling in the grit on the sand paper. To bring aluminum to a high polish, the metal should be powder sanded with succeedingly finer grades of sandpaper starting with 80 mesh and ending with 600 mesh. If the surface is smooth but not shiny it may not need sanding unless it is scratched or otherwise damaged. In that case sand only the damaged area. If large areas are to be sanded the final sanding should be performed with a random oscillating double action sander. The DA sander which should be used with 120 mesh to 600 mesh papers will break up the sanding pattern left by other tools into a totally random pattern. Finally the random scratch pattern left by the DA sander is removed by buffing the surface with a powder polisher. The polisher must run at high speeds and be equipped with a wool bonnet. Orange rubbing compound would be applied to the metal during the buffing as it is the rubbing compound which cuts the surface of the metal. The rubbing compound will leave a dull, even, satinlike finish without scratch marks. If a mirror finish is de-

sired the metal should be wiped clean of the rubbing compound and then polished with a clean wool bonnet and white polishing compound. Both the rubbing compound and the polishing compound are products used in automobile maintenance and can be obtained in any store selling automotive paints.

The techniques of gluing, soldering, and brazing aluminum have escaped many fabricators of the metal. The processes are quite simple if every step is properly executed. To glue aluminum clean the joint with a solvent like acetone or lacquer thinner, immerse the joint for ten to fifteen minutes in a solution of 1 part sodium dichromate, 10 parts sulphuric acid, and 30 parts warm distilled water by weight. The temperature of the solution should not exceed 150° F. (65.6° C.). Finally wash the joint with distilled water and dry with clean warm air from a hair drier. The joint must remain untouched and perfectly clean through every step. The metal can now be glued with epoxy cements, preferably the slow cure variety.

To solder aluminum except those alloys that are not suitable for soldering, wash the joint with trisodium phosphate or some other good detergent; lightly sand the joint with a very fine sandpaper (do not use wet or dry paper as they will deposit a resin that will ruin a solder joint); apply the flux that is sold for that brand solder to the metal and heat the metal until the flux boils; apply the solder and move the solder along the line of the joint immediately in front of or behind the soldering iron tip, whichever works best. The iron may be passed over the joint to level the solder or spread the bond.

Aluminum is rather easy to braze if it is an alloy suited to brazing (figure 7-54). The joint is washed with a detergent, and sanded (especially if the braze fails to take the first time), then the appropriate flux is applied to the metal and heated around the joint, not on the joint. The flux should boil and clean the joint. When the flux boils, touch the braze to the joint and the metal should flow to the area of heat.

Zinc Based Alloys

White Metals—Pot Metal

Zinc based alloys are commonly used for die casting of low strength and plated and decorative objects such as carburators, auto trim, door handles, bathroom accessories, electrical appliance parts, small gas engine parts and toys. Sheet stock is also available, but rarely seen outside of industrial situations. It is used for offset printing plates, weather stripping, photo engraving plates and so on. These alloys (there are literally hundreds) are becoming attractive to the sculptor because they cast easily, are relatively inexpensive, and usually can be plated to attractive surfaces. Some of these alloys corrode very badly in mildly humid

Figure 7-54. Aluminum alloy rejecting repaired areas through corrosion.

atmospheres, resulting in powdrely pitted surfaces which are most difficult to repair. These alloys are also difficult to weld or solder.

Pot metals have been considered junk materials for so long that it would be difficult for the sculptor to present serious work in the metal. Critics are certain to hold the works produced in the metal in disdain; nevertheless before long the sculptor is certain to "discover" this readily available metal and will develop forms and finishes which will overcome the stigma long associated with it.

Zinc alloys are useful to the bronze caster. Occasionally the small percentage of zinc tin alloy can be added to a bronze melt to increase its fluidity.

Stainless Steel

The stainless steel alloys consist primarily of steel alloyed with chromium and nickel. They may also contain carbon, manganese, phosphorous, sulphur,

silicon, molyblendum, tungsten, titanium, and columbium. Standardized combinations of these elements result in over thirty commercial grades of stainless steel.

These metals have a reputation of being very tough, corrosion resistant, and hard to work. Unfortunately, most of this is true.

There are three broad types of stainless steel. The chromium nickel, the austenitic martensitic chromium and the ferritic chromium types.

The chromium nickel stainless steels are non-magnetic, corrosion resistant, non-hardening (by heat treatment), with good mechanical properties. They will harden as they are cold worked.

The austenitic martensitic chromium types are hardenable (by heat treatment) stainless steels and are produced mostly for bar, rod and wire stock.

The ferritic chromium stainless steels are ductile, non-hardenable by heat treatment and supposedly do not harden appreciably from cold working.

The steels vary widely in their weldability, solderability and machinability. Fabrication of sculptural form with sheet and rod stainlesses can be a nasty experience. The alloys are hard to drill or cut with ordinary tools. They will shear and can be punched if the proper equipment is used. Most of the alloys would also rather kink than bend smoothly. The virtue of stainless steel is that it will retain a mirror finish in adverse environments because of its corrosion resistance. Actually it does stain easily with many ordinary food juices.

Because stainless has many industrial and commercial uses it is available in sheets, rods, tubing, and many other shapes. It is also available in finishes such as bright, dull (cold rolled), ground (100 grit), satin, high lustre polish and mirror. The finishes can be obtained on one or both sides with or without protective cover sheets.

In a pinch, stainless steel can be worked with ordinary high speed metal working tools provided that the tool speed is slow enough that the work never gets warm. Typically when drilling stainless sheet the drill will penetrate about 1/32″ (.79375 mm) and then suddenly stop penetrating. The drill bit will just turn and burn because the metal will have work hardened. The hole could have been drilled with a very slow turning drill and a little kerosene for a coolant. Silicon carbide tipped drills will drill stainless quite easily, but they cost roughly thirty times as much as a high speed drill bit. Additional information concerning fabricating stainless steel will be found on page 202.

Nickel

Nickel based alloys (Monel, Inconel, Incoloy, Duranikel, etc.). Nickel is a metal similar in its mechanical

Figure 7-55. Detail of Figure 2-6 stabile-mobile by Alexander Calder.

properties to mild steel except that it does not corrode as easily. The metal is silver white and is not generally available in finished surfaces. Possibly the best known nickel alloy is monel metal. It is about as perfect an alloy as the fabricator could want. It has high strength and great corrosion resistance, good hardness, ductility, weldability, and can be fabricated easily. Its only disadvantage is its high cost.

Fabricating Metal

Of the three ways of joining metals, the one most commonly used for sculpture is welding. Mechanical fastening with self-tapping screws, with nuts and bolts, and with rivets, and adhesive joining with glues or cement are just now being exploited as sculptural joining systems (figure 7-55).

Rivets have been used to join materials for almost as long as metal has been used by man. In their simplest form, they are shafts of metal with expanded ends, which prevent the fastened material from slipping off. Unlike the nut and bolt, a rivet alone will not pull pieces together, but also unlike the nut and bolt, solid rivets can be expanded by impact so that they swell

(upset), filling their holes (preventing side movement) and gripping the joined materials firmly. Sound riveting requires that the hole drilled for the rivet be just large enough for a snug fit.

Usual practice requires that a heavy bar of iron (bucking bar) be placed against the head of the rivet while the shank of the rivet is swollen by impact from a ball peen hammer (figure 7-62B) or a pneumatic riveting tool (figure 7-63).

Light blows will only bend the shank or swell just the very end, while heavy blows will cause the shank to swell along its full length. Solid rivets used properly will join metal with strength as great as or greater than welding.

A riveting tool is used to spread hollow rivets (figure 7-61B). The flared head of the tool is centered over the opening in the shank of the hollow rivet (figure 7-56), and struck—squarely and repeatedly—until the wedging action of the tool forces the walls of the rivet to spread. Washers are sometimes used on rivets to prevent them from pulling through soft materials.

A tool known as a "pop riveter," which has been used in industry for many years and is now available in an inexpensive household model, allows riveting in blind spots (where the head of the rivet is not accessible). A rivet is placed in the tool (figure 7-57), and the shank of the rivet is placed through the holes in the material to be joined (figure 7-58). If necessary, a washer can be placed over the shank of the rivet (figure 7-59) before the handle of the rivet tool is depressed. When the handle is squeezed, the tool pulls the long shaft through the hollow rivet, drawing behind it a large knob, which swells the rivet. When the head of the shaft wedges itself tightly inside the rivet (against the riveted material), the shaft breaks free (figure 7-60) at a weak point on the shaft immediately behind the head.

Rivet Types and Tools

a. Brazier head split rivets—for soft materials (figure 7-61A)
b. Rivet tool for hollow rivets (figure 7-61B)
c. Flat head hollow rivets (figure 7-61C)
d. Brazier head hollow rivets (figure 7-61D)
e. Brazier head solid iron rivets (figure 7-61E)
f. Countersunk solid rivets and burrs (washers) (figure 7-61F)
g. Aircraft-grade aluminum brazier rivets (note the identification mark on the head) (figure 7-61G)
h. Brazier head soft aluminum rivets (figure 7-61H)
i. Pop rivets and washers (figure 7-61I)
j. Self spreading rivets (figure 7-60J)
k. Bucking bar (figure 7-62A)
l. Ball peen hammer (figure 7-62B)

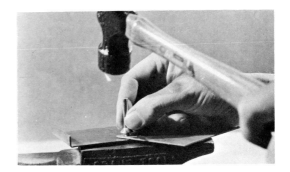

Figure 7-56

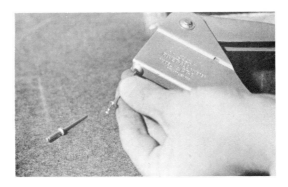

Figure 7-57

Figure 7-58

Figure 7-59

Figure 7-60

Welding

Welding is the process of joining similar metals by melting both metals along a common joint line and causing the molten metal to flow together, forming one unit. A filler of a similar metal is often used to build up thickness or strength along the joint line, or anywhere else that thickness is needed. Brazing is similar to welding, in that the intent is to join metals through application of heat, but the metals need not be similar, and they are not melted.

Instead a foreign metal, usually high in copper or silver content, with a melting point lower than that of the parent metals is melted into the red or nearly red hot joint. On cooling the braze having a "molecular grip" bonds the joint. A brazed joint does not have the strength of a welded joint and should not be used for joints which will be stressed, flexed, or subject to vibration.

Welding requires heat and sometimes pressure. Practically any source of heat is useable, heat from gas, electricity, friction or impact have all been used in welding systems. A wide range of welding systems have grown around these heat sources, some as rudimentary as smithing (hand forging and metal joining over coal, coke, or gas fire) and some involving space age technology.

Cutting

Cutting is the action of burning away a thin channel (kerf) of ferrous metal, in order to separate the metal into more than one piece or shape. Nonferrous metals will not oxidize rapidly enough to be cut with a cutting torch; instead, these metals can be separated by melting a section of metal, blasting the molten metal away with a sharp blast of oxygen from the cutting torch (page 205), and then continuing this action until a kerf is formed.

Electric Welding

The most common method of electric welding is arc welding. This is welding with the heat produced by a spark occurring between a metal rod and the metal to be welded. Arc equipment is readily available and relatively inexpensive. To some extent its costs are minimized because the system does not require the resupply of gas or the maintenance costs of storage tanks (as in gas welding). As long as a supply of dry stick electrodes is available and the electric bill is paid the welder is ready to use. The only great disadvantage of the arc welder is its lack of portability.

Inexpensive welding machines require access to an external 110 volt or 220 volt power source. The sculptor often has the need to weld a long way from an adequate 220 volt power outlet. Extension cords capable of handling the loading required to operate the welder over distances of 100' (2540 mm) are prohibitively expensive. Gasoline powered generators are available to power the welders, but they cost roughly five to seven times the cost of the welder alone. There are, in addition to the simple "buzz box" utility welders, two types of welders of great use to the sculptor. The Metal Inert Gas (MIG) and Tungsten Inert Gas (TIG) welders are expensive to obtain and operate, but they will weld materials that others cannot weld.

The TIG welder uses a tungsten element to form the arc and uses stick electrodes for the filler. It has plumbing so that it can surround the weld area with an inert gas such as argon, carbon dioxide, or mixtures of gases. The gas prevents oxygen and other undesirable gases from contaminating the weld. Sophisticated TIG equipment is water cooled.

The MIG welder uses a continuous wire (frequently fed from a spool) to form the arc and act as a filler. As in the TIG an inert gas is fed to the weld area through a tube to prevent contamination of the weld. In both systems a high frequency current is passed through the welding system to help start and maintain the arc.

The gases used to shield the arc in the MIG and TIG welding processes can be horrendously expensive. A large tank of argon used for aluminum welding may cost as much as a 180 amp utility type arc welder, complete with accessories. Of course the argon may last for some time (in production a couple of weeks, in the artist's studio a couple of years). To complicate matters, different metals require different gases, or mixes (usually to reduce costs).

The welder most likely encountred by the self-equipped sculptor will use the inexpensive utility type 180 amp or 220 amp single phase alternating current (AC) welder. These welders are found in many home workshops, auto garages, machine shops, most large farms, and so on. They will perform adequately on most steel and iron alloys if they are not used continually at high amperage.

The unit which can be purchased as a complete package will consist of: the transformer and controls,

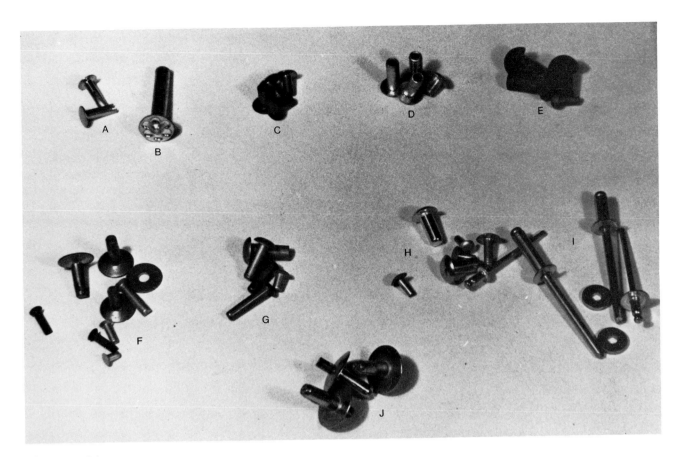

Figure 7-61

Figure 7-62

a line cord plug similar to an electric range receptical for 50 amps or 60 amps, a pair of cables with plugs, a ground clamp, an electrode holder, a helmet with a dark green lens, and perhaps a chipping hammer, an assortment of electrodes, and on occasion an instruction book. The operator will probably have to supply welding gloves, apron, proper welding rods and an electrical outlet.

Figure 7-63

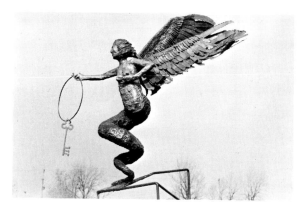

Figure 7-64. *Two Faces of Eve,* David L. Cayton, American (1940-), welded metal.

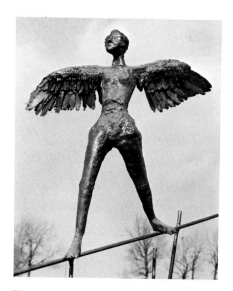

Figure 7-65. *Wife of Dedaelus,* David L. Cayton, American (1940-), welded metal.

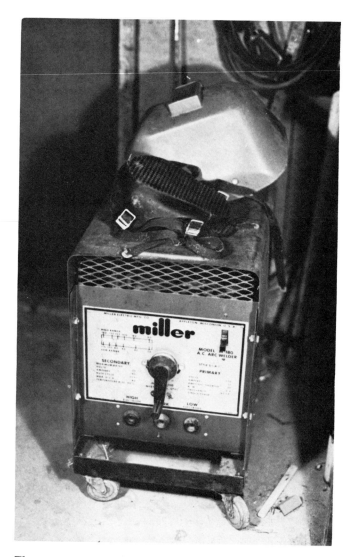

Figure 7-67

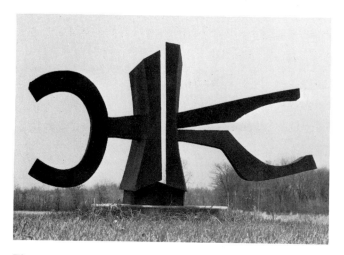

Figure 7-66. *Point Counterpoint,* welded 14 gauge hot rolled mild steel.

Each welder has limited capabilities built into the machine by the manufacturer. An inexpensive welder (figure 7-67) may have a maximum output of 180 amps allowing the use of welding rods up to 3/16″ (4.7625 mm) diameter, except for low hydrogen and iron powder coated electrodes which should not exceed 5/32″ (3.96875 mm) in diameter. These machines may have a 20% duty cycle. The duty cycle is the number of minutes out of ten minutes that the machine can be operated at its full amperage. The 20% duty cycle welder can be operated for two minutes and cooled for eight minutes at 180 amps, which is sufficient for most welding except for production. At 80 amps the same machine may have a 100% duty cycle (figure 7-68).

Many welders have more than one open current range. Open current is the current available before the arc is struck. Typically an open-current low range

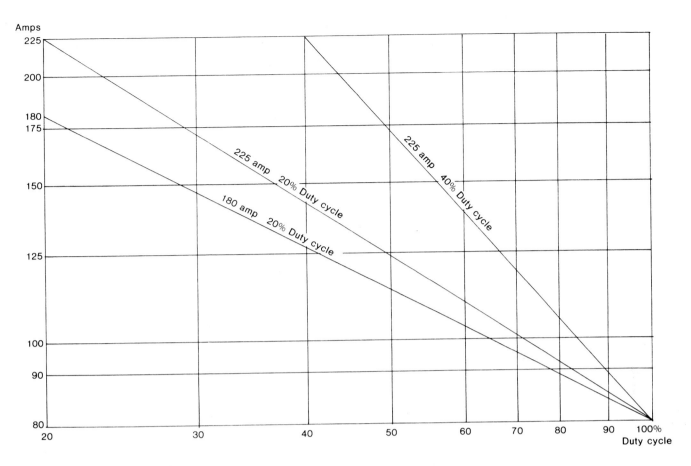

Figure 7-68. Duty cycle.

voltage may have a potential of 80 volts while it may have a potential of 55 volts in the high open current range. Mild steel electrodes will generally weld with low voltage, therefore larger diameter mild steel rods can be used at high amperage on the high range (180 amps at 55 volts). Stainless steel, iron powder, low hydrogen, and many other rods will not arc well on the low open voltage of the high amperage range. These electrodes should be used on the low amperage range which has a higher starting voltage (80 volts).

The low amperage range should be used where small diameter electrodes with amperage requirements are of 155 amps or less.

Any welder worth carrying home will have some system of amperage control. Moveable shunt welders have a crank which allows the operator an infinite range of adjustments between the lowest and highest capacity of the welder.

Other welders using tapped transformers are a little simpler in construction, but they do not offer the full range of control of the moveable shunt welder. Tapped transformers use a series of holes each marked for a specific amperage, or a switch with positions for specific amperage to select the desired power output.

More expensive welders will have a greater duty cycle and may include a rectifier to permit direct current (DC) welding. AC welding minimizes arc blow, the tendency for the arc to dance around away from the desired area. AC current in effect stabilizes the arc. Arc blow is not much of a problem when welding thick flat sections, but when welding deep in a groove or deep in an angle the arc would go anywhere but in the bead if it were used on the DC side of the welder. AC welding unfortunately has limitations that make the inexpensive welders useless for some work. Their greatest limitations are that the AC welder cannot be used for welding all metals and alloys. Perhaps of more importance to the sculptor, AC welding has a tendency to blow holes in thin sheet metal edges.

The DC capacity of expensive welders will permit the fabricator to eliminate these problems. DC welding is considerably easier and smoother than AC welding. Unlike AC current, DC current does not alternate; it therefore has polarity. The operator has a choice of polarities dependent on the welding requirements and the nature of the welding rod. Straight polarity (DC—) means that the electrode holder cable is

MASTER CHART OF LINCOLN ELECTRODE IDENTIFICATION AND OPERATING DATA

IDENTIFICATION MARKING

E S G AWS Number L Lincoln Trademark
308-16

COATING COLOR	(E) END	(S) SPOT	(G) GROUP	(L) or AWS No.	AWS[10] CLASS	ELECTRODE	POLARITY	3/32"	1/8"	5/32"	3/16"	7/32"	1/4"	5/16"
MILD STEEL														
White					E6010	Fleetweld 5	DC(+)		100	130	180	240	280	350
Brick Red					E6010	Fleetweld 5P	DC(+)	60	100	130	180			
Tan		White			E6012	Fleetweld 7	DC(−); AC	75	110	175	240	260	300	375
Gray		White			E6012	Fleetweld 7MP	DC(−); AC		125	160	220			
White		Blue			E6011	Fleetweld 35	AC; DC(+)		100	130	160	210	250	
Dark Tan		Brown		Green	E6013	Fleetweld 37	AC; DC(−)	75a	115	150	220			
Gray-Brown	Black	Brown			E7014[1]	Fleetweld 47	AC; DC(−)		125	175	225	280	360	425
Tan		White		Green	E6012	Fleetweld 77	DC(−); AC		110	160	220	250	300	
Brown		Blue			E6011	Fleetweld 180	AC; DC(+)	65	100	130	180			
Dark Gray	Black	Yellow			E7024[2]	Jetweld 1	AC; DC(+)		175	225	275	335	390	
Red Brown		Silver			E6027[3]	Jetweld 2	AC; DC(±)		220	275	330	380	525	
Gray	Black	Yellow		Green	E7024[2]	Jetweld 3	AC; DC(±)	95	150	215	275	330	380	525
Gray			7018		E7018[4]	Jetweld LH-70	DC(+); AC	90	140	180	240	290	340	420
Grey-Brown			7028		E7028	Jetweld LH-3800	AC; DC		215	280	330	400		
LOW ALLOY, HIGH TENSILE STEEL														
Pink	Blue	White			E7010-A1[5]	Shield-Arc 85	DC(+)	65	100	130	180		280	
Pink	Blue			Green	E7010-G	Shield-Arc 85P	DC(+)				180			
Pink					—	Shield-Arc 90	DC(+);		110	140	180			
Dark Red	Blue	Yellow	Silver		E7020-Al	Jetweld 2-HT	AC; DC(±)		220	275	335	390		
Gray			9018		E9018-G[6]	Jetweld LH-90	DC(+); AC		140	180	240			
Gray			11018		E11018-M	Jetweld LH-110	DC(+); AC		140	180	240	290	340	
STAINLESS STEEL														
Pale Green	Yellow		Black	308-15	E308-15	Stainweld 308-15	DC(+)	60	90	120	160		200	
Gray	Yellow		Yellow	308-16	E308-16	Stainweld 308-16	DC(+); AC	60a	90	120	160		225	
Gray	Brown		Yellow	308L-16	E308L-16	Stainweld 308L-16	DC(+); AC	60	90	120	160		225	
Pale Green	Red		Black	310-15	E310-15	Stainweld 310-15	DC(+)	60	90	120	160		200	
Gray	Red		Yellow	310-16	E310-16	Stainweld 310-16	DC(+); AC	60	90	125	170		240	
Gray	Brown	White	Yellow	316L-16	E316L-16	Stainweld 316L-16	DC(+); AC	60	90	120	160		225	
Pale Green	Yellow	Blue	Black	347-15	E347-15	Stainweld 347-15	DC(+)	60	90	120	160		200	
Gray	Yellow	Blue	Yellow	347-16	E347-16	Stainweld 347-16	DC(+); AC	60	90	120	160			
BRONZE & ALUMINUM														
Peach	Yellow	Blue	Blue		E-CuSn-C	Aerisweld	DC(+)		90	140	180			
Peach					A1-43	Aluminweld	DC(+)	40	100	140	180			
CAST IRON														
Light Tan	Orange				ESt	Ferroweld	DC(+); AC		90					
Black	Orange	Blue	White		ENi	Softweld	DC(±); AC		90	120				
HARDSURFACING														
Black						Abrasoweld	DC(±); AC		100	140	200		300	
Slate	Yellow					Faceweld 1	DC(+); AC				125			300
Slate	Pink					Faceweld 12	DC(+); AC				125			300
Gray						Jet-Hard BU-90	DC(±); AC				180	250	330	
Dark Gray	Orange	Red				Mangjet	DC(±); AC			175	235		310	
Slate						Toolweld A&O	DC(−); AC	70	110					
Dark Gray						Wearweld	DC(+); AC				230		275	

SIZES AND TYPICAL CURRENTS (amps)[9] (electrodes manufactured in sizes for which currents are given)

NOTES:

1. Also classed E6014
2. Also classed E6024
3. Also meets requirements of E6020
4. Also classed E6018 and meets requirements of E6016 & E7016.
5. Also meets requirements of E7010-G; and E6010 in 3/32" size.
6. Also meets requirements of E8018-B2.
7. When AWS number is printed on the electrode, no color code is used. On Stainweld electrodes color code is used on 3/32" and smaller sizes, while numbers are printed on 1/8" and larger sizes.
8. These electrodes also available in 5/64" sizes.
9. Currents given are typical values for welding in downhand position. Any given job may require 10 to 20% adjustment either higher or lower.
10. Electrodes conform to test requirements of ASTM-AWS specifications in the classes listed.

Figure 7-69. Master chart of Lincoln Electrode identification and operating data. Courtesy of the Lincoln Electric Company.

plugged into the DC— (negative) socket, and the ground clamp cable is plugged into the DC+ (positive) socket. Reverse polarity indicates that the position of the cables are reversed at the welder.

Electrode manufacturers vary polarity of the rods in order to control the welding characteristics of the rod. Straight polarity rods for instance produce greater heat in the rod than in the joint unless the gas which shields the arc alters the temperature. Electrodes are designed to do specific jobs. There are rods for stainless steel, aluminum, steel, cast iron, magnesium, copper, titanium; for welding horizontally, vertically, and overhead. There are fast freeze, fill freeze, deep penetrating, shallow penetrating, hard surfacing, cutting and many more. Electrode manufacturers publish catalogues, usually available free, describing their rod types and uses (figure 7-69). These catalogues should be consulted for the best rod for a given weld job.

Electrodes are common in only two lengths, 12″ (304.8 mm) and 9″ (228.6 mm). The 9″ (228.6 mm) rods are thin rods used primarily for the welding of thin auto body metal. The rods are produced in various diameters, those of interest to the sculptor being 1/16″ (1.587 mm), 3/32″ (2.38125 mm), 1/8″ (3.175 mm), 5/32″ (3.96875 mm), 3/16″ (4.7625 mm), 7/32″ (5.55625 mm), 1/4″ (6.35 mm), and 5/16″ (7.9375 mm). There is no significance to the length of the rod, but the diameter of the rod determines to some extent the amperage with which the rod is used (figure 7-70).

Diameter	min. Amperage	max.
1/16″	20	50
5/64″	20	50
3/32″	40	80
1/8″	65	125
5/32″	90	160
3/16″	120	180

Iron powder coated, low hydrogen, stainless steel, and some hard to run electrodes require higher currents than regular mild steelelectrodes and should be used according to manufacturers' directions.

Figure 7-70. General current requirements for mild steel electrodes.

Electrodes are usually available from auto supply stores, farm supply outlets, discount houses, welder's suppliers, and so forth. Most of these suppliers will have a limited selection of rods. They usually stock a utility rod which is a fast freeze mild steel all position rod that is serviceable but a compromise, therefore mediocre for all but average welding on mild steel.

For a large selection of special rods, services which supply industrial and commercial users should be contacted. Even then many types of rods such as the sculptor's favorite small diameter nickel bearing rod for welding Cor-tenT is nearly impossible to find in small quantities.

Special care should be taken to select the proper rod for the position of the weld. If a deep penetration slow freezing rod for horizontal welding were used for overhead welding, molten metal would drip out of the weld, onto the operator in a most unpleasant way. Instead a fast freeze rod should be used over heat so that the metal will freeze before it can bag up and fall like rain. The American Welding Society and the American Society for Testing Metals has provided standards and regulations concerning electrode chemical composition, diameter, lengths, tensil strength, packaging, and so on for the welding industry. They have adopted a four digit code prefixed by the letter E to identify the purpose and characteristics of the electrode.

In addition to this AWS code each manufacturer identifies the electrodes with a company code. This code may consist of a combination of coating color, color spots on the coating or on the end of the rod, or printed letters or numbers on the coating. (figure 7-69).

Electrodes require care if they are to remain serviceable. They are hermetically sealed prior to shipment by the manufacturer in order to prevent the absorption of moisture by the rods, which will ruin them for welding. Once the rods have become damp, they should be discarded except for junk welding. The rods should be stored in a warm dry place. Warm boxes that are heated electrically can be purchased to store the rod, but they can also be stored in a closed tin box like a mail box if they are stored over a source of heat (over a gas hot water heater). If no constant source of heat is available a heat tape or a long life light bulb can be inserted into the box with the rod to keep it warm. Normal safety precautions should be taken to prevent fire or electrical shock from homemade storage units. If the rod becomes damp, rust will appear on the metal end and the coating may change color and begin to crack. Those rods should be removed from the container and discarded.

The rod coating is important to the weld. The heat of the arc melts and vaporizes the coating, producing an envelope of inert gas around the weld, and a layer of glasslike material that covers the fluid metal. This gas and glass cover protects the metal from contamination. The coating also is designed to stabilize the arc, control the fluidity and penetration of the metal, shape the bead, and control the composition of the deposit.

When the electrified rod is struck against grounded metal, the arc struck produces a temperature of about

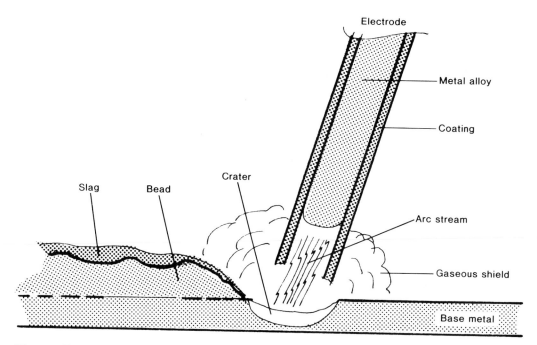

Figure 7-71

Figure 7-73

Figure 7-72

6500° F. (3593.3° C.). The metal alloy rod melts up in the coating and migrates to the weld area while the coating slowly vaporizes to form the gas envelope (figure 7-71).

Tools Required for Arc Welding

a. Arc welder with cables, ground clamp, and electrode holder (figure 7-72)
b. Electrodes as required (figure 7-73D)
c. Safety hood with dark lens (figure 7-73A)
d. Heavy leather gloves and welder's apron (figure 7-73B)
e. Chipping hammer (figure 7-73C)
f. Various clamps (figure 8-13)

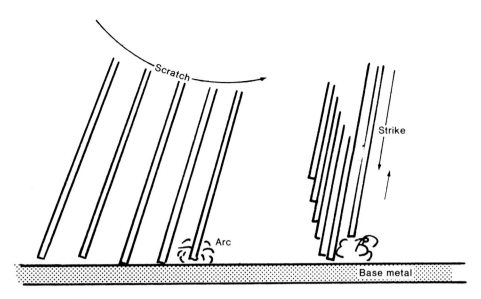

Figure 7-74

Operating the Arc Welder

Set up the arc welder by connecting the power cable to the appropriate recepticle, plugging the electrode cable into the proper sockets, connecting the ground clamp to the work and hanging the electrode holder on an insulated hanger. The electrode holder and electrode must not be in contact with any metal object when the welder is turned on. The least that might happen if the electrode becomes shorted is uncontrollable arcing. The worse might be a badly shocked operator, a fire, or a damaged welder.

Next the amperage should be adjusted to match the metal and the electrode and the proper electrode inserted in the electrode holder. When the welder is prepared the operator should put on a welding apron, welding hat, a welding helmet with a dark green lens, and a pair of welding gloves. If the welding is to take place above the operator, leather shoulder protectors should also be worn.

The power switch on the welder can now be turned on in order to strike an arc. Starting an arc will require a little practice before it can be accomplished perfectly. To start an arc, the rod, which is installed in the electrode is quickly scratched along the grounded metal to be welded, then lifted a fraction of an inch once an arc is formed (figure 7-74). If the arc stops, the action is repeated, but the rod is not lifted as high as during the previous attempt. If the rod is dragged too slowly, it will arc and stick to the work, at which time the holder and rod should be instantly twisted and bent as to break the weak weld. If the rod does not break loose, the rod should be released from the electrode holder by squeezing the handle of the electrode holder. If the rod is not re-

leased and the machine continues to run fully shorted, it may be damaged. Once proficiency is gained at scratching the arc, the operator will find that striking the arc will be easier to control and give greater accuracy of the placement of the rod. To strike an arc the rod tip is placed slightly above the line of the weld and bounced off (straight down) of the metal with a quick snap. The rod should be bounced back about 1/32" (.79375 mm) to maintain the arc. If the rod is bounced too high the arc will go out; if it is allowed to rest it will freeze to the metal. A little practice will permit the welder to poise the rod over the weld area, drop his helmet and then strike the rod forming an arc directly on the weld area. Scratching an arc, although a little easier, leaves burn lines outside of the weld area and causes the welder to hunt for the weld line with the arcing rod.

Maintenance of the arc requires accurate positioning of the rod. The rod should be spaced its diameter above the crater, and angled slightly away from the bead. There are some electrodes called drag rods designed to be in constant contact with the metal. Drag rods are not lifted from the metal to form an arc gap; the rod coating controls the gap. The expert welder can tell the proper arc length by the sound of the arc. A proper arc will produce a constant sharp snapping sound. Too short an arc will produce a frying sound and will produce a bead which rests on top of the metal. Too long an arc will produce an intermittant explosive flame like spattering arc which will leave a burned weak weld. Oxygen and nitrogen are able to penetrate the extended and erratic envelope of shielding gas around an extended arc.

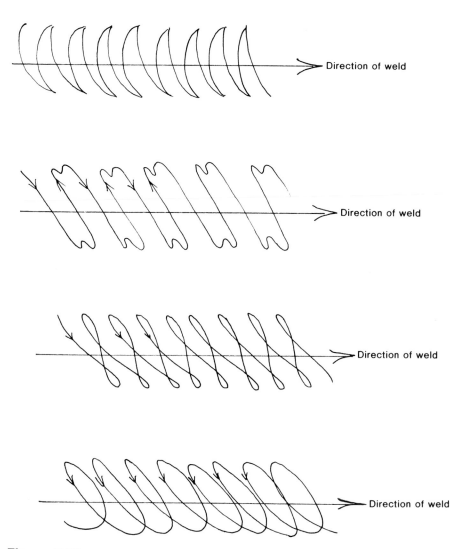

Direction of weld

Direction of weld

Direction of weld

Direction of weld

Figure 7-75

To run a bead (weld along a line) the arc is passed back and forth across the joint gap in a sewing motion (figure 7-75), slowly enough that the arc melts the base metal, penetrating to form a crater, and forms a puddle of molten material that will seem to follow the rod. The width of the bead should not exceed two and a half times the diameter of the welding rod. If thick metal is being welded to thin metal, the arc should be moved across the thin sheet at a faster rate than it is across the thick sheet to avoid blowing holes in the thin sheet. If necessary multiple passes may be used to build up the desired width or thickness of weld. Before a second pass is made along a bead, all of the slag should be removed from the weld area. Many types of electrodes will deposit a thick glass-like coating over the bead which can be removed by striking the slag along the edge with a sliding stroke of a chipping hammer. The hammer should be moved as if to slide under the edge of the slag forcing it up and off. Do not strike the slag on the top as it will

most likely fragment, leaving a lot of residue on the bead. Remaining material can be brushed away with a stiff wire brush. Eye protection must be worn during this cleaning as the slag is razor sharp and has an affinity for eyes.

Arc Welder Safety Rules
1. Do not pick up hot objects. Assume that every metal object around the welder is hot.
2. Do not overload the machine or the cables. Do not use worn or cut cable with poor connections or with defective clamps, plugs or holders.
3. Do not use an electrode holder with exposed metal which can be electrically charged. Screw heads should not be exposed.
4. Never touch the electrode holders of two different machines at the same time.
5. Do not operate polarity or range switches (or plugs) while the machine is under load (while it is arcing).

Figure 7-76. Rolled and welded 14 gauge mild steel, bell with arc welded decorative texture.

6. Do not work on the machine wiring, controls, etc., without disconnecting the welder from the main circuit.

7. Do not make body contact with electrically charged parts of the system. Non-insulated parts of cables, connectors, clamps, etc., can supply from 28 volts to 440 volts.

8. Never work in damp areas or while wearing wet clothing.

9. Do not leave the electrode in contact with a metal table top or any grounded surface while it is not in use.

10. Use proper face and eye protection. Do not use cracked masks or lenses, or lenses designed for gas welding.

11. Do not look at the arc, not even out of the corner of the eye without adequate eye protection.

12. Do not strike an arc without checking the area to be certain that it is free of bystanders without safety equipment.

13. Use welding screens where necessary, to prevent injury by bystanders.

14. Always wear non-flammable clothing, heavy shoes laced tightly at the top, and a covering for the hair. Avoid permanent press and nylon clothing because of the difficulty of putting out their fire. Nylon will tend to stick to the skin while it burns and is nearly impossible to remove while it is flaming. Clothing should be dry, heavy, and dark to prevent the reflection of and passage of radiation and electrical currents. Do not wear cotton while gas shield arc welding. Wear leather or asbestos gloves with long cuffs.

15. When welding vertically or overhead wear leather sleevelets and aprons, and earplugs.

16. Wear goggles when grinding or chipping beads.

17. Do not weld on containers which may have contained flammables or which may have contained toxic fumes. See the recommendations of the American Welding Society Pamphlet A6.0 "Welding or Cutting Containers Which Have Contained Combustibles."

18. Do not weld on containers or hollow castings which do not have vents.

19. Never weld near flammables or in an explosive atmosphere. Combustibles must be at least 35′ (10.668 m) away from the arc or otherwise suitably protected.

20. Do not weld in the presence of solvent vapors, not even minimal amounts. Ultraviolet light from the arc can decompose the vapors of such solvents as trichlorethylene, or perchloroethylene to form phosgene, a deadly poisonous gas.

21. Never weld without adequate ventilation. Many electrode coatings are toxic.

22. Follow proper safety rules when using a gasoline driven welder indoors.

23. Never weld alone. Many welders have set fire to their clothes or hair without knowing of the problem until it became serious.

24. Do not leave the welding area for thirty minutes after welding to make sure that there are no smoldering fires.

25. Clothing can be made flame resistant by soaking them in a solution of 3/4 pound (340.2 g.) of sodium stannate in one gallon (3.785 l.) of water, wringing them out and then dipping them in a solution of 1/4 pound (113.4 g.) of ammonium sulphate per gallon (3.785 l.) of water. These clothes should be dry cleaned to preserve the flame resistance.

Joint	Thickness of metal in inches	Diameter of electrode in inches	Amps	Cup diameter in inches	Gas flow Cu. Ft. per Hr.	Number of passes
Butt	0.020	0.040	17-25	1/4	15-20	1
"	0.040	0.040	25-50	1/4	15-20	1
"	1/16	1/16	60-90	1/4	15-20	1
"	1/8	3/32-1/8	110-145	3/8-7/16	20-25	1
"	3/16	1/8	160-220	7/16	20-25	2
Edge	0.020	0.40	13-25	1/4	15-20	1
"	0.040	0.40	17-45	1/4	15-20	1
"	1/16	1/16	50-70	1/4	15-20	1
"	1/8	3/32	100-120	3/8	20-25	1
"	3/16	1/8	150-170	7/16	25-30	1
Lap	0.020	0.040	17-25	1/4	15-20	1
"	0.040	0.40	25-45	1/4	15-20	1
"	1/16	1/16	55-90	1/4	15-20	1
"	1/8	3/32-1/8	120-160	3/8-7/16	20-25	1
Corner	0.020	0.040	17-25	1/4	15-20	1
"	0.040	0.040	25-45	1/4	15-20	1
"	1/16	1/16	60-90	1/4	15-20	1
"	1/8	3/32-1/8	110-140	3/8	20-25	1
"	3/16	1/8	160-220	7/16	25-30	1
Fillet	0.020	0.040	17-25	1/4	15-20	1
"	0.040	0.040	25-50	1/4	15-20	1
"	1/16	1/16	70-90	1/4	15-20	1
"	1/8	3/32-1/8	110-160	3/8-7/16	20-25	1
"	3/16	1/8-5/32	190-245	7/16-1/2	25-30	1

Figure 7-77. Typical Tungsten Inert Gas welding settings.

Tungsten Inert Gas (TIG) Welding

The TIG welder is only an expensive, sophisticated arc welder. Instead of using a consumable coated electrode to carry the welding current and form the arc, it uses a tungsten rod, which is not supposed to burn away, connected to the electrode cable. Some inexpensive "add on" TIG equipment actually uses the electrode holder to hold the TIG head. These little sets consist of a torch handle, a gas cup, a tungsten electrode, a high frequency box, a cable to carry high frequency current and a tube to carry the inert gas (figure 7-78). These minimum machines will weld only very lightweight metal and only very short beads, but they will allow the welding of thin non-ferrous metals which are difficult to weld with simpler welders. These welders are a problem because they cause terrific radio and television interference unless elaborate precautions are taken to shield the system.

The larger industrial TIG welders use water cooled torches and have controls for gas flow and arc current built into the torch handle. For general use the gas supplied to the torch cap is 99.99% pure argon and the electrodes used should be 2% thoriated tungsten electrodes of varying diameters. Lightweight equipment will commonly use .040″ (635 mm) 1/16″ (1.5875 mm), 3/32″ (2.38125 mm), 1/8″ (3.175 mm), 5/32″ (3.96875 mm) and 3/16″ (4.7625 mm) diameter electrodes(figure 7-77).

All TIG welders have a device which produces high frequency electricity which arcs easily and eliminates the necessity of striking the rod to start the arc.

The metal which is to be welded with the TIG must be clean of paint, rust, grease and other foreign matter. Trash can be removed by filing, chiseling, wire brushing, solvent cleaning (before the joint is assembled), but grinding should not be used. Solvents, grease, paint, etc., can interfere with the flow of the molten metal along the bead, and contaminate the shielding gas, resulting in porosity, rough welds, undercutting and other weld faults.

To weld with the TIG, the operator must first make the proper adjustments to the gas flow valve adjustment, adjust the amperage, and place the proper electrode and cup on the torch hand. The electrode is then positioned above the weld area. The electrode must not contact the metal or the electrode may be damaged. Turn on the welder and an arc will start immediately. The usual sewing pattern is employed to melt

Figure 7-78

Figure 7-79

a puddle to form the bead. Filler rods may be used to add metal to the bead.

TIG welding is considerably easier than consumable electrode welding, because the arc is easier to maintain. The gas shield is much more stable (less burnt metal), and less skill is required to control the moving electrode.

Metal Inert Gas (MIG or Wire Welder) Welding

The MIG or wire welder is another expensive and sophisticated arc welder (figure 7-79). It uses a consumable electrode like the less expensive welders but the wire is uncoated and comes as a spool of continuous wire. The MIG is similar to the TIG in that high frequency is used to start and maintain the arc and that a stream of inert gas passes through the torch handle to protect the melt. The reel of wire is positioned near or inside of the MIG welder and is fed through a tube and through the torch handle, along with the inert gas.

Welding with a MIG is a real pleasure once the wire speed and current is propertly adjusted. Until the proper adjustment is achieved, welding with the MIG can be a monumental pain. If the wire feed is too fast the torch is kicked away from the work while the wire is spastically burning and scarring the metal. If the feed is too slow the arc may work back and weld the wire to the inside of the tip, ruining the tip and perhaps kinking and jamming the wire in the feed mechanism. Problems with steel wire are not as common as with aluminium which is difficult because it is so soft. If the adjustments are correct the wire will feed into the puddle of the bead leaving an absolutely bright, clean, well formed bead.

The MIG has one tremendous drawback for the sculptor, that is the cost of stocking wire for the machine. Each kind of metal requires a different wire, and the spools are large and expensive. They are also supplied in various diameters so that stocking one diameter wire may not be sufficient. In addition, each diameter wire requires different feed tube liners and feeder tip. This is no problem in industry, but few sculptors can afford to purchase several different kinds of wire at twenty-five pounds a roll for a half a dozen short welds.

Electric Heat Cutting

Cutting electrodes can be obtained to cut many kinds of metal including some non-ferrous and cast iron which is both difficult and expensive to cut with oxygen acetylene torches. The cutting rods are simply placed in the holder, the work grounded, the proper amperage supplied, and the welder turned on. The rod is struck against the area of the cut (kerf). The rod cuts primarily by melting the metal, but some cut-

ting electrodes are constructed so as to produce a "blowing" action, thereby throwing the metal out of the kerf. The tip of the rod should be pushed and sawed in the kerf, deepening the cut as desired. Cutting rods can also be used to gouge or bevel cut (chamfer) solid blocks of metal.

Typical cutting and gouging rod
Suitable for all metals

Rod Diameter Inches	Amperage
1/8	120-250
5/32	200-350
3/16	300-450

Either AC or DC— can be used to cut. For gouging point the electrode in the direction of travel with an angle of less than 30° and push the electrode into the metal. Deeper gouges are created in a "weaving" fashion.

For cutting point the electrode in the direction of travel with an angle of 45° and saw the tip using a push pull motion.

For piercing hold the rod vertically and use a push pull motion to drive the rod through the metal.

It is possible to use the TIG and MIG for cutting but the cost of operating these machines for cutting purposes is exhorbitant.

Electric Spot Welding

Electric spot welding, as a system of joining metal, is of limited but valuable use to the sculptor. The primary use of the spot welder is to join like ferrous metals at particular points, or along a continuous path of points. The technique does not offer the potential of modifying surfaces, of joining unlikes (rods to the center of flat sheets), or of building across open spaces (as is possible with gas welding), but warping from excessive heat and scar-like beads (both common to gas welding) are almost completely eliminated. In addition to these advantages, no skill is required to operate most spot welders (figure 7-80); they are almost completely automatic. The metal to be welded is placed between the jaws of the welder (figure 7-81), and the machine is then activated, in this case by depressing the handle. A proper weld (figure 7-82) will be small and circular, about the size and shape of the jaws, and will be stronger than the surrounding metal.

Figure 7-80

Figure 7-81

Figure 7-82

Gas Welding

Gas welding, a method of creating heat for a weld by burning gas, primarily oxygen and acetylene, is used by the artist in ways which would be considered strange and unprofessional, if not unsafe, by the mechanic or technician. Frequently, the artist uses the torch to build masses of metal, layers thick, only to cut into the layers with a cutting torch, or to braze a thin layer of brass over the surface of sheet iron,

Figure 7-83

Figure 7-84

for the sole purpose of creating color or texture (at the expense of the strength of the iron sheet). The artist is not always concerned with achieving strength in his welding, so it is permissible for him to deliberately burn crusts of scale on the surface of the metal, if that particular visual effect is desired, even though burning the metal in this way might weaken the structure of the metal.

The primary seams used by the artist for gas welding are the overlapping weld (figure 7-83A), the butt weld (figure 7-83B), and the "T" weld (figure 7-83C). Only similar metals may be welded with these seams. The technique of welding either seam is similar, except for the positioning of the metal during the weld.

Compressed Gas Cylinder Safety
1. Avoid electrical contact or application of heat to a cylinder.
2. Do not subject the cylinder to impact of any kind.
3. Properly identify the content of the cylinder (do not depend on labels).
4. Do not use the contents for other than its intended purpose.
5. Do not get grease or oil on oxygen cylinders, valves, regulators, etc.
6. Do not transport or lift cylinders with straps, slings, or magnets.
7. Do not lift the cylinders by the caps or valves.
8. Do not transport the cylinders without the caps in place.
9. Do not alter or mix gases in a cylinder.
10. Do not try to refill a cylinder.
11. Do not tamper with markings or number stamped on a cylinder.
12. Do not hammer on stuck valves or their handles. If the valve cannot be opened by hand return it to the supplier.
13. Keep valves closed on empty cylinders.
14. Chain or fasten cylinders in an upright position at all times.
15. Do not store cylinders in an unventilated area.

Tools Required
a. Acetylene cylinder (figure 7-84). The actylene cylinder is a low pressure tank. Acetylene gas cannot be compressed at high pressure because it becomes unstable so the gas is absorbed by a sponge-like liquid such as acetone, which allows the pressure to remain low and keeps the gas stable. As

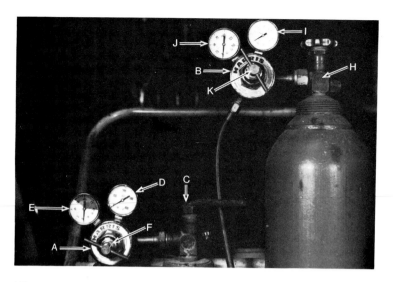

Figure 7-85

much as three hundred cubic feet of acetylene can be dissolved in a *standard* tank at 250 psi at 70° F. The pressure reading on the acetylene pressure gauge is not an accurate indicator of the total volume of gas remaining in the cylinder. To determine the contents of the cylinder, it must be weighed. Each pound over empty weight is equal to 14½ cu. ft. of gas. Acetylene is *dangerous,* as it is explosive and anesthetic, but its presence can be easily detected by an odor which has been added to the gas by the manufacturer.

b. Oxygen cylinder (figure 7-84B). Oxygen is bottled in high pressure tanks and is usually obtained charged from 1,800–3,000 p/si of pressure. The oxygen cylinder pressure gauge will accurately indicate the contents of the tank. The gas is not normally harmful, but large quantities of pure oxygen should not be breathed. Oxygen does not burn, but it can cause some materials, like grease or oil, to burst into flame or explode; therefore, *do not get grease or oil on the tanks, torches, valves, or gauges.* Oxygen tanks can also explode if subjected to shock or excessive heat. Never use gas tanks unless they are fastened firmly in an upright position.

c. Torch (figure 7-86). The torch consists of a welding tip (figure 7-88B), mixing handle (figure 7-88B), and gas valves (figures 7-86C, and 7-86D). The cutting torch consists of the cutting tip (figure 7-87A), cutting attachment (figure 7-87B), mixing handle (figure 7-87C), cutting oxygen valve (figure 7-87D), and the oxygen valve (figure 7-87E).

d. Oxygen and acetylene regulators (figures 7-85B). Each regulator consists of two pressure gauges and a pressure valve (figures 7-85E, 7-85D, 7-85J, 7-85I; and 7-85C and H). There are two hoses, one for each regulator. The green hose carries oxygen and the red carries the acetylene.

e. Flint or spark lighter (figure 7-88E)

f. Dark goggles (figure 7-88H)

g. Wrenches (figure 7-88I)

h. Gloves

i. Tongs (figure 4-77A)

j. Wire brush (figure 7-88A)

k. Tip cleaners (figure 7-88F)

l. Pliers (figures 7-88B, 7-88C, and 7-88D)

m. Fluxes (figure 7-88G)

n. Power grinder (figures 8-38A, 8-38E, 8-38G and 8-38H).

Installation of Regulators on Cylinders

1. Open the cylinder valve momentarily to clean the valve seat (figures 7-85C and 7-85H).

2. Turn the regulator valves off (counterclockwise) (figures 7-85F and 7-85K).

3. Attach the regulator to the proper cylinder. The oxygen cylinder has a right-hand thread (clockwise) female thread; the acetylene cylinder has a left-hand (counter-clockwise) male thread.

4. Attach the greeen hose to the oxygen outlet on the oxygen regulator (right-hand thread) (figure 7-85L).

5. Attach the red hose to the acetylene outlet on the acetylene regulator (left-hand thread) (figure 7-85G).

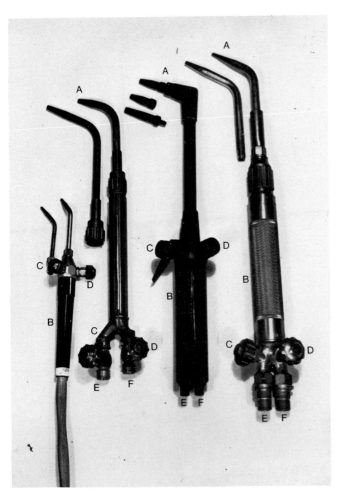

Figure 7-86

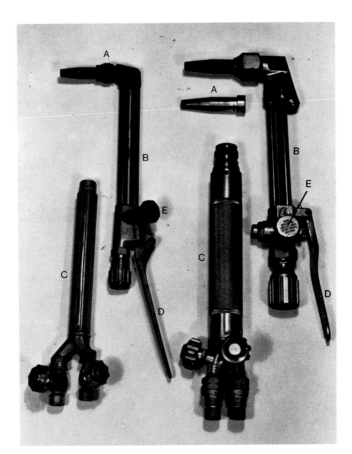

Figure 7-87

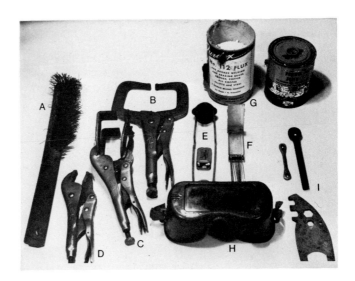

Figure 7-88

6. Close the cylinder valves, then shut off the regulator valves.
7. Attach the hoses to the proper inlets on the mixing handle (figures 7-86E and 7-86F) of the torch. The oxygen inlet has a right-hand thread, the acetylene inlet has a left-hand thread.
8. Install the welding tip (figure 7-86A).

CAUTION! Do not stand directly in front of or behind the gauges when opening the cylinder valves.

Operation

Each brand of welding equipment has its own operating requirements, so manufacturer's operating instructions should be consulted before the equipment is assembled or used. In general, equipment will be operated as indicated in the following paragraphs.

To Light the Torch

1. Select and install the proper tip for the thickness and kind of metal to be welded (figure 7-86).
2. Check the manufacturer's pressure chart for the proper pressures for the thickness and kind of metal to be welded.

3. Adjust the oxygen pressure:
 a. Open the oxygen tank valve all the way (figure 7-85H).
 b. Open the torch oxygen valve one-half turn (figure 7-86D).

c. Open the oxygen regulator valve (figure 7-85K) until the proper reading appears on the delivery gauge (figure 7-85J).

d. Close the torch oxygen valve.

4. Adjust the acetylene pressure:

a. Open the acetylene tank valve three quarter of a turn (figure 7-85C).

b. Open the torch acetylene valve one-half turn (figure 7-86C).

c. Open the acetylene regulator valve (figure 7-85F) until the proper reading appears on the delivery gauge (figure 7-85E).

d. Close the torch acetylene valve.

5. Light the torch:

a. Put on dark goggles.

b. Open the torch acetylene valve one-half turn.

c. Spark the lighter at the end of the welding tip to ignite the gas (figure 7-90).

d. Open the torch acetylene valve further, until the flame is strong enough that there is no soot floating away from the flame—the flame should remain in contact with the tip, however.

e. Slowly open the torch oxygen valve until the proper flame is achieved (see Step 6).

f. If the flame jumps away from the tip, either the pressure is too high at the regulator, the torch valves are open too far, or the welding tip is dirty and needs to be cleaned.

6. The flame. Four kinds of flame are possible with a welding torch.

a. The acetylene flame is smoky yellow and of little use except for depositing a layer of soot (figure 7-91).

b. The reducing flame has too little oxygen and is used to avoid burning a crust on the molten metal. There are three distinct areas visible in the flame (figure 7-92):

(1) Brilliant white inner cone;

(2) Glare-white "feather";

(3) Violet or pale blue transparent outer cone.

c. The neutral flame is the flame considered proper for most welding. Oxygen is added to the flame until the glare-white feather of the reducing flame just disappears (figure 7-93).

d. The oxidizing flame contains an excess of oxygen. The glare-white feather disappears, and the inner cone becomes pale. This flame will burn scale into the molten metal (figure 7-94).

7. Turn off the torch:

a. Turn off the torch acetylene valve;

b. Turn off the torch oxygen valve.

8. Drain the gauges before putting the equipment away. Do not leave gas in the lines for extended periods of time.

a. Close both cylinder valves.

Figure 7-89. Self-contained soldering and welding torches.

Figure 7-90

b. Open the torch oxygen valve to drain the oxygen hose, regulator, and gauge. The indicated pressure at the gauges should drop to zero.

c. Close the oxygen regulator valve, and remove the key.

d. Close the torch oxygen valve.

e. Open the torch acetylene valve, and drain the lines, gauges, and regulator. The indicated pressure on both gauges should drop to zero.

f. Close the acetylene regulator valve, and remove the key.

g. Close the acetylene torch valve.

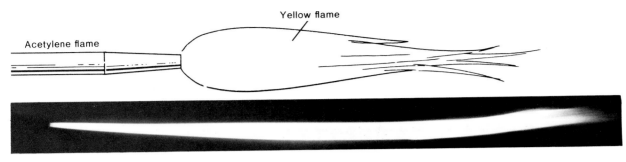

Figure 7-91

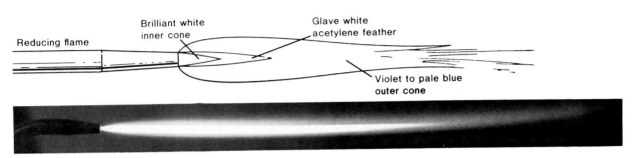

Figure 7-92

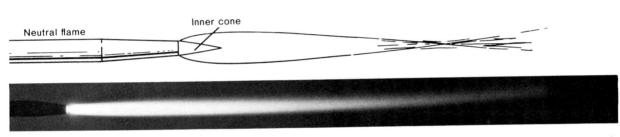

Figure 7-93

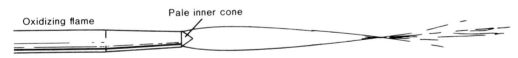

Figure 7-94

If the pressure gauge on either bank begins to climb, that tank valve is not closed tight, and the valve should be tightened and the draining process repeated for that particular tank, to prevent damage to the regulator and to eliminate a potential safety hazard.

Welding a Seam
1. Clean the areas to be welded.
2. Place and clamp the metal, if necessary, into position. For a butt weld, join the sheets along their edges, but do not place them tightly together to start the weld. Leave a 1/16″ (1.588 mm) gap at the start of the weld and a 3/16″ (4.763 mm) gap for each foot at the end of the weld, in order to prevent buckling. Overlapping seams simply have the sheets overlapping between 5 and 10 times the thickness of an individual sheet.

3. Light the torch (page 200).
4. Tack weld the corners by heating the metal at the start of the weld until the metal of the pieces flow together. The torch should be held with the white cone about 1/16″ (1.588 mm) from the metal, at a 30° angle pointing towards the weld line, and moved in a small horizontal or vertical circle, depending on the thickness of the metal. The circular motion will aid the flow of the metal.
5. Start the weld by heating the seam at the flame end of the seam (figure 7-95) until a puddle of molten metal is formed, then add welding rod to the puddle to be melted to act as a filler. Melt the rod with the puddle, not with the torch. The weld should progress in the direction of the flame like

a continuous tack weld (Step 4), with the addition of the welding rod as a filler (figure 7-96). Thin metal should be welded with a vertical circular motion of the torch, to prevent burning holes in the seam; thick metals should be welded with a horizontal circle, so that both sides of the weld get enough heat to melt the metal.

Some metals, unlike soft iron, require special handling. Stainless steel should be welded with an acetylene feather about 1/16″ (1.588 mm) larger than the inner cone (reduction flame). The flame should be held at an 80° angle, with the tip of the inner cone 1/16″ (1.588 mm) from the work. Stir the puddle as little as possible. Cast iron welding should not be attempted by an amateur welder; it requires special fluxes, slow movement, and pre-heating and slow cooling to prevent damage to the cast. If a cast must be welded by oxyacetylene the object to be welded should be blocked into proper position and a slow fire built around the entire cast, bringing the metal up to a high even temperature. It should then be wrapped in asbestos paper and a hole torn in the paper through which the weld is made. The welding process is normal except that cast iron flux and cast iron rods are used instead of steel. The cast rod will flow easily into the joint. Once the weld is complete the asbestos paper should be closed and the cast covered with hot ashes to cool slowly. Chilling the cast will probably crack it.

Some aluminum alloys can be welded with an acetylene torch if special aluminum welding rod and aluminum flux are used, and if the torch is adjusted for stainless steel. The metal should be pre-heated over a charcoal fire or a low gas flame until it is hot enough to cause a pine stick to smoulder when the stick is rubbed over the metal. The pieces to be welded must not touch each other or the puddle will collapse. The puddle must be kept small by flicking the flame up off of the puddle when necessary. Avoid the fumes of this weld.

If the torch backfires or "pops" in the mixing handle the torch should be shut off. Backfire is caused by incorrect gas pressure, loose tip, dirty tip seat, or splatter stuck in the orifice of the tip. The most common cause of backfire is caused by the operator touching the hot puddle of metal with the tip causing pre-ignition. The torch should not be put back into operation until the problem has been corrected. Another problem encountred by the welder is flashback. Flashback can be identified by a squeal, or shrill hiss inside of the mixing handle. The torch should be shut off immediately by closing the torch oxygen valve, then closing the torch acetylene valve. Wait several minutes for the torch to cool, then re-light. If flashback re-occurs, the unit must be returned for repair.

Figure 7-95

Figure 7-96

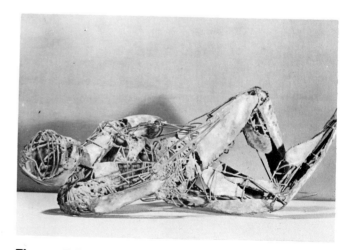

Figure 7-97

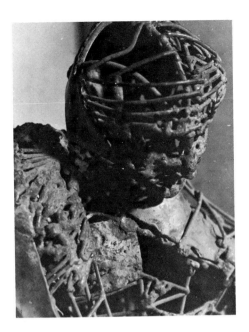

Figure 7-98

Figure 7-99

Brazing (Silver Soldering, Silver Brazing)

There is a wide variety of brazing alloys that are used at high temperatures, but lower than the melting point of the metal to be brazed. The alloys are manufactured for various purposes and strength and can be obtained in different colors suitable for the same joint. Manufacturers' catalogues will clearly identify the alloys and the appropriate fluxes to be used with them (figure 7-100). Almost all brazing alloys require fluxes as an aid to brazing. The fluxes are usually a powder, paste or liquid; however some types of brazing rod which is used for production work have a flux coating on the rod which simplifies application of the flux.

The purpose of the flux is to remove any residue that remains after mechanical cleaning of the joint area. Braze joints, unlike welded joints must be fitted very accurately because the melted alloy is drawn into the joint by capillary action. A gap of any size will not permit the drawing of the metal to the heat by capillary action. Although most brazing alloys will not build up (fillet) around the joint, there are a few types of brazing alloy which can be used where good fit-ups are impossible or where build up is desirable. Filleting and filling a joint is for cosmetic purposes only because poorly fitted joints will be weak.

Brazing

1. Mechanically clean the area with sand paper, grinding, etc.
2. Position and clamp the work. Do not place clamps near the joint or the clamps will act like heat sinks and draw heat away from the braze area.
3. Paint the appropriate flux on the area to be brazed and dip a heated brazing rod into the flux to coat the end of the rod. Do not get flux on areas where solder or braze is not wanted. Do not dip silver solder in the flux because the flux will often act like an insulator and prevent the silver solder from melting until the base meal has become overheated.
4. Using a fuel rich flame heat the metal around the flux. Do not place the flame on the flux or it will scorch and be ruined. Continue working the flame around the joint area outside the area of flux until the flux boils, dries into a powder, then finally turns glassy.
5. When the flux turns glassy the metal should be slightly red with heat. Quickly apply solder or braze to the joint on the side opposite the source of heat. The braze or silver braze should quickly melt into the joint and run towards the heat stopping only at a gap or at the edge of the fluxed area.
6. Remove the heat at the instant of the melt and permit the joint to cool. Continued heating may burn the alloy making it brittle. If the braze joint is a long one, continue moving the flame along the joint drawing the melted brazing alloy along with the flame.
7. If succeeding braze joints endanger existing joints, heat sinks (clamps or wet wads of paper) can be used to prevent melting of existing joints. If brazing alloys and silver solders of varying working temperatures are available, the alloy with the highest working temperature should be used in order from the highest to the lowest.

ALL-STATE BRAZING & SOLDERING ALLOYS FOR THE SERVICE TRADES

CATEGORY OF FILLER METAL	ALL-STATE PRODUCT	DESCRIPTION	WORKING TEMP.	TENSILE STRENGTH	FLUX
SILVER BRAZING ALLOYS	No. 101	Contains 45% silver — Joins wide variety of metals with great strength. (Order in 1/16" x 18" rods; 8-oz., 1-lb. and 2-lb. coils; Silver Dispenser Units; special packaging called Siltube.	1125°F to 1145°F	To 52,000	No. 110 S-200 or S-300
	No. 101 FC *TRUCOTE	Same alloy, but with extruded coating. (Order in 4-oz. tubes, containing 1/16" x 18" rods.)			None
	No. 155	Cadmium Free silver brazing alloy used to braze objects from stainless steel food handling equipment to hot water systems. (Order in 1/16" x 18" rods; 8-oz., 1-lb. and 2-lb. coils.)	1150°F to 1200°F	To 50,000	No. 110 or S-200
	No. 155 FC *TRUCOTE	Same alloy, but with extruded coating. (Order 1/16" x 18" in 4-oz. plastic tubes.)			None
	No. 111 Coils Right-'N-Ready Pack	Contains 41% silver, plus toughening elements for ideal repair work—Lowest melting silver brazing alloy.	1110°F to 1150°F	To 50,000	No. 110 or S-200
	No. 155 Coils Right-'N-Ready Pack	Cadmium-free low temperature silver brazing alloy.	1150°F to 1200°F	To 50,000	No. 110 or S-200
COPPER-SILVER-PHOSPHORUS BRAZING ALLOYS	*SILFLO "5"	A 5% silver alloy for copper to copper joining where close fit-up cannot be maintained. (Order in .050" x 1/8" x 18", or .050" x 1/16" x 18" rods).	1300°F to 1500°F		None (†)
COPPER-SILVER-PHOSPHORUS BRAZING ALLOYS	*SILFLO "15"	A 15% silver alloy for copper to copper where joint ductility is vital. (Order in .050" x 1/8" x 18", or .050" x 1/16" x 18" rods).	1300°F to 1500°F		None (†)
COPPER-PHOSPHORUS BRAZING ALLOYS	*SILFLO "0"	Self fluxing alloy for copper to copper non-moving joints. (Order in 3/32" x 36", or 1/8" x 36" rods; or in *Phostubes, containing 4 oz. of rods in 18" lengths).	1350°F to 1550°F		None (†)
ALUMINUM BRAZING ALLOY	No. 31	For brazing light gauge aluminum sheet and tubing. (Order in 3/32" x 18", or 1/8" x 18" rods).	1075°F	To 30,000	No. 31
SOLDERS	No. 430	Unique, high strength solder for joining all metals except white metals; color matches stainless, and adheres to chrome plate. Cadmium Free. (Order in 1-lb. spools, 1/16" dia. and up, or in *Dynagrip Solder Kits, containing No. 430 Solder and *Duzall Flux).	430°F	To 15,000	*Duzall
	No. 430 Silver Bearing Paste Solder	Minutely pulverized silver-tin alloy suspended in an active flux to form a paste for application on all ferrous and non-ferrous metals (except white metals).	430°F	To 15,000	None
	*STRONGSET No. 509	For joining aluminum to aluminum or aluminum to dissimilar metals; "takes" to anodized aluminum without removing the anodizing. Yields unbelievable physical properties for a solder-range alloy. (Order in 1-lb. spools, 1/16" or 1/8" dia., or in *Strongset Solder Kits, containing No. 509 Solder and No. 509 Flux).	509°F	To 29,100	No. 509
	Paste Solder	Paint-on solder—Quick and easy to use—For plumbing applications, tubing, tinning, etc.—Water soluble. (Order in 1-lb. plastic jars).	375°F	To 6,500 Pressure	None

° Reg. U.S. Pat. Off.
†Use All-State No. S-200 Flux on copper to brass or bronze alloys.

Figure 7-100. All-state brazing and soldering alloys for the service trades.

Oxyacetylene Cutting

Many alloys of iron can be cut by applying a stream of oxygen to a red hot area of metal. Mild steel is probably the alloy most often cut as other alloys are not as common or are difficult to cut with a torch. Some alloys can be "cut" by heating the metal to the melting point and then blowing the molten metal away with a blast of oxygen or compressed air.

Stainless steel can be cut by laying mild steel rod into the kerf to dilute the chrome and nickel alloy.

Cast iron should be avoided because it requires excessive amounts of oxygen and special cutting tips. Non-ferrous metals, like copper and brass, can be separated by running a line of a paste made of iron cement (used in the repair of iron furnaces) and water, 1" wide along each side of the desired cut line. The metal is then heated with a torch until it is fluid, and the molten metal blown away with a blast of oxygen from the torch.

Figure 7-101

Figure 7-102

To Adjust the Torch for Cutting

1. Refer to the manufacturer's pressure chart for proper tip and tank delivery pressure for the kind of metal and the thickness to be cut. Adjust the delivery regulator to deliver the proper pressure (page 200).
2. Remove the welding attachment from the mixing handle, if there is one, and attach the cutting attachment to the mixing handle (figure 7-87B). Attach the cutting tip (figure 7-87A). The cutting tip has at least five holes in the end (figure 7-101A), unlike the welding tip, which has only one hole (figure 7-101B).
3. If the cutting attachment has an oxygen adjustment valve, open the torch oxygen valve all of the way, and make the necessary oxygen adjustments with the cutting attachment oxygen valve (figure 7-87B).

4. The cutting torch is lighted in the same way as the welding torch (page 200), except that the final adjustment is made with the oxygen cutting valve (figure 7-87D) held open.

To Cut

1. Light the cutting torch.
2. Start heating the metal to be cut, on a line of cut, at the edge of the metal, if possible. The flame should be angled slightly towards the line of cut to preheat the cutting area.
3. When the metal is cherry red, slowly press the oxygen cutting valve all the way open (figure 7-102).
4. As the metal burns away, slowly move the flame along the line of cut so that new metal is continually being preheated for cutting. If the kerf closes behind the flame, the cutting action is too slow, or the tip is too far from the metal. If the cut is not all the way through the metal, or if the melting action stops, the motion is too fast, or the flame needs to be angled ahead in order to preheat the metal at a faster rate.

Finishing Fabricated Metal

There are two basic ideologies concerning the finishing of any material. The purist would leave the material "be itself." Welded steel may retain its monotonous scaly bead line and metallic surface then turn a lush rich rust red before it eventually becomes a rust out.

Others would grind, polish, plate, paint or otherwise treat the surface of the metal for appearance or protection. The rationale for surface manipulation and decoration in recent art forms seems to be that the medium is only a vehicle for the concept of the artist and may only support the effect that the artist desires.

If metal sculpture is to be finished it should first be cleaned of any residue of the forming process which may cause it to corrode. Welds should be brushed to remove scale, brazing fluxes washed away and so on.

Welded steel can be ground free of its scale if it is hot rolled to the same bright color as cold rolled, and then sprayed with one of the new clear enamels that are used to paint truck bodies and aircraft. If the surface of the metal is clean, grease, and rust free, a heavy unbroken coat of an industrial clear enamel will keep the metal bright and rust free for over ten years except in the salty atmospheres of the coastal regions.

If bead lines are to be retained on the sculpture for aesthetic reasons (figures 7-103, 7-104, and 7-105) and they cannot be cleaned by grinding or sanding,

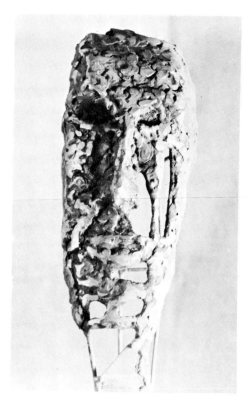

Figure 7-103

Figure 7-105

Figure 7-104

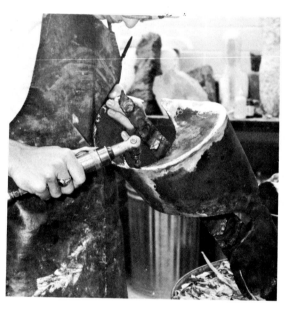

Figure 7-106

they can be sand blasted (page 265) with satisfactory results. If the metal is to be polished, all rough areas should be ground smooth (figure 7-106) then sanded with #220, 340, 400, and 600 wet or dry sandpaper in that order. The final two sandings should be performed with the random double action orbital sander to break up sanding patterns caused by the sanders, especially the disc sander. Once a random

pattern is obtained the metal is buffed with a high speed buffer using a wool bonnet and orange rubbing compound. The steel is then cleaned and polished with a clean wool bonnet and white polishing compound. The metal must be waxed, oiled, or painted to prevent instant rust. If the metal is to be painted it need not be sanded with #400 or #600 paper, but the #220 and the #340 paper should be used with the random DA Orbital sander.

After sanding, the dust must be removed and the surface washed down with a solvent cleaner (such as Prep-Sol). Do not use water. Most solvent type preparation cleaners have an etching quality to enhance the tooth of the metal which allows the primer sur-

facer to get a grip. Immediately before painting, a tack rag should be used to lightly wipe down the metal surfaces. Heavy pressure on the tack rag will leave a waxy residue which will reject paint.

A medium thin wet coat of primer should be sprayed over the surface. Heavy applications of primer (usually to cover poor surface preparation) should not be attempted. The primer will dry on top but will stay soft underneath. Thick primers often pinhole and occasionally cause problems because of crazing. After the primer is dry it should be wet hand sanded lightly with #400 wet or dry sandpaper, and then washed down with solvent. Most primers are slow in releasing solvents which will injure the top coat and may cause wrinkling of the finish due to the primer shrinkage. These problems can be avoided by delaying painting for about thirty days after the primer is applied.

There are literally dozens of paint systems available on the market. The most common are cellulose lacquers, enamels, acrylic lacquers, latexes, alkalyds, polyurethanes, polypropelene and the epoxies. Each kind of paint, in fact many brands of paint, is developed as a system. There may be sealers, primers, reducers, thinners, accelerators, hardeners, and top coats formulated to be compatable with each other but not necessarily with similar materials of other types or brands of paint.

Enamels, for instance, can usually be painted safely over lacquer primers or lacquer top coats, but lacquers over enamels, no matter how old, will cause the enamels to wrinkle and lift. Thinners for cellulose nitrates cannot be used with butyrate nitrates.

It is important that the artist consider the characteristics of a compatible system when choosing a finish. Enamels dry slowly and are subject to atmospheric dust contamination, but they are a one coat process with good leveling and covering. Lacquers are fast drying (not much dust), but with poor covering, requiring several coats with between coat sanding and final rub out. Unlike enamels, lacquers can be rubbed out if dust becomes a problem.

Epoxies and urethanes are difficult to apply, may be highly toxic, may require special mixing, and are super tough. They are limited in color availability. Some of the epoxies must be mixed an hour or so before they can be used and are temperature sensitive.

Most paint systms for finishing metal are spray paints and as they are purchased are too thick to be sprayed. They must be thinned (in the case of lacquers) or reduced (in the case of enamels), so that the paint will pass through the nozzle of the spray gun and atomize at the proper air pressure.

Brushing paint can be applied directly from the can but the paints are seldom used for fine work except for trim. Enamels which will brush well and level out

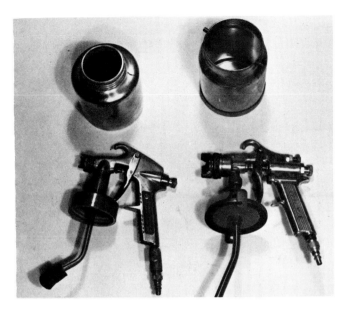

Figure 7-107

may take up to four hours to dry tack free and may take several days to harden.

Because weather has a great effect on spray paints manufacturers formulate thinners and reducers to compensate for variations in temperature and humidity. The diluting agent must allow the paint to flow over the surface and level out, while keeping the pigment suspended. The dilutant must evaporate quickly enough to prevent the paint from running or sagging. Dilutants for hot dry weather do not evaporate as quickly as the dilutants for cool humid weather. If the dilutant evaporates too quickly, the paint will thicken in the air between the spray gun and the surface of the metal and will result in a paint surface which will be pebbly or sandy (orange peel). Lacquers which are sprayed under hot humid conditions may pick up moisture from the air and "blush." Blush is a hazy dull mist where the surface should be bright and lustrous. Dilutants which evaporate too slowly will result in runs and sags while sprays which go on too dry (dilutants evaporate too quickly) will often produce a great amount of over spray—a fog of semi-dry particles of paint that do not melt in with the paint but will stick leaving a sandy surface.

Sealers used in paint systems are designed to seal old paint or surfaces that may release solvents or colors that will bleed through and ruin freshly applied top coats. Red and maroons for example are notorious for their ability to migrate through top coats. Accelerators and hardeners are used in two part paint systems which require chemical action to form complex molecular chains which produce the plastic which is the paint. In some cases (as in acrylic enamels) where hardeners are not required, they may be added to make the paint

Pattern Problems	
Pattern too small	clean dried paint from air cap openings material too lumpy needle adjustment set too small too little pressure
Poor pattern shape	material too heavy dirty air cap needle adjustment too large
Excessive spray mist	too much air pressure material too diluted material requires retarding
Will not spray	wrong air cap needle adjustment shut off material too heavy air pressure regulator improperly adjusted pick up tube blocked or not in material needle valve orfice blocked

Typical Spray Patterns		
Normal spray pattern		
Top or bottom heavy pattern	plugged air cap holes or material build up on air horns	
Heavy left or right hand pattern		
Heavy center pattern	too much material and too thick	
Split spray pattern	not enough material increase material flow or reduce air pressure	
Fluttering spray	not enough material in the canister blocked hose or passages leaking pick up tube loose fluid tip material too heavy	

Figure 7-108

much more durable, and increase the finishes resistance to chemical damage and wrinkling.

Paint to be sprayed must be thoroughly mixed and free of dirt, lumps, and skum, so it must be strained before being placed in the spray gun container. The spray gun material tube (the paint pick up tube) should have a paint strainer installed on the pick up end (figure 7-107). The cannister should be installed on the gun, the air pressure regulator adjusted to the recommended pressure (usually 65 pounds per square inch [4.57 Kg. per sq. cm.] for enamel and 45 pounds per square inch [3.1639 Kg. per sq. cm.] for lacquer), and the air hose then connected to the gun. The gun should be held at about 12" (304.8 mm) from and perpendicular to a clean piece of cardboard and the gun triggered quickly to test the spray pattern. The pattern adjustments should be made according to the instructions of the manufacturer. See figure 407-1 for typical spray patterns and corrections. CAUTION! Some spray guns are limited to a maximum of 50 PSI (3.5154 Kg. per sq. cm) for safe operation. Higher pressure may blow the container off of the gun.

Once a uniform delivery pattern is established the prepared surface can be sprayed by moving the spray gun 9" (228.6 mm) to 12" (304.8 mm) away from and across the surface to be painted. Succeeding strokes should overlap slightly and the speed of the stroke should be constant. Slow travel speed will cause heavy paint buildup. The spray gun must not be swung in an arc; it must be held perpendicular to the painted surface at all times. In order to prevent paint buildup at the edges of the painted surface, the gun must be triggered before the pattern sweeps onto the surface and not released until after the pattern has left the surface. It is usually preferable to spray in straight lines, otherwise excessive overlapping may occur which may cause heavy local buildup of paint which will probably run.

The choice of paint types depends to a large extent on equipment available to the sculptor. Enamels with four hour tack free drying time require an exceptionally dust free finishing area. Lacquers on the other hand which may set up dust free in ten minutes, do not require as elaborate a finishing room and, in fact, may be applied out of doors in the best of weather because minor dust blemishes can be rubbed out. Enamels as opposed to lacquer require fewer coats, are thick, relatively opaque, are slightly cheaper and do not require rubbing out (cannot be rubbed out). Lacquers on the other hand, require more coats, more material, are transparent (richer in appearance) are thin (will not fill minor scratches) and are more expensive. Lacquers are also much more versatile than enamels. Because they are transparent, they can be mixed with reflective metal or plastic flakes or powder, can be made pearlescent, or candied. Candied (candy apple) colors are special effects which may be mottled, irridescent, and rich vibrant colors achieved by laying many coats of slightly tinted lacquer over a layer of metallic reflective lacquer.

Other paint systems have specific if less common uses. Butyrate cellulose and nitrate cellulose dope for instance, is used in the finishing of fabric covered aircraft, and is useful to the sculptor in finishing fabric covering over metal framework. The dope is used to seal and shrink the cotton or linen covering. The nitrate cellulose dope which is highly flammable, wet or dry, will take a superior finish to butyrate. Butyrate now used almost exclusively for finishing fabric covered aircraft is fire resistant but the finish has a dull cast. Nitrate finished products are not safe to use indoors because the slightest flame may cause a flash fire.

A recent development in a paint consisting of a free zinc supporting resin promises to significantly reduce the problem of rust formation on steel. It is sold under several brand names (i.e., Cold-Galv.) and is sprayed on the clean, or mildly rusty but scale free, bare metal. Manufacturers claim that the undercoater is compatible with all primers and paint systems.

Non-ferrous metals can be painted in much the same way as mild steel but usually the paint system will differ. Aluminum for example should have an undercoat of zinc chromate primer to retard corrosion, especially where it may come into contact with other metals.

Spray Gun Safety Precautions
1. Never smoke while spray painting, mixing, or preparing paint.
2. Never spray in an area with an open flame, or where there are sparking motors or machines.
3. Never spray where there is inadequate ventilation.
4. Always wear the proper respirator. Some new paints are so toxic that they are deadly and require canister type respirators, or an outside air supply.
5. Use proper air pressure. Many inexpensive spray guns are limited to a maximum of 50 pounds of air pressure. Excessive pressure will blow the canister off of the gun with considerable violence.

Wax

Built-up wax sculpture is by nature rather fragile, not the least resistant to shock, heat, or abrasion, and so it is almost always coupled with the substitutive technique, the final result being a casting in metal. Sheets of wax (page 47) are cut with simple tools, such as a butter knife or mat knife, into the desired shapes and patterns. These wax sheets can be stretched,

Figure 7-109

Figure 7-110

bent, and otherwise formed, and have their surfaces manipulated by warming the shapes or patterns before they are joined (figures 7-109, 7-110, and 6-99). Joining can be effected either by pressing the edges of the shapes together with some force or by heating the wax along the seams until the joints melt and flow together. If the wax is not strong enough to support itself, a wire or pipe armature can be used for added strength.

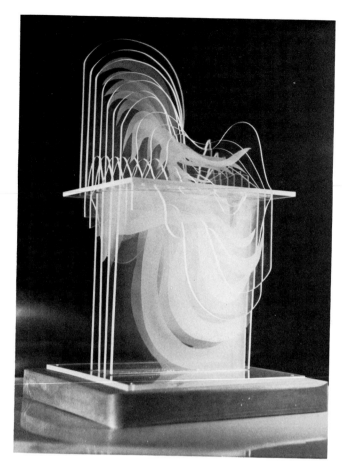

Figure 7-111. *Laminar Spiral Forms,* Elaine Schmitt (1956-), acrylic plastic.

Wax sculpture can also be built up of lumps of wax in much the same way that clay can be built up. Warm lumps of wax are pressed onto a wax core, building the desired form "from the inside out."

Plastic

Many plastic materials such as compounds and mixtures of polyesters, epoxies, acetates, PVC, polycarbonate, vinyl, TFE fluorcarbons, acrylics, polypropylene, and phenolic are available for sculptural use. Most of these materials are similar in appearance, though each has individual characteristics. TFE fluorocarbon is probably the slipperiest of the plastics and, for all practical purposes, cannot be cemented. Epoxy resins are among the most adhesive of all materials; PVCs can be produced in an unlimited color range; and some acrylics can be heated from a rigid state to a rubbery one. Regardless of their similar characteristics, joining characteristics differ greatly. All can be bolted or riveted except the fluid resins; some, like PVC, can be welded with hot air or hot helium; and some, like the acrylics, can be cemented.

Because plastics are found in both the rigid and fluid state, two additive system are employed in their use. Mechanical and chemical joining are used for solid plastics; fluid or putty-like build-ups are used for the liquid plastics.

Solid Plastic

Acrylic plastic (Plexiglas,® Lucite®), is a thermoplastic material which can be softened with heat and will retain its shape when cooled. It is probably the most popular rigid plastic used for its visual qualities by sculptors and students today. Other rigid plastics like the polystyrenes and the urethanes which are used in large quantities by artists are used primarily for their capabilities as substitutive or armature media.

Acrylics are manufactured in many kinds and grades from super hard and crystalline to soft and flexible, from easily cemented to nearly impossible to cement, from transparent to opaque, from colored to mirrored, from smooth to textured and on and on. At one time these plastics were very hard to procure, but now they are available in hobby supply stores, hardwares, discount houses, lumber yards, as well as plastic supply houses. Obviously the plastic supply houses can supply the greatest variety of shapes and kinds of the plastic.

A little preparation for working rigid acrylic saves a great deal of repair and clean up at a later time. A work table, partly covered with a piece of short nap carpet or medium density felt will help prevent scratching and gouging of plastic sheet. A good brush is needed to keep the carpet clear of chips and a damp cloth will be handy to break down static charges that attract trash to the surface of the plastic while it is being worked. Compressed air is also helpful for blowing chips and acrylic sawdust from outlines and cleaning large surfaces. Compressed air can be a problem in that it can generate static on the plastic surfaces. Wiping with a damp cloth or shooting the plastic with a static eliminator (figure 7-112), will remove the static charge. A little alcohol added to the dampening water will make cleaning easier and will make the plastic dry faster.

Scribing, Breaking, and Cutting

The protective covering on the plastic sheet should be left on the surface whenever possible to protect the scratch sensitive surface of the material. Ordinary pencils, ball point pens or marking pencils can be used to draw on the paper covering but only grease pencils and few types of ball point pens will mark on the filmy plastic protective covering which is found on some acrylics.

Untextured acrylic sheet stock up to 1/4″ (6.35 mm) thick can be cut on a straight line by scoring a line

Figure 7-112

along a straight edge with a sharp blade such as a mat knife. The scored line made with seven to ten draws with the blade, should extend from edge to edge of the sheet. The score line should be placed score up directly over and parallel to a rod 3/4″ (19.05 mm) or larger in diameter. The largest portion of the sheet should be held firmly and the smaller area of the sheet should be pressed down to start the break. The hands should be adjacent to each other on either side of the score line and slightly behind the break. Narrow strips usually cannot be separated successfully by this method. WARNING! Occasionally the sheets will break with a sudden violent snap yielding razor sharp, sometimes irregular, edges that have in several instances severely cut the fabricator's wrists. It is advisable to wear gloves with cuffs and face shields when scoring and breaking acrylic sheet.

Circular saws are commonly used for cutting straight lines in thick plastic (figure 7-113). Normally saw blades for wood can be used for small amounts of cutting, but where large amount of material must be cut, a carbide tipped blade should be used. Unfortunately carbide tipped blades are prohibitively expensive and the average sculptor finds it difficult to own one.

Perfectly sharpened steel blades with all teeth at the same height and the same shape, and uniform hook or rake on the teeth will normally make satisfactory short cuts if the work is fed steadily with the blade slightly higher (1/8″ [3.175 mm] to 3/16″ [4.7625 mm]) than the thickness of the work. The work must be fed in a perfectly straight line parallel to the blade. The saw should be fitted with a kerf splitter and the blade should be lubricated with oil or white soap to

Material thickness in inches	Blade thickness in inches	Teeth per inch	S.F.P.M.	Type of blade	Utility
.040-.080	1/16"-3/32"	8-14	8,000-12,000	Carbide tip Hollow ground	
.1000-.150	3/32"-1/8"	6-8	"	Carbide tip Hollow ground	smooth cut combination
.187-.375	3/32"-1/8"	5-6	"	Carbide tip Spring set	"
.438-.750	1/8"	3-4	"	"	" short cuts for cooling
1.00-4.00	1/8"-5/32"	3-3½	"	Carbide tip Spring set	NONE

Figure 7-113. Preferred circular saw blades for cutting acrylic plastic

prevent heating and gumming of the blade. When the blade gums up further cutting is both impractical and dangerous.

The protective papers and contact cements used to hold them in place will dull and gum circular saw blades. Since it is desirable to keep the protective covers intact, as much as possible, a narrow strip of protective paper can be torn away from the line of the cut on both sides of the plastic relieving the blade of the nuisance of gumming.

The rate of feed requires considerable judgement. Material forced into the blade causes chipping and overheating. Slow feeding causes gumming and melting with attendant binding of the blade. Heat build up can become great enough to warp and buckle the blade which will often begin to vibrate and perhaps shatter the plastic.

Where thick sections or curved cuts are desired bandsaws offer both convenience and utility. Metal cutting blades are more durable than wood cutting blades but either can be used satisfactorily. Two problems encountered with the bandsaw in cutting acrylic plastics. Acrylic sawdust may follow the blade onto the tyres of the machine, eventually building a hard uneven deposit of plastic which will cause the blade to "run off" track or to jump off of the wheels. A more obvious problem as it occurs much more rapidly, occuring when the cutting speed is too fast, is the melting of the plastic which loads the entire cutting area. The soft gummy plastic will gather in a frothy waxy looking mass around the blade and blade guides, and freeze, resulting in a monumentally jammed saw.

Almost any bandsaw blade will cut acrylic plastic but not with consistently good results. The best service will be obtained by using a metal cutting blade with 14 teeth per inch (25.4 mm) and running at 3000 FPM for plastic under 3/4" (19.05 mm) thick.

Not all types of acrylic plastics can be cut satisfactorily with skip tooth blades. Practicality should be determined by trial cuts. Acrylic tubing and rods are not safe to cut with skip tooth blades. Bandsaws which do not have variable speeds can be used if the blade speed is between 2,300 and 5,000 SFPM. The thicker the material the slower the blade speed. The teeth should be large enough to cut clean chips. Teeth which are too small will run in their own chips, overheat and gum up the blade.

Saber saws and jig saws with blades of 14 or more teeth per inch can be used to cut sheet acrylic, but forcing the cut or failure to hold the sheet stock firmly will cause chatter. Chattering frequently results in shattering of the plastic. If the work tends to chatter white soap or kerosene on the blade may lubricate the blade enough to keep it cool and prevent it from heating the plastic and grabbing it. If the plastic developes a crack while it is being worked the crack may continue unless it is stop drilled. A fracture can be stop drilled by drilling a small hole (1/16") a hairs width beyond the end of the crack, ordinarily the cracking may continue as far as the hole, but will stop there.

Carpenter saws with eight to ten teeth per inch, very little set, and held at about 45 degrees will cut the plastic if the work is progressed slowly. Scroll and coping with narrow blades may also be used. In each case lubricating the blade will aid in the cut.

Piercing

Acrylic plastics can be pierced by punching and drilling. Punching consists of heating a rod or shape and pressing that shape into or through the plastic. Dies (thin edged shapes similar to cookie cutters) can be pressed into hot plastic sheets to cut out shapes. Ordinarily heavy pressures are used to punch the plastic but the pressure can be executed on a drill press. The table of the press must be fitted with a plate which will hold the hot plastic without chilling it. Then the die is pressed through the plastic by pulling the lever that would normally feed the drill down into the work.

An interesting variation of the hot piercing process is that of hot sealing. A headed pin or threaded rod can be heated and pressed into the plastic where it is permitted to freeze, in effect, integrating the fastener in the body of the plastic.

Drilling acrylic plastic can be a traumatic experience. Regular twist drills for wood or metal can be used with predictable results if the cutting edges are altered so that they are scrapers instead of cutters. The simplest modification is to remove the rake from the cutting edge. If the drills are not altered, except for sizes below 1/4″ (6.5 mm) the drill will dig into the plastic as it emerges from the bottom of the drilled material, splitting or chipping the stock, or running the plastic up the bit where it will spin and probably break and fall off after striking the operator's knuckles.

Electric hand drills, drill presses, or any manual drill or pin vice can be used to turn the twist drill. In every case a small quantity of lubricant such as kerosene or soapy water should be used to cool the cut and prevent burning the hole walls.

Spade bits, a common inexpensive wood bit sold in discount houses, have proved to be superior to twist drills for drilling holes of any size in acrylic. The only problem with the spade bit is that it should be run at a slightly higher speed than the twist drill and must be used in a drill press. Spade bits should never be used in a drill press. Spade bits should never be used in a hand held electric drill. If the appropriate spade bit size cannot be located, a satisfactory bit can be manufactured by any competent craftsman from one of a larger size. Fortunately spade bits are common in sizes larger than non-industrial twist drills.

Turning acrylics on a lathe is no exercise for the novice. A metal turning lathe, because of its rigid cutting tool, is the best lathe for precision shaping of the plastic. The wood lathe offers more versatile free form shaping, but because the tool is not held in a rigid frame there is ample opportunity for the tool to dig into the brittle material. Flying chunks of sharp edged plastic and whole or broken chisels are the result of such an encounter. Needless to say lathe turn-ing of this plastic should be attempted only in the presence of a qualified instructor. Qualified lathe operators will find that acrylics can be turned using the same procedure and tool shapes used for brass.

Joining

Most of the methods of joining used with wood and some used with metal can be used with plastics. Mechanical joints, rivets, nuts and bolts, cement, and welding techniques are available to the sculptor. The mechanical joints illustrated for wood (pages 168-174), though excessively complex for plastic, are possible and can be used because of their decorative qualities. Riveting, on the other hand, is a very simple joining system which has not been exploited by the artist. Ordinary soft metal aluminum or copper rivets can be upset to join the plastic, but steel rivets require too much impact to upset without endangering the plastic. Pop rivets are suitable for assembling, but the large shank (¼″ [6.35 mm]) variety exert a bit more crushing pressure than is safe, and may cause cracking. The most interesting rivets for plastic are made of plastic. Plastic pins are cast into the product, or plastic pins are inserted into holes drilled to fit. The pins may extend slightly beyond the stock being fastened. The ends of the rivets are then melted with a hot clean tool like a soldering iron, effectively swelling and sealing the plastic pin against the work. Some of the plastics are cemented in addition to riveting by dropping cement into the seam between the pin and the walls of the pin hole. Capillary action draws the cement into the hole and bonds the pin to the walls.

A neater joint can be established if the sheet stock to be joined is counterbored so that the heated rivet head will be melted flush or below the surface of the stock.

Nuts and bolts can be used to draw up and fasten the plastic shapes. In many thicknesses of stock, nuts need not be used because the plastic can be drilled and tapped. Self tapping screws can be used if the pilot holes are drilled for a 50% thread (page 252). Holes drilled for a higher percent thread such as 75% or 100% will split out when threaded with self tapping screws.

Tapping for regular bolts follows the same procedures as for tapping metal except that the plastics are quite sticky and require clearing of the threads more often. The tap should be backed completely out of the hole and the tap and hole cleared of the chips frequently. If the flutes of the tap load up, the tap may begin to bind. It may then be discovered that the tap cannot be backed out without breaking. Compressed air can be used to attempt to cool the plastic and to blow out the offending chips from the flutes

of the tap. A little soapy water should be used as a lubricant and the tap worked forward and backward. With luck the tap can be removed. If the tap is hopelessly locked in the plastic the tap can be heated until the plastic softens and then the tap can be removed leaving a mess behind.

Many acrylic plastics lend themselves to fabrication by cementing. The best adhesive for joining the plastic stock is a cohesive cement. Cohesive cements are solvents that soften the bodies to be joined so that they melt together becoming a single mass on hardening. In the case of transparent acrylic plastic (of the cementable variety) the joints are transparent and reasonably strong.

Household cements and contact cements can be used to laminate some materials such as fabric to the surface to the stock if the surface has been sanded to produce a tooth which will allow a mechanical bond. The use of these cements is limited to lamination. They will not give satisfactory results for joining edges. As a matter of fact, not even the epoxies which are noted for their strength are satisfactory for joining these plastics.

In order to make strong joints with cohesive cements the joint must be a perfect fit. One of the edges or surfaces to be joined must be softened with a cohesive cement and a slight pressure maintained on the pieces forming the joint. This is done until the solvent has softened the opposite member, melted together, and finally evaporated. The joint will usually set up in fifteen to twenty minutes and cure in twenty four hours. Annealing will speed up curing and strengthen the joint (figure 4-55 and 4-56).

The fit of the joint, which is critical, can be determined by wetting the joint with a couple of drops of water. If the joint is not a good fit, gaps will show in the water film along the joint. A slightly irregular edge can be heated and pressed to the joint, at which time it will form fit the joint. Perfect fits of edge cemented flat stock can be obtained by wet sanding the edge to be bonded on a sheet of 240 to 360 grit wet or dry sandpaper which has been contact cemented to a sheet of glass or some other perfectly flat surface. Care must be taken to keep from rocking the stock from side to side which will round off the edge. A simple wood jig can be used to keep the edge flat.

The simplest method of cementing the stock is to clamp the stock in position with light pressure forcing the stock to the joint. Then a minimum of cement should be dropped into the joint with a fine needle applictor or a glass hypodermic needle. The cement should instantly be drawn along the joint by capillary action. If it does not spread along the entire joint, drop additional cement in the dry areas. Do not drop ce-

ment on the surface of the plastic as it will scar the surface. These joints are quick but not very strong. They have a nasty habit of falling apart if they are not perfectly made.

More perfect joints can be made by soaking the edge of the joint in a shallow trough of cement for thirty seconds to three minutes. The stock will swell slightly as it absorbes the cement; it can then be pressed against the joint. The dry surface will absorb some of the solvent and bond to the swollen area. Light pressure must be applied to the stock to squeeze out trapped air bubbles. Excessive pressure will force out the solvent, leaving weak or unbonded spots. Dry spots can sometimes be touched up with cement applied with a fine applicator.

It is advisable to procure cements from suppliers of the plastic being cemented as different kinds of plastic respond differently to various kinds of cement.

The most commonly used cements are acetone, glacial acetic acid, ethylene dichloride, 1,1,2, trichloroethan, methylene dichloride, and chloroform. These cements are all toxic and most are inflammable to the point of being explosive. They must be used only with adequate ventilation and adequate fire safety (see pages 49-50).

Small pieces of plastic can be heated and pressed together to form heat welds. The plastic should be heated to the point where the material softens and swells. It should not be allowed to turn black or burn. The soft plastic sections should be forced together then immediately annealed. If the plastic is not annealed the material is likely to crack. Even if it does not break because of extreme internal stress, the plastic will be horrendously brittle.

Too much heat will shrink, gather and melt the plastic. Acrylic plastics are not as suited to this type of welding as are the heat shrink plastics used in the food wrap process in every supermarket.

Surface Treatment

Acrylic plastic is unique and fascinating because of some peculiar visual effects created by it. Possibly the strangest effect is caused by the ability of the acrylic plastic to pipe light. Acrylics have a high refractive index, so lights tend to bounce from surface to surface instead of passing through the surface as it travels edgewise through the plane, or lengthwise through a rod. Rods can be literally tied in knots, and the lights will travel through the plastic-like water through a tube. Sharp angles in excess of 42° will permit the light to pass through the walls of the rod, cutting off the light in the pipe. A single source of hidden light can be used to light any number of flexible light pipes and the pipes will easily transmit the light around corners and through opaque planes

(through holes drilled in the plate through which the rods can be passed). The hue of the projected light can be changed (programmed) by moving filters between the light source and the light pipes. Light passing through light pipes cannot be seen, just as the light in an edge lighted sheet of acrylic plastic cannot be seen except at the edges or ends. Pipes and sheets which are unblemished will be illuminated only where there are sharp angles. In order for the surface of flats or sheets, or the surfaces of the rods to be illuminated, the surfaces must be pierced, cut, or roughened. Drilling, cutting, engraving, chemical etching, sanding and sandblasting are simples ways of marking the surface to achieve visually satisfying light patterns.

Chemical etching is a simple process involving the use of solvents which dissolve or affect the surface of the sheet in a way that breaks up the smooth surface. Textures can be impressed in the surface after the plastic has been softened through the action of a solvent. The solvent can be floated on the plastic or applied to a textural material which can be pressed into the plastic. The textured material must be removed before it becomes cemented to the plastic. The solvents used for etching may be the same as for cementing the plastic.

Finishing

These plastics can be finished by the usual processes of filing, scraping, sanding, and polishing. Filing is sufficient for preparing a surface for polishing if large (10″ [254 mm] to 12″ [304.8 mm]) sharp smooth cut files are used. The file should be kept flat, filed in one direction only, and the file held at an angle to the direction of the cut. Filing in line or nearly in line to the direction of the cut may result in cutting deep grooves in the plastic. The file should be wire brushed frequently to keep the teeth clear. Clogged teeth will score the surface.

Scraping is often used in place of filing if the surface is reasonably smooth to start with. Scraping is similar to filing except that scrapers can be made in many shapes. They are often made out of old saw blades or spring steel blanks which are sold as scraper blanks. Heavy duty paint scrapers with replaceable blades work very well for leveling edges of thick sheet stock. For narrow edges a stiff single edges razor blade will work quite well. The scraper blade is pressed against the plastic at about a 45° angle towards the direction of cut. The blade is then drawn towards the operator, scraping off a fine thin film of material. Squaring or flattening an edge is easier with a scraper than it is with a file. Cleaning an edge carefully with a scraper will bring a surface to a clean almost polished surface then light buffing will then bring the surface to a transparent finish.

Sanding can be used where filing or scraping is impractical. Sanding plastic is very much like sanding wood except that wet-on-dry papers are used on the plastic. The other great difference between sanding plastic and sanding wood is in the grade of paper used. While a coarse paper for wood would be in the 40 grit to 60 grit range, the course range for plastic would be around 240 grit to 300 grit. The work should be kept wet to keep the paper clean and the dust from scratching the plastic. Sanding should begin with 240 grit paper then proceed with successively finer papers typically 320, 340, 360, 400 and finally 600 grit. Each sanding should be across the previous sanding direction until the sanding marks of the previous sanding are removed. The finishing paper (600 grit) is the finest paper readily available and will leave the surface soft, satiny, and slightly opaque. It may be difficult to obtain wet-or-dry papers in every locality. Auto paint suppliers commonly have 60, 80, 120, 180, 240, 360, 400 and sometimes 600 grit.

Sanding of flat surfaces may be accomplished most easily by working the plastic against the paper in the same manner as preparing an edge for a perfectly fitted joint. The sand paper can also be contact cemented to wooden rods and shaped blocks to simplify sanding complex shapes.

Power sanders can be used with ease on acrylics but the plastic should be sanded in short intervals with adequate intervals between sanding to allow the material to cool. If the plastic is moved constantly and only light pressure applied the plastic mass may not heat sufficiently to gum up. Belt sanders and disc sanders can generate heat quickly enough to cause the plastic surface to become rubbery, at which the sander may snatch the plastic, throwing the sander or the plastic violently.

Hand polishing large areas of acrylic plastic is not practical and in some cases not possible. When it is possible the plastic is rubbed with a cotton flannel cloth to which a fine abrasive such as mutton tallow and whiting has been applied.

Buffing by machine is much more practical than hand polishing. Felt or cotton flannel buffs will polish provided that the buffs are not dirty and excessive pressure is not applied to the plastic. The buff should be built up to a width of about 3″ (76.2 mm) with layers of 3/16″ (4.7625 mm) felt or a series of cusion buffs about 1/4″ (6.35 mm) thick. The sections should be drawn up tightly on the buffing machine by bolting the buffs between large diameter flanges which can be obtained commercially for that purpose. Flange diameters should be about 80% of the buff diameter for cutting and 50% for coloring.

Cutting buffs are used to remove minute surface imperfections and are slightly stiffer than coloring buffs.

Coloring buffs do not remove visible imperfections, instead they bring out natural lustre or brilliant transparency of the plastics. Either cushion sewed buffs or loose buffs are satisfactory for coloring plastics (page 263).

Abrasives used for acrylic plastic should be similar to those used for coloring stainless steel, chrome, and nickel plate and often consist of tallow and artificial abrasives or whiting. Excessive or prolonged exposure to the buffs will burn the plastic and destory the surface. Burning is the migration of surface material as a result of slight fluidity through melting. The heated plastic may also craze unpredicably.

Final polishing may be made with a clean off buff. This is a loose cotton flannel coloring buff with small mounting flanges. It is used without tallow or abrasives and should not be run at high speeds. The plastic should quickly and lightly "kiss" the buff and be moved on. This clean off buff removes the last of the junk from the plastic. Buffs for polishing should be run from 1800 SFPM to 7500 SFPM (548.64 to 2286 SMPM) but will polish at speeds as low as 800 SFPM (243.84 SMPM).

If the proper finishing materials are not available, ordinary "orange" rubbing compound for auto finishing can be used as a cutting compound and the "white" polishing compound can be used for coloring plastics. Cheap rag buffs seem to work adequately with these materials.

Flame polishing is a method of polishing that is not recommended but used frequently. The edges or on some occasions small surface areas of acrylic can be made brilliant and transparent by heating the area with a smokeless flame. The method works but may produce many problems including swelling, boiling, cracking and more commonly, crazing. Swift passage of the flame over the area to be polished and thorough annealing may result in successful polishing.

Fluid Plastic

Many plastics can be obtained in a fluid state so that they can be used to build up mass in the same way that cement or plaster is used to build up mass. Plastics, such as polyester and epoxy resins, which require the addition of a hardening agent, can be mixed with aggregates or fillers, to give color, to add to the bulk (significantly reducing cost), to produce desired textures, and most importantly, to greatly increase strength or machinability. Many of these resins are compounded with fillers and sold commercially as "liquid metal" to be used for patching auto bodies, leaking tanks, cement floors, and so on. Filler materials include glass fibers, talc, cement, dry pigment, silica flour (flint), dyes, stone chips, stone powder, metal chips or powder, wood flour, shell flour (walnut shells), cotton flock, sisal fibers, chopped paper, crepe paper, wood bark, soybean meal, ground feathers, asbestos, mica, clay, chalk, perlite, cork, and water soluble materials which can be dissolved from the plastic after it has hardned. It is necessary to formulate the matrix in such a way that the medium is putty-like (sag-resistant), but still fluid enough to retain its strength and adhesive ability.

Plastics which depend on evaporation to effect hardening, like some latexes and polyvinyl latexes, cannot be readily mixed with fillers by the sculptor because of their rapid hardening time. Some of these plastics are factory-mixed with fillers and sold commercially as self-hardening modeling compounds, plastic metal, or sealing compounds.

More detailed information concerning modeling fluid plastics will be found on pages 119-123.

Glass

Recent years have revealed a strong interest in glass as a viable medium for the sculptor. In the 1960s and early 1970s many facilities for hot glass working were constructed, primarily in the universities. The high cost of fuel for operating the furnaces and the difficulty encountered by the single artist in producing large complex sculptured forms led some artists to search for sculptural form by working cold glass.

The technology of making glass, too complex for this text, is not necessary for the creation of sculpturally satisfying forms. Glass which is compatible with the facilities and capabilities of the sculptor is available commercially.

Soft glass sheets, typical of window panes (lights) and tubing, and rods (cane) sold for the manufacture of cold cathode light (neon signs) are easily worked by the artist, but have severe limitations due to their tendency to crack when heated or cooled suddenly, or when reheated without annealing.

Pyrex, an expensive hard glass, is not bothered by thermal shock and can be heated suddenly or reheated without fear of its cracking. This medium is also available to the sculptor, but it requires special equipment to work because its melting temperature is so high.

Glass of the window pane variety can be cut, sanded, etched, sandblasted, engraved, and drilled. It can be cemented surface to surface easily, but not edge to edge. It can also be joined by drilling and bolting, but more often it is joined with mechanical fasteners such as framing or restraining clips, or with silicon cement of the bath caulking tub variety.

Glass tubing, cylinders or rods (cane) are available in many sizes and colors and can be cut, sanded, etched, drilled and so on. In addition to this some

Figure 7-114

glass tubing and cane can be shaped through the use of heat. Since the amount of heat is restricted to small areas at any one time and the glass does not become a fluid mass, working it in this way is still considered "cold glass." Sheet glass can be heated and slumped but because of the heating requirements and problems of annealing, slumped glass should be considered as hot glass.

Drilling Glass

Glass sheet can be drilled by placing the glass on the drill press with the glass resting on a felt or rubber pad which is just slightly larger than the desired hole and directly below the chuck. A brass or copper tube with the diameter of the desired hole is placed in the chuck and revolved at a surface speed of 100 feet per minute (page 270). Place a paste of light machine oil and 80 to 100 grit carborundum in the area to be drilled. Bring the tube down against the glass with slight pressure to cause the carborundum to grind the glass. Lift the tube frequently and press additional paste into the work areas with a plastic or wooden paddle. When the hole is ground halfway through the sheet, clean the glass turn it over and

finish boring from the opposite side. The jagged edges of the hole can be cleaned off with a round second cut file lubricated with kerosene.

Cutting Glass

There are several tools used to cut glass, the best of which is diamond point but the least expensive and most common is a hardened steel wheel glass cutter. This tool consists of a shaft with a small diameter sharp edged wheel on an axle inserted in the end of the tool. Some brands of cutters have a notched section on the shaft and a ball on the end opposite the wheel. The notches are used to break the glass and the ball is used to tap the glass along a scribed line to aid in fracturing the glass. Some cutters have replaceable wheels which may be stored in the shaft behind a screw on cap.

Tools Required
a. Carpet square (figure 7-114A)
b. Straight edge (figure 7-114B)
c. Cracking board (figure 7-114C)
d. Glass cutters (figure 7-115A&B)
e. File (figure 7-114D)

Figure 7-115A

Figure 7-115B

Figure 7-116

Figure 7-117A

Cutting Sheet Glass

1. Place the glass on resilient pad such as a short nap carpet. Using a new or still sharp glass cutter, press the cutter firmly onto the glass and draw the cutter to the near edge. The cutter should make a continuous crisp sound and leave a fine powdery white line in the glass. The line should extend from edge to edge and the cutter should not be allowed to roll over the edge of the glass as this will usually chip or crack the glass. If the cutter skips in evenly distributed short spaces the wheel is damaged and should be replaced. If it is difficult to prevent the cutter from slipping sideways, or if it is difficult to press the cutter into the glass to make the cut, the cutter is dull and should be replaced. In the event of an intermittent or light cut, the ball of

the cutter may be used to lightly tap the cut line. Impact along the cut line will tend to extend the fracture into the glass, along the already stressed line.

2. Small pieces of glass can be lifted as indicated in figure 7-117A, then pressure should be applied by the thumbs in an arclike movement, away from the cut line. The glass should then break (figure 7-117B). On large pieces of glass, thumb pressure applied gently and continuously on the cut line will separate the sections. In stubborn cases the sheet can be rested over a 1/4″ (6.35 mm) dowel and then the break started at the near edge by using the thumbs and index fingers (figure 7-117C). Old window glass should not be used if it can be avoided. Not only is old glass full of imperfections

Figure 7-117B

Figure 7-117C

which cause it to break erratically, but glass becomes brittle with age to the point that pressure of the glass cutter may cause it to shatter.

Cutting Cane and Tubing
1. Grind the edge of a fine file to remove any teeth or rough surfaces. Grinding the edge of the file will expose sharp fresh edges of the teeth on the flat of the file.
2. Hold the cane or tubing in one hand and draw the corner or the freshly sharpened file across the glass in a line perpendicular to the axis of the cane or tube. The line does not have to extend all the way around the glass. On small diameters all that is necessary is a notch, on larger diameters (over 1/2″ [12.7 mm]) a line 3/8″ (9.525 mm) long should be sufficient. Do not saw on the line with the file, and do not recut the line. If it is felt that the cut is insufficient, instead its length may be continued instead of deepening the cut.
3. Grasp the cane or tubing with both hands, one on each side of the cut with the thumbs below the scratch line and the scratch line facing up (figure 7-118).
4. Pull the hands outward, downward, and away from the cut line, breaking the glass over the thumbs.

Forming Glass Cane

Soft glass cane is fairly easy to bend by applying gentle heat and then gradually increasing the heat until the glass begins to glow faintly. The rod will bend easily at this temperature. For more complicated business than a simple bend the glass should be

Figure 7-118

brought up to a red color; if the temperature is too high the glass will sag uncontrollably. If the cane is bent while it is too cold, it may split lengthwise or crack at a later time, perhaps in two or three days. The glass should be cooled slowly. Too rapid cooling will cause the glass to crack.

Bending Tubing

Tube bending requires skill which will take a great deal of practice to acquire. It is also a skill which cannot be acquired from a book and will require constant practice and experimentation to perfect.

Figure 7-119

Figure 7-120

Figure 7-121

Tools and Materials Required

a. Fires: cross fire (figure 7-119), ribbon fire (figure 7-120), cannon fire (figure 7-121A), hand fire (figure 7-121B)
b. Asbestos paper
c. File (figure 7-123A)
d. Rubber tubing (figure 7-123B)
e. Variety of corks (figure 7-123C)
f. Glass blower's swivel (figure 7-124A)
g. Grease pencil (figure 7-123D)
h. Tubing gauge (figure 7-122)

Bending Tubing

1. Light the ribbon fire or fan flame. Ribbon fires use natural or bottled gas and forced air to produce the proper flame. The flame must be hot and neutral. If the flame is rich it will deposit carbon on the glass. If the flame is lean it will burn the glass turning it dark and will foam the glass making it brittle. The gas should be turned on and

Figure 7-122

Figure 7-123

Figure 7-124

ignited and the air valve opened slowly; the lazy yellow tipped flame will become active, lose its yellow color, develop small cones, and burn with a hiss. The flame should be tight against the orifices of the ribbon fire with sharp blue cones and pale blue tips. If a fan flame from a bernzamatic type torch is used, the flame cannot be adjusted, and will have to be used as it is. The best that can be done is to keep the glass away from the tips of the flame.

2. Select a length of tubing and cork one end. Fit the other end with a cork and neroprene tubing adapter and a swivel fitting to which a length of rubber tubing has been connected. The tubing should have a plastic or glass mouth piece on the free end (figure 7-124B).

3. Hold the tubing lightly in both hands with the fingers positioned so the tubing can be rolled over the flame.

4. Place the tubing just over the tips of the flames and slowly roll the tubing until the glass begins to glow. When the glass is sufficiently soft it will begin to sag. Rolling the tubing will keep the glass from sagging out of control. It will take quite a little skill to develop the ability to prevent the glass

from suddenly dropping and kinking. If it does throw a kink it can sometimes be straightened by placing the tube on a flat surface covered with an asbestos sheet (normally the working table), and rolling the tubing across the table. The tube must be rolled along its entire length or it will twist and be a worse mess.

Figure 7-125A. Amos Barcus Sr., Master glass bender.

Figure 7-125B. Amos Barcus Sr.

Figure 7-125C. Amos Barcus Sr.

Figure 7-126

5. When the glass has softened the tubing should be pressed inward on itself to thicken the wall of the tubing in the area of the bend.

6. With the fingers balancing the tubing on either side of the area of the bend, allow the center of the tube to drop slowly allowing the heated area to bend. While the tubing is bending slight positive pressure should be applied to the inside of the tube by blowing in the glass tube through the rubber hose. If too much air pressure is applied to the tube it will expand into a bubble and thin the walls or pop a hole in the glass. If too little pressure is applied the tubing will kink. If a large radius is desired the lengths of tubing are pulled slightly as the curve is dropped, to spread the arc (figure 7-125).

7. When the desired curve is attained the shape is placed on the work table and pressed lightly with an asbestos covered flat block of wood, to maintain the flatness of the plane of the bend figure 7-125). If a compound curve is desired the tubing can be placed on the work table and the curve continued through another plane. Obviously the shaping must take place rather quickly or the glass will freeze. If the glass is too cool to continue bending, but it is still very hot, it can be returned to the heat and brought up to bending temperature. If the glass cools to room temperature, it cannot be reheated unless it has been annealed.

8. While the glass is still hot and on the asbestos work table it can be pushed or pulled to produce specific desired shapes. If the glass is too hot while it is being manipulated it will take a print from

the work table or from the pressing block and the surface will be marred or textured.

9. Tubing will often turn colors while it is being heated. The color should disappear after the tube cools. If the coating is silvery or black and mirror-like, the glass is being burned by the flame. Either the flame is too rich, the glass is being held too far from the flame, or the flame tips of the cross fire are too close to each other. Burnt glass is brittle and will not join satisfactorily. This condition can sometimes be corrected passing the still hot glass back and forth through the very tip of the flame. Burnt glass will develop leaks when it is used with a vacuum for cold cathode light and should be avoided or corrected whenever possible.

Welding Glass Tubing

Glass tubing can be welded to other tubing by heating the tubing to the melting point and then pressing the melted glass sections together.

1. Light the crossfire.
2. Select the tubing to be joined and cut the ends square.
3. If the tubes are coated remove the coating. If the inside of the tube is lined with powder it can be removed by wiping the inside wall with a small cork. There should be no dirt, powder, glass fibers or any other foreign material on the edges of the tubing to be joined.
4. Close the unworked tube end by melting it shut or fitting it with a cork.
5. Fit the second tube with a cork, glass blower's swivel and rubber tube and mouthpiece.
6. Balance the tubes one in each hand and pass them back and forth through the flame with the open ends facing each other and just touching the tips of the flame (figure 7-127). The tubes must be rolled between the fingers to prevent hot spots from developing. If hot spots develop the tubing will sag at these points.
7. When the edges of both pieces are heated to an even soft glowing red, press them squarely together with a slight rotating motion (about 3° of rotation), as if being screwed together, then unscrewed. The glass should swell slightly on being pressed together.
8. Roll the joined tubing and pull slightly to bring the thickened walls back to their original thickness by stretching the glass.
9. The stretching glass tube will begin to narrow. This narrowing is prevented by blowing in the rubber tube to create enough positive pressure to maintain the original tube diameter (figure 7-128). Too little pressure will allow the tubing to become narrow while too much pressure will blow a bubble

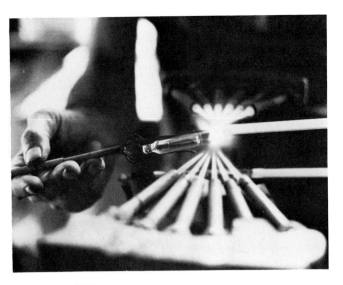

Figure 7-127

Figure 7-128. Amos Barcus Sr., Master glass bender.

at the joint. If the wall is allowed to remain thick as it is when it is first pressed into the joint, the glass will probably crack.

Welding "T" Joints

1. Light the crossfire and a cannon fire.
2. Select the tubing to be joined and clean and square the ends to be joined.
3. Close one end of the tube which is to be the top bar of the "T" in the joint by melting it closed, or corking it. Fit the other end with a cork, swivel and rubber tube (pressure fitting). Put aside a cork to replace the pressure fitting.
4. Place a pressure fitting on the tube which will be the stem of the "T" joint. If a second pressure fitting is not available, the fitting can be removed from the top bar where the joint is being made, which at times can be an awkward procedure.
5. Using the cannon fire or the edge of the crossfire if a cannon fire is not available, heat the area of the joint on the top bar of the "T" joint. The heat should be concentrated on a small spot and the glass should not be allowed to burn, and the heat should not soften the entire circumference of the tubing.
6. When the area of heat glows light orange, apply pressure to the joint area by blowing gently into the rubber tube. The heated spot will blow up into a bubble and burst. If the area heated is too large the hole blown in the tubing will be too large to close against the tubing of the stem. If the hole is too small, it will be very difficult to weld the joint and the hole in the top bar may close again. To some extent, the hole can be controlled by varying the pressure and velocity of air used to form the bubble.
7. At the instant the bubble breaks remove the pressure fitting and fit the hole with the cork which was set aside for that purpose.
8. Quickly begin heating the joint end of the stem tubing by rolling it between the fingers with the end of the tubing in the flame of the crossfire. Keep the blown hole hot by working it near the edge of the crossfire.
9. When the joint end of the stem tubing begins to glow bring both the blown hole and the stem end to light orange by working them in the crossfire or at the edge of the crossfire.
10. When the joint ends reach light orange press the stem squarely against the edges of the blown hole. The stem should be screwed into the joint with a slight twist of about 3° in each direction.
11. When the joint has sealed, apply slight air pressure and back the stem away from the top bar by pulling slightly, to thin the joint walls.

Closing Glass Tubing

Glass tubes can be welded closed by heating and shrinking the glass. It is possible to weld a tube closed then join the welded end with another tube. This joint has application in the production of cold cathode light sculpture.

1. Light the crossfire.
2. Roll the end of a squarely cut and cleaned tube at the end of the tip of the flame. If the glass burns, pass the glass quickly back and forth through the flame but not fast enough to fan it cool. If the burn disappears, continue heating the glass closer to the flame.
3. When the glass begins to color red, lower the cold end of the tube well below the crossfire so that the melted glass will be pulled into the center of the tube by gravity.
4. If the glass fails to close, fit a pressure tube to the glass and quickly draw out the air using vacuum to pull the end of the glass in on itself (use caution).
5. The instant the glass seals, apply slight positive pressure to blow the end of the tube round and to thin out the joint walls. If the walls bubble beyond the diameter of the tubing, the glass can be replaced on the work table and rolled forcing the bubble to assume the wall thickness. If a but end is required, rather than a rounded closing on the tube, the freshly sealed glass should be blown slightly to thin the glass, then pressed against the asbestos work table to flatten the end.

Closing Glass Tubing by Stretching

1. Light the crossfire.
2. Fit a length of glass tubing with a pressure fitting.
3. Roll the tubing in the flame of the crossfire in the area where it is to be closed (and separated from the remaining tubing).
4. When the glass reaches light orange, pull the tubing apart quickly. It will thin to a capillary tube which should be melted off.
5. Roll the freshly separated end in the cross fire for a second until it rounds slightly.
6. Apply slight pressure to shape the end of the tube.

Cold Cathode Light

Neon (more properly cold cathode light) is a result of the passage of a high voltage electrical current through certain gases, such as argon, neon, and helium, at low pressure. The advertising and sign industry made extensive use of cold cathode light until the introduction of fluorescent light illuminated plastic signs and the restrictions of zoning regulations. Pressure or vacuum formed, multicolored, one piece, repeatable, prefabricated, plastic signs made by semi-

skilled labor has pretty much taken the place of the fragile, one of a kind, hard formed, intricate, custom erected signage produced by highly skilled neon craftsmen. Although at the present time the neon industry is shrinking; the artisans that bent the glass are dying off, there is still a business for neon repair and a limited demand for neon signs. In a area like Reno, Nevada, neon is still being developed into a highly visual, hyperactive art form.

Oddly enough, living, active, thriving cities have a substantial amount of "neon," but those metropolitan areas that have died and are being resurrected by city planners into the usual government or business oriented, bland, architectural grave yards, are devoid of the action and brilliance of the lights.

Although cold cathode light is at least fifty years old as an art form, it has, as yet, not been fully explored as part of the language of transmitted light. The light transmitting tubes can be produced fairly easily in a small shop, if the pumping down, filling, and bombarding is farmed out to a commercial service. If the tubes are to be shaped, tabulated, evacuated, bombarded, and charged in the sculptor's studio, a significantly complex (and expensive to operate) facility is required.

Most cold cathode materials are obtainable from neon sign supply companies. Glass tubing, electrodes, asbestos paper, fluorescent tube coating, rare gases, and mica are products that are usually stocked or can be easily ordered. The fires, blower, vacuum pump, and bombarder can occasionally be found when an old sight shop closes down, or in used equipment catalogues; otherwise the equipment may have to be ordered from scientific equipment supply houses or ordered custom built.

The soft glass tubing used for neon signeage is available in twelve diameters (5mm, 6mm, 7mm, 8mm, 9mm, 10mm, 11mm, 12mm, 13mm, 15mm, 18mm, 20 mm, and 25mm) and standard lengths of four feet (1.2192 m). Lamp blanks (20mm and 25mm) are available in eight foot lengths (2.4384 m). The tubes come in clear, color coated (green, deep green, dark blue, blue, turquoise, ruby red, gold, yellow, and whites having tints including pink, orchid and lavender). The tubing can also be obtained in colored glass (yellow, soft red, ruby, and dark blue). Some of these colors have disappeared from the market, but they can be ordered in quantities, something like 10,000 pounds (4536 Kg.) minimum.

Small diameter tubing (5mm, and 6mm) is used for tabulation. The tiny tubes can be used for lights but they are difficult to bombard and their resistance is so high they run hot and are hard on transformers.

The gases used in commercial neon are neon for red or blue (when mixed with mercury), argon for

Figure 7-129

Figure 7-130

blue, and helium for red and to produce heat for starting in cold weather. The gases are sold in one liter glass flasks which are welded onto the vacuum manifold.

Electrodes are sold in four sizes (12 mm, 15 mm, 17 mm, and 19 mm) and in two styles, tubulated and non-tubulated. The tubulated electrode has a small diameter glass tube protruding from the end of the electrode. The tube is welded onto the manifold so that the cold cathode tube can be evacuated. Usually only one tubulated electrode is necessary on each cathode tube.

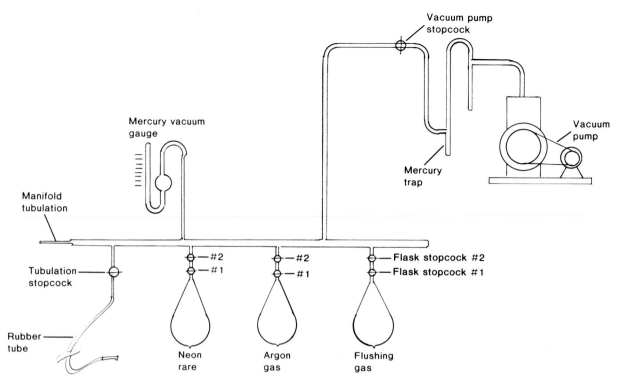

Figure 7-131. Vacuum manifold.

Transformers (ballasts) which are necessary to light the cathode tubes are available in many types and for many uses. Core and coil types are small, inexpensive, and must be enclosed in a protective box of some sort. Window type transformers are typical of those found attached to hanging beer signs. They are usually designed for flashing, are totally contained with high tension lines, line cord, usually a switch, and may contain two complete transformers. They are for indoor use only. Outdoor transformers may or may not be enclosed in a protective box, and have terminals for connections rather than insulated line cords and high tension lines. Most transformers are expensive, but can often be obtained used. A used transformer may not look neat, but if the case is not damaged and the transformer works, it may continue to work as long as a new one. Transformers must be selected according to the dimensions of the cathode tube being lighted. A 12 mm clear tube filled with neon gas to 11 mm and 22" (5588 mm) long would require the maximum of a 9,000 volt 30 ma transformer. A higher voltage transformer would operate the tube, making it brighter and hotter. A lower voltage transformer would be overloaded and might be damaged with the continued operation of the tube. An overloaded transformer is a fire hazard.

Construction of a cathode tube is simple. A glass tube is shaped in any way desired; an electrode is welded on each end of the tube, and the tubulation

tube is welded onto the manifold. The manifold can evacuate the tube and supply the rare gases needed to make a light, or it can supply flushing gas which is used to burn impurities out of the tube (figure 7-132). The electrodes are connected to the bombarder and the tube is pumped down slightly with the vacuum pump (figure 7-131). The bombarder heats the tube to facilitate the evacuation and then the pump down is continued. When the tube is evacuated one of the rare gases is released into the tube and the tubulation tube is melted closed and off of the manifold (figure 7-130). The cathode tube is then burned in with a higher voltage transformer than would normally be used with the tube. Burn-in may take several hours until the color in the tube lights pure and even.

If the tube is to be used in freezing temperatures, a little helium or mercury may be introduced into the tube at the time it is filled to lower the starting resistance of the tube. If a brilliant red light is desired pure neon can be burned in clear tubing. Argon will burn blue, as will neon if it is mixed with mercury. If an insufficient quantity of merucry is added to neon the tube will burn red until it gets warm, then it will burn blue; any part of the tube which is cooled may return to red again.

Coated tubes can be made to fluoresce in many colors by mixing the coating and varying the gases. Different colored or coated tubing welded together and filled with one gas will produce multicolored light in the same tube.

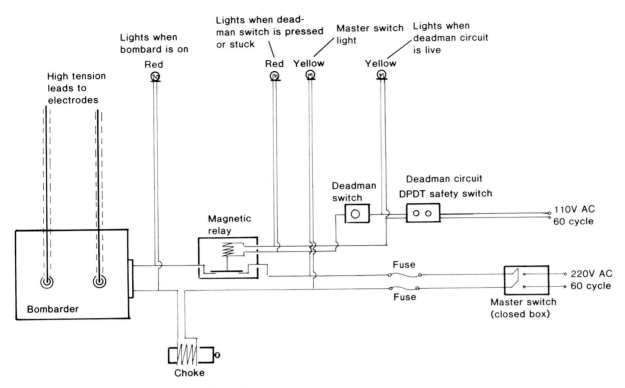

Figure 7-132. Bombarder wiring diagram.

The electricity which energizes the cathode tubes passes through the tube along the path of least resistance. The current will travel from one electrode to another unless there is an easier way through a thin section of glass, a pin hole, or through impurities such as powdered metal in the tube. It is possible because of this to produce a tube with a series of electrodes along its length so that sections of the tube can be energized producing various patterns and colors. By connecting the electrodes to a distributor, the lights can be made to flash in a predetermined speed and pattern.

The current not only takes the path of least resistance, it also seems to use the smallest area possible. If electrodes are welded to the opposite sides of a sphere, the current will travel across to the opposite electrode, making a line of light rather than lighting the entire sphere. Coated tubes may light the entire sphere, but leave a strong line of light through the center of the sphere. The line of light may be a slightly different color than the light of the sphere (figure 7-133).

If excessive pressure is introduced into the sphere the line of light would appear to be very thin and move erratically through the sphere, at times crawling along the inner walls of the glass. Cathode tubes operating to this degree of overload will become very hot and may damage the transformer and could also be a fire hazard.

Figure 7-133

Electrical and mechanical devices are often used to bring action to the lights. The most common device in use is the timer. Timers are designed as switches that either turn on or turn off at a prescribed time of day or night, or at some other cue, such as the opening or closing of a door. They are also designed to turn on or off continuously in a fixed sequence (figure 7-136). Timers that simply switch on and off

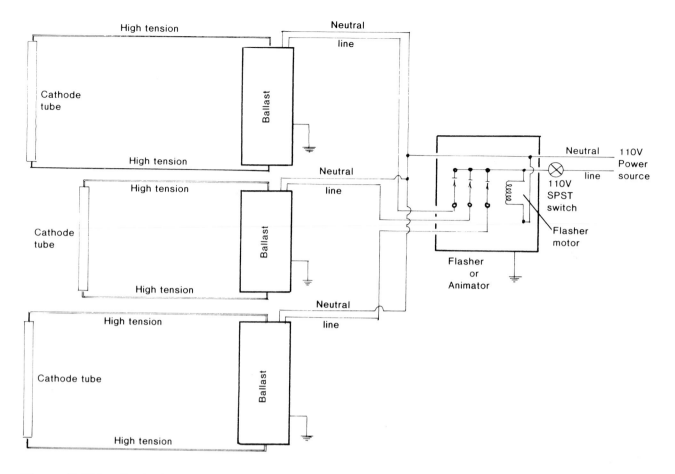

Figure 7-134. Typical animation circuit.

continuously are known as "off and on flashers." The most common switch used in the sign industry is a double switch that operates a two tube sign in such a way the sign alternates colors or words. These switches are called alternators. Another common switch is known as a high speed border chaser flasher. This switch is designed to switch a set of three or four circuits in such a way as to give the appearance of linear movement. When the tubes form a square or circle, the "border" seems to move around the sign. The most versatile of the switching systems, with the greatest utility for the sculptor, is the speller or animator (figure 7-134). The animator is composed of any number of banks of switches (up to five switches per bank) connected to a motor drive unit. The animator can be programmed to operate at a wide range of speeds and has cams that can be cut to set the on and off interval of any switch in any bank. Animators are used to produce various images, such as running letters, or cascading bands of lights.

Switches of these types are low voltage switches (110V) and cannot light a cathode tube. Instead each switch in the animator controls a complete circuit consisting of cathode tubes, wiring, and transformer.

A three circuit animated flasher, for instance, requires three sets of tubes, three sets of wiring, and three transformers connected in the flasher to be fully functional.

Low voltage switches are easy to use, can be easily and inexpensively remoted (operated great distances from the point of application), are quiet and do not cause radio or television interference, or produce ozone problems. On the other hand, low voltage switching requires a bulky, heavy, expensive transformer for every circuit.

High voltage animators (distributors) produce a similar light response to the low voltage animators, but the high voltage animator does not switch the circuit on or off (figure 7-135). It distributes the current to different parts of a common circuit from a single transformer which is on constantly. The distributer, which looks like an automobile distributor, uses a wiper arm, moving in a circle, to send the current out of any one of up to ten high tension lines. Distributors are less expensive to use than low voltage animators because they require only one transformer. Their disadvantages lie in their inability to be programmed to produce complex patterns; they are diffi-

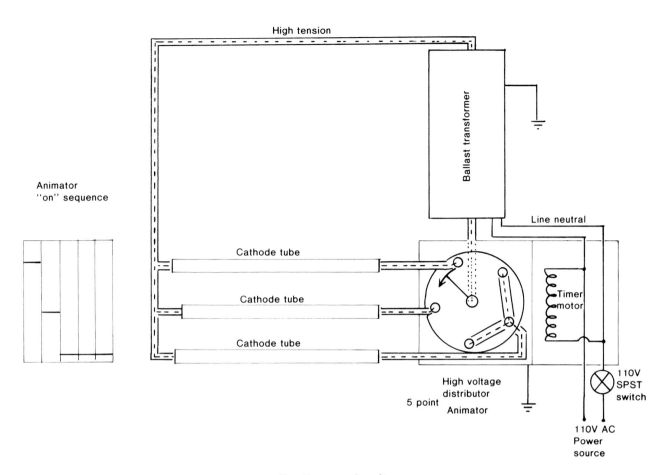

Figure 7-135. Typical high voltage distributor circuit.

cult to remote; they are noisy, and they arc constantly which produces both heat and ozone. Distributors also require more maintenance than low voltage flashers.

Commercial use of cold cathode light has been directed towards visibility and readability because the lights were designed to attract attention and to convey a message. Most neon, as a result, is brash and intense, but the cathode tubes can be designed to appear soft or delicate. Transformers are manufactured to start a tube at great intensity, then drop the intensity slightly. The intensity can be decreased further by lowering the voltage of the transformer by plugging it into a lamp dimmer or by installing a dropping resistor in the primary circuit. The lamp will remain lighted at a lower voltage than its starting voltage. Which means that the lamp may have to be started at a high voltage, then the voltage reduced to dim the tube. Mechanical or electrical circuits can be designed to start and dim the tubes automatically.

The manifold is a device comprised of a vacuum pump connection, mercury trap, gas flasks, interconnected with glass tubing and stopcocks (figure 7-131). It is used to direct the flow of gas during evacuation and filling of the cathode tube. The gas flow is con-trolled by stopcocks which require special care and handling. The stopcock consists of a glass barrel and a glass stopper with a lateral hole through which gas can pass when the cock is open (figure 7-137). Stopcocks used in the vacuum manifold must be greased and seated properly or they will leak. Unfortunately, stopcocks do not stay sealed and require frequent regreasing.

Seating a Stopcock

1. Remove the stopper from the barrel.
2. Clean the barrel and the stopper with a lint-free cloth.
3. Place a very thin film of silicon stopcock grease on the mat surface of the stopper.
4. Use a pipe cleaner to remove any excess grease from the hole in the stopper.
5. Pass the stopper about 18″ (457.2 mm) above and back and forth 15″ (381 mm) to 20″ (508 mm) over a lighted crossfire or some other clean flame to warm the grease on the stopper. The grease should be heated to about 115° F. (46.1° C.). If the stopper gets hot it will crack and the stopcock on the manifold will have to be replaced.

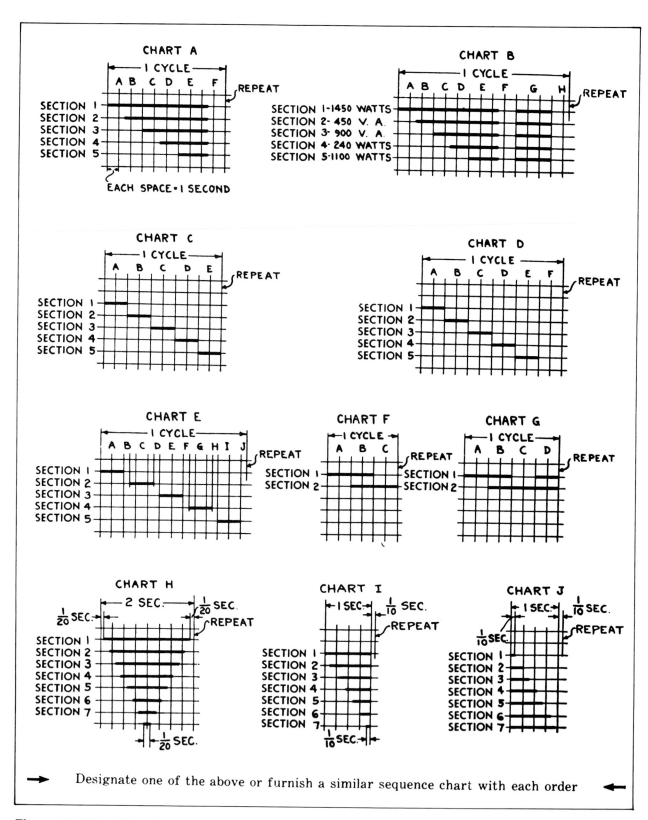

Figure 7-136. Standard sequence charts for speller type "S" flasher operation. Courtesy, Time-O-Matic, Inc.

Figure 7-137

6. Press the stopper gently into the barrel and turn it clockwise about fifteen turns. Do not press down firmly against the stopper or the grease will be forced out and the stopcock will leak.
7. Remove the stopper by twisting and lifting.
8. Clean the hole in the stopper and in the manifold with a pipe cleaner. Do not disturb the grease on the barrel or stopper.
9. Replace the stopper in the barrel and twist the stopper twenty-five times clockwise.
10. Before operating the manifold, each stopcock except those closing the flasks of gas should be rotated five or six times to rejuvinate the seal. The stopcocks should not be turned backward. If they are started counter-clockwise then they should be operated counter-clockwise.

Stopcocks also have a nasty habit of losing their seal in hot weather because the grease softens. Poorly fitted stopcocks which will seal in cold weather will frequently fail in hot weather and may have to be replaced. If the bombarder is operated in such a way that the current passes through a closed stopcock, the current may erode a fine line around the barrel or the stopper so that they will only seal with thick grease. Unfortunately leaks in stopcocks of this type are so small that they cannot be seen. They can be located only by testing for their ability to maintain a vacuum.

The creation and use of cold cathode light involves some unusual risks to the sculptor and the community unless proper precautions are observed. The most dangerous device in a neon plant is the bombarder. This is a very powerful transformer with enough power to kill instantly (for all practical purposes). The bombarder is used to heat the cathode tube during the pump down, which means that the operator may be in close proximity to the equipment while operating the manifold and the bombarder. Many neon craftsmen have been killed by the bombarder because of faulty deadman switches or thoughtlessly reaching on the work table while the bombard is on. The current from the bombarder may travel through the manifold to the operator if it is operated improrperly or is not adequately grounded. The smallest charge produced by the bombard and received through the manifold (at a greatly reduced load) will feel like being struck at the base of the skull with a huge rubber mallet. Most of the muscles of the body may be sore for a week or more from the violent contractions that will be caused by the shock, *if* the victim lives through the first few minutes.

The bombard must be isolated from the operator by a grounded heavy metal screen equipped with an interlocking switch that shuts off the bombard when the screen is moved. The bombard must also have a "deadman switch" that will shut down the bombard if the switch is released, and arranged in such a way that the operator cannot reach both the switch and the tube or bombard high tension lines at the same time. Indicator lights should be connected to the deadman switch to indicate that the system is powered and that the switch is turned on. This may be the only warning that the deadman switch is on, or perhaps is jammed and has not shut off.

The high voltage transformers used to light the tubes also produce enough power to kill, but they are much easier to handle than the bombard. A direct shock from one of the high tension leads of a 9,000V transformer will be very painful with severe pain in the muscles which may last for up to a week. Because of the electrical dangers involved, cold cathode light power supplies and systems must be installed in accordance with national and local codes.

Making a Cold Cathode Tube
1. Select the tube, color, diameter, and create the desired form by bending, joining, etc. Square and clean the ends of the tube.
2. Weld an electrode to one end of the tube. The electrode should be the same diameter as the tube if possible; if not the electrode should be the next larger size. The electrode may have to be held in an electrode holder during welding if necessary (figure 7-127E).

Figure 7-138

Figure 7-139

3. Weld a 5 mm or 6 mm stem into the side of the tube near the electrode for evacuation of the tube (figure 7-138C).

4. If a tubulated electrode is available (figure 7-138A, B), do not weld the stem into the tube; instead weld the tubulated electrode onto the remaining end of the cathode tube.

5. Turn off the vacuum pump stopcock (figure 7-132).

6. Start the vacuum pump to warm up and to pump down part of the manifold.

7. Open the tubulation stopcock and fit the nipple with a rubber pressure tube (figure 7-132).

8. Rest the cathode tube and a series of glass rods or tube shorts. Using a hand fire, weld the tubulation tube onto the manifold while applying slight air pressure to prevent the tubulation from welding closed (figure 7-139).

9. Close the tubulation stopcock.

10. Connect a 15,000 V transformer (burn-in transformer to the electrodes and turn on the transformer. There should be no light in the tube, but there might be a slight crackling or frying sound from the high voltage leads of the transformer. The bombard can be used for this step if desired.

11. Slowly open the vacuum pump stopcock and pump a slight vacuum. As the vacuum increases the tube will begin to light. The pump stopcock should be shut off as soon as the tube lights. If

the tube is over pumped, the pump stopcock can be closed and a little air admitted through the tubulation stopcock.

12. When the tube lights, turn off the pump stopcock and turn off the burn-in transformer.

13. Verify that all of the power to the transformer and the bombarder is off; check the indicator lights to be sure that the power is off (figure 7-131). Disconnect the burn-in transformer and connect the leads to the bombarder.

14. Tear several 1″ (25.4 mm) x 3″ (76.2 mm) paper strips from the pages of a telephone book; fold them tentlike and rest them on the cathode tube at each electrode and along the length of the tube, or attach a temperature indicator to the tube.

15. Close the safety screen.

16. Turn on the bombard master switch and the deadman safety switch.

17. Press the deadman safety switch for short intervals of about 1 second with about a 3 second break. The tube will begin to heat. Continue for about 10 seconds; if the tube does not begin to get hot, the voltage into the tube may be increased by depressing the choke lever.

18. After the tube has been bombarded for a short time, it will begin to heat and the voltage can be increased slightly by operating the choke. The typical choke is a coil with a heavy steel slug

which is pulled out of the center of the coil to increase the voltage supplied by the bombard. The most convenient choke arrangement consists of a foot operated device which pulls the slug out of the coil as the lever is depressed. The slug may be drawn back into the coil with considerable force so the weight of the body may have to be used to hold the foot pedal at the desired level. Continue to depress the deadman switch, gradually lengthening the "on" interval. The tube will begin to get very hot. If the tubing is smaller than 7 mm the tube should be bombarded without using the choke, as it will overheat and collapse into the partial vacuum. If the tubing is over 11 mm, the choke may have to be used extensively to bring the tubing up to heat.

19. When it is judged that the tubing is almost hot enough to scorch the paper (220° C. to 225° C.) the bombard should be held on long enough (with very short off intervals) for the electrodes to become red hot. The choke may have to be depressed in order to heat the electrodes more than the tube.

20. When the paper begins to smoke, switch off the bombard. If the cathode tube has more than two electrodes, the tube should be bombarded in segments so that each of the electrodes and lengths of tubing is only bombarded once if possible.

21. Open the pump stopcock and the #2 stopcock to the desired gas flask in order to evacuate the tube and manifold (figure 7-132).

22. When the mercury in the vacuum gauge (figure 7-132) stops descending, switch on the bombard and the deadman safety switch, tapping the deadman switch. If the tube is evacuated, the tube will not light. Pumpng may have to be continued

for a considerable time to achieve a satisfactory vacuum in the tube. Ordinarily a vacuum will be obtained before the tube is cool.

23. When the tube is evacuated, turn off the vacuum pump stopcock.

24. Close the open #2 stopcock and open the #1 stopcock to the desired gas flask (figure 7-132).

25. Turn off the #1 stopcock. A quantity of gas will be trapped between stopcocks #1 and #2.

26. Turn off the bombarder and the deadman safety switch. Disconnect the bombarder and reconnect the 15,000V burn-in transformer in order to watch the progress of filling the tube.

27. Slowly open stopcock #2 and watch the mercury vacuum gauge. Release the proper amount of gas into the tube (figure 7-139). If the pressure is too low repeat steps 23, 24, and 25.

28. The tube will be seen to light when the gas is released into the cathode tube and will increase in intensity as the pressure is increased, until excessive pressure reverses the process and the tube loses intensity and heats up.

29. If the tube has excess pressure, quickly rotate the pump stopcock to draw down the vacuum slightly.

30. Turn off the burn-in transformer and, using a hand torch, melt the tubulation closed and separate the cathode tube from the manifold near the electrode, or the tube if a tubulation stem was used (figure 7-130).

31. Connect the tube to a burn-in transformer and burn the tube for several hours. The burn-in transformer can be placed away from the manifold so that other tubes may be pumped.

32. Turn off the vacuum pump and slowly leak air into the system through the tabulation stopcock.

33. Turn off the master switch to the bombarder.

LUMINOUS-TUBE FOOTAGE CHART

NORMAL MAXIMUM NUMBER OF FEET OF TUBING OPERATED (Based on Average Grade of Tubing)

Tube Size, Millimeters columns for each section: 25, 22, 20, 18, 15, 14, 13, 12, 11, 10, 9

Secondary Voltage, Volts	Short-Circuit Current, mA	Input at Sec. Short Circuit, VA	Approx. Watts	Clear or Fluorescent Red (Also Recommended for Neon Fluorescent Gold) 25 22 20 18 15 14 13 12 11 10 9	Clear or Fluorescent Mercury Filled Tubes, All Colors – Indoor Applications* 25 22 20 18 15 14 13 12 11 10 9	Clear or Fluorescent Mercury Filled Tubes, All Colors – Outdoor Applications† 25 22 20 18 15 14 13 12 11 10 9
15,000	60	900	466	102 85 78 72 60 54 50 45 39 33 27	120 100 90 80 72 64 60 54 47 40 32	90 76 69 65 54 47 45 40 35 30 24
	30	450	234	102 85 78 72 60 54 50 45 39 33 27	120 100 90 80 72 64 60 54 47 40 32	90 76 69 65 54 47 45 40 35 30 24
	20	270	140	50 47 44 40 34 27 24	62 56 52 47 40 34 28	45 41 39 36 30 25 20
12,000	60	720	374	79 67 61 55 45 42 39 35 30 25 21	95 79 70 62 55 50 46 42 36 30 25	71 60 55 49 40 37 36 31 27 22 19
	30	360	187	79 67 61 55 45 42 39 35 30 25 21	95 79 70 62 55 50 46 42 36 30 25	71 60 55 49 40 37 36 31 27 22 19
	20	225	117	40 38 33 30 26 21 18	47 45 40 34 30 26 20	36 33 29 26 22 19 17
9,000	120	1080	561	77 65 55 46 38 34 33 30 25 22 17	92 77 63 52 46 41 38 35 30 26 20	69 59 50 41 35 31 30 26 23 19 15
	60	540	281	67 57 48 40 33 30 29 26 22 19 15	80 67 55 45 40 36 33 31 26 23 18	60 51 43 36 30 27 26 23 20 17 13
	30	270	140	67 57 48 40 33 30 29 26 22 19 15	80 67 55 45 40 36 33 31 26 23 18	60 51 43 36 30 27 26 23 20 17 13
	20	180	94	28 26 24 22 18 15 13	34 31 29 26 22 18 16	25 23 22 20 18 13 11
7,500	120	900	466	59 47 39 32 28 26 25 23 18 15 13	70 55 45 36 32 31 31 27 22 18 14	52 42 35 29 24 23 23 21 17 14 11
	60	450	234	51 41 34 28 24 23 22 20 16 13 11	61 48 39 31 28 27 27 24 19 16 12	46 37 30 25 21 20 20 18 15 12 10
	30	225	117	51 41 34 28 24 23 22 20 16 13 11	61 48 39 31 28 27 27 24 19 16 12	46 37 30 25 21 20 20 18 15 12 10
	20	150	78	22 21 20 18 14 12 10	25 25 23 21 17 13 11	19 18 18 16 13 11 9
6,000	120	720	374	46 39 32 26 22 20 19 18 15 12 10	55 46 37 30 26 24 23 20 17 14 13	41 36 29 23 19 17 17 16 14 11 9
	60	360	187	40 34 28 23 19 18 17 16 13 11 9	48 40 32 26 23 21 20 18 15 12 11	36 31 25 20 17 15 15 14 12 10 8
	30	180	94	40 34 28 23 19 18 17 16 13 11 9	48 40 32 26 23 21 20 18 15 12 11	36 31 25 20 17 15 15 14 12 10 8
	20	130	68	17 16 15 14 10 9 7	20 19 17 16 12 11 8	15 14 14 12 9 8 6
5,000	120	600	312	38 32 26 22 19 18 17 14 11 10 8	46 38 31 25 22 22 18 16 14 12 9	34 29 23 19 17 16 16 14 10 9 7
	60	300	156	33 28 23 19 17 16 15 12 9 9 7	40 33 27 22 19 19 16 14 12 11 8	30 25 20 17 15 12 14 12 9 8 6
	30	160	83	33 28 23 19 17 16 15 12 9 9 7	40 33 27 22 19 19 16 14 12 11 8	30 25 20 17 15 12 14 12 9 8 6
	20	100	52	14 13 13 11 8 7 6	17 15 15 13 10 8 7	13 12 12 10 9 8 5
4,000	60	240	125	27 23 19 16 13 12 11 10 8 7 6	32 27 22 18 16 14 13 12 10 8 7	24 20 17 15 12 11 11 10 7 6 5
	30	140	73	27 23 19 16 13 12 11 10 8 7 6	32 27 22 18 16 14 13 12 10 8 7	24 20 17 15 12 11 11 10 7 6 5
	20	90	47	11 10 10 9 7 6 5	13 12 11 10 8 7 6	10 9 9 8 7 6 4
3,000	60	180	94	17 14 12 10 9 9 8 7 6 5	22 18 16 14 12 10 10 10 8 7 6	14 12 11 9 9 8 8 7 6 5 4
	30	100	52	17 14 12 10 9 9 8 7 6 5	22 18 16 14 12 10 10 10 8 7 6	14 12 11 9 9 8 8 7 6 5 4
	20	75	39	8 7 6	10 9 8 7 6 5	7 6 6 5 5 4
2,000	30	75	39	7 6 6 5 5 4	9 8 8 7 6 6 5 5 5 4 3	9 8 8 7 6 6 5 5 5 4 3
	20	50	26	6 5 5 4 4 3	7 7 6 5 4	5 ... 2
Recommended gas pressure, mm/Hg				6 7 7½ 8 9 10 11 12 13 15	6 7 7½ 8 9 10 11 12 13 15	6 7 7½ 8 9 10 11 12 13 15

*No. B10, No. 50, or No. 1050 gas and fluorescent mercury. These footages are also recommended for OUTDOOR use where temperature does not fall below 40°F.

†No. B19 or No. 20 gas and fluorescent mercury.

Note: Deduct approximately 1 foot from the above figures for each pair of electrodes.

Figure 7-140. Luminous tube footage chart. Courtesy Jefferson Electric Company.

8
Miscellaneous Useful Information

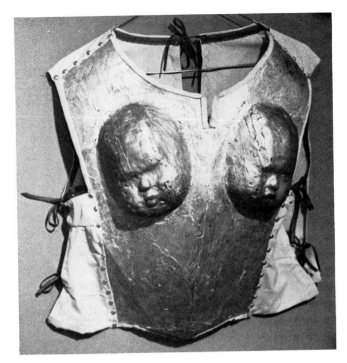

Figure 8-1. *Mother's Breast Plate,* Judith Greavu, American, (1941-), fiberglass and cloth.

Bases (Presentation)

Bases for sculpture can serve at least four functions. They may be visually separate from the art object but serve to stabilize it; they may isolate the art object; they may appear to be, to some degree, a part of the object and serve as a transitional agent; they may be purely cosmetic covering for a functional me-mechanism of the sculpture.

Of course many sculptures do not require a base of any kind. Sculptures designed around programming in which the time factor is measurable and may involve elements of nature, or sculptures which are designed to be atmospheric or aquatic may require the expansion of the concept of the base to include non mass media such as light. There concept must be functional in the nature of the base in that they must be able to either isolate the art form or serve as a transition from the environment into the art form.

The sculpture in figure 8-1 is designed to be a "situation" piece in which the placement of the work becomes a part of an aesthetic statement and as in the case of performance or programatic pieces, the consideration of a base for this piece is inappropriate.

The vast majority of sculptural forms however, have a relatively fixed position and if they are not suspended, most can use the benefits of basing.

Bases which are primarily stabilizers are designed to protect the public from the hazards of toppling and the artists from law suits. Second in importance, the base should also protect the sculpture.

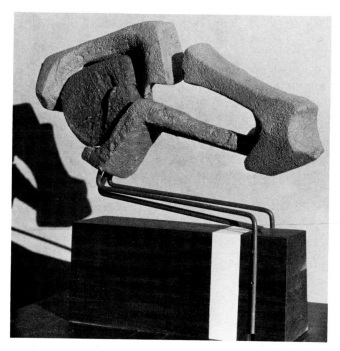

Figure 8-2. *Red Moon Streak,* Catherine A. Bell, American, (1955-), cast aluminum, acrylic plastic.

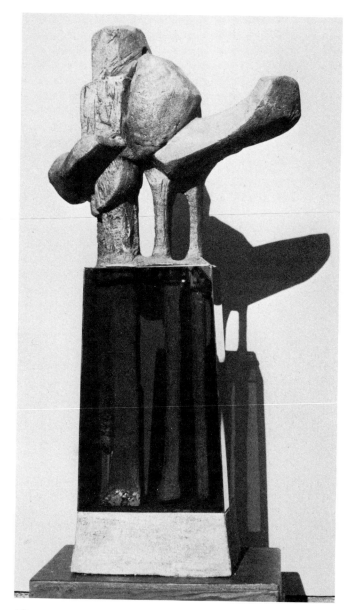

Figure 8-3. *Guardian, Second World,* Catherine A. Bell, American, (1955-), cast aluminum, acrylic plastic.

Sculptures which are visually subdued often require bases which isolate the object from the chaos of its environment. A base of this nature will make the art form appear precious and special. This effect is often achieved by a high level of contrast between materials, hue, and value of the sculpture to the base. These bases are almost always extremely simple in shape so as not to compete with the sculpture.

Transitional bases are designed to give easy visual access from the environment to the sculpture and to some extent integrates the concept of the sculpture and the environment. Bases designed to be transitional agents will often repeat design elements, such as texture, color, or rhythmic patterns occuring in the sculptural form. Transitional bases may incorporate the same as well as contrasting materials as the sculpture (figures 8-2 and 8-3).

Fully involved transitional bases may become integrated into the art form and the environment so that the function of the base as a stabilizing device may not be recognizable. It may be impossible to determine where the sculpture leaves off and the environment begins (figure 8-4).

When a base is primarily cosmetic, it usually contains or covers an electrical or mechanical device on which the art form is dependent. Many kenetic works are motorized or even computerized. When the mechanics for these sculptures are not visually compatible or significant to the form, the machinery may be covered by an independent shape. More often the base

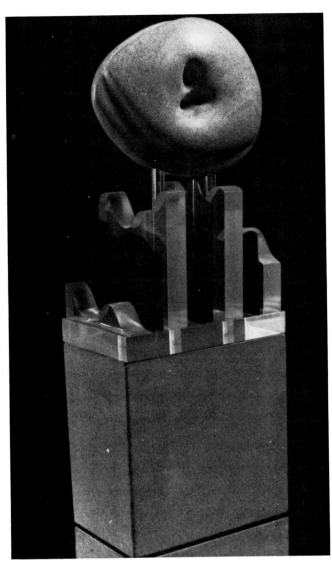

will be more than purely cosmetc; the artist being economy oriented out of necessity will when feasible combine functions and use the base as a stabilizing agent as well as a cosmetic one.

If a piece of sculpture is to be mounted on a base, it should, whenever possible, be mounted securely but semi-permanently because it is often preferable to remove a sculpture from its base for purposes of transportation, cleaning, repair, and so on.

The usual method of fixing a sculpture to a base is by pinning or bolting. Matching holes are bored in the sculpture and the base and threaded rods are cemented into the sculpture, passed through the base and locked in place with a washer and nut. The base must be countersunk or counterbored so that the nut will not protrude below the bottom of the base.

A single pin or bolt will be satisfactory on small objects but larger pieces will require at least two rods. When more than one pin or bolt is used to hold a piece to a base, the alignment of the pins becomes critical. If the pins are fastened into the sculpture before sculpture and base are connected, the pins must be perfectly perpendicular to the base and parallel to each other. If however, the pins cannot be paralled, the holes can be drilled at angles (figure 8-5) and the pins or bolts can be passed through the base into the sculpture. In this case it would be wise to thread the holes in the sculpture so that the bolts may be removed. If the bolts were to be cemented in place in this situation, the mounting might be rather permanent.

Figure 8-4. *Bakeita,* Sally A. Hobbib, American, (1952-), acrylic plastic and stone.

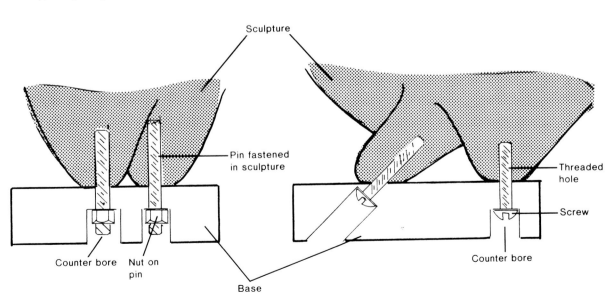

Figure 8-5

Safety Procedures

Safety Procedures in Chemical Handling

Many receipts and formulas used in this text utilize chemicals which range from mildly toxic to deadly poisonous, and from dangerously corrosive to highly explosive. Because of these hazards, individuals untrained in the handling of hazardous materials should *not* attempt to use these materials without proper supervision, proper facilities, and proper safety equipment. Lack of knowledge of standard laboratory technique could result in severe injury to the fumbling experimenter. The following rules must be observed.

1. The operator must wear proper eye and face protection. Aprons and gloves are recommended.
2. When chemicals are used that may produce vapors or fumes, the area must be properly ventilated. Acids, cyanides, and similar dangerous gas producing chemicals should be used only in closed and vented fume hoods. All cyanide solutions release prussic gases. When these solutions contact acids, large volumes of deadly gases are released. Under no circumstances should these gases be inhaled. High concentrations of these gases can be absorbed through the skin, resulting in death.
3. Never store chemicals where they will be adversely affected by heat or cold.
4. Do not store chemicals where their proximity could result in a dangerous condition.
5. When mixing chemicals, pour acid into cold water. *Do not* pour water into acid.
6. Do not use solvents or chemicals in the presence of sparks or flames without sure knowledge of the effects of fire on the chemicals and any fumes they may produce.
7. Chemicals should be stored in locked areas to prevent accidental misuse.

Safety Procedures in the Studio

1. Wear safe clothing. No neckties, baggy sleeves, no shirt tails out, no permanent press (fire hazard) no plastics, no gloves around machines.
2. Avoid adornments — rings, loose watchbands, bracelets, etc.
3. No long exposed hair. Wear a cap.
4. Use eye protection goggles and full face shields with colored lenses where appropriate.
5. Do not engage in horseplay.
6. Do not talk or otherwise divert your attention while operating power equipment.
7. Do not use compressed air to clean your clothing or body, and do not blow particles into others.
8. Do not operate equipment unless you are capable and authorized to do so.
9. Do not "invent" ways of operating equipment. Follow the directions of authorized supervisor.
10. Do not try to slow or stop coasting machines. Never grasp rotating parts or belts.
11. Do not clean chips from work or equipment with bare hands; always use a brush.
12. Do not leave machines while they are running.
13. Do not lean on or sit on machines.
14. Keep work areas free of trash scraps, oils, etc.
15. Avoid leaving rod-tubing pointed or sharp-edged stock in a position which would permit someone to walk into them. Drape cloth over the exposed ends.
16. Store flammables in safety containers, and do not store or use them around welding equipment or grinders.
17. Know where fire fighting equipment is stored and know how to use it.
18. Be familiar with all fire exits.
19. Use the buddy system. Do not work alone.

Hardware

The sculptor more than any other "hands on" artist has need of a great variety of hardware items which may be available through hardware stores, discount houses, auto supply stores, lumber yards, upholstery shops, and so on. Almost all of these businesses obtain their stock from industrial or hardware supply houses. These supply houses have catalogues showing the products, sizes, weights, quantities available, and sometimes their purpose. Modern catalogues seldom list prices; instead the companies have current price lists which they send out.

Unfortunately industrial and hardware supply houses seldom sell by the piece to individuals; they usually sell only in quantities. Sculptors with established studios should have little difficulty in establishing wholesale accounts with these firms.

Because the full catalogue of a wholesale house may contain tens of thousands of items, the catalogues are not easy to obtain, but often the companies will provide condensed catalogues of common hardware items like the one reproduced in figures 8-6, 8-7, 8-8, 8-9, 8-10, 8-11, and 8-12.

Hand Tools

Safety Procedures

1. Always use the proper well conditioned clean tool appropriate for the job.
2. Keep tools sharp and dressed with well-fitting handles when appropriate.
3. Split handles should be replaced; mushroomed chisels should be dressed.
4. Do not carry pointed tools in pockets (not even the hip pockets).

"ALLEN" HEX SOCKET SCREWS
Ask for Complete Catalog

ALLEN SOCKET SET SCREWS NC & NF THREADS

DIAMETERS	LENGTHS
#0 to #3	1/16 to 1/4"
#4 to #6	1/8 to 3/4"
#8 to 1"	1/8 to 3"

#0 to 1/2 in Stainless Steel

SET SCREW POINT STYLES

CUP CONE OVAL

HALF-DOG FLAT

See Allen Catalog

ALLEN SOCKET CAP SCREWS
NC & NF THREADS

DIAMETERS	LENGTHS
#0 to #8	1/8 to 1 1/2"
#10 to 1"	3/8 to 8"
1 1/4 to 1 1/2"	3 to 12"
STAINLESS & SILICON BRONZE	
#0 to 5/8"	1/8 to 3"

ALLEN FLAT HEAD CAP SCREWS
NC & NF THREADS

DIAMETERS	LENGTHS
#4 to 3/4"	1/4 to 3"

See Allen Catalog

ALLEN BUTTON HEAD CAP SCREWS
NC & NF THREADS

Alloy Diameters to 5/8"
Lengths to 2" long

Ask for Allen Catalog

ALLEN PIPE PLUGS

1/16 to 1 1/2" Pipe Sizes

ALLEN NUTS

#4 to 1" NC & NF THREADS

ALLEN KEYS

028 to 1" Hex

ALLEN "TRU-GROUND" DOWEL PINS

DIAMETERS	LENGTHS
1/8 to 1"	3/8 to 6"

ALLEN SHOULDER SCREWS

DIAMETERS	LENGTHS
1/4 to 4"	1/4 to 6"

ALLEN NYLOK Socket Screws

ALLEN STAINLESS STEEL SCREWS

CARRIAGE BOLTS

DIAMETERS	LENGTHS
3/16"	1/2 to 4"
1/4"	1/2 to 8"
5/16"	3/4 to 10"
3/8"	3/4 to 12"
7/16"	1 to 8"
1/2"	1 to 18"
5/8"	1 1/2 to 12"
3/4"	2 1/2 to 10"

MACHINE BOLTS

DIAMETERS	LENGTHS
1/4"	1/2 to 8"
5/16"	3/4 to 8"
3/8"	3/4 to 12"
7/16"	1 to 8"
1/2"	1 to 24"
5/8"	1 to 24"
3/4"	1 to 24"
7/8"	1 1/2 to 24"
1"	2 to 18"
1 1/8"	4 to 18"
1 1/4"	4 to 18"
1 3/8 to 2"	4 to 30"

(3 to 7 Days Delivery)

HIGH-STRENGTH BOLTS
ASTM Specification A-325.

PLOW BOLTS #3 HEAD

DIAMETERS	LENGTHS
3/8"	1 to 3"
7/16"	1 1/2 to 3"
1/2"	1 to 3 1/2
5/8"	1 1/2 to 4"
3/4"	2 to 5"
7/8"	2 1/4 to 5"
1"	3 to 5"

Heat Treated - Also NF -
Available in 3 to 7 Days
| 3/8 to 1" | 1 to 6" |

ELEVATOR BOLTS #1 HEAD

DIAMETERS	LENGTHS
3/16"	5/8 to 1 3/4"
1/4"	3/4 to 2"
5/16"	3/4 to 2"
3/8"	1 to 3"

STEP BOLTS

DIAMETERS	LENGTHS
3/16"	5/8 to 1 1/2"
1/4"	3/4 to 5"
5/16"	3/4 to 3 1/2"
3/8"	1 to 3"

STOVE BOLTS
(ROUND & FLAT HEAD)

ROUND HEAD FLAT HEAD

DIAMETERS	LENGTHS
1/8"	3/8 to 2"
5/32"	1/2 to 2 1/2"
1/4"	1/2 to 6"
5/16"	1/2 to 6"
3/8"	1/2 to 6"
1/2"	1 to 6"

(TRUSS "OVEN" HEAD)

TRUSS HEAD

5/32"	1/2 to 1 1/2"
3/16"	1/2 to 1 1/2"
1/4"	1/2 to 2"

U BOLTS

3/8 to 5" Pipe Sizes
Special Shapes & Sizes to order

EYE BOLTS – FORMED GALVANIZED

DIAMETERS	LENGTHS
5/32"	1 1/2 to 2"
3/16"	2 to 4"
7/32"	2 3/16"
1/4"	2 to 6"
5/16"	3 to 7"
3/8"	4 to 9 1/2"
7/16"	6 to 12"
1/2"	5 to 12"

EYE BOLTS – FORGED GALVANIZED

DIAMETERS	LENGTHS
1/4"	2 & 4"
5/16"	2 1/4 & 4 1/4"
3/8"	2 1/2, 4 1/2, 6"
1/2"	3 1/4 to 12"
5/8 to 1 1/2"	4 to 20"

EYE BOLTS – FORGED SHOULDER

DIAMETERS	LENGTHS
1/4 to 1 1/2"	1 to 3 1/2"

Figure 8-6. Courtesy of the Walter Gogel Co., 1819 13th St., Toledo, Ohio.

Figure 8.7. Courtesy of the Walter Gogel Co., 1819 13th St., Toledo, Ohio.

STEEL & BRASS WING NUTS

6-32 to 3/4"

HANDLE NUTS

5/16 to 3/4"

KNURLED NUTS – BRASS SCREWS

4-36 to 5/16"

ROD COUPLINGS

3/8 to 1 1/2"

WASHERS

US WROUGHT STEEL

3/16 to 3 1/2"

Also Brass, Stainless & Aluminum.

SAE WROUGHT STEEL

#6 to 1 1/2"

BEVEL WASHERS

1/4 to 1"

BRASS WROUGHT

#2 to 1 1/4"

FENDER (CANOPY, PLASTER)

1/4, 5/16 & 3/8"

LOCTITE SEALANT

"The Liquid Lock Washer"

INDUSTRIAL RETAINING RINGS

INTERNAL EXTERNAL EXTERNAL

and IRR Pliers

LOCK WASHERS

STEEL, BRONZE, STAINLESS

#2 to 2 1/2"

Hi-Collar in Stock

SHAKEPROOF – LOCK

EXTERNAL - Steel,
 Bronze,
#4 to 1" Stainless

INTERNAL

Steel, Bronze, Stainless

#2 to 1 5/16"

COUNTERSUNK

Steel Plated

#2 to 1/2"

EXTERNAL - INTERNAL

#6 to 5/8" Plated

FINISHING WASHERS BRASS

#6 to 3/8"

MACHINE SCREW WASHERS STEEL & BRASS

#4 to 1/4"
Stainless & Aluminum Available

MACHINERY BUSHING WASHERS

1 1/8 to 2 1/2" Steel

MALLEABLE RIBBED WASHERS

3/8 to 1 1/4"

COTTER PINS

ALL SIZES IN STOCK

DIAMETERS	LENGTHS
3/64 to 5/8"	1/2 to 6"

CLEVIS PINS

DIAMETERS	LENGTHS
3/16 to 3/4"	1/2 to 4"

HAIR PIN COTTERS

ROLL PINS – ESNA

DIAMETERS	LENGTHS
1/16 to 1/2"	3/16 to 4"

TAPER PINS

DIAMETERS	LENGTHS
#7/0 to 2	1/2 to 3 1/2"
#3 to 10	3/4 to 6"

KEY STOCK

ALL SIZES

WOODRUFF KEYS

ALL SIZES

THREADED ROD – (Continuous Thread)

STEEL

6-32 to 2 1/2" DIAMETERS

ALLOY STEEL A-193, Grade B7:

3/8 to 1 1/2" DIAMETERS 2H NUTS

BRASS

6-32 to 1" x 24"

ALUMINUM

1/4 to 1/2" x 24"

STAINLESS

1/4 to 3/4" x 24"

Cast Iron Also Available.

PLUG BUTTONS

1/4 to 1"

Figure 8-8. Courtesy of the Walter Gogel Co., 1819 13th St., Toledo, Ohio.

Figure 8-9. Courtesy of the Walter Gogel Co., 1819 13th St., Toledo, Ohio.

RIVETS

ROUND FLAT TRUSS COUNTERSUNK

CONE, COUNTERSUNK, & PAN HDS.
STEEL - SOLID, TUBULAR, SPLIT
BRASS - SOLID, TUBULAR, SPLIT
ALUMINUM - SOLID, TUBULAR

TRADE ARRO MARK

ANCHORING
ASK FOR ARRO CATALOG
LEAD SCREW ANCHOR (FOR WOOD &
SHEET METAL SCREWS)

SCREW DIAMETER
#6 to #24
LEAD SCREW ANCHOR

MACHINE SCREW ANCHOR

SCREW DIAMETER
6-32 to 1"
For Screws & Bolts
MACHINE SCREW ANCHOR

HAMMERLESS SETTING TOOL
SIZES
8-32, 10-24, 12-24, & 1/4"-20

CINCH TYPE ANCHORS
1/4 to 1 1/4" Threaded & Plain

EXPANSION SHIELDS
1/4 to 1" Closed & Open End

TOGGLE BOLTS
TWO WING
SPRING-TYPE
ROUND & FLAT HEADS
1/8 x 2" to 1/2 x 6"
MUSHROOM HEAD in 1/8, 3/16, & 1/4"
dia. in full inch length only.

CARBIDE MASONRY DRILLS
5/32 to 1 1/2"
ARROFLITE CARBIDE
MASONRY DRILL

CORE TYPE MASONRY DRILLS
1/4 to 4"

STAR DRILLS
3/16 to 1 1/2"

SPIRAL-DRIVE NAIL ANCHORS
3/16 to 1/2"
See Arro Catalog

JORDAN PLASTIC ANCHORS
#4 to 7/16" Sizes

CONCRETE DRILL ANCHORS

RAWLPLUGS
RAWLPLUG

DIAMETERS	LENGTHS
6	3/4 & 1"
8	3/4 to 1 1/4"
10	1 to 2"
12	1 to 2"
14	1 1/4 to 2"
16	1 1/2 & 2"
20	2"

RAWLDRILLS
See Rawl Products Catalog

"POP" RIVETS

RIVETERS

PIN GRIP
RIVETS

WALL - GRIPS
How To Install

FLATTENED END LAG SCREWS
1/4 x 3"
5/16 x 3 1/2"
3/8 x 4"
1/2 x 5"

FLATTENED END MACHINE SCREWS
10-24 x 3" & 4"
1/4-20 x 3" & 4" 3/8-16 x 3" & 4"
5/16-18 x 3" & 4" 1/2-13 x 3" & 6"

EYE SOCKETS
1/4 to 3/4"

PERFORATED HANGER IRON

TURNBUCKLES
STUB END
1/4 to 1 1/2" DIAMETERS
EYE & HOOK STYLES
1 1/2" DIAMETERS

DIE CAST TURNBUCKLES
EYE & EYE AND HOOK & EYE STYLES
5/32 to 3/8" Dia.

Figure 8-10. Courtesy of the Walter Gogel Co., 1819 13th St., Toledo, Ohio.

ROD ENDS

1/4 to 1" DIAMETERS

YOKE ENDS

10-32 to 3/4"
Tapped, Milled and Stud Holes Drilled

BEAM CLAMPS

CHAIN

"MISSING LINKS"
FORGED AND HEAT TREATED

SIZES: 3/16 to 1 1/4"
Pear shaped also available.

CLEVIS GRAB &
SLIP HOOKS

SIZES IN STOCK
1/4, 5/16, 3/8, 7/16, 1/2"

GRAB &
SLIP HOOKS

HEAT TREATED

1/4 to 1"

THIMBLES

1/8" to 1"

LOAD BINDERS – DROP
FORGED

FOUR SIZES

SAFETY SNAP HOOKS

GALVANIZED

#G-3515
CAPACITY
750 - LBS.

HOIST HOOKS

#22 to 36 (3/4 to 20 ton)

SWIVEL HOIST
HOOKS

SIZES

3/4 to 15-Tons
Capacity

ANCHOR SHACKLES SCREW
PIN GALVANIZED

SIZES

1/4 to 2"

S HOOKS

5/32 to 3/8"

SWIVELS

WELDLESS SLING LINKS

PEAR
SHAPED
SIZES

WELDLESS RINGS

ROUND
SIZES

ROPE CLIPS

Sizes
1/8" to 1"

CEILING HOOKS

Sizes #10 to #2
Plated

SCREW EYE BOLTS

SCREW EYES & HOOKS

BUTTERFIELD CUTTING
TOOLS

DRILLS

TAPS

BUTTERFIELD

REAMERS -- TAPER PIN

SCREW EXTRACTORS

MACHINE COUNTERSINKS
82° Included Angle

CARBIDE TIPPED

MASONRY DRILL

HEXAGON
RETHREADING
DIES

Figure 8-11. Courtesy of the Walter Gogel Co., 1819 13th St., Toledo, Ohio.

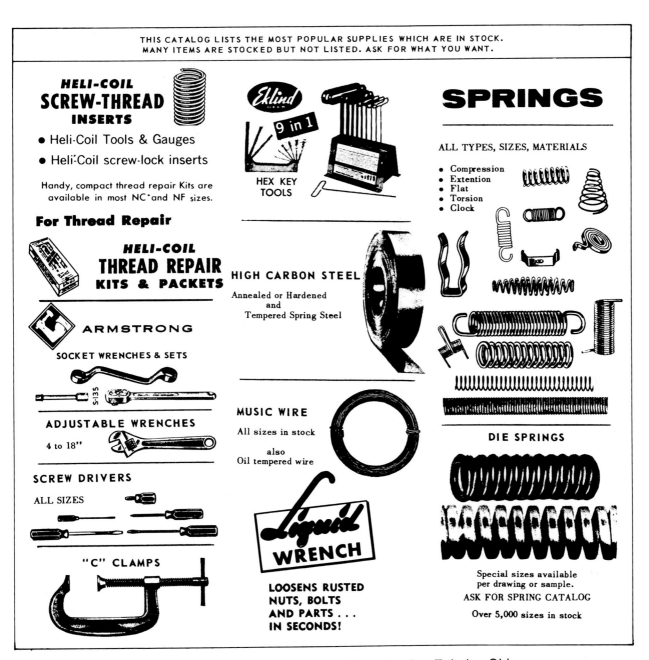

HELI-COIL SCREW-THREAD INSERTS

- Heli-Coil Tools & Gauges
- Heli-Coil screw-lock inserts

Handy, compact thread repair Kits are available in most NC and NF sizes.

For Thread Repair

HELI-COIL THREAD REPAIR KITS & PACKETS

ARMSTRONG

SOCKET WRENCHES & SETS

S-135

ADJUSTABLE WRENCHES

4 to 18″

SCREW DRIVERS

ALL SIZES

"C" CLAMPS

Eklind **9 in 1**

HEX KEY TOOLS

HIGH CARBON STEEL

Annealed or Hardened
and
Tempered Spring Steel

MUSIC WIRE

All sizes in stock

also
Oil tempered wire

Liquid **WRENCH**

LOOSENS RUSTED NUTS, BOLTS AND PARTS . . . IN SECONDS!

SPRINGS

ALL TYPES, SIZES, MATERIALS

- Compression
- Extention
- Flat
- Torsion
- Clock

DIE SPRINGS

Special sizes available per drawing or sample.

ASK FOR SPRING CATALOG

Over 5,000 sizes in stock

Figure 8-12. Courtesy of the Walter Gogel Co., 1819 13th St., Toledo, Ohio.

Clamps

There are three types of clamps that are quite useful to the sculptor. They are screw clamps, spring clamps, and cam action clamps. The most common types follow:

Screw Clamps

Hand Screws—These clamps consist of two opposing wooden bars and two parallel threaded shafts which adjust the angle and spacing of the wooden jaws. They are considered to be cabinet makers' clamps and are excellent for laminating (figure 8-13A).

"C" Clamps—Sometimes known as "G" clamps, these are the cheapest and most common of the screw action clamps. These clamps come in three types.

All consist of a metal "C" shaped frame, the best of which are malleable iron, and have one or more screws to hold the work rigid. Multiple screw clamps are usually used for edging plywood but they are also fine for clamping up difficult welding jobs (figure 8-13D and 8-13E).

Pipe Clamps—Pipe clamps are similar to "C" clamps except that the back bone of the clamp is a tube or a pipe and the head and tail stock of the clamp can be moved along the pipe to vary the clamping distance (figure 8-13B).

Bar Clamps—The bar clamp is similar to the pipe clamp except that a bar is substituted for a pipe (figure 8-13C).

Miscellaneous Useful Information 245

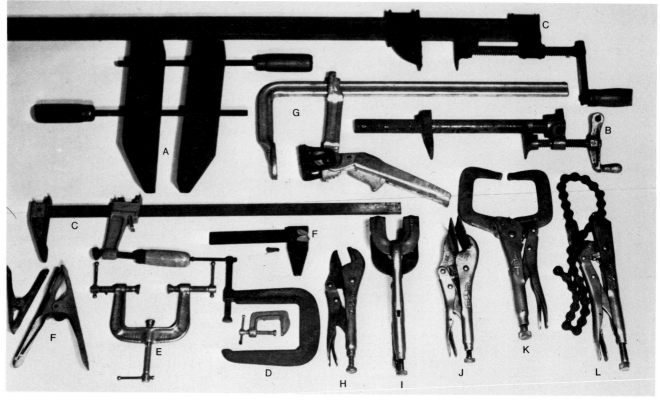

Figure 8-13

Spring Clamps—Spring clamps rely on springs built into the clamps (often in the handle like a clothes pin). They exert constant but yielding pressure. They are good for quick light work but cannot exert unyielding pressure typical of screw or cam action clamps (figure 8-13F).

Cam Action Clamps—Cam action clamps depend on leverage exerted by an eccentric or an "over the center" lever to hold the work. These clamps come in a variety of types such as bar clamps (figure 8-13G), chain tightners, pliers (Vice-Grips®) and so on. Vice-grips are available in a large variety of types and can be altered by cutting and welding convenient shapes in the jaws. Standard shapes include the pliers type (figure 8-13H), welding grips (figure 8-13I), sheet metal grips (figure 8-13J), "C" clamp grips (figure 8-13K), and chain grips (figure 8-13L). The cam action is limited in the length of its clamping action, but is much faster and more positive in operation than other clamps. Even though the cam action has a very limited stroke, it can exert tremendous pressure.

Most clamps use rigid structures. One variety of clamp which does not have a rigid structure is the column clamp (band or flexible). It consists of flexible bands, chains, nylon, or canvas webbing and a taughtening mechanism. These clamps are useful for squeezing irregular shapes, such as fluted columns or guitar bodies. The nylon web belt variety commonly found in discount houses often have tremendously strong belts but weak tension devices.

There are a great many special half clamps that can be acquired from suppliers of odd and unusual tools. Half clamps are designed to be attached to a bench, the floor, wall, or whatever so that the taughtening device will be able to work in opposition to the bench or table, etc.

Chisels

Chisels are constructed with tangs or sockets to hold a handle (figure 8-14A and 8-14B). Tang chisels are the most common and the least expensive of the chisels. They are also hard on the wooden handles, with which they are usually equipped. The tang acts like a wedge and may split the handles, which can be made somewhat more durable if they are grooved for a binding wire at each end of the handle. The wire should be covered with a fabric or plastic tape to protect the hands of the operator. The sculptor will discover two broad classes of chisels—those used in carpentry and construction, and those used in carving. The carving chisels are usually the tang type and are smaller in cross section than construction or carpentry tools.

Construction and carpentry chisels are available in the following types:

The firmer chisel—strong thick blades.

The paring chisel—thin slender blade often tapering along the edges.

The framing chisel—very heavy squarish blade, usually the socket type with an iron binding ring around the top of the handle.

The butt chisel—similar to any of the above but very short.

The mortising chisel—similar to a firming chisel but thick near the handle so that it can be used as a lever.

The gouge—gouges are chisels that are curved in their crossection. Gouges that are sharpened on the convex side of the blade are called inside-bevel gouge, the opposite are called outside-bevel gouge. Some gouges have offset handles and are known as bent shank gouges.

Carving chisels are available as gouges, parting chisels ("V" shape blade), skew chisels (thin chisel with a cutting edge not perpendicular to the edge of the shank), veining chisels (very narrow "V" shaped blade) (figure 5-14).

The adz is a tool similar to the chisel (figure 5-15). Its purpose is the same except that the adz has a head area and a handle like a hammer, but it has chisel or axelike blades. The hand adz (sculptor's adz) is used like a hatchet except that it is not designed to split; it is designed to skim the wood and take off thin chips. The foot adz, sometimes called a grub hoe, is used in a manner similar to a pick. The operator stradles the work and the foot adz is swung skimming the work between the feet. The foot adz can be a dangerous tool. It has been used for leveling the surface of large blocks of wood or for squaring up timbers. Both the hand and foot adz save the sculptor a little work because they are simpler to use than the chisel and mallet and they have more weight which does the work.

Figure 8-14

Files, Rasps and Rifflers

Files have cutting edges that are the result of grooves cut in parallel rows. Single cut files have one row of parallel cutting edges that are oblique to the length of the file (figure 8-15A). Double cut files have two rows of cutting edges at angles to each other, forming a diamond like pattern (figure 8-15C). Open cut files are similar to single cut except that the cutting edges are not continuous (figure 8-15B). They are open at regular intervals.

Files are designed for different degrees of cut ranging from the coarsest to the smoothest: course, bastard, second cut, smooth, and dead smooth. They are also available in various shapes i.e., blunt (constant cross sectional size), taper (narrowing width but the same thickness), and square, round, half round, triangular, and flat (all of which may have varying cross sections).

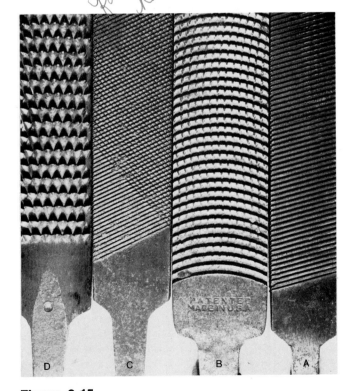

Figure 8-15

Type of file	Cut	Use
Mill file	Single cut Bastard	general purpose finishing brass and bronze finishing
Flat Taper	Double cut Bastard	common file, general purpose
Flat Taper	Second cut	common file, general purpose,
	Smooth cut	finishing steel, general purpose
	Dead smooth cut	finishing steel, general purpose
	Double cut	used for finishing flat surfaces
Hand file taper in thickness	Bastard Second cut Dead smooth	hand files have safe edges
Square file	Double cut Bastard	used for enlarging or shaping holes
Round file (rat-tail-file)	Bastard Single cut Double cut	used for shaping concave surfaces and enlarging and shaping holes
Half-round file, Taper	Second cut Double cut Dead smooth	for finishing concave surfaces
Triangular (three square)	Double cut Bastard	for filing corners and acute angles
Half-round Wood file	Double cut Coarse	used for shaping wood and coarse cutting brass
Cabinet file	Double cut Coarse Bastard	used for shaping and smoothing wood
Combination file, half-round	Flat and half-round rasp and coarse single cut sections	utility and dual purpose wood and soft stone in short sections
Body files	Single coarse curved cut	used for fast cutting and finishing leaded surfaces
Aluminum files	cross between open cut and double cut	used for cutting and finishing aluminum, non-clogging

File cuts

Number

Toolmaking File	Domestic File	
000 00 0 1 2 3 to 8	Rough Bastard Second cut Smooth Super smooth	Coarse cutting Medium cutting Medium cutting Fine cutting Extra fine cutting Extra fine cutting

Figure 8-16. Common files and rasps and their uses

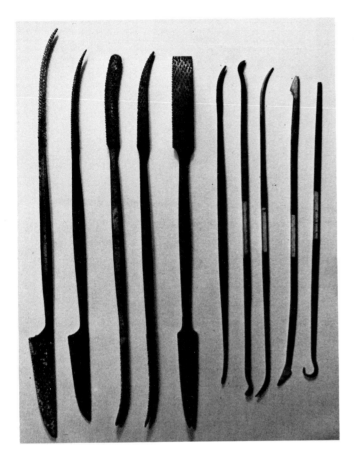

Figure 8-17

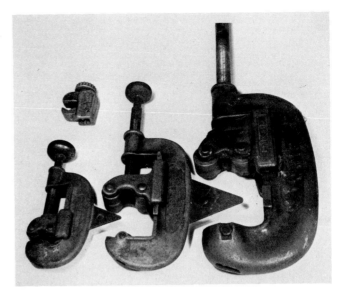

Figure 8-18

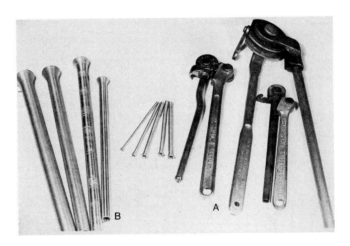

Figure 8-19

Not all of the surfaces of a file are toothed. Clear surfaces are called "safe." There are also open face single cut rasps typical of the "Stanly SurformT". This tool is a cross between the file and a chisel.

Rasps, unlike files, do not have teeth in tight parallel rows (figure 8-15D). The teeth are individually shaped gouged up projections, and do not come in as great a variety of shapes as do files. The most common rasps are the round and 1/2 round. A new style rasp-like material is being marketed which is like the pierced hardened steel sheet of the SurformT, but comes in sheets like sandpaper, and is called dragon skin.

Rifflers are tools which have the shapes of files (triangular, round, square, half round, etc.) and the cut of the file, but the teeth are made like the teeth of the rasp. Only the ends of the riffler, which are often curved, are toothed. Rifflers are used to shape or finish hard to reach areas (figure 8-17).

Tubing Benders and Pipe Cutters

Specialized tools are available to bend tubing without kinking it and to cut it cleanly and accurately. The pipe cutter (figure 8-18) is placed over the pipe so that the pipe fits in the rollers and the handle

screwed against the pipe. The cutter is then moved around the pipe while the handle is screwed tighter until the pipe separates. This style cutter will cut heavy iron pipe as well as copper or aluminum.

Bending tubing and pipe without kinking it is a difficult problem. It is possible to pound a pipe full of sand, cap the ends and bend it over any solid rounded shape, but it is difficult to ram the pipe tightly enough to prevent the tube from collapsing.

Small diameter tubing can be bent with tubing benders (figures 8-19 and 8-20) used in the aircraft industries if the tool is lightly greased and the tubing bent a little at a time. These benders create a rather small radius and are somewhat inflexible for the artist. The spring wound benders (figure 8-19B) available in some discount houses will allow reasonably shallow bends but will not prevent the tubing from collapsing in a tight bend.

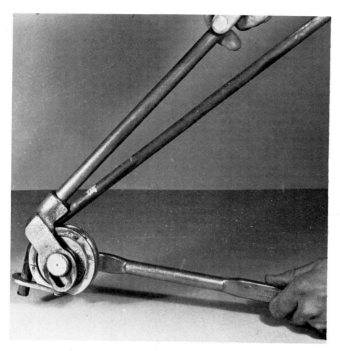

Figure 8-20

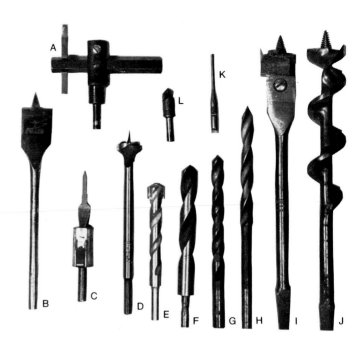

Figure 8-21

Safety Precautions—Drill Press

1. Clamp up work securely. Use a stop to hold down thin stock.
2. Do not leave the chuck key in the chuck.
3. Wear safe clothing.
4. Use the appropriate drill for the job.
5. Wear safety goggles.
6. Do not slow or stop the coasting quill or chuck with the hands.
7. Do not wear gloves while operating the drill.
8. Do not touch freshly drilled work or chips as they may be very hot.
9. Keep all safety covers, etc., intact.

Drills

A drill is a device which turns a tool known as a bit which is designed to bore a hole. Naturally not all materials can be easily bored with the same kind or style of bit and not all styles of bits will run straight or can be run at the same speed.

The flycutter in figure 8-21A is a high speed cutting tool used in a drill press to cut large holes in thin wood or similar material. It should not be used in hand drills or run at slow speeds.

The spade bit (figure 8-21B) is an inexpensive but reasonably efficient bit for boring large straight holes in wood, some plastics, and similar materials. It cannot be used on most metals. It should only be used in a drill press and run at high speeds.

The combination bit with the depth gauge (figure 8-21C) is similar to a spade bit except that it bores

two sizes of holes and countersinks for the head of a wood screw. This bit can be used in any type of drill and works best when run moderately fast.

The inexpensive modified Foerstner bit in figure 8-21D is used for boring large diameter holes in soft materials like wood. They are often used in the manufacture of furniture because they drill straight holes and do not wander.

The masonry bit (figure 8-21E) is a twist drill onto which a cutting bar of silicon or tungsten carbide has been brazed. It is used to drill through cement and many kinds of stone. This bit should be used in power drills at slow speed and pressed firmly into the hole. Light pressure may chip the carbide.

The bit (figure 8-21F) is a carbon steel twist drill with a 1/4″ shank. It is used to drill wood, plastic, and soft metal at moderately slow speeds. The 1/4″ shank permits the bit to be used in small electric hand drills.

The High Speed steel twist drill bit (figure 8-21G) is typical of drill bits used for wood, plastic, and most common metals (except hardened steels, stainless steel etc.). The cutting edges must be altered for various materials and the bits should be turned at the appropriate speed and properly lubricated (figure 8-30). This kind of drill bit is probably the most common bit available.

The wood boring bit (figure 8-21H) is an inexpensive bit for boring wood. It can be turned at moderate speeds, will bore deep, reasonably straight holes at production speeds, and cannot be used on metal.

The bit in figure 8-21I is an expanding wood boring bit and is used for boring rough holes of almost

Num-bered & Lettered	Frac-tional	Decimal Equiva-lents	Num-bered & Lettered	Frac-tional	Decimal Equiva-lents	Num-bered & Lettered	Frac-tional	Decimal Equiva-lents	Num-bered & Lettered	Frac-tional	Decimal Equiva-lents
800135	420935		13/64	.2031		13/32	.4062
790145		3/32	.0937	62040	Z4130
	1/64	.0156	410960	52055		27/64	.4219
780160	400980	42090		7/16	.4375
770180	390995	32130		29/64	.4531
760200	381015		7/32	.2187		15/32	.4687
750210	371040	22210		31/64	.4844
740225	361065	12280		1/2	.5000
730240		7/64	.1094	A2340		33/64	.5156
720250	351100		15/64	.2344		17/32	.5312
710260	341110	B2380		35/64	.5469
700280	331130	C2420		9/16	.5625
690292	321160	D2460		37/64	.5781
680310	311200	E	1/4	.2500		19/32	.5937
	1/32	.0310		1/8	.1250	F2570		39/64	.6094
670320	301285	G2610		5/8	.6250
660330	291360		17/64	.2656		41/64	.6406
650350	281405	H2660		21/32	.6562
640360		9/64	.1406	I2720		43/64	.6719
630370	271440	J2770		11/16	.6875
620380	261470	K2810		45/64	.7031
610390	251495		9/32	.2812		23/32	.7187
600400	241520	L2900		47/64	.7344
590410	231540	M2950		3/4	.7500
580420		5/32	.1562		19/64	.2969		49/64	.7656
570430	221570	N3020		25/32	.7812
560465	211590		5/16	.3125		51/64	.7969
	3/64	.0469	201610	O3160		13/16	.8125
550520	191660	P3230		53/64	.8281
540550	181695		21/64	.3281		27/32	.8437
530595		11/64	.1719	Q3320		55/64	.8594
	1/16	.0625	171720	R3390		7/8	.8750
520635	161770		11/32	.3437		57/64	.8906
510670	151800	S3480		29/32	.9062
500700	141820	T3580		59/64	.9219
490730	131850		23/64	.3594		15/16	.9375
480760		3/16	.1875	U3680		61/64	.9531
	5/64	.0781	121890		3/8	.3750		31/32	.9687
470785	111910	V3770		63/64	.9844
460810	101935	W3860	1		1.0000
450820	91960		25/64	.3906			
440860	81990	X3970			
430890	72010	Y4040			

Figure 8-22. Drill sizes—lettered, numbered, and fractional.

any depth and various diameters in construction work. This bit is usually turned slowly by hand in a brace rather than a drill. They may be used in a very slow turning electric drill equipped with a chuck adapter, but are dangerous and inaccurate when used this way.

The auger bit (figure 8-21J) is similar to the expansion bit except that it cannot drill more than one size hole. These bits can be found in antique shops in sizes up to 4″ in diameter, and they are often supplied with their own handle because they are too large to be turned by an ordinary electric drill.

The bit in figure 8-21K is a screwdriver driven straight fluted drill bit. It is often supplied with ratchet drills or ratchet screwdrivers. This style bit will drill small accurate holes in wood and will not drill metal.

The tool illustrated in figure 8-21L is a countersink used to taper the edges of a hole to match the shape of the heads of countersink screws. Countersinks are available in various angles and for various materials. They are especially common for aluminum and wood and should be turned moderately fast in power drills.

Drill bits occasionally cause problems, usually binding, breakage, or rough or oversized holes. Whenever problems are encountered in drilling, the work should be checked to ascertain that it is held firmly and not flexing. The drill should be checked to make sure that it is suitable for the material being drilled, and that it is correctly sharpened for the material. Finally the lubricant should be verified as satisfactory. Common problems and their causes follow:

Problem	Cause
Drill breaking	improper drill shape
	feed speed too great
	failure to clear chips from deep holes
	dull drill
	poorly tempered bit (bargain imported bits)
	work not held firmly
Corner of cutting edges breaking or rounding	improper drill shape
	bit turning too fast
	bit running hot, improper lubrication
	poor material, some materials such as cast iron may have sand inclusions or scale
	wrong material for the drill
Hole too large	improper drill shape
	worn drill press
	work not held firmly
	chips not cleared from the hole
Rough hole	dull drill
	improper lubrication
	feed speed too great
	failure to clear chips
	old drill worn to a taper

Wood bits designed for use in hand tools such as a brace or breast drill have square shanks and cannot be used in the chucks of power tools without adapters. The round shanks of drill bits for power tools generally cannot be tightened adequately in the chucks of the brace or the breast drill. Fitting the wrong type of shank in a drill chuck will usually result in an unsatisfactory boring experience.

Taps and Dies

Taps and dies are tools designed for cutting threads in a hole or on a rod. There are four common types of taps available. The rethreading tap is a tap that is designed to repair damaged threads and should not be used to cut new threads. The tap most often encountered is a plug tap that is used to cut new threads through the work or in a deep hole. It is not satisfactory for use in a shallow (blind hole). Plug taps are sometimes used to start a thread in a shallow blind hole then they are ground down to make a bottoming tap to finish the hole. Bottoming taps differ from plug taps in that they do not have much taper and can thread to the bottom of a shallow blind hole. Taper pipe taps are designed for cutting threads for pipe fittings and produce a thread which will tighten and make a leak proof joint.

In order to properly tap a thread a correctly bored hole of the right size must be drilled to match the tap (figure 8-23). For the most part a 75% thread will give as strong a thread as the sculptor will require so the drill chart (figure 8-31) gives the drill size for a 75% thread. The entrance to the hole to be tapped should be countersunk slightly to give the tap a start. Once the hole is drilled and countersunk the tap should be inserted in a tap handle and started in the hole. The tap and the hole should be properly lubricated (figure 8-30). The tap must be started straight in order to prevent damage to the stock and breakage of the tap (figure 8-24). In difficult cases the tap can be inserted in the chuck of a drill press and aligned with the hole to assure a good start. The tap should then be turned clockwise (for right hand threads). As the tap cuts, metal turnings will spiral into the flutes of the tap. If these turnings are not broken by backing out the tap every quarter or half turn, the tap will jam and probably eventually break in the hole. If the material being tapped requires lubrication it must be kept flooded through the entire process. When the hole is threaded the tap should be backed out and the hole cleaned (figure 8-25).

The process of cutting a thread with a die is similar to tapping. The rod to be threaded should be beveled to help start the cut and the rod should be from .005" to .010" smaller than the nominal size of the die. The die to be used should be inserted in a die holder and turned down at right angles to the rod. The work should be kept lubricated if required (figure 8-26), and the die should be backed off every quarter to half turn to break up the chips.

Taps and dies are identified by a standard marking system established by the Metal Cutting Institute. The tools are identified by the thread diameter, the number

Figure 8-23

Figure 8-24

Figure 8-25

Figure 8-26

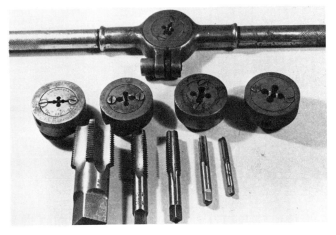

Figure 8-27

of threads per inch, and a symbol establishing the thread type. Common thread types available follow:

NC—National Coarse (U.S.S.)
NF—National Fine (S.A.E.)
NS—National Special (Non-standard number of threads per inch)
NPT—National Pipe Taper
Metric—International metirc thread

Taps and dies can be acquired individually or in sets (figures 8-27 and 8-28) which consist of a variety of taps, matching dies, a tap handle, a die holder, and a thread gauge (figure 8-29). The thread gauge is used to determine the thread by pitch, size, and number of threads per inch.

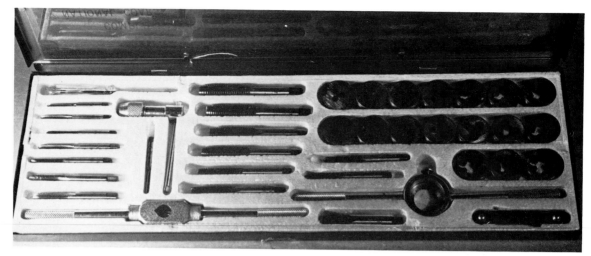

Figure 8-28

Figure 8-29

Nickel alloy	sulphurized mineral oil
Steel	lard oil, cutting oil (sulphur based)
Carbon sheet steel	sulphur based oil
Cast iron	no lubricant—clear flutes with air blast
Acrylic plastic	kerosene
Aluminum bronze	kerosene 1 part and lard oil 2 parts
Cast brass	kerosene, light mineral oil, soluable oil
Magnesium	no lubricant, mixture of 1 part lard oil, 3 parts kerosene, 9 parts mineral oil
Zinc	kerosene
Laminated plastic	no lubricant, water
Bakelite	no lubricant
Hard rubber	no lubricant, commercial tapping oil
Bronze	kerosene, soluable oil
Stainless steel	kerosene and lard oil mix, soluable oil with sulphur added, lead paste mixed with high sulphur based lard oil

Figure 8-30. Drilling and threading lubricants.

To tap a thread (75% full thread) for a screw.

Tap size		Drill size		Decimal Equivalent	Nearest fract. drill size in inches
		Number	Letter		
4 x 36	NS	44		.0860	
4 x 40	NC	43		.0890	3/32
6 x 32	NC	35		.1065	7/64
8 x 32	NC	29		.1360	9/64
10 x 24	NC	25		.1495	5/32
12 x 24	NC	16		.1770	11/64
1/8 pipe thread		5/16		.3125	5/16
1/4 x 20	NC	7		.2010	13/64
5/16 x 18	NC	17/64"	F	.2656	17/16
3/8 x 16	NC	5/16"		.3125	5/16
7/16 x 14	NC	3/8"	U	.3750	3/8
1/2 x 13	NC	27/64"		.4219	27/64
9/16 x 12	NC	31/64"		.4844	31/64
5/8 x 11	NC	17/32"		.5312	17/32
3/4 x 10	NC	21/32"		.6562	21/32
4 x 48	NF	42		.0935	
5 x 44	NF	37		.1040	
6 x 40	NF	33		.1130	
8 x 36	NF	29		.1360	9/64
10 x 32	NF	21		.1590	5/32
1/4 x 28	NF	3		.2130	7/32
5/16 x 24	NF	9/32"	I	.2812	17/64
3/8 x 24	NF	21/64"	Q	.3281	21/64
7/16 x 20	NF	25/64"		.3906	25/64
1/2 x 20	NF	29/64"		.4531	29/64
9/16 x 18	NF	33/64"		.5156	33/64
5/8 x 18	NF	37/64"		5781	37/64
3/4 x 16	NF	11/16"		.6875	11/16

Note: Taps and Dies must be continuously lubricated while in use. Ordinary machine oil will yield rough or torn threads; cutting oils are available at most hardware stores.

Figure 8-31. Common taps and drill sizes.

Marks or symbols for identifying threads on taps.

NC National Coarse (U.S.S.)
Coarse thread suitable for rugged construction.
NF National Fine (S.A.E.)
Fine thread with shallow depth of thread suitable for use in plugging chaplet holes in cast metal.
NS National Special (non standard number of threads)
NPT National Pipe Taper
Thread used in the construction of water pipe armatures.

Dies are used to thread rods to make screws or to put threads on pipe so that they can be connected. The die is marked with the size rod which is to be threaded A 1/4" rod would be threaded with a 1/4" die.

Threads which have been blocked by broken screws can sometimes be cleared by drilling a small hole in the center of the screw and inserting an "easy out" which when pressed into the hole and turned counterclockwise (for right hand threads) should back out the broken screw (figure 8-32). The "easy out" identified as figure 8-32B is by far the most efficient though the most expensive and the hardest to obtain. This tool should be driven lightly into the hole in order to establish a grip and then turned out with a wrench.

"Easy outs" will not remove a tap which is broken off in a hole because the taps are too hard to drill and too hard for the "easy out" to dig into in order to establish a grip. Taps can sometimes be loosened by placing a few drops of nitric acid in the hole to etch away some of the thread surface. The tap is then juggled back out of the hole and the acid neutralized with baking soda.

Figure 8-32

Power Tools

Safety Precautions

The Circular Saw

1. The table saw (circular saw) should never be operated by an untrained person.
2. Individuals subject to medical disabilities such as epilepsy or split vision, accident prone, nervous or mechanical morons should *never* operate the circular saw.
3. Do not operate the saw with improper or badly set dull blades. The teeth should point toward the operator.
4. Do not work on a slippery or cluttered floor.
5. Mind your business. Do not talk to others or otherwise allow your attention to be diverted.
6. Use the proper guards. (The splitter and saw guard).
7. Do not cut with the blade higher than 1/4" (6.35 mm) above the work.
8. Use a notched push stick to move the work past the blade.
9. Do not reach over the blade for any reason or at any time.
10. Wear safe clothing. (Nothing loose or hanging.) No gloves.

Figure 8-33

11. Do not saw "free hand." Use the fence or the square (mitre gauge).
12. Do not place stock against the square and fence at the same time.
13. Wear proper eye protection.
14. Avoid standing in line with the cutting line (kick back may throw the stock into the operator with considerable force).
15. Do not allow sawdust to accumulate under the saw (a gummed up blade may heat up enough to set fire to the waste).

Band Saw

1. The floor and machine must be free of scraps and sawdust.
2. Use the proper blade and cutting speed.
3. Check blade alignment and set the foot of the upper blade guide one-fourth inch above the thickest part of the work.
4. Wear eye protection
5. Wear safe clothing.
6. Do not use throat plates with excessive blade clearance.

7. Do not free cut cylindrical stock. Hold short stock in a square (miter gauge).
8. Do not push the fingers close to the blade.
9. Do not stand where a broken blade can cause injury.
10. If a blade breaks, turn off the machine immediately; do not touch the blade until the wheels come to a complete stop.

The speed of a band saw blade can be determined by painting a 3" white mark on the outside of the blade so that it can be seen while the saw is running. Then by counting the number of times the white mark passes a predetermined mark such as the saw table in one minute and multiplying that number by the number of feet in the blade.

The Reciprocating Saw
(Sabre Saw—Do All—Jig Saw)

1. Ascertain that the blade is fixed firmly in position.
2. Use the proper blade. The wrong type blade may cause the blade to seize and shake the tool violently, or may break the blade sending it flying with considerable force and speed.

Material	Thickness of Material					
	Under 1/4"		1/4" to 3/4"		1" and over	
	Teeth per in.	Feet per min.	Teeth	FPM	Teeth	FPM
Angle iron	24	160	14	160		
Chromium steel	24-18	85	14	60	14	40
Cold Rolled Steel	24-18	220	14	220	14	160
Drilled rod	14	85	14	60		
Nickel steel	18	40	14	40	14	40
Silicon Manganese	18	85	14	85	14	60
Stainless Steel	24	40	14	40	10	40
Structural Steel	24	160	14	160	14	115
Brass	18	335	14	335	10	335
Bronze-Aluminum	18	335	14	335	14	335
Bronze Manganese	18	160	14	115	14	85
Bronze Naval	18	160	14	115	14	85
Bronze Phosphorus	18	335	14	335	14	220
Cast Iron Gray	18	115	14	85	10	60
Cast Iron Malleable	18	160	14	115	14	85
Cast Steel	18	160	14	115	14	85
Monel	18	115	14	85	10	60
Nickel Silver	18	220	14	220	14	220
Silver	24	220	18	220	14	220
Slate	24	335	18	220	14	160
Transite	24	335	18	220	14	85
Bakelite	10	335	10	330	10	160
Mica	32	350	24	300	14	250
Rubber (Hard)	14	5000	10	4500	6	3500

Figure 8-34. Band saw blades and suggested operating speeds.

Material	Feet per minute	Under 1/2"	1/2" to 2"	Over 2"
Aluminum	3000	3	3	3
Magnesium	3000	3	3	3
Hardwood	3000	6	4	4
Plywood	3000	6	4	4
Softwood	3000	6	4	4
Plastics	3000		4	4

Band saw blades are limited as to the smallest diameter that they can cut by the width of the blade.
Minimum radii for band saw blades

Width of blade	1/16"	3/32"	1/8"	3/16"	1/4"	3/8"
Minimum radius	3/32"	1/8"	7/32"	3/8"	5/8"	1 1/4"

Figure 8-35. Suggested skip tooth band saw blades.

Material to be cut	Blade Metal	Type Cut	Material Thickness	# Teeth per inch*
Rough lumber	Hi-carbon steel	Straight line-fast	over 1"	3-4
hardwood	"	Keyhole-roughing-in	over 1/2"	6
composition-plastic	"	"	over 1/4"	8
green wood	"	straight line	"	6
wood	"	smooth finish	"	8 (hollow ground)
Misc. material with embedded nails, non-ferrous metals, abrasive materials, etc.	Hi-chrome alloy steel	any cut	over 1/2"	6
"	"	"	1/4"-1/2"	10
Nonferrous	Hi-speed steel	any cut	1/4"-1"	10
Ferrous metal	"	"	3/16"-3/8"	14
"	"	"	1/8"-1/4"	18
"	"	"	1/8" or less	24

*Never have fewer than two teeth in the cut at one time or teeth may be broken out of the blade.

Figure 8-36. Characteristics of saw blades for high speed reciprocating saws.

3. Do not cut without adequate clearance for the blade below the cut line. If the top of the blade strikes down on a solid surface, it will usually break.
4. Do not attempt to reinsert the blade in the cut line while the saw is running.
5. Do not saw in such a position that the switch cannot be released immediately.
6. Do not saw blind (across close areas which cannot be inspected for electric wires—gas lines).
7. Do not rest materials to be cut on your lap or support the cut line with any part of the body.
8. Do not saw in the presence of flammable gas or liquids.
9. Clean metal residue from working area. Metal chips are slippery and sharp.
10. Do not touch the blade or reciprocating parts of the saw while it is in motion. (The tip of the blade may not be visible while the saw is running.)
11. Do not touch the hot blade after finishing a cut.
12. Be careful of the sharp burr on the cut edge in metal.
13. Wear proper eye protection.

Power Hacksaw

1. Do not adjust the saw or clamp up work unless the machine is turned off.
2. Do not use cracked, broken, or too thin blades.
3. Support long stock being cut.
4. Do not drop the frame or blade onto the work.
5. Wear safe clothing.
6. Avoid the moving frame while the machine is in operation.
7. Use care to avoid being cut by the saw blade or by sharp edges of burrs left in freshly cut stock.
8. Wear adequate eye protection.
9. Use the proper blades (improper blades or blade use will occasionally cause a blade to shatter with explosive force, sending shrapnel all over the shop).

Pedestal Disc Sander

1. Do not wear loose clothing.
2. Wear proper eye protection.
3. Do not operate the sander without operating dust removal equipment.
4. Clear the floor and the machine of sawdust before operating the sander.
5. Work from the front of the sander.
6. Do not operate the sander while someone is standing at either side of the sander.
7. Be certain that the sander disc is properly adhered and centered.
8. Do not use a torn or cut disc.
9. Sand on the down side of the disc only.
10. Use a miter guide or fence to help control the material being sanded.

Figure 8-37

11. Do not touch the spinning disc.
12. Do not sand objects containing plastics, fiberglass, metals, or stone without wearing a respirator.
13. Do not sand the end grain of long lengths of material without a guide or back stop.
14. Do not surface sand thin stock without a holding stick.
15. Do not allow the fingers or knuckles to touch the moving disc.
16. Do not sand metals (especially iron, aluminum, or magnesium) in a dusty atmosphere or in the presence of metal dust or wood flower residue around the machine on the floor.
17. Do not sand objects containing asbestos, or which are normally toxic or allergenic (cocobolo—greenhart—poison sumac).

Hand Grinders—Sanders—Polishers

1. Wear proper eye protection.
2. Do not wear loose clothing.
3. Do not use frayed belt, torn or ragged discs, or cracked wheels.
4. Do not use power tools with frayed cords or cracked plugs.
5. Be certain that cords are grounded if applicable.
6. Do not stand on wet floors or work in wet clothes while using portable power tools.
7. Do not lay tools down until they have come to a complete stop or they may react violently or snag loose material (figure 8-39).
8. Do not remove guards from tools.

Figure 8-38. A. Eight inch sander grinder, electric 1 1/2 horsepower; B. Belt sander 4″ x 24″ belt, electric; C. Double action oscillating random action 6″ disc sander, air operated; D. Belton, hand held belt sander 1′ x 42″ belt, air operated; E. Dremel hand held grinder and sander, electric; F. Die filer hand held, air operated; G. Air grinder (die grinder) air operated 20,000 r.p.m.; H. Die grinder 18,000 r.p.m. air operated; I. Oscillating finishing sander to fit on electric drill; J. Sander polisher, 2 speed electric; K. Oscillating finishing sander, electric.

Figure 8-39

Figure 8-40. Assortment of tools for die grinders.

Figure 8-41. Die filler in operation.

Material					Usually available grit											Use
	Hardness	Commercial name of abrasive	Natural	Man made	Extra coarse	Coarse	Medium	Fine	Very fine	Polish	Cloth back	Paper back	Waterproof available	Open coat	Closed coat	
Crocus	6.	Iron oxide	X								X	X	X			Crocus cloth is used to polish corroded metal without changing dimensions or removing precious metal.
Flint	6.9	Flint quartz	X			3	0	3/0				X		?	X	Poor abrasive, sold in variety packs in discount houses for household use. For hand sanding wood or paint.
Garnet	7.5 to 8.5	Garnet Almandite	X			$3\frac{1}{2}$ 2/2	$\frac{1}{2}$ 0 2/0	3/0 4/0	6/0 9/0		?	X	?	?	X	Fair to good for hand sanding wood and paint. Fair sanding for machine sanding wood and some soft metals.
Emery	8.5 to 9.0	Corundum Aluminum oxide plus iron oxide	X			40 46 — 3	54 — $2\frac{1}{2}$ 2	— $1\frac{1}{2}$ 1 $\frac{1}{2}$ 0	— 2/0 3/0	polish 60-70-80-90 brilliant 100-120 F-FF	X	X	X		X	Good for machine finishing metal and some plastics. Slow cutting.
Silicon Carbide	9+	Silicon Carbide Crystolon Carborundum		X	36	40 60 80	100 120	150 180 200	240 320 360 400	600	X	X	X	X	X	Good for hand or machine sanding wood, metal, plastic, stone and low tensil strength materials. Excellent fast cutting abrasive.
Aluminum Oxide	9+	Alundum Adalox Metalite		X	36	40 60	80 100 120	150 180	200 240 320 360 400	600	X	X	X	X	X	Excellent for hand or machine sanding metal, wood, plastic, etc. Better for high tensil strength materials like steel than silicon carbide.

Figure 8-42. Coated abrasives (sand paper)

Figure 8-43

Figure 8-44

9. Do not sand hazardous, toxic, or allergenic materials such as cocobolo, greenhart, or poison sumac.
10. Do not sand metals, especially aluminum or magnesium, in a dusty atmosphere or in the presence of metal dust or wood residue on the machine or on the floor.
11. Be sure that blades, discs, and belts are installed properly so that they turn in the right direction.

Belt Sanders
1. Do not wear loose clothing.
2. Wear proper eye protection.
3. Do not operate the sander without operating the dust removal system.
4. Clean the floor of sawdust and scrap wood before operating the sander.
5. Work from the side or from the end of the sander with the belt moving away from the operator.
6. Do not operate the sander while someone is standing at the wrong end of the sander.
7. Do not use a belt which is stretched in the center and will not center on the machine.
8. Do not operate a frayed, split or torn belt.

9. Do not sand hazardous, toxic or allergenic materials such as cocobolo, greenhart—poison sumac.
10. Do not sand metals (especially aluminum, iron magnesium) in a dusty atmosphere or in the presence of metal dust or wood residue on the machine or on the floor.

Grinder (Figure 8-38A, 8-38E, 8-38G and 8-38H)
1. Wear safety goggles (not glasses).
2. Do not grind on the side of the wheel unless it is specifically designed for this type of grinding.
3. Adjust the tool rest and spark arrester 1/16"-1/8" (1.5875-3.175 mm) from the face of the wheel.
4. Hold the work firmly against the tool rest while grinding.
5. Do not move or remove safety shields, guards, or hoods from their proper positions.
6. Do not operate a damaged, out-of-round vibrating, or otherwise unsafe, appearing grinder.
7. Allow the grinder to run for a full minute before standing in front of it or before grinding. Use light pressure for the first three or four minutes.

8. Do not touch the spinning grinding wheel. Do not try to slow or stop the wheel while it is coasting at slow speed.
9. Do not stop the wheel by forcing metal against it while it is coasting.
10. Do not wear loose or baggy clothes, neckties, loose shirt tails or sleeves or fuzzy clothing (sweatshirts turned inside out or angora sweaters).
11. Be sure that the area around the grinder is free of combustible materials. (Grinding steel will throw sparks hot enough to ignite clothing, magnesium dust, wood flower, etc.)
12. Make certain that the grinding wheels are operated within the proper RPM range, and that they have washer and clamp in place.

Polishing—Buffing—Coloring

1. Wear goggles or protective face mask.
2. Wear proper light fitting clothing.
3. Hold the work firmly below the center of the wheel.
4. Use light pressure.
5. Do not use out of balance wheels.
6. Do not allow yourself to become distracted.

Polishing—Buffing—Coloring

Technically, polishing refers to the use of revolving wheels which have abrasives adhered to the surface of the wheel. Buffing, on the other hand, refers to th euse of revolving wheels to which an adhesive is loosely applied. Coloring is the final delicate buffing which brings out the true color or natural lustre of the material.

There are many types of polishing wheels available but actually seldom used outside of industry. The wheels are made of glued walrus hide, wool, canvas, wood, rubber, plastic, bull neck leather, paper, and metal. The abrasives are glued directly to the surface of the wheel or strips of abrasive material are clamped or nailed to the wheels. The only wheels readily available for public use are rubber wheels saturated with abrasive particles. The wheels are only 4″ and 6″ in diameter and are fairly expensive. They do a fine job of polishing steel, sharpening blades, and removing light corrosion.

Buffing wheels are more often used than polishing wheels in the nonindustrial sectors. These buffs consist of layers of various materials sewn together into 1/4″ sections. The sections may be used singularly or stacked to form buffs of any thickness. The wheels may be stiffened by clamping them between metal flanges on the arbor or spindle.

There are four types of sewed buffs. The spiral sewed buff is sewed from the center out to the face of the wheel in a continuous spiral between ¼″ (6.35 mm)

and ½″ (12.7 mm) wide in spacing. These buffs usually have a hard body and are used for heavy cutting and coarse buffing.

Cushion sewed buffs are sewen circularly around the arbor hole two or more times. Cushion buffs are used for light cutting and coloring. The fewer stitched circles around the arbor and the nearer the arbor hole the softer the buff. Cushion sewed buffs are probably the easiest to obtain. Buffs with a single stitching around the arbor hole and near the hole are known as loose buffs and because they are very soft are used primarily for coloring and cleaning.

Creso sewed buffs are sewed radially, with the stitching curving from the hole to the face and are dual purpose buffs. If the buff is turned into the stitching they work as cutting buffs. If they are turned away from the stitching they work as coloring buffs. Unfortunately creso sewed buffs are hard to find and usually expensive.

Buffs available for general public use and sold through discount houses are usually "piece-sewed" buffs and may contain almost any kind of cloth. "Full-disc" buffs, however, consist of high quality materials such as cotton sheeting, fine woven cotton sheeting, flannel, felt, bleached or unbleached muslin, and wool. Bleached cloth buff being harder and stiffer than the unbleached buffs are used for cutting. Hard metals such as nickel would require a close woven, bleached cloth, spiral sewed, or clamped up (between flanges) buff.

Except for the last few passes where a soft cleaning buff is used to "kiss" color into a finished piece, cutting or coloring compounds are applied to the buffs. The compounds can be made up from emery grits or flour, iron oxide, silicon carbide, tin oxide, and tallow, vaseline, or some other thick body, but it is usually simpler and more convenient to purchase the compounds in stick or paste form. Commercial compounds are generally colored brown, black, gray, white, red, and sometimes green.

Black compounds are coarse containing emery and are fast cutting and are almost grinding compounds. Brown compounds known as tripoli are medium coarse and usually contain amorphous silicon dioxide. Tripoli is mild cutting on base metals and has good coloring capabilities.

White compounds often contain tin oxide and have a soft cutting action and good coloring action.

Red compounds such as jewelers rouge are iron oxidized which have very little cutting action but excellent coloring capabilities.

There are of course many other compounds some containing silicon carbide flour for fast cutting and coloring. They are especially suited for cutting hard metals like chrome. Other compounds may contain

pumice which is used to color precious metals without removing the metal.

The speed of polishing and buffing wheels is critical to producing a proper cutting or polishing action. Perfectly balanced wheels with wood or iron centers can be run from 3000 to 7500 S.F.P.M. (surface feet per minute). The wheels must be in excellent condition in a proper buffing machine to survive 7500 S.F.P.M.

Polishing and buffing procedures are relatively simple. A separate buff is prepared for each compound by placing it on the arbor or spindle so that it turns over the top of the arbor towards the operator. The buff is lightly loaded with compound by pressing the compound against the wheel slightly below the center of the wheel for a few seconds. The compound is then spread by pressing a piece of clean metal against the spinning wheel for a few seconds.

The object to be polished is pressed *lightly* against the face of the wheel slightly below center. The work must be held firmly and kept in motion. The wheel must not be allowed to snatch the object or it will smash the object around the wheel guard or around the room.

Buffing should procede from coarse compounds and hard wheels to fine compounds and soft wheels. Buffs should be reserved for only one kind of compound. The object should be cleaned with a soft flannel cloth saturated with a little solvent, or soapy water before progressing to the next wheel and compound in order

Horsepower	Maximum Wheel Thickness		
	4″ Dia.	6″ Dia.	8″ Dia.
1/6 to 1/8	1″	1/2″	None
1/4	1½″	1″	1/2″
1/3	2½″	2″	1½″
1/2	3″	2½″	2″

Figure 8-45. Polishing and Buffing Motor Capacity

Material	Compound	Wheel	Compound	Wheel	Compound	Wheel	Compound	Wheel
	Black Emery		Brown Tripoli		White Tin Oxide		Jewelers Rouge Iron Oxide	
Aluminum			X	A, 1	X	B, C, 2, 3	X	C, 2, 3
Brass Plate							X	C, 2, 3
Brass	X	B, 1, 2	X	B, 1, 2	X	B, 2	X	C, 2, 3
Chrome	X	A, 1					X	B, 2
Copper	X	B, 1, 2	X	B, 1, 2	X	C, 2	X	C, 2
Copper Plate					X	C, 2, 3	X	C, D, 2, 3
Gold			X	B, 2	X	C, 2, 3	X	C, 2, 3
Iron	X	A, 1						
Nickel	X	A, 1						
Stainless Steel							X	B, 2
Steel	X	A, 1					X	C, 2
Pewter	X	B, 2	X	B, 2			X	C, D, 2, 3
Sterling			X	C, 2	X	C, 2, 3	X	C, 2, 3
Silver Plate			X	C, 2	X	C, 2, 3	X	C, 2, 3
Acrylic Plastic			X	B, 2	X	B, 2, 3	X	C, 2, 3
Bakelite			X	A, 1	X	B, 2, 3	X	C, 2, 3

Wheel code
A Stiff 1. Spiral sewn
B Medium stiff 2. Cushion sewn
C Medium soft 3. Loose sewn
D Soft 4. Creso sewn

Figure 8-46. Polishing-buffing-coloring sequence

to prevent scratching the surface. Powdered whiting can also be used to clean the residue from the object.

Sandblasting

Sandblasting is the act of blowing sand with high pressure air onto some object so that the sand will cut away the surface, or rub the surface of the object. There are two kinds of sandblasting equipment available to the sculptor. The least expensive and least efficient is the suction feed (syphon or venturi draw) commonly sold through mail order and discount houses (figure 8-47 and 8-48). The unit which is reasonably portable uses high pressure air (below 90 to 150 psi [6.3277 to 10.545 Kg per sq Cm]). Because the initial volume of air used is relatively small it can be used for short intervals with small air compressors (minimum 1 horsepower and 10 gallon [37.85 L.] storage tank). Increased storage will increase the blast duration but will also increase the tank recharging time. The sand blaster will of course operate continuously with a larger compressor, but because of the design the internal parts of the sandblaster is eaten away by the action of the sand and must be replaced frequently.

Suction feed sandblasters are fairly easy to operate. Although the procedures are generally the same the manufacturer's directions should be consulted and adhered to. Install the proper air jet and nozzle in the gun body. Make certain that the abrasive hose is clear and that the vent hole is not blocked. Fill the sand hopper with clean sand and connect the abrasive hose to the gun body. Set the air pressure at less than 150 psi (10.545 Kg per sq. Cm) when using jets 13/16" or 5/64" (20.6375 or 1.984375 mm). Air hoses in other cases may bypass the regulators as long as the air supply hose can withstand the full air pressure of the compressor. If possible the air hose should be no longer than 50' (15.25 m), (better 25' [7.62 m]) and have an inside diameter of no less than 3/8" (9.525 mm). The air hose should be connected to the gun *after* all other preparations have been completed.

The blast gun should be directed at the work at a slight angle so that the sand will not rebound at the operator. The distance of the gun from the work will effect the speed of cut, the surface texture, and so on, and should be determined by trial and error. When using metal shot the container should be raised above the level of the gun. If the gun fails to blast sand and air comes from the gun, check to see that the abrasive supply hose is connected at both ends, not blocked, the vent is open, and that there are no leaks in the hose. If clods of sand are found in the hose or in the nozzle of the gun the trouble is probably wet sand or water in the air line. If this is the case a moisture and oil separator will have to be installed on the

Figure 8-47

Figure 8-48

air line and dry sand placed in the container. If sand blows out of the vent in the supply hose, the nozzle and air jets are the wrong combination, or the nozzle is blocked.

Pressure feed sandblasting differs from suction feed in that the entire system is under pressure and the sand is not drawn into the nozzle, instead it is moved along the entire length of the abrasive supply hose by high speed high pressure air. Pressure feed equipment is considerably more expensive, usually larger, less portable, but considerably more efficient than suction systems. Pressure feed systems operate on low pressure but high volume air.

The operation of the pressure feed system varies from the suction feed system in that the sand hopper is sealed once the clean dry sand is loaded (some types are self sealing). The entire system is then pressurized by setting the desired pressure on the air regulator and closing the exhaust valve and opening the air supply valve (figure 520-1B). The operator (wearing a respirator and full coverage hood) (figure 520-1F) then holds the blast hose firmly, directed toward the blast area, then releases the air by opening the blast valve on the nozzle of the hose or by opening the air supply valve on the sand container (figure 8-49B). If no sand comes from the hose, the sand supply valve must be adjusted. The stream of sand coming from the nozzle should hardly be visible.

If the sand is seen as a mist, the sand supply valve should be closed slightly (figure 8-49D). There may be a fairly strong hose recoil when the air is turned on, so the operator must be prepared to resist the recoil and point the nozzle towards the blast area. A "wild" sandblasting hose can break arms and legs or blind someone almost instantly. If the hose belches sand and jerks in the hands of the operator, the hose is loaded with sand and the sand feed valve should be closed until the excess sand has blown from the hose. If the problem persists the system should be shut down, the pressure released, and the hose removed and emptied of sand.

The pressure feed system is shut down by closing the air pressure supply valve and slowly opening the exhaust valve (figure 8-49A). On equipment with an air valve on the nozzle the valve should be left open to relieve the hose of excess sand that may have accumulated. If the equipment is being closed down for the day the air should be allowed to blast while the

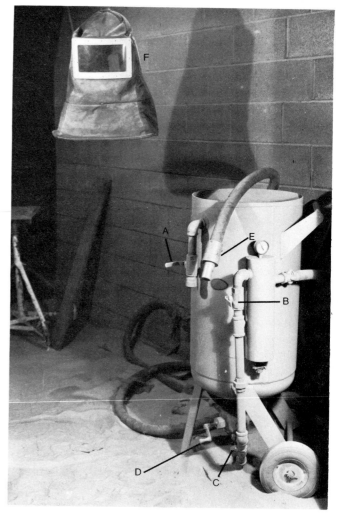

Figure 8-49

abrasive feed valve is closed in order to clear the hose of sand. The air supply valve should then be closed and the exhaust valve opened slowly to bleed the system.

There are many kinds of materials which can be used in the sand blaster. Abrasives can be used to sand, (aluminum oxide, silicon carbide, or sand), clean and harden the surface (glass beads, metal shot), and polish (walnut shells, ground corn cobs). Normally great care must be taken to avoid mixing abrasives.

The operator must be aware of the danger of abrasives and high pressure air. Every safety precaution must be followed.

Appendix

Length

1 inch = 2.54 cm + 25.4 mm

12 inches = 1 foot = .3048 meter (M.) = 30.48 cm = 304.8 mm

36 inches = 1 yard = .9144 M. = 91.44 cm = 914.4 mm

5280 feet = 1760 yards = 1 mile = 1,609 km = 1,609 M = 160,900 cm = 1,609,000 mm

Area

1 sq. in. = 6.452 sq. cm. (cm^2)

144 sq. in. = 1 sq. ft. = .0929 sq. M. (M^2)

9 sq. ft. = 1296 sq. in. = 1 sq. yd. = 0.836 sq. M. (M^2)

3,097,600 sq. yd. = 27,878,400 sq. ft. = 1 sq. mile = 2.5899 sq. Km (Km^2)

Volume

1 cu. in. = 16.38716 cm^3

1728 cu. in. = 1 cu. ft. = 7.481 U.S. Gal. = .02832 M^3 = 28.317 Liter (l.)

27 cu. ft. = 46,656 cu. in. = 1 cu. yd. = .7645 m^3

Fluid

8 Drachms = 1 oz. = .0295625 l.

4 ozs. = 16 drachms = 1 gill = .11825 l.

16 ozs. = 128 drachms = 4 gills = 1 U.S. pint = 1 fluid pound = .473 l.

2 U.S. pints = 1 U.S. quart = .946 l.

4 U.S. qt. = 231 cu. in. = 1 U.S. gal. = 1.3368 cu. ft. = 3.785 l.

Weight

Troy Weight (for Precious Metals)

1 penny weight = 24 grains = 1.56 grams

1 ounce = 20 pennyweight = 480 grains = 31.103 grams

12 ounces = 240 penny weight = 5,760 grains = 373.24 grams = 1 pound troy

1 pound (troy) = .822857 pound (avoirdupois)

1 grain (troy) = 1 grain avoirdupois

Avoirdupois Weight (for Chemicals and Commerce)

16 drachms = 437.5 grains troy = 28.35 grams = 1 ounce

16 ounces = 256 drachms = 7,000 grains = 453.6 grams = 1 pound = .4536 Kg

2240 pounds = 1 ton = 1.016 metric ton = 1016 Kg

1 pound avoirdupois = 1,21528 pound troy

British Measure

1 British imperial bushel = 8 imperial gallons = 1.2837 cu. ft. = 2218.19 cu. in. = 36.349834 l.

1 British imperial gallon = 1.2009 U.S. gallon = 277.42 cu. in. = 4.5461249 l.

1 British fluid ounce = 1.732 cu. in. = 28.382561 cm^3 .0283825e liter

Decimal Equivalents Millimeters to Inches

metric	inch	metric	inch	metric	inch	metric	inch
.001 mm	.000039	1.9 mm	.0748	6.7 mm	.2638	22.0 mm	.8661
.002 mm	.000078	1.95 mm	.0768	6.75 mm	.2658	22.5 mm	.8858
.0025 mm	.0001	2.0 mm	.0787	6.8 mm	.2677	23.0 mm	.9055
.003 mm	.000118	2.05 mm	.0807	6.9 mm	.2716	23.5 mm	.9252
.004 mm	.000157	2.1 mm	.0827	7.0 mm	.2756	24.0 mm	.9449
.005 mm	.000196	2.15 mm	.0846	7.1 mm	.2795	24.5 mm	.9646
.006 mm	.000236	2.2 mm	.0866	7.2 mm	.2835	25.0 mm	.9843
.007 mm	.000275	2.25 mm	.0886	7.25 mm	.2855	26.0 mm	1.0236
.008 mm	.000314	2.3 mm	.0905	7.3 mm	.2874	27.0 mm	1.0630
.009 mm	.000354	2.35 mm	.0925	7.4 mm	.2913	28.0 mm	1.1024
.010 mm	.000394	2.4 mm	.0945	7.5 mm	.2953	29.0 mm	1.1417
.01 mm	.00039	2.45 mm	.0965	7.6 mm	.2992	30.0 mm	1.1811
.02 mm	.00078	2.5 mm	.0984	7.7 mm	.3031	31.0 mm	1.2205
.025 mm	.001	2.55 mm	.1004	7.75 mm	.3051	32.0 mm	1.2598
.03 mm	.00118	2.6 mm	.1024	7.8 mm	.3071	33.0 mm	1.2992
.04 mm	.00157	2.65 mm	.1043	7.9 mm	.3110	34.0 mm	1.3386
.05 mm	.00196	2.7 mm	.1063	8.0 mm	.3150	35.0 mm	1.3780
.051 mm	.002	2.75 mm	.1083	8.1 mm	.3189	36.0 mm	1.4173
.06 mm	.00236	2.8 mm	.1102	8.2 mm	.3228	37.0 mm	1.4567
.07 mm	.00275	2.9 mm	.1142	8.25 mm	.3248	38.0 mm	1.4961
.076 mm	.003	3.0 mm	.1181	8.3 mm	.3268	39.0 mm	1.5354
.08 mm	.00314	3.1 mm	.1220	8.4 mm	.3307	40.0 mm	1.5748
.09 mm	.00354	3.2 mm	.1260	8.5 mm	.3346	41.0 mm	1.6142
.10 mm	.00394	3.25 mm	.1280	8.6 mm	.3386	42.0 mm	1.6535
.102 mm	.004	3.3 mm	.1299	8.7 mm	.3425	43.0 mm	1.6929
.127 mm	.005	3.4 mm	.1339	8.75 mm	.3445	44.0 mm	1.7323
.152 mm	.006	3.5 mm	.1378	8.8 mm	.3465	45.0 mm	1.7717
.178 mm	.007	3.6 mm	.1417	8.9 mm	.3504	46.0 mm	1.8110
.20 mm	.0078	3.7 mm	.1457	9.0 mm	.3543	47.0 mm	1.8504
.203 mm	.008	3.75 mm	.1477	9.1 mm	.3583	48.0 mm	1.8898
.229 mm	.009	3.8 mm	.1496	9.2 mm	.3622	49.0 mm	1.9291
.254 mm	.010	3.9 mm	.1535	9.25 mm	.3642	50.0 mm	1.9685
.30 mm	.0118	4.0 mm	.1575	9.3 mm	.3661	51.0 mm	2.0079
.35 mm	.0138	4.1 mm	.1614	9.4 mm	.3701	52.0 mm	2.0472
.4 mm	.0157	4.2 mm	.1654	9.5 mm	.3740	53.0 mm	2.0866
.45 mm	.0177	4.25 mm	.1674	9.6 mm	.3780	54.0 mm	2.1260
.5 m m	.0197	4.3 mm	.1693	9.7 mm	.3819	55.0 mm	2.1654
.55 mm	.0217	4.4 mm	.1732	9.775 mm	.3839	56.0 mm	2.2047
.6 mm	.0236	4.5 mm	.1771	9.8 mm	.3858	57.0 mm	2.2441
.65 mm	.0256	4.6 mm	.1811	9.9 mm	.3898	58.0 mm	2.2835
.7 mm	.0276	4.7 mm	.1850	10.0 mm	.3937	59.0 mm	2.3229
.75 mm	.0295	4.75 mm	.1870	10.5 mm	.4134	60.0 mm	2.3622
.8 mm	.0315	4.8 mm	.1890	11.0 mm	.4330	61.0 mm	2.4016
.85 mm	.0335	4.9 mm	.1929	11.5 mm	.4528	62.0 mm	2.4410
.9 mm	.0354	5.0 mm	.1968	12.0 mm	.4724	63.0 mm	2.4803
.95 mm	.0374	5.1 mm	.2008	12.5 mm	.4921	64.0 mm	2.5197
1.0 mm	.0394	5.2 mm	.2047	13.0 mm	.5118	65.0 mm	2.5591
1.05 mm	.0413	5.25 mm	.2067	13.5 mm	.5315	66.0 mm	2.5984
1.1 mm	.0433	5.3 mm	.2087	14.0 mm	.5512	67.0 mm	2.6378
1.15 mm	.0453	5.4 mm	.2126	14.5 mm	.5709	68.0 mm	2.6772
1.2 mm	0472	5.5 mm	.2165	15.0 mm	.5906	69.0 mm	2.7165
1.25 mm	.0492	5.6 mm	.2205	15.5 mm	.6102	70.0 mm	2.7560
1.3 mm	.0512	5.7 mm	.2244	16.0 mm	.6299	71.0 mm	2.7953
1.35 mm	.0531	5.75 mm	.2264	16.5 mm	.6496	72.0 mm	2.8346
1.4 mm	.0551	5.8 mm	.2283	17.0 mm	.6693	73.0 mm	2.8740
1.45 mm	.0571	5.9 mm	.2323	17.5 mm	.6890	74.0 mm	2.9134
1.5 mm	.0591	6.0 mm	.2362	18.0 mm	.7087	75.0 mm	2.9528
1.55 mm	.0610	6.1 mm	.2401	18.5 mm	.7283	76.0 mm	2.9921
1.6 mm	.0629	6.2 mm	.2441	19.0 mm	.7480	77.0 mm	3.0315
1.65 mm	.0650	6.25 mm	.2461	19.5 mm	.7677	78.0 mm	3.0709
1.7 mm	.0669	6.3 mm	.2480	20.0 mm	.7874	79.0 mm	3.1102
1.75 mm	.0689	6.4 mm	.2520	20.5 mm	.8071	80.0 mm	3.1496
1.8 mm	.0709	6.5 mm	.2559	21.0 mm	.8268	81.0 mm	3.1890
1.85 mm	.0728	6.6 mm	.2598	21.5 mm	.8465	82.0 mm	3.2283

Decimal Equivalents Millimeters to Inches

metric	inch	metric	inch	metric	inch	metric	inch
83.0 mm	3.2677	88.0 mm	3.4646	93.0 min	3.6614	98.0 mm	3.8583
84.0 mm	3.3071	89.0 mm	3.5039	94.0 mm	3.7008	99.0 mm	3.8976
85.0 mm	3.3465	90.0 mm	3.5433	95.0 mm	3.7402	100.0 mm	3.9370
86.0 mm	3.3858	91.0 mm	3.5827	96.0 mm	3.7795		
87.0 mm	3.4250	92.0 mm	3.6220	97.0 mm	3.8189		

The Metric System

Length

1 mm = 0.03937 inch
10 mm = 1 cm = .3937 "
10 cm = 1 dm = 3.937 "
10 dm = 1 m = 3.2808' = 39.37"
1000 m = 1 Km = .6214 mi.

Area

1 mm² = .00155 sq. in.
100 mm² = 1 cm² = .155 sq. in.
100 cm² = 1 dm² = 15.5 sq. in.
100 dm² = 1 m² = 10.746 sq. ft. = 1.196 sq. yd.

Volume

1000 mm³ = 1 cm³ = .061 cu. in.
1000 cm³ = 1 l. = 1 dm³ = .0353 cu. ft. = 61.023 cu. in. = .2642 U.S. gal. = 1.0567 U.S. qt.
1000 dm³ = 1 m³ = 35.314 cu. ft. = 1.308 cu. yd. = 264.2 U.S. gal.

Dry and Liquid Measure

10 ml. = 1 cl. = 3.53 cu. ft. = 61.023 cu. in. = .2642 U.S. gal. = 1.0567 U.S. qt.
10 cl. = 1 dl. = .353 cu. ft. = 6.1023 cu. in. = .02642 U.S. gal. = .10567 U.S. qt.
10 dl. = 1 l. = .0353 cu. ft. = 61.023 cu. in. = .2642 U.S. gal. = 1.0567 U.S. qt.
100 l. = 1 Hl. = 3.53 cu. ft. = 6102.3 cu. in. = 26.42 U.S. gal. = 105.67 U.S. qt.

Weight

10 mg. = 1 cg.
10 cg. = 1 dg.
10 dg. = 1 g. = .03215 oz. troy = .03527 oz. avoirdupois = 15.432 grains
10 g. = 1 Dg.
10 Dg. = 1 Hg.
10 Hg. = 1 Kg. = 2.2046 lbs. = 35.274 ozs. avoirdupois
100 Kg. = 1 ton metric (T.) = .9842 tons (of a 2240 pound ton) = 2204.6 pounds
1 kg. per mm² = 1422.32 pounds per sq. in.
1 Kg. per m = 7.233 ft. pounds

To convert Fahrenheit (F.) to Centigrade (C.)
Subtract 32 from the degrees fahrenheit,
multiply by 5,
divide by 9

To convert Centigrade (C.) to Fahrenheit (F.)
multiply the degrees centigrade by 9,
divide by 5,
add 32

Circumference of a circle = 3.1416 × 2 × radius
Area of a circle = 3.1416 × radius squared
Area of a rectangle = multiply the length of 2 of the sides that meet at a corner.
Volume of a sphere = diameter cubed × .015236
Volume of a cylinder = 1/4 diameter × circumference × length
Volume of a cube = length × width × height
To determine the angle of a mitered joint— divide the number of sides into 180° and subtract from 90°.

Weights of Materials by Cubic Inch

Brass	.2960 lb.	Zinc (cast)	.248 lb.
Aluminum	.0924 lb.	Fir	.0199 lb.
Copper	.3184 lb.	Lignum Vitae	.0397 lb.
Steel	.2816 lb.	Mahogany	.0325 lb.
Cast iron	.2599 lb.	Fired red clay	.065 lb.
Bronze	.3194 lb.	Portland cement	.1119 lb.
Lead	.407 lb.	Marble	.0975 lb.
Silver	.38 lb.	Plaster of Paris	.065 lb.
Gold	.697 lb.	Sandstone	.083 lb.

Common Recipes

(Unless otherwise indicated, proportions are given in volumes.)

Slip Clay for Slip Casting (Cone 04)

Kentucky ball clay #4	16	parts by weight
Kentucky ball clay	16	parts by weight
Kentucky ball clay special	2	parts by weight
Plastic vitrox	16	parts by weight
Talc	50	parts by weight
Whiting	3	parts by weight
Water	50.5	parts by weight
Silicate of Soda	0.4	parts by weight
Soda ash	0.1	parts by weight

Feet Per Min. / Diam. — REVOLUTIONS PER MINUTE

Diam.	10	15	20	25	30	40	50	60	70	80	90	100	110	120	130	140	150	160	170	180	190	200	210	220	230	240	250	260	270	280	290	300	325	350	375	400
1/16	611	917	1223	1528	1834	2445	3057	3668	4280	4891	5502	6114	6725	7337	7948	8560	9171	9782	—	—	—	—	—	—	—	—	—	—	—	—	—	—	—	—	—	—
1/8	306	459	611	764	917	1222	1528	1834	2139	2445	2750	3056	3362	3667	3973	4278	4584	4890	5195	5501	5806	6112	6417	6723	7028	7334	7639	7945	8251	8556	8862	9171	9935	10699	11463	—
3/16	204	306	408	509	611	815	1019	1222	1426	1630	1834	2038	2242	2446	2649	2853	3055	3261	3465	3668	3872	4076	4278	4482	4686	4890	5093	5297	5501	5705	5908	6114	6623	7133	7642	8152
1/4	153	229	306	382	458	611	764	917	1070	1222	1376	1528	1681	1832	1986	2139	2292	2445	2598	2750	2903	3056	3209	3361	3514	3667	3820	3972	4125	4278	4431	4584	4966	5348	5730	6112
5/16	122	183	245	306	367	489	611	733	856	978	1100	1222	1344	1466	1589	1711	1833	1955	2077	2200	2322	2444	2567	2689	2811	2934	3056	3178	3300	3423	3545	3666	3971	4277	4582	4888
3/8	102	153	204	255	306	408	509	611	713	815	916	1018	1121	1222	1323	1425	1527	1629	1731	1832	1934	2036	2139	2241	2343	2445	2546	2648	2750	2852	2954	3057	3311	3566	3821	4076
7/16	87	131	175	218	262	349	437	524	611	699	786	874	961	1049	1136	1224	1311	1398	1486	1573	1661	1748	1833	1921	2008	2095	2183	2270	2357	2445	2532	2620	2838	3057	3275	3494
1/2	76	115	153	191	229	306	382	459	535	611	688	764	840	917	993	1070	1146	1222	1299	1375	1452	1528	1604	1681	1757	1833	1910	1986	2063	2139	2215	2292	2483	2675	2866	3057
9/16	68	102	136	170	204	272	340	407	475	543	611	679	747	813	883	951	1019	1086	1154	1222	1290	1358	1426	1494	1562	1630	1698	1766	1833	1901	1969	2037	2207	2377	2547	2717
5/8	61	92	123	153	184	245	306	367	428	489	552	612	673	736	796	857	918	979	1040	1102	1163	1224	1283	1345	1406	1467	1528	1589	1650	1711	1772	1834	1987	2139	2292	2445
11/16	56	83	111	139	167	222	278	333	389	444	500	555	611	666	722	770	833	888	944	999	1054	1110	1167	1222	1278	1333	1389	1445	1500	1556	1611	1667	1806	1941	2084	2223
3/4	51	76	102	127	153	203	254	306	357	409	458	508	559	610	661	711	762	813	864	914	965	1016	1070	1120	1171	1222	1273	1324	1375	1426	1477	1528	1655	1783	1910	2038
13/16	47	71	95	119	142	190	237	282	332	379	427	474	521	569	616	664	711	758	806	853	901	948	987	1034	1081	1128	1175	1222	1269	1316	1363	1410	1528	1646	1763	1881
7/8	44	66	87	109	131	175	219	262	306	349	392	438	482	526	569	613	657	701	745	788	832	876	917	960	1004	1048	1091	1135	1179	1222	1266	1310	1419	1528	1637	1746
15/16	41	61	81	101	122	163	204	244	285	326	366	407	448	488	529	570	611	651	692	733	773	814	857	896	937	978	1019	1059	1100	1141	1182	1222	1324	1426	1528	1630
1	38	57	76	96	115	153	191	229	267	306	344	382	420	458	497	535	573	611	649	688	726	764	802	840	879	917	955	993	1031	1070	1108	1146	1241	1337	1432	1528
1-1/16	36	54	72	90	108	144	180	215	251	287	323	359	395	431	467	503	539	579	610	646	682	718	755	791	827	863	899	935	971	1007	1043	1078	1168	1258	1348	1438
1-1/8	34	51	68	85	102	136	170	204	238	272	306	340	374	408	442	476	510	544	578	612	646	680	714	747	781	815	849	883	917	951	985	1018	1103	1188	1273	1358
1-3/16	32	48	64	81	97	129	161	193	225	258	290	322	354	386	419	451	483	515	547	580	612	644	675	708	740	772	804	836	868	901	933	965	1045	1126	1206	1287
1-1/4	31	46	61	76	92	122	153	183	214	245	275	306	336	367	398	428	459	490	520	551	581	611	642	672	703	733	764	794	825	856	886	917	993	1069	1146	1222
1-5/16	29	44	58	73	87	116	146	175	204	233	262	291	320	349	378	407	437	466	495	524	553	582	611	640	669	698	728	757	786	815	844	873	946	1018	1091	1164
1-3/8	28	42	56	69	83	111	139	167	195	222	250	278	306	334	361	389	417	445	472	500	528	556	584	611	639	667	694	722	750	778	806	833	903	972	1042	1111
1-7/16	27	40	53	66	80	106	133	159	186	212	239	265	292	318	345	371	398	424	451	477	504	530	558	584	611	638	664	691	717	744	771	797	863	930	996	1063
1-1/2	25	38	51	64	76	102	127	153	178	204	230	254	279	305	330	356	381	406	432	457	483	509	535	560	586	611	637	662	688	713	738	764	827	891	955	1018
1-9/16	24	37	49	61	73	98	122	146	171	195	220	244	268	293	317	342	366	390	415	439	464	488	514	538	562	587	611	636	660	684	709	733	794	855	916	978
1-5/8	23	35	47	59	71	94	117	141	165	188	212	235	258	282	305	328	351	374	398	421	445	468	493	517	541	564	588	611	635	658	682	705	764	822	881	940
1-11/16	23	34	45	57	68	91	113	136	158	181	203	226	249	271	294	316	339	362	384	407	429	452	475	498	521	543	566	589	611	634	656	679	735	792	849	905
1-3/4	22	33	44	55	66	87	109	131	153	175	196	218	240	262	283	305	327	349	371	392	414	436	459	481	502	524	546	567	589	611	633	654	709	764	818	873
1-13/16	21	32	42	53	63	84	106	127	148	169	190	211	232	253	274	295	317	338	359	380	401	422	443	464	485	506	527	548	569	590	611	632	685	737	790	843
1-7/8	20	31	41	51	61	82	102	122	143	163	184	204	224	244	265	286	306	326	347	367	388	408	428	449	469	489	509	530	550	570	591	611	662	713	764	815
1-15/16	20	30	39	49	59	79	99	118	138	158	177	197	217	236	256	276	296	315	335	355	374	394	414	434	453	473	493	513	532	552	572	591	640	690	739	788
2	19	29	38	48	57	76	96	115	134	153	172	191	210	229	248	267	287	306	325	344	363	382	402	421	439	458	477	497	516	535	554	573	620	668	716	764
2-1/8	18	27	36	45	54	72	90	108	126	144	162	180	198	216	234	252	270	288	306	324	342	360	378	395	413	431	449	467	485	503	521	539	584	629	674	719
2-1/4	17	25	34	42	51	68	85	102	119	136	153	170	187	204	221	238	255	272	289	306	323	340	357	374	390	407	424	441	458	475	492	509	551	594	636	679
2-3/8	16	24	32	40	48	64	80	97	113	129	145	161	177	193	209	225	241	258	274	290	306	322	338	353	370	386	402	418	434	450	466	482	522	563	603	643
2-1/2	15	23	31	38	46	61	76	92	107	122	138	153	168	183	199	214	229	244	260	275	291	306	321	336	351	367	382	397	413	428	443	458	496	534	573	611
2-5/8	15	22	29	36	44	58	73	87	102	116	131	145	160	174	189	203	218	232	247	261	276	290	306	320	335	349	364	378	393	407	422	436	472	509	545	582
2-3/4	14	21	28	35	42	56	69	83	97	111	125	139	153	167	181	195	208	222	236	250	264	278	292	306	319	333	347	361	375	389	403	416	451	486	520	555
2-7/8	13	20	27	33	40	53	66	80	93	106	120	133	146	159	173	186	199	213	226	239	252	266	279	292	306	319	332	345	359	372	385	398	431	465	498	531
3	13	19	25	32	38	51	64	76	89	102	114	127	140	153	165	178	191	203	216	229	241	254	267	280	293	306	318	331	344	357	369	382	413	445	477	509
3-1/8	12	18	24	31	37	49	61	73	86	98	110	122	134	147	159	171	183	195	207	219	232	244	257	269	281	293	306	318	330	342	354	366	397	427	458	488
3-1/4	12	18	24	29	35	47	59	71	82	94	106	118	129	141	153	165	176	188	200	212	223	235	247	259	270	282	294	306	317	329	341	353	382	411	441	470
3-3/8	11	17	23	28	34	45	57	68	79	91	102	113	124	136	147	158	170	181	192	203	215	226	238	249	260	272	283	294	306	317	328	339	367	396	424	452
3-1/2	11	16	22	27	33	44	55	65	76	87	98	109	120	131	142	153	164	175	186	196	207	218	229	240	251	262	273	284	295	306	317	327	355	382	409	436
3-5/8	11	16	21	26	32	42	53	63	74	84	95	105	116	126	137	147	158	169	179	190	200	211	221	232	242	253	263	274	285	295	306	316	342	369	395	421
3-3/4	10	15	20	25	31	41	51	61	71	82	92	102	112	122	132	143	153	163	173	184	194	204	214	224	234	244	255	265	275	285	295	306	331	356	382	407
3-7/8	10	15	20	25	30	39	49	59	69	79	89	99	108	118	128	138	148	158	167	177	187	197	207	217	227	237	246	256	266	276	285	295	320	345	369	394
4	10	14	19	24	29	38	48	57	67	76	86	96	105	115	124	134	143	153	163	172	182	191	201	210	220	229	239	248	258	267	277	286	310	334	358	382

UNIVERSAL-CYCLOPS SPECIALTY STEEL DIVISION

650 WASHINGTON ROAD, PITTSBURGH, PENNSYLVANIA 15228

CYCLOPS CORPORATION

Figure A-1. $\left.\begin{array}{c}21/7\\3.1417\end{array}\right\} \times \text{Dia.} \times \text{RPM} \div 12 = \text{SFPM}$

Conversion of SFPM to RPM

Slip Clay for Slip Casting (Cone 04)

Red art clay*	66.3	parts by weight
Water	33.7	parts by weight
Soda ash	0.14	parts by weight
Sodium silicate ("N" Brand)	0.4	parts by weight

Mix the electrolyte with the water before sifting in the clay.

*Cedar Heights Clay Co.

Slip Clay for Slip Casting (Cone 04)

Kentucky ball clay #4	38	parts by weight
Kentucky ball clay special	38	parts by weight
China clay	25	parts by weight
Plastic vitrox	224	parts by weight
Talc	1.75	parts by weight
Water	232	parts by weight
Sodium silicate	1.6	parts by weight
Soda ash	0.75	parts by weight

Wax to be Brushed on to Form a Cast

Paraffin	12	parts by weight
Rosin	14	parts by weight
Carnauba wax	2	parts by weight
Talc	3	parts by weight
Zinc oxide	0.5	parts by weight

Wax for Making Molds

Paraffin	54	parts by weight
Bayberry wax	21	parts by weight
Carnauba wax	5	parts by weight
Stearic acid	20	parts by weight

Wax for Making Molds

Beeswax, yellow	1 pound
Linseed oil	½ pint
Tallow	1 pound
Flour or talc	2 pounds

Wax for Making Molds

Mix paraffin, olive oil, and whiting or talc to desired quality. Use talc to separate the model from the wax.

Wax for Modeling

Mobile wax 2300 may be softened with Vaseline or stiffened with paraffin.

Wax for Modeling

Microcrystalline 3602 wax — add Venice turpentine or Vaseline to condition the wax for winter or summer.

Wax for Modeling

Yellow beeswax	4	parts by weight
Venice turpentine	1	parts by weight

Wax for Modeling

Esso Microvan 1650, and motor oil to soften to suit.

Wax for Modeling

Dental wax, soften with Venice turpentine and harden with paraffin.

Wax for Modeling

Candle wax, white	8	parts by weight
Venice turpentine	1.5	parts by weight
Flake white	1	parts by weight

Wax for Modeling

Burgundy pitch	1	parts by weight
Beeswax	10	parts by weight
Tallow	1	parts by weight
Venice turpentine	1	parts by weight

Wax for Modeling

Paraffin	14	parts by weight
Beeswax	16	parts by weight
Lanolin	1	parts by weight
Venice turpentine	1	parts by weight
Lead oleate	1	parts by weight

Wax for Modeling

Beeswax, white	10	parts by weight
Paraffin	10	parts by weight
Vaseline	5	parts by weight
Cocoa butter	2.5	parts by weight
Lanolin (to harden) up to	1	parts by weight
Druggists' lead*	5	parts by weight

*Prepare druggists' lead by boiling together, in water, equal parts of lead monoxide, olive oil, and lard.

NOTE

Waxes should be melted in a double boiler, not directly over an open flame. Do not spill water into the molten wax, or a violent eruption of hot fluid wax may result. To make thin sheets of wax, pour the molten wax onto sheets of wet plywood or formica. If the wax tends to stick, either the plywood was not wet enough, or the wax was too hot.

Pitch for Repoussé

Burgundy pitch	8 parts by weight
Tallow, mustard oil, or linseed oil	1 parts by weight
Pumice, plaster, or brick dust	add to the density desired

Pitch for Repoussé

Burgundy pitch	10	parts by weight
Tallow	0.5	parts by weight
Plaster or talc	4	parts by weight

To Separate (mold)	From (Cast)	Treat Mold
Rubber	Plaster	Rinse with soapy water.
Rubber	Wax	Rinse with soapy water.
Metal	Plaster	Lard or fish oil.
Plaster	Plaster	A solution of gum mastic and amyl alcohol.
		A solution of yellow beeswax and carbon tetrachloride.
		A solution of the following: hot water 10 parts shellac powder 1 part borax ½ part
		Concentrated potters mold soap.
		A solution of 1 cake of Ivory soap chipped and dissolved in one gallon of water, simmered for about an hour and add 4 drops of kerosene.
		Apply a solution of equal parts by weight of zylene and parafin.
Polyester resin	Plaster	Treat with 2 coats of 15 parts acetate dissolved in 85 parts Methyl ethyl ketone, and 1 coat of thin SAE 10 motor oil, or polish on a coat of paste wax.
Polyester resin	Plaster	1 coat of acetate solution (as above) and one coat of 1 part polyvinal alcohol to 20 parts of an equal mixture of water and alcohol, then 1 coat of SAE 10 motor oil or 1 polished coat of paste wax.
Plaster	Wax	Soapy water.
Wood	Cement	Paraffin dissolved in coal oil.
Iron	Cement	Coal oil or 3-in-one oil.
Plaster	Cement	Mutton tallow and coal oil mixture.
Glue	Cement	Coat with 3-in-1 oil.

Figure A-2. Separators for casting and molding

Mold Materials

Gelatin—Glue Mold

Use #1 technical grade in flake or powdered form.

1. Soak the powder in water.
2. Melt in a double boiler until a syrupy mixture is obtained.
3. Pour the solution before it cools below 100° F., its gelling point.

Gelatin can be used over, but zinc sulfate or carbolic acid must be added to prevent spoilage. The surface of the mold can be toughened by painting with a soluton of alum water. The gelatin will be softened by the heat created by the hardening of some casting materials such as plaster and cement, resulting in damage to the mold and cast. A three percent solution of formaldehyde and water painted on to the surface of the mold will help the gelatin resist the heat of recrystalization.

Investments for Nonferrous Metals

a. Nonferrous investment #1 (U.S. Gypsum)

b.
Number 1 molding plaster, white	1 part
Luto	1 part
Water	as required

c.
Number 1 molding plaster	2 parts
Silica flour (flint)	2 parts
Luto	3 parts
Water	as required

d. PVI #10
Water—as directed by manufacturer

e.
Plaster	1 part
Silica flour	1 part
Silica sand (banding sand)	1 part
Water	as required

f.
Plaster	1 part
Luto	1 part
Silica sand (banding sand)	1 part

g.
Plaster	1 part
Luto	1 part
Silica sand	½ part
Silica flour	½ part

Investment for Aluminum Only

a.
Number 1 molding plaster	5 parts by weight
Sawdust	1 parts by weight
Sand	28 parts by weight
Water	16 parts by weight

(Allow to cure overnight, then heat at 190° F. for 2-4 hours, then heat to 575° F. for 1-2 hours.)

b.
Number 1 molding plaster	1 part
Pumice	1 part
Water	as required

Investment for Lead Casting

a.
Plaster of Paris	10 parts by weight
Asbestos fibers	12 parts by weight
Chalk	4 parts by weight
Marble dust	4 parts by weight

(Dry and warm the investment before casting.)

b.
Plaster #1 molding	6 parts by weight
Chalk	3 parts by weight
Crushed grog	3 parts by weight
Marble dust	3 parts by weight

Sulphur Molds for Metal Masters or Dies

Flowers of sulphur	8 parts
Iron filings (cleaned of oil)	1 part

(Melt together and pour over the metal master; use grease as a separator.)

Modeling Media

Plastic Wood (Wood Filler)

a.
Wood flour	100 ounces
Castor oil	½ fluid ounce
Acetone	½ fluid ounce
Rosin (powdered)	½ ounce
Alcohol	½ fluid ounce

Mix the powders, mix the liquids, then mix the two. Keep in airtight container.

b.
Wood glue (gelatin)	heat and boil
Tissue paper	shred and add to
Linseed oil	boiling glue
Chalk	

Mix to a paste, so that it will crumble when cold but will become pliable when warmed in the hand. This material can be pressed into molds and will dry in two or three days.

c.
Xylol	1 quart
Acetone	1¼ pint
Ethyl acetate	1 pint
Castor oil	6 drams
Celluloid	1½ pounds (Avoirdupois)
Wood flour	to suit

Mix the xylol, acetone, and ethyl acetate, then add the castor oil and celluloid, and allow to dissolve. Add the wood flour to the desired consistency.

Liquid or Cold Solder

Butyl acetate	1 part by weight
Ethyl acetate	7 part by weight
Methyl acetate	7 part by weight
Benzol	8 part by weight
Methyl alcohol	3 part by weight
Toluol	4.5 part by weight
Gum ester	0.75 part by weight
Proxyline	2 part by weight
Metal powder	4 to 5; add the kind and color to suit

Mix all materials except metal powder in an airtight container by shaking. Mix in the metal powder when desired.

Oil Base Clay

Kaolin	56 parts
Sulphur	24 parts
Lithopone	20 parts

Dry mix these materials; add the following materials until the desired plasticity is attained.

Lanolin	60%
Glycerine	40%

Color may be added as desired (chrome oxide or burnt sienna).

Oil Base Clay
 Ball clay
 Lanolin
 Glycerine

Mix to achieve the plasticity desired.

Core Sand—for Strong and Intricate Cores

Sharp sand	50 parts
Linseed oil (boiled)	1 parts

(Heat the cores to between 350° F. and 425° F.; never exceed 500° F.)

Core Sand—for Small Cores

Beach sand	10 parts
Flour	1 part

(Mix with molasses water; dry with heat.)

Core Sand—for Large Cores

Sharp fire sand	8 parts
Strong loamy sand	2 parts
Flour	1.5 parts

(Mix with clay, water; dry with gentle heat.)

(1) Core Sand—for Small, Intricate Cores

Beach sand	15 parts
Fire sand	15 parts
Rosin	2 parts
Flour	1 part

(Mix with molasses water and dry with heat—too much water will make the sand stick; too little, crumble.)

(2) Core Sand—for Small, Intricate Cores

Beach sand	15 parts
Molding sand	5 parts
Flour	2 parts
Core oil	1 part

(Mix with molasses water; dry with heat.)

Plaster Accelerators
a. Heat the mix water.
b. Add 1 teaspoon of sodium chloride to each quart of mix water.
c. Add 1 teaspoon of potassium alum to each quart of mix water.
d. Add 1 part of a saturated solution of potassium sulphate and water to each 10 parts of mix water.
e. Add 10% lime.

Plaster Retarders
a. Add 1 part saturated solution of borax and water to each 10 parts of mix water.
b. Add carpenter's glue to the mix water.
c. Add ½ teaspoon of calcined lime to each quart of mix water.
d. Add alcohol, sugar, or citric acid to the mix water.

Plaster—to Harden the Surface
a. Brush with lime water.
b. Brush with a hot saturated solution of potassium alum and water.
c. Immerse in boiling 2% solution of borax or in a saturated solution of sodium bicarbonate.

Plaster—to Harden
a. Add magnesium fluosilicate to the mix water, from 4% to 5%.
b. Add 1 part white dextrine or gum arabic to 100 parts of plaster.
c. Add 5% white portland cement to the plaster.

Plaster—to Seal for Outdoor Use
Mix the plaster with lime water. When dry, coat with hot boiled linseed oil at least three times. Paint with linseed oil varnish and cover with white oil paint. Every part of the plaster must be sealed, including the bottom.

Plaster—to Seal with Wax
Dry and warm the plaster, and coat with a solution of stearin and turpentine.

Plaster—to Make Soluble Molds

Number 1 molding plaster	3 parts
Potato starch	1 part

Mix dry and add to water in the usual fashion. The finished mold can be dissolved away with boiling water. Do not pour the casting with the soluble mix.

Plaster—to Color
Polished white: Brush a thin solution of Ivory soap flakes onto the plaster, and polish with a soft cloth. Then make a thicker soap solution and repeat the first step until a satisfactory surface is obtained.
White opaque: Brush the plaster with white liquid shoe polish, then polish with a soft cloth.

Plaster—to Color with a Shellac Vehicle
Mix 1 part clear shellac and 1 part alcohol to form a vehicle. Add dry pigment such as powdered tempera to the shellac, and rub the color into the plaster. Unwanted color can be removed with alcohol. To prevent streaking, brush a layer of shellac over the plaster before applying color.

Plaster—to Color with an Oil Vehicle
Mix 1 part rectified turpentine and 1 part artist grade linseed oil to form a vehicle. Add dry pigment and brush or rub onto the plaster. To prevent streaking, paint the plaster with a coat of the vehicle before adding color. This vehicle is compatible with artists' oil colors, which can be used for the color instead of the dry pigment.

Cement

Foundation Cement for Built-Up Cement

First application:	Portland cement	3 parts
	Lime putty (aged)	1 parts
	Hydrated lime	7% by weight
Second application:	Portland cement	2 parts
	Clean sand	1 part
	Hydrated lime	5% by weight
Finish application:	Portland cement	4 parts
	Lime putty	1 part
	Hydrated lime	add up to 10% to increase plasticity, if required

Stucco—for Built-Up Cement

a.	Portland cement	1 part
	Lime	1 part
	Sand	6 parts
b.	Portland cement	1 part
	Lime	2 parts
	Sand	5 parts

(Second mix more plastic than preceding mix.)

Common Mortar

Portland cement	1 part
Sand	3 parts

Note: For the first seven days the cement is subject to freeze damage if exposed to freezing temperatures. Calcium chloride can shorten the critical time to three days by increasing the curing action. The calcium chloride solution of 1¼ lbs. calcium chloride dissolved in one quart of water should be added to each 100 lbs. of dry mix batch (before the water of the mix is added.)

Cement Accelerators
Calcium chloride (over 1%, but less than 3%), ammonium carbonate, alkalai carbonates (carbon dioxide), aluminum chloride, and magnesium chloride.

Cement Retarders

Ferric chloride, if less than 2%, ammonium bicarbonate, ferrous bicarbonate, calcium sulphate, and plaster of Paris in small quantities. Sugar can completely retard the setting of cement. Aggregates in cement can be exposed by spraying a solution of sugar water over fresh cement. When the underlayer has hardened, the top soft skim of cement can be brushed away with a stiff brush.

Cement—to Color

The following pigment should be mixed into the cement by machine, or an even color cannot be obtained:

Iron oxide, 5% to 10%—red, yellow, brown, black
Manganese dioxide, upto 10%—black, brown
Chromium oxide, 8%—green
Ultramarine blue, to 10%—blue
Carbon (plumbago, charcoal), to 10%—black
Red lead, 8%—red
Zinc white, to 20%—white
(Pigments utilizing artificial fillers such as talc should not be used.)

Wood

Wood—to Bleach

a. Treat with sodium hypochlorite (clorox)
b. Apply oxalic acid (5% to 10%); flush with water, and dry; then apply sodium bisulphite (10%); flush with water, and dry.

Finishing Wax for Wood

Beeswax	1 part
Linseed oil (boiled)	1 part
Turpentine	1 part

Heat the materials to melt and mix, then cool to form a paste.

Wood—to Color

a. Brown — Brush on a solution of sulphuric acid and water; a strong solution produces a dark stain.

Stop the coloring action by brushing on ammonia water.

b. Brown — Brush on a concentrated solution of potassium permangenate and water.

c. Darken oak — Brush on strong ammonia water.

d. Darken oak — Brush on a concentrated solution of potassium bichromate and cold water.

e. Darken oak (and some other wood) —

Iron filings (powder)	1 part
Sulphuric acid	1 part
Water	20 parts

Apply as many coats as desired allowing the wood to dry between coats.

f. Oak—to turn olive to olive brown — Place a strong ammonia water solution in an open dish beneath the wood to be colored. Enclose the wood and ammonia bath in a black plastic bag. The color will not show unless the wood is wet or oiled.

g. Walnut—to darken — Wash with a weak solution of iron sulphate and water then rinse with water.

h. Walnut—to darken — Wash with a solution of 1 part calcium hydroxide to 4 parts water then rinse with water.

| i. Walnut—to darken | Wash with a solution of 1 part potassium carbonate and 4 parts of water, then rinse with water. |
| j. Mahogany—to darken | Wash with a weak solution of calcium oxide (lime water). |

Many kinds of wood can be dyed with mordants used for dying cotton or wool if the dye is dissolved in alcohol instead of water. These dyes produce strangely brilliant colors. Unevenly colored wood may have to be bleached before coloring with dyes.

Cement (Glue)—for Stone

a. Yellow resin (or equal parts yellow
 resin and beeswax) 1 part
 Plaster of Paris ½ part

Melt the ingredients together and apply to the heated stone. Allow to cool.

b. Gum arabic (thick solution) 1 part by weight
 #1 molding plaster 1.5 part by weight
 Quicklime 0.34 part by weight

Mix the ingredients and apply to the heated stone.

Litharge Cement—Leak Proof Metal to Glass Joints

Litharge (PbO) 460 grams
Glycerine 133 cc
Water 66 cc

Mix the liquids, add to the litharge slowly while grinding in a mortar. When mix begins to stiffen, put in place and allow to set 24 hours.

Casting Alloys

Low-Melting Alloys for Casting in Metal

Lipowitz's alloy—soften at 140° F. (60°C.), melts at 158° F. (70°C.); silverwhite.

Cadmium	3 parts
Tin	4 parts
Bismuth	15 parts
Lead	8 parts

Cadmium Alloy with a Melting Point of 179.5° F. (81.94°C.)

Cadmium	2 parts
Tin	3 parts
Bismuth	16 parts
Lead	11 parts

Cadmium Alloy with a Melting Point of 167° F. (75° C.)

Cadmium	10 parts
Tin	3 parts
Lead	8 parts
Bismuth	8 parts

Wood's Metal—Melts Between 140° F. (60° C) and 161.5° F. (71.95° C.) Platinum Color

Lead	4 parts
Tin	2 parts
Bismuth	5-8 parts
Cadmium	1-2 parts

Alloy for Reproducing Woodcuts or Medallions

Tin	3 parts
Lead	13 parts
Bismuth	6 parts

Alloy for Reproducing Woodcuts or Medallions

Tin	6 parts
Lead	8 parts
Bismuth	14 parts

Soldering and Tinning Fluxes

a. Tin:

Muriatic acid (saturate with zinc)	1	part
Water	2	parts
Ammonium chloride	0.1	part

b. Brass and copper:

Muriatic acid	1	pound
Zinc	4	ounces
Ammonium chloride	5	ounces

c. Iron:

Muriatic acid	1	pound
Tallow	6	ounces
Ammonium chloride	4	ounces

d. Gold and silver:

Muriatic acid	1	pound
Tallow	8	ounces
Ammonium chloride	8	ounces

Cleaning and Pickling Solutions

Pickling Solutions for Aluminum

a.

sodium hydroxide (lye)	1 part
sodium chloride (salt)	To saturation point
water	10 parts

Boil the solution and immerse the metal

b.

nitric acid	1 part
water	1 part

To brighten dull aluminum. Use at room temperature and dip the metal for only a few seconds.

c. Immerse in boiling potassium hydroxide, then plunge into nitric acid, rinse and dry (for pure aluminum only).

Mat Dip for Aluminum

Plunge the metal into hot bath of 10% sodium hydroxide solution saturated with table salt. Wash in clean water, brush and repeat as necessary.

Decolor Aluminum

Wash the metal with a mixture of 30 parts borax, 1000 parts water and ½ teaspoon of ammonia water.

Pickling Solutions for Brass, Bronze, and Copper

a.

potassium chlorate	1 ounce
hydrochloric acid	5 ounces
water	40 fluid ounces

b.

ferric chloride	2 ounces
water	3 ounces

c.

nitric acid 40° Baume'	2 parts
sulphuric acid 66° Baume'	1 part

To remove fire scale use at 70° F. to 90° F.

d.	nitric acide 40° Baume'	1 quart
	sulphuric acid 66° Baume'	1 quart
	muriatic acid	1 gill
	water	1 pint

Mat Dip

hydroflouric acid	2 pints
nitric acid 40° Baume'	1 pint
muriatic acid	½ pint
water	5 pints

Store in a wax lined container. Do not heat this solution.

Mat Dip

hydrochloric acid	1 part
sulphuric acid 66° Baume'	6 parts
water	6 parts

Pickling Solution Moderate Action

sulphuric acid 66° Baume'	1 part
water	8 parts

Pickling Solutions for Resistant Stains

sulphuric acid 66° Baume'	16 parts
sodium dichromate	1-to-32 parts
water	128 parts

Use from 70° F. (21.1° C.) to 90° F. (32.2° C.)

To Clean Copper Based Alloys
a. Apply a solution of 6% acetic acid saturated with table salt, with a wool cloth.
b. Rub the metal with oxalic acid, then polish with a paste of 1 part oxalic acid and 4 parts tripoli.

Pickle for Iron and Steel

a.	hydrochloric acid	2 parts
	water	1 part
b.	sulphuric acid	1 part
	water	100 parts

Pickle for Cast Iron

sulphuric acid 66° Baume'	1 part
water	2 parts

Apply with an acid-proof brush, then rinse with water after 10 hours, then brush away scale.

Lead—to Clean

Immerse in a 6%, or stronger, solution of acetic acid.

Pickling Solutions for Nickel and Nickel Alloys

hydrochloric acid	1 quart
cupric chloride	4 ounces
water	½ gallon

Dip or swab solution on heated metal or use the solution hot but below 150° F. (65.5° C.)

Coloring Metals

All of the following receipts for coloring metals have been tested and have proven to be useful. Unfortunately because of varying environmental conditions, alloy variations, impure chemicals (including treated water supplies) and poorly cleaned metal the desired results may not be obtained.

Patinization is often most successful when the work is a proper alloy for the receipt, perfectly cleaned, and the patina is applied slowly. Variations in the technique of application of the patina may result in unpredictable color change or patina permanence.

Aluminum—to Color Black

a.
copper sulfate	1.5 ounces
zinc chloride	1 pound
water	2 quarts

Immerse the metal in the hot solution.

b.
white arsenic	1 ounce
iron sulfate	1 ounce
hydrochloric acid	12 ounces
water	2 quarts

Immerse the freshly sanded metal, dry, then lacquer.

c. Polish the metal with fine emery paper, brush on a thin coat of olive oil, heat slowly over an alcohol flame. Repeat until the desired color is obtained and polish with wool or leather.

d.
sodium hydroxide	4 ounces
calcium chloride	1 ounce
water	1 quart

Dissolve the sodium hydroxide in water, and heat to 200° F. Dissolve the calcium chloride in the solution. Immerse the metal for 10-20 minutes. Then dip the metal into the following solution for a few seconds.

hydrochloric acid	1 quart
white arsenic	4 ounces
iron sulfate	4 ounces
water	1 quart

Dry in sawdust and polish with an oily cloth.

e. Treat the aluminum with a commercial gun blue compounded for aluminum parts of guns, cameras, etc.

Aluminum—to Dye

Clean the aluminum in a bath of hot hydrogen potassium hydroxide; rinse in hot, then cold water. Suspend the aluminum in an 18% solution of sulphuric acid in lead or plastic tanks and apply high amperage and low voltage for 20-30 minutes at 28° F. (−2.2° C.) to 31° F. (−.55° C.). Rinse in cold water; then dye by immersion in acid colors at 75° F. (23.9° C.) for 1 to 5 minutes or highly concentrated household dyes for 30 minutes. Immerse the metal in a bath of boiling acetic acid to seal the aluminum.

Aluminum—to Color Blue

ferric chloride	1 part
potassium ferrocyanide	1 part
water	30 parts

Paint or dip the heated metal with the heated solution.

Bright Dip
nitric acid 40° Baume' 1 part
water 1 part

Apply to hot metal or swap on hot solution.

Brass—to Color

a. Red:
Immerse in solution of copper sulphate 5 ounces
potassium permanganate 7 ounces
water 500 ounces

b. Red to blue to lilac:
arsenic trisulphide 75 grains
sodium carbonate 150 grains
water 10 ounces

c. Fire red:
Immerse in a solution of potassium chlorate 75 grains
nickel carbonate 30 grains
salt of nickel 75 grains
water 16 ounces

d. Blue:
Immerse in a solution of potassium sulphide 2 ounces
sodium chlorate 2 ounces
water 1,000 ounces

e. Blue:
Use hot solution of sodium thiosulphate 4 ounces
lead acetate 2 ounces
water 1 quart

f. Green:
Use hot solution of potassium bitartrate 24 grains
sodium chloride 48 grains
ammonium chloride 8 grains
copper nitrate 1 ounce
water 6 fluid ounces

g. Green:
Use hot solution of copper sulphate 120 grains
ammonium hydrochlorate 30 grains
water 1 quart

h. Brown:
iron nitrate 18 ounces
sodium thiosulphate 18 ounces
water 1 gallon

i. Brown to orange:
potassium chlorate 150 grains
copper sulphate 150 grains
water 1 quart

j. Red to blue:
copper sulphate	32 drachms
sodium hyposulphate	14 drachms
potassium bitartrate	12 drachms
water	1 quart

k. Fire red:
potassium chlorate	30 drachms
nickel carbonate	10 drachms
salt of nickel	30 drachms
water	32 ounces

l. Dark brown:
potassium chlorate	30 drachms
salt of nickel	60 drachms
water	20 ounces

Bronze—to Color

a. Green:
Use hot solution of ammonium chloride — 1 part
potassium bitartrate — 3 parts
sodium chloride — 3 parts
water — 10 parts
add to the boiling solution — 8 parts copper nitrate solution

b. Blue-green—yellow-green:
Apply boiling solution of sodium thiosulphate — 1 ounce
iron nitrate — 8 ounces
water — 1 gallon

c. Green-yellow—dip in dilute nitric acid—then treat with the following solution:
ammonium chloride — 7 parts
copper acetate — 4 parts
water — 6 parts (by weight)

d. Dark green to black
Use hot solution of potassium sulphide — 1.5 ounces
sodium hydroxide — 2.5 ounces
water — 1 gallon

Immerse the metal in this solution; remove; then paint on the following solution:
copper nitrate — 8 ounces
ammonium chloride — 4 ounces
acetic acid (6%) — 4 fluid ounces
chromic acid — 1 fluid ounce
water — 1 gallon
Repeat when dry.

e. Blue-black: heat the metal
ammonium sulphide — 2 ounces
water — 1 quart

f. Brown:
 Use hot solution of ammonium chloride 4 parts
 potassium oxalate 1 part
 acetic acid 5% 200 parts
 Treat and dry; repeat treatment; dry and brush.

Copper—to Color

a. Steel gray:
 Immerse the metal in a boiling solution of water, 1 pint; and arsenic chloride, 1 drachm.
b. Various colors:
 Immerse the metal in a boiling solution of water, 1 quart; lead acetate, 300 grains; and sodium hyposulphite, 600 grains.
c. Steel gray:
 Immerse the metal in a hot solution of muriate of arsenic, 4 ounces; and water, 2 quarts.
d. Red:
 Immerse object in a hot solution of water, 1 pint; arsenic sulphide, 2 drachms; and potassium carbonate, 1 ounce.

e. Brown:
(Use hot)	
red lead oxide	59.9 parts by weight
chalk	12.0 parts by weight
acetic acid (glacial)	3.0 parts by weight
alcohol	6.0 parts by weight
water	19.1 parts by weight

f. Brown:
(Use hot)		
water	1	pint
iron nitrate	5	drachms

g. Brown:
(Use hot)		
acetic acid (6%)	1.5	pints
potassium oxalate	1	ounce
ammonium chloride	3	ounces

h. Dark Brown:
(Use hot)		
water	1	pint
copper sulphate	1	ounce
sodium hyposuluhate	1	ounce
hydrochloric acid	2	drachms

i. Antique:
potassium sulphide	1	cubic inch
water	1	pint
ammonia	6	drops

j. Orange
 Immerse the metal in a hot solution of copper acetate.

k. Violet
 Immerse the metal in a hot solution of antimony chloride, when dry, rub with cotton.

l. Blue

ammonium chloride	1 part
ammonium carbonate	3 parts
water	25 parts

m. Black

copper nitrate	10 parts
silver nitrate	1 part
water	30 parts

Brush the solution on warm metal.

Iron and Steel—to Color

a. To blue iron or steel:

Dissolve 14 parts sodium hyposulphate in 100 parts of water.

Dissolve 3.5 parts lead acetate in 100 parts of water.

Mix the two solutions, boil, and immerse the metal to be blued.

b. Clean the metal with potassium bichromate/sulphuric acid mixture.

Wash with ammonium hydroxide and dry.

Apply ammonium polysulphide to obtain the desired color.

Dry and rub with soft cloth to polish.

Repeat the application if necessary.

Polish with boiled linseed oil.

c. Blue-black on iron or steel:

Immerse the metal in a hot solution of sodium thiosulphate and water.

d. Blue-black:

nitric acid	15 parts
copper sulphate	8 parts
alcohol	20 parts
water	125 parts

Spread over dry, clean metal. Dry and rub with soft cloth.

e. Blue-black:

Prepare a solution of tin chloride, 1 part; hydrochloric acid, 2 parts; and water, 2 parts.

Prepare another solution of cupric sulphate, 1 part; water, 16 parts; and add ammonia until there is complete dissolution.

The metal is immersed in the first solution, then in the second solution in order to build a deposit of copper on the iron. The metal is then washed with water, after which it is immersed in a solution of sodium hyposulphite (with a few drops of hydrochloric acid added) and heated to 185° F. When the proper color is obtained, the metal is removed, dried, and polished.

f. Black:

Boil 1 part sulphur in 10 parts turpentine.

Brush a light coat over the metal, and heat the metal in the flame of an alcohol lamp to obtain the desired color.

g. Brown:

Wet the metal with a solution of iron perchloride, cupric sulphate, and nitric acid. Dry at 86° F. Steam over boiling water for 30 minutes, dry again at 86° F. Brush with a wire brush. Repeat the treatment until the proper color is achieved.

h. Brown:

Immerse the metal in a hot solution of nitric acid, 1 part; sweet spirits of nitre, 1 part; copper sulphate, 4 parts; tincturn muriatic iron, 2 parts; water, 60 parts.

i. Brown:
 Clean the metal with a paste of whiting and soda, then immerse in a bath of dilute sulphuric acid, and rub with fine pumice powder. Expose the metal to the vapor of a mixture of 1 part concentrated hydrochloric acid and 1 part concentrated nitric acid. Heat the metal to 600° F., until a bronze color appears. When cool, coat with Vaseline, and reheat until the Vaseline begins to break down. Repeat the operation until the desired shade is obtained. (By adding acetic acid to the mixture of acids, yellow can be added to the metal in amounts in proportion to the amount of acetic acid in the solution.)

j. Brown:
 Brush a coat of a paste of 1 part muriatic acid and 15 parts of antimony chloride on the heated metal. Wash with clean water when the desired effect is achieved.

k. Brown to Black
 Paint the metal with concentrated amonium hydroxide and dry with slow heat, then paint the metal with muriatic acid and dry with slow heat. Finally immerse the metal in 3,4,5-trihydroxy benzoic acid (Tannin). Wash the metal with clean water when the desired color is achieved.

Lead—to Color Black
Immerse the object in a solution of hydrochloric acid, 4 parts by weight; and water, 1 part.

Tin—to Color Black
Immerse the metal in a solution of copper chloride, 8 ounces; antimony chloride, 3 ounces; and water (hot), 2 quarts.

To Copper Plate Tin Plating

Use earthenware, stoneware, or pyrex containers that can be heated with a hot plate or immersion heaters. Electricity for plating can be supplied by a toy train transformer, dry cells, battery chargers etc., as long as they produce direct current.

1. Clean the metal using industrial detergent (such as trisodium phosphate).
2. Pickle in a 10% solution of sulphuric acid.
3. Degrease the anode, which should be a pure copper plate which conducts current in the solution.
4. Suspend the anode in the solution with copper wires fastened to wooden rods placed across the container.
5. Heat the plating solution to 120° F.
6. Suspend the object in the solution with copper wires attached to the wooden bars.
7. Connect the negative terminal of the power source to the cathode (the object to be plated).
8. Connect the positive terminal to the copper sheet (the anode). The anode, the cathode, and their wires must not touch.
9. Turn on the current. A copper strike will appear almost instantly; a satisfactory thickness will take about 2 hours.
10. The solution should be aggitated with a glass or plastic stirring rod, or by a slow turning electric mixer.
11. The solution level should be maintained with distilled water or additional solution.
12. Turn off the electric power, remove the cathode, rinse in hot water and air dry, or dry with a heat gun.
13. The plate can be polished or patina'd as desired.

Copper Plating Solutions	131° F. 55° C.	131° F. 55° C.
copper sulphate	5 ounces	2.5 ounces
sodium cyanide 130%	4.5 ounces	4 ounces
sodium carbonate	2 ounces	2 ounces
sodium hyphosulphite	1/64 ounce	
water	1 gallon	1 gallon
sodium bisulphite		3 ounces
sodium hydroxide		.25 ounce

To Electroplate Plaster (Copper)

Coat the plaster with shellac, spar varnish, or wax. Apply a coating of plumbago (powdered graphite); polish. Prepare a solution as follows:

Add 1/2 ounce of hydrochloric acid to each quart of water, then suspend a bag containing 1/2 pound of copper sulphate in the solution until it is saturated with copper sulphate.

Suspend a copper plate at the positive terminal, hanging clear in the solution. Immerse the treated plaster or object to be plated in the solution, and connect it to the negative terminal. Use low voltage (1-16 volts) and 6-8 amperes per square foot of surface to be plated.

Amperes Required to Plate 1-Square-Foot Area

Nickel	4	amperes
Brass	6-8	amperes
Bronze	6-8	amperes
Copper	6-8	amperes
Silver	2	amperes
Gold	1.5	amperes
Zinc	10	amperes

Current must be D/C (direct current), and can be supplied by one or two automobile generators (in parallel) driven by a 1/4 h.p. electric motor.

Plating Solutions

a. Silver:

silver cyanide	4 parts by weight
potassium cyanide	10 parts by weight
water (distilled)	70 parts by weight

Use pure silver at the positive terminal.

b. Brass:

copper sulphate	1 part by weight
zinc sulphate	10 parts by weight
potassium cyanide	16 parts by weight
water (distilled)	1024 parts by weight

Use brass at the positive terminal.

c. Copper:

copper acetate	20 parts by weight
sodium carbonate	17 parts by weight
potassium cyanide	20 parts by weight
sodium sulphite	25 parts by weight
water (distilled)	1024 parts by weight

Use pure copper at the positive terminal.

d. Nickel:

nickel sulphate	10 parts by weight
sodium citrate	9 parts by weight
water (distilled)	288 parts by weight

Use pure nickel at the positive terminal.

Ivory and Bone—to Clean and Bleach

a. Wash with soap and warm water.
b. To bleach make a paste of fine damp sawdust. Saturate the paste with the juice of 2 lemons. Pack the ivory in the sawdust, and brush it away after it has dried.
c. Wash in mildly hot solution (by weight) of 1 part sodium bicarbonate to 10 parts water.

d. To bleach away yellow due to age, suspend the material a few inches above a container of lime chloride moistened with hydrochloric acid. Cover with a glass, and expose to direct sunlight. Remove and wash the object with a solution of sodium bicarbonate, then rinse in clear water and dry. (Brittle ivory or bone can be rendered more flexible by soaking them for a short time in dilute phosphoric acid.)

Ivory—to Soften and Make Elastic

Ivory can be softened and made elastic by soaking the material in pure phosphoric acid until it loses some of its opacity. Then the ivory is washed in cold water and dried. Eventually it will again harden, but it can be softened again by soaking the material in hot water.

Ivory—to Harden

To harden ivory that has been softened by the above method, heat table salt (without burning) until it loses its crystalline appearance; then wrap the ivory in sheet of white writing paper, and cover it with the salt for at least 24 hours.

Ivory—to Etch

Paint the ivory with varnish or shellac, and scratch away the design to be etched. Apply a solution of 1 part sulphuric acid and 6 parts water. The etched lines will turn black. To obtain brown lines, dissolve 1 part silver nitrate in 5 parts water, and etch for a short time. Expose etched areas to the light until they turn brown.

Ivory—to Color

a. Black

Wash in potassium hydroxide; then immerse in silver nitrate solution. Drain off the solution, and place in direct sunlight.

b. Red:

Soak in a solution of water

water	1,000 parts
acetic acid	100 parts
aniline red	5 parts

(Soak 24 hours; then dry and polish.)

c. Yellow:

Soak in a solution of lead acetate, rinse, and dry; then immerse in a solution of potassium chromate.

Glossary of Terms

Abstract—The simplification or generalization of forms usually found in nature, sometimes to the extent that they become unrecognizable.

Abstract textures—The simplification and rearrangement of existing tactile qualities.

Academic—Traditional; conforming to an established order, usually sacrificing originality and expression.

Accelerators—Additive materials utilized to increase the rate of a chemical action, or a process.

Adz—A hatchet like tool for shaping wood.

Aggregate—Inactive substances added to cohesive or adhesive materials, often for the purposes of increasing strength or bulk.

Alloy—A metal formed by the fusion of two or more metals to obtain physical characteristics unlike either of the original metals.

Anneal—The controlled heating and cooling of a material to alleviate internal stress which causes fracturing.

Arc welding—The use of an electric spark to produce heat for the joining of metal through melting.

Asymmetric balance—Balance which occurs through the manipulation of unlikes.

Autographic—Being so sensitive that every impression is recorded, as a finger print on clay.

Balance—A state of equilibrium.

Bat—A plaster slab used to absorb excess moisture from clay.

Bead—The line formed by a continuous weld, usually along a seam.

Binder—A material which causes a state of cohesion.

Bisque ware—The first heating of unglazed clay which turns the ware into a hard, consolidated mass.

Blind hole—A hole with a bottom, not drilled all the way through.

Bluing—A laundry additive used to tint plaster. The action of oxidizing iron or steel to a color known as gun blue.

Blunge—To mix, forming a liquid suspension.

Bombard—A transformer used to heat a cathode tube to facilitate evacuation.

Bonnet—A fabric cover which can be stretched over a sanding pad for the purposes of polishing.

Braze—To join metals using heat and a foreign metal as a binding agent.

Break—A machine used to bend or fold metal.

Bucksaw—A sawblade for cutting wood fixed in a frame and used by one person.

Buff—The act of putting a smooth bright finish on a surface through the action of a spinning fabric disc. The fabric disc used for buffing.

Burn-out—The heating of a flask in order to drive out water and other volatile materials, especially wax.

Burr—An irregular fragment of metal along an edge resulting from a cutting, punching, tearing or similar action.

Cameo—Relief carving in which the image stands above the background.

Cane—Thin solid glass rods.

Carbide tip—Silicon or tungsten carbide cutting edges brazed or soldered on to a tool shank.

Carborundum slip—A thin sharpening stone made of silicon carbide.

Carver's drill—A plug drill; a drill that depends on impact rather than rotary cutting motion to cut holes in stone.

Casting—To reproduce a given shape by pouring a temporarily fluid material into a mold. The solidified material is the reproduction.

Centrifugal—Outward force exerted on a body moving in a curving (circular) path.

Ceramic—Referring to all which is related to the consolidation of silicates of aluminum through heat of fusion, including glass and clay.

Charge—To load, as to load a furnace or crucible.

Color—1. A general term for the character of light; includes hue, value, and intensity. 2. A term used in sculpture to describe the shading on a three-dimensional surface.

Compound curve—A surface which is curved two ways.

Cone—A device used to measure the heat work of a kiln.

Content—The meaning or significance of a work of art which is a product of Form, and evidenced in aesthetic experience.

Contour—The outer edge of a shape when viewed from any given position.

Corrosion—The chemical alteration of material, usually metal, and frequently destructive, typified by the rusting of iron.

Crucible—A container made of refractory material or metal and used to heat substances to high temperatures.

Decant—To remove liquid which forms at the top of a mixture as the solids settle.

Distort—To deviate from the normal shape of an object.

Distortion—A condition of all works of art which occurs through interpretation or conception by an artist and which results in exaggeration.

Draft—An angle or taper frequently given to pattern edges in order to enable the pattern to be drawn from a mold without causing injury to the mold; a shallow groove.

Dross—A waste product taken off of molten metal during melting in the form of scum (a granular oxide).

Edge—A condition which exists when planes intersect, or at the contour of an object, and usually interpreted as a drawn line in the graphic arts.

Elaboration—To add details or to give more extensive treatment.

Emery stone—A stone of considerable hardness, consisting of silicon carbide mixed with an oxide of iron, used for grinding or polishing.

English hone—A fine, dense sharpening stone.

Excelsior—Stringy, curled wood-shaving used as a packing material.

Expressionism—An art form based on emotional interpretation of the relationships of the elements.

Filter press—A machine which extracts excess water from slip clay through hydraulic, pneumatic, or mechanical pressure.

Fire—To heat or burn objects in a controlled situation.

Flask—A complete mold box, or an invested model.

Flux—1. Any substance used to aid fusion of metals. 2. A material which combines with surface impurities on metal, in effect cleaning the metal.

Forge—1. A furnace used to heat metal. 2. To shape metal through heat and impact.

Form—Unity or order which can be achieved in the use of the elements of sculpture.

Free standing—Sculpture which is designed to be seen from all sides including the top and which usually supports itself and is not part of, or attached to, a wall or background.

Function—To serve.

Galvanized iron—Iron which is coated with zinc to prevent rust.

Gate—A system of openings or channels in a mold through which molten metal is poured in order to fill a mold cavity.

Gesso—A heavy fluid used as a base coat for paint, traditionally made of plaster of Paris and glue, but more recently of white pigment and a synthetic binder.

Glaze—A heat-created vitreous glass surface, a covering for ceramic ware.

Glyptic—Retaining the visual quality of a material and the basic geometric nature of the mass.

Graphic—Two-dimensional art forms, i.e., painting, drawing, and printmaking.

Greenware—Finished clay ware that is dry but has not been heated into a homogenous mass.

Grog—Burned, crushed clay that is added to plastic clay or investment plaster.

Harmony—Agreement or accord; orderly.

Heliarc—An electric welding machine that surrounds the area of the weld with inert gas to prevent oxidization of the metal in the weld.

Hone—To sharpen a cutting edge to its finest edge.

Hue—The term which describes specific wave lengths of light, such as red, yellow, or blue.

Hypothesis—An assertion or assumption.

Idealized—To represent in an ultimate character; a state of perfection beyond possibility.

Illusionistic—To misrepresent a medium to the extent that images created through the medium appear to be real.

Impressionism—An art form based on the interpretation of visual sensation.

Intaglio relief—Sculpture in which the surface of the image is below the surface of the background.

Intrinsic—Belonging to the essential nature of a thing.

Investment—A refractory material used in the making of molds for the casting of metals.

Jig—A tool or device for clamping or holding work in a steady position while work is being performed.

Kerf—A groove; the space left by a saw blade during a cut, and equal to the width of the blade across the teeth.

Ladle—A container for dipping and pouring metal, usually made of iron.

Laminate—A thickness built up of layers of material, usually glued together.

Lapidary—Pertaining to the art of cutting stones.

Latex—Formerly raw rubber; now any rubber-like plastic mass.

Law of Frontality—A position in sculpture in which a figure faces forward, rigid, without twist to the body.

Lean flame—A flame with too little fuel.

Lignum vitae—A heavy hardwood ranging in color from orange to dark brown.

Linear—Involving or consisting of lines; looking like a line, narrow or elongated.

Load up—The destruction of sanding, grinding, or cutting tools by clogging of the cutting edges.

Lost pattern process—A casting process in which the pattern is enclosed in the mold then removed by some destructive process such as melting or dissolving.

Luto—Used investment which has been crushed to be used again.

Malleable—Capable of being extended or shaped by impact or pressure.

Mass—A body of apparently coherent matter.

Matrix—A material that gives foundation to something embodied or enclosed in it.

Media—The materials used by the artist.

Medium—Singular form of *media*.

Mobility—Movable, the state or quality of being movable.

Model—1. To shape by pressure. 2. A master or mother shape.

Mold—1. A shell containing a reverse image of a model or master which serves as a shaping container when filled with a temporarily liquid material and which becomes the casting when it has hardened. 2. To shape by pressure.

Monolithic—A mass which is solid, not composed of smaller units.

Monumentality—A condition of sculpture in which it has the quality of hugeness or massiveness, regardless of actual size—often with the result that the object appears to be larger than it is.

Muffle—A furnace designed so that its contents are protected from direct contact with flame.

Muller—A machine which uses large rollers to condition clay through a smashing action.

Natural texture—A texture resulting from nature, not man-made.

Naturalism—Imagery as close to nature as possible, without editorializing by the artist.

Nonferrous—Metals other than iron.

Opaque—Not transparent; without the ability to transmit light.

Orientation—Acquaintance with an existing environment, or the establishment of a fixed direction.

Oxidizing flame—A flame with an excess of oxygen.

Parting—A powder without binding qualities used to separate layers of sand in a sand mold.

Patina—Originally, the natural color of oxidized metal surfaces; more recently, the surface coloring given to various materials such as metal, wood, and plaster when used in relation to sculpture.

Perspective—The systematic depiction on a flat surface of the illusion of consistent depth.

Pick—A metal working hammer with a long thin pointed head for reaching into crevices or deep into holes. A thin pointed wire in a wooden handle.

Pickle—An acid bath used to remove burnt sand, scale, or specific impurities from the surface of metal.

Piece mold—A mold constructed in sections so that it can be used repeatedly.

Pigment—A minute particle, which reflects a specific hue, used in the formation of paint or ink.

Pitch—A residue from the distillation of tar and petroleum.

Plane—A curved or flat continuous surface defined by edges.

Plastic—1. A material malleable enough to be manipulated by hand. 2. A synthetic coherent material.

Plumb bob—A weight on a string used to indicate vertical direction.

Pot metal—White metal, i.e., lead, tin, and cadmium-based metals.

Print—The surface impression imparted on a casting by the mold.

Proportion—Size relationship of part to part, often in comparison to forms found in nature.

Proportional dividers—A measuring tool which mechanically adjusts size ratios.

Pug mill—A machine, similar to a meat grinder, which prepares plastic clay.

Pumice stone—A porous volcanic glass used in polishing.

Putty powder—A crude stannic acid powder used for fine polishing.

Quench—To cool heated metal by immersion in a liquid.

Rake—Slant or slope.

Realistic—Pertaining to general appearances as found in nature.

Reducing flame—A flame with insufficient oxygen to support complete combustion.

Refraction—The bending of light as it passes through a transparent material.

Refractory—A material which resists the action of heat.

Relief—An art form which is graphic in concept, but utilizes shallow depth (projection) to establish images.

Repoussé—A relief in which the image is produced primarily by impact on the back of the medium, usually soft sheet metal.

Resin—Certain solid or semisolid organic or synthetic substances with significant binding qualities.

Retaining shell—An outside casing used to hold a piece mold together.

Retarder—A material or condition such as temperature which slows up a process or chemical action.

Rhythm—A continuous measured sequence of similar or equal units.

Rich flame—A flame with too much fuel.

Riddle—1. A screen (sieve) used to sift casting sand. 2. To sift casting sand onto a model from considerable height.

Riser—A space in a mold above the cavity that is used to supply liquid metal to thick sections of a casting that may shrink during cooling.

Rub out—The process of polishing a surface by hand rubbing with cloth and rubbing or polishing compounds to bring out lustre.

Runner—A channel in a mold which feeds metal from the sprue to the cavity.

Scraper—A tool which cuts with a dragging action.

Scribe (metal)—A hard, pointed metal tool (sometimes tipped with a diamond) used to draw on metal.

Self tapping screws—Hardened metal screws with threads designed to cut or thread common metal.

Separator—A surfacing material used to prevent sticking or bonding and often used in casting to prevent the casting material from sticking to the mold.

Shape—Closed, definable area.

Sharpening slip—A small abrasive stone used for putting a cutting edge on tools.

Shim stock—Thin metal usually brass or steel, used in industry as spacer material. It is generally measured in thousandths of an inch.

Siccative—A binding material used to give a clay body added adhesion.

Simulated Texture—A tactile quality which has been copied.

Slake—To soak in water.

Slip—A thin, runny suspension of clay in water.

Slurry—A watery mud-like substance.

Smoke—The application of gentle low temperature heat to cure, dry or otherwise alter a body of material.

Solder—To bond metals using heat to melt in the joint between them, low temperature alloys of lead which adhere to the two adjoining metal surfaces.

Space—1. A three-dimensional expanse. 2. The interval between objects.

Spalls—Fragments, chips, or splinters, usually related to stone.

Sprue—A channel or opening in a mold which conveys molten metal to the runners, and the metal which solidifies in the channel.

Stake—Shaped metal tool which fits into a square hole on an anvil or similar base, and which serves as an extension of the anvil, for the creation of selective shapes through impact.

Stamps—Textured objects which are used to impress textures or designs in clay, wood, leather, metal, and so on.

Subject matter—The theme or story often associated with a work of art.

Subordinate—Of secondary importance.

Symmetrical—Divisible into identical parts by passing a plane through the center. (Commonly, in graphic forms, the plane is passed vertically through the forms.)

Syncopation—Accenting rhythmic patterns in an unexpected way, usually to create interest.

Tactile—Pertaining to the sense of touch.

Tamp—To force by impact; to stamp.

Tap—To cut a screw thread in a hole.

Temper—The degree of hardness or elasticity acquired by metals after being subjected to controlled heating and cooling.

Tensile—Relating to the ability of a material to be stretched or drawn.

Tension—A state of strain, stress, or excitement resulting from form or position.

Terrazzo—A polished conglomerate consisting of cement and colored stones.

Texture—The surface quality of any material which can be sensed, or appear to be sensed, by touch; having tactile qualities.

Thermoplastic—Material which becomes pliable with the application of heat, while maintaining other inherent characteristics.

Thermosetting plastic—Plastic that hardens to the application of heat.

Thermowelding—A method of joining materials with heat; usually refers to the bonding of plastic with jets of hot gas or by passing the plastic between hot rollers.

Three-dimensional—Physically measurable in a constant scale, on three axes—length, height, and depth.

Time—A system indicating duration, measured by a consistent sequence of events not occurring simultaneously.

Torque—The result of forces applied in such a way as to cause twist or rotation.

Totality—The state of being whole or complete.

Translucent—The ability to permit the passage of light but not image.

Transparent—Allowing the passage of light without significantly obscuring the image.

Tubulate—The attachment of fine glass tubing to a cathode tube to aid in the evacuation of the unit.

Twist drill—A drill having a round shank and spiral fluting.

Value—The comparative quantity of light reflected, appearing to range from light to dark or black to white, and related to shading.

Vent—A passage in a mold designed to exhaust gasses incurred during the casting of metal.

Void—An empty space; a negative area.

Volatile—Having the ability to readily pass into a gaseous state.

Volume—Three-dimensional quantity, often easily measurable; in sculpture, usually rigid.

Waste mold—A mold which must be destroyed to release a casting.

Wedge—To mix plastic clay by cutting and squeezing.

Weld—To fuse; to join like metals by melting the metal along the bond line so that molten metals flow together forming one unit, sometimes with the addition of a filler metal.

Wire edge—A burr on the edge of a cutting tool resulting from pressure exerted against the tool during the sharpening process.

Work harden—To change the structure of a material through impact or flexing, resulting in a stiffening or hardening of the material.

Bibliography

Arnheim, Rudolf, *Art and Visual Perception,* University of California Press, Berkeley, California, 1969. London, Faber, 1967.

Arnheim, Rudolf, *Visual Thinking,* University of California Press, Berkeley, California, 1971. London, Fabor, 1970.

Barret, Cyril, *An Introduction to Optical Art,* Studio Vista, London, 1971.

Barret, Cyril, *Op Art,* Viking Press, New York, 1970. Studio Vista, London, 1970.

Batten, Mark, *Stone Sculpture by Direct Carving,* The Studio Publications, London, 1957.

Benthall, Jonathan, *Science and Technology in Art Today,* Praeger, New York, 1972.

Blum and Hogaboom, *Principles of Electroplating and Electroforming,* McGraw-Hill Book Company, New York, 1950.

Brett, Guy, *Kinetic Art, the Language of Movement,* Van Nostrand Reinhold Co., New York, 1968. Studio Vista, London, 1968.

Burnham, Jack, *Beyond Modern Sculpture,* George Braziller Inc., New York, 1967.

Campbell, Harry L., *Metal Castings,* John Wiley and Sons, Inc., New York, 1936.

Carraher, Ronald C. and Thurston, Jacquelin B., *Optical Illusions and the Visual Arts,* Van Nostrand Reinhold Co., New York, 1966. Studio Vista, London, 1967.

Chase and Post, *A History of Sculpture,* Harper and Brothers Publishers, New York, 1925.

Collingwood, G. H., and Brush, Warren D., *Knowing Your Trees,* Washington, D. C., American Forestry Association, 1955.

Cook, J. Gordon, *The Miracle of Plastics,* Dial Press, New York, 1964.

DeDani, A., *Glass Fiber Reinforced Plastics,* Inter-science, New York, 1961.

Edlin, Herbert T., *What Wood is That?* New York, Viking Press, 1969.

Ellenberger, Baum, and Dittrich, *An Atlas of Animal Anatomy for Artists,* Dover Publications, Inc., New York, 1956.

Grohmann, Will, *The Art of Henry Moore,* New York, Harry Abrams, Inc., 1960.

Hammond, Donnelly, Harrod, and Rayner, *Wood Technology,* Bloomington, Ill., McKnight & McKnight Publishing Co., 1966.

Holtrop and Hjorth, *Principles of Woodworking,* The Bruce Publishing Company, Milwaukee, Wis., 1961.

Hunter, Sam, *David Smith,* New York, The Museum of Modern Art, 1957.

Jefferson, T. B., and MacKenzie, L. B., eds., *The Welding Encyclopedia.* New York, McGraw-Hill Publishing Co., Inc., 1951.

Kepes, Gyorgy, *The Language of Vision,* Paul Theobald and Co., Chicago, 1951.

Lynch, John, *Metal Sculpture,* New York, Studio-Crowell, 1957.

Mayer, Ralph, *The Artist's Handbook of Materials and Techniques,* The Viking Press, New York, 1957.

Meilach, Dona and Seiden, Don, *Direct Metal Sculpture,* New York, Crown Publishers, 1966.

Miller, Samuel, C., *Neon Signs and Cold Cathode Lighting,* New York, McGraw-Hill Book Company, 1952.

*References listed alphabetically by author surname where possible; volumes not so listed appear—alphabetically by book title—at the conclusion of the Bibliography.

Miner and Miller, *Exploring Patternmaking and Foundry,* D. Van Nostrand Company, Inc., Princeton, N. J., 1964.

Moholy-Nagy, L., *Vision in Motion,* Paul Theobald, Chicago, 1947.

Mumford, Lewis, *Art and Technics,* New York, Columbia University Press, 1952.

Nelson, Glen C., *Ceramics,* Holt, Rinehart and Winston, Inc., New York, 1960.

Neumann, Robert, von, *The Design and Creation of Jewelry,* Chilton Co., Philadelphia, 1961.

Newman, Thelma R., *Plastics as an Art Form,* Philadelphia, Pa., Chilton Company, 1964.

Read, Herbert, *A Concise History of Modern Sculpture,* Frederick A. Praeger, Publisher, New York, 1964.

Read, Herbert, *The Philosophy of Modern Art,* New York, Meridian Books, 1955.

Rhodes, Daniel, *Clay and Glazes for the Potter,* Greenberg Publishers, New York, 1957.

Rhodes, Daniel, *Kilns: design, construction and operation,* Philadelphia, Pa., Chilton Book Co., 1968.

Rich, Jack, *The Materials and Methods of Sculpture,* Oxford University Press, Inc., New York, 1947.

Richter, H. P., *Wiring Simplified,* Minneapolis, Minn.: Park Publishing, Inc., 1965.

Ritchie, Andrew C., *Sculpture of the Twentieth Century,* The Museum of Modern Art, New York.

Rodman, Selden, *Conversations with Artists,* New York, Capricorn Books, 1961.

Rood, John, *Sculpture in Wood,* University of Minnesota Press, Minneapolis, Minn., 1950.

Rood, John, *Sculpture with a Torch,* Minneapolis, University of Minnesota, 1963.

Roszak, Theodore, *Fourteen Americans,* ed. Dorothy C. Miller, New York, Museum of Modern Art, 1946.

Roukes, N., *Sculpture in Plastic,* New York, Watson Guptill Publications, 1968.

Royce, Joseph, *Surface Anatomy,* F. A. Davis Co., Philadelphia, 1965.

Schider, Fritz, *An Atlas of Anatomy for Artists,* Dover Publications, New York, 1957.

Seitz, William C., *The Art of Assemblage,* New York, Museum of Modern Art, 1961.

Seuphor, Michel, *The Sculpture of This Century,* George Braziller, Inc., New York, 1961.

Sloane, T. O'Connor, *Henley's Twentieth Century Book of Ten Thousand Formulas, Processes and Trade Secrets,* New York: Books Inc., 1970.

Struppeck, Jules, *The Creation of Sculpture,* Henry Holt and Co., New York, 1952.

Verhelst, Wilbert, *Sculpture Tools, Materials, and Techniques,* Prentice-Hall, Inc., Englewood Cliffs, N. J., 1973.

Wilenski, R. H., *The Meaning of Modern Sculpture,* London, Faber and Faber Ltd., 1932.

Woldman, Norman E., Ph.D. *Metal Process Engineering.* New York, Reinhold Publishing Corporation, 1948.

Zorach, William, *Zorach Explains Sculpture,* American Artists Group, New York, 1947.

Dictionary of Modern Sculpture, Robert Maillard, (Ed.), Tudor Publishing Company, New York, 1960.

How To Use Castolite Liquid Plastics and Fiberglass, Castolite Company, Woodstock, Illinois, 1959.

Modern Plastics Encyclopedia, New York, McGraw-Hill Book Company, current issue.

Plastics Engineering Handbook, New York, Reinhold Publishing Corp., 1960.

The Oxy-Acetylene Handbook, Linde Air Products Co., New York, 1954.

Vasari on Technique, L. S. Machelhose (Tr.), New York, 1907.

Source List

Possibly the most useful approach to locating sculpture supplies would be as follows:

1. Consult the yellow pages of the telephone book, seeking retail outlets of manufacturers.
2. Consult industrial publications such as FOUNDRY CATALOG FILE or MODERN PLASTICS ENCYCLOPEDIA.
3. Consult Thomas Register of American Manufacturers.

The following lists of materials and sources may be useful. It must be noted that large companies may not sell in small quantities and may refer the buyer to retail outlets; and because of the mobility of our industry addresses may change and should be checked against current sources such as the Thomas Register of American Manufacturers.

The numbers following the items in the List of Materials refer to the identifying numbers on the accompanying List of Firms.

Plastic dip dyes, 266
Plastic film, 87, 145, 153, 194
Plastic foam, 87, 106, 117, 145, 374, 389
Plastic heat-sealing equipment, 340, 445
Plastic, honeycomb, 144
Plasticizers, 140, 226, 227, 228
Plastic mill shapes, rods, tubes, 87, 362
Plastic-molding compounds, 24, 311, 396
Plastic mold material, 462
Plastic ovens, 222
Plastic powders, 145, 153, 362
Plastic putty, 136
Plastic resins, 24, 87, 117, 153, 156, 311, 363, 389, 396
Plastic-scratch remover, 441
Plastic sheet material, 24, 87, 145, 153, 194
Plastic-spray equipment, 195
Plastic vacuum forming machines, 361
Plastic vacuum pumps, 241
Plastic water-extendable polyester resins, 363
Plastic welders, 254, 283
Plexiglas (paints), 66, 196, 258, 273, 413, 465, 492
Pneumatic tools, 9, 44, 45, 67, 83, 125, 184, 202, 241, 284, 452, 463
Polishing buffs, 209, 248, 271, 286
Polishing compounds, 50, 100, 120, 150, 176, 209, 210, 271, 285, 286, 425, 457
Polishing supplies, 121, 181, 452, 483, 497, 498
Polyester resins, 24, 87, 117, 357, 363, 379, 387, 389 396, 498, 500
Polystyrene foam, 106, 145
Polyurethane resins, 117, 242, 389
Portable power tools, 74, 126, 304, 395, 419, 434
Portland cement, 497, 499
Power-coating equipment, 381
Prepared gel coats, 117, 379
Press polishing plates, 213
Protective clothing, 125, 275, 375
Pumice stone, 452
Pumps, 126, 233, 259, 345
Putty powder, 452
Pyrometers, 252, 275
R-2 spray gun, 374
Radiant heaters, 147, 155, 158, 188, 233, 239, 437
Rasps and rifflers, 120, 322, 405, 407
Refractories, 37, 41, 58, 131, 253
Refractory brick, 37, 131, 499
Refractory washers, 179, 181, 484
Release agents, 118, 156, 161, 363, 369, 372, 379
Respirators, 27, 375, 482
Rosin, 68, 399, 501
Router bits, 30, 52, 157, 241, 268, 334, 338, 395, 434
Routing equipment, 157, 338, 364, 367, 434
Roving, 317
Rubber, 136

Safety controls (ovens to furnace), 252, 479
Safety equipment, 27, 375, 482
Sand binder, 42, 46
Sandblasting equipment, 14, 109, 201, 298, 398
Sand equipment, 251
Sand (foundry), 128, 203, 474
Sanitizing chemicals, 249, 455, 475
Saw blades, 2, 74, 92, 177, 272, 416, 436, 456
Sawing equipment, 2, 47, 74, 123, 138, 177, 216, 257, 268, 272, 361, 364, 367, 417, 434
Saws, 74, 123, 138, 216, 257, 361, 364, 367, 434
Scales, 120, 131, 336
Scotch tape, 305, 347
Sculpture benches, 83, 121, 181
Sculpture supplies, 120, 275, 322, 404, 405, 407
Sealing compounds, 88, 115, 305, 370, 373
Separators, 118, 156, 161, 363, 369, 372, 422
Sharpening stones, 93, 120, 405, 407, 486
Shellac, 496, 497, 500
Silica sand, 484
Silicon flour, 316, 382
Silver, 200, 483
Solar cells, 154
Solder, 497
Soldering flux, 497
Solenoid valve, 48
Solvent adhesives, 87
Solvents, 117, 226, 227, 228, 363, 379
Sound barrier ear muffs, 482
Speed controls, 267, 276
Speed-reduction motors, 81, 82, 154
Spray-equipment, 71, 137, 497, 498
Spray-equipment (plastics), 71, 195
Spray-paint equipment, 70, 71, 120, 137, 381
Spray-plating equipment, 429
Spring paper clips (for hanging plexiglas sheets in forming ovens), 230
Spring type clamps, 8, 108, 263
Stainless steel, 101
Stainless steel wire, 220
Stakes, 483
Static eliminators, 267, 458
Steam cleaners, 234
Stearine, 68, 501
Steel, 70, 459
Stone, 62, 193, 236, 237, 420, 448, 469, 470
Stone carving tools, 68, 120, 165, 201, 202, 322, 404, 405, 407, 452, 454
Stone saws, 125
Strip heaters, 479
Styrene, 379
Styrofoam, 91, 500
Styrofoam cement, 181
Styrofoam surfacing wax, 181

Talc, 131, 191
Tallow, 209, 210
Tapes, 305, 315, 347, 446
Thermostats for electric ovens, 479
TIG welders, 454
Timers, 63, 321, 323, 447
Toggle clamps, 135, 264
Tongs, lifting, 252, 275
Tool plastic, 392
Tools, 112, 113, 114, 129, 138, 358, 486, 487, 494
Traveling saw, 74
Trichlorethane, 316
Trichloroethylene, 379
Ultrasonic welders, 340, 445
Urethan foam, 7, 117, 119, 389
Vacuum-forming equipment, 361
Vacuum forming machine (automatic), 55
Vacuum forming machine (non automatic), 170, 359, 361
Veneer blades, 2, 47, 417

Ventilating equipment, 126, 137
Vermiculite, 499
Water-extendable resins, 363
Wax, 15, 61, 68, 150, 156, 174, 287, 309, 341, 351, 399, 402, 405, 418, 425, 440, 475, 483, 489, 496, 497, 501
Wax-melting pot, 15, 479
Wax rods and shapes, 15, 425
Wax top cartridges, 443
Welding equipment, 313, 421, 454
Welding goggles, helmets, etc., 27, 375
Welding rods, 17, 166, 218, 313
Welding supplies, 10, 83, 102, 166, 497, 498
Wetting agents, 316
Wire, 70, 267
Wire brushes, 36, 464
Wood, 12, 83, 251, 300, 404, 405, 406
Wood tools, 83, 84, 120, 121, 165, 181, 202, 404, 405, 407, 430, 438, 485, 486, 494, 497
Woodworking equipment, 366, 395
Zonalite, 499

1. Ackerman-Gould Co.
 92-96 Bleecker St.
 New York, N. Y. 10012
2. Acme-Detroit Saw Corp.
 2441 Goodrich Ave.
 Ferndale, Mich. 48220
3. Acme Neon Accessory
 588 Broadway
 Buffalo, N. Y. 14212
4. Acushnet Process Co.
 776 Belleville Ave.
 New Bedford, Mass.
5. A. D. Alpine Inc.
 353 Coral Circle
 El Segundo, Calif. 90245
6. Ade-O-Matic Co.
 Wrigley Bldg.
 Chicago, Ill.
7. Adhesive Products Corp.
 1660 Boone Ave.
 Bronx, N. Y. 10460
8. Adjustable Clamp Co.
 417 North Ashland Ave.
 Chicago, Ill. 60622
9. Aeorquip Corp.
 Subsidiary Libbey-Owens Ford
 300 S. East Ave.
 Jackson, Mi. 49203
10. Airco Welding Products
 P.O. Box 486
 Union, N. J. 07083
11. Alabama Metal Industries, Inc.
 Box 3928
 Birmingham, Ala. 35208
12. Albert Constantine and Son, Inc.
 2050 Eastehider Rd.
 Bronx, N. Y.
13. Alcan Metal Powders
 Division of Alcan Aluminum Corp.
 Box 290
 Elizabeth, N. J. 07207
14. A.L.C. Co., Inc.
 Box 506
 Medina, Ohio 44256
15. Alexander Saunders and Co.
 Box 265
 Cold Spring, N. Y. 10516
16. Allied Radio
 100 N. Western Ave.
 Chicago, Ill. 60680
17. All-State Welding Alloys Co.
 840 N. Michigan Ave.
 Chicago, Ill. 60611

18. Aluminum Co. of America
 (ALCOA)
 1501 Alcoa Bldg.
 Pittsburg, Pa. 15219
19. Aluminum Smelting and Refining Co.
 5463 Dunham Rd.
 Maple Heights, Ohio 44137
20. Amerace Esna Corp.
 Chemical Specialties Div.
 74 Hudson Ave.
 Tenafly, N. J. 07670
21. American Art Clay Co.
 4717 W. 16th St.
 Indianapolis, Ind. 46224
22. American Buff International, Inc.
 624 West Adams St.
 Chicago, Ill. 60606
23. American Crayon Co.
 Sandusky, Ohio
24. American Cyanamid Co.
 Plastics Div.
 Wayne, N. J. 07470
25. American Handicrafts Co.
 193 Williams St.
 N. Y., N. Y.
26. American Hoechst Corp.
 Fabric Color Div.
 Mountainside, N. J.
27. American Industrial Safety Equipment Co.
 3500-T Lakeside Ave.
 Cleveland, Ohio 44114
28. American Neon Supply Co.
 715 W. 23rd St.
 Kansas City, Missouri 64108
29. American Optical Co.
 Southbridge, Mass.
30. American Rotary Tool Co.
 44 Whitehall St.
 N. Y., N. Y., 10004
31. American Smelting and Refining Co.
 Federated Metals Div.
 120 Broadway
 N. Y., N. Y., 10005
32. Amoco Chemicals Corp.
 130 E. Randolph Dr.
 Chicago, Ill. 60601
33. Anaconda American Brass Co.
 Waterbury, Conn. 06720
34. Anchor Packing Co.
 401 N. Broad St.
 Philadelphia, Pa., 19108
35. Anderson Cob Mills Inc.
 507 Illinois Ave.
 Maumee, Ohio 43537

36. Anderson Corp.
 1029 Southbridge St.
 Worchester, Mass 01610
37. A. P. Green Refractories Co.
 Green Blvd.
 Mexico, Miss. 65265
38. Apogee Chemical Inc.
 De Carlo Ave.
 Richmond, Calif.
39. Arcair Co.
 Box 406
 Lancaster, Ohio 43130
40. Archer Rubber Co.
 Milford, Mass
41. ARC Inc.
 Allen Refractories Co.
 3320 Winchester Southern Rd.
 Canal Winchester, Ohio 43110
42. Arcoa Corp.
 South Ave.
 Toledo, Ohio
43. Armstrong Cork Co.
 Lancaster, Pa.
44. (The) Aro Corp.
 Industrial Div.
 Bryan, Ohio, 43506
45. Arrow Tool Co.
 1900 S. Costner Ave.
 Chicago, Ill. 60623
46. Ashland Chemical Co.
 Foundry Products Div.
 P.O. Box 2219
 Columbus, Ohio 43216
47. Atkins Saw Div.
 Borg-Warner Corp.
 Greenville, Miss.
48. Atkomatic Valve Co., Inc.
 545 W. Abbot St.
 Indianapolis, Ind. 46225
49. Atlantic Chemicals and Metals Co.
 1921-1927 N. Kenmore Ave.
 Chicago, Ill.
50. Atlantic Compond Co.
 2 Charles St.
 Chelsea, Mass 02150
51. Atlantic India Rubber Works, Inc.
 571 W. Polk St.
 Chicago, Ill., 60607
52. (The) Atrax Co.
 240 Day St.
 Newington, Conn.
53. Auburn Plastics Inc.
 Auburn, N. Y.
54. Automatic Switch Co.
 Florham, N. J.

55. Auto-Vac Co.
 105 Meadow St.
 Fairfield, Conn.
56. Avnet-Shaw
 Commercial St.
 Engineers' Hill
 Plainview, L. I., N. Y.
57. AWS Foundry Supplies and Equipment
 ARCO Welding Service
 4727 S. Hoyne Ave.
 Chicago, Ill. 60638
58. Babcock and Wilcox
 Refractories Div.
 Old Savannah Rd.
 Augusta, Georgia 30930
59. Bakelite Corp.
 247 Park Ave.
 N. Y., N. Y.
60. Barber-Colman Co.
 Motors and Components Div.
 1300 Rock St.
 Rockford, Ill.
61. Bareco Wax Co.
 917 Enterprise Bldg.
 Tulsa, Oklahoma
62. Barre Granite Co. Stone
 Barre, Vermont 05641
63. Bayside Timers, Inc.
 43-69 162nd. St.
 Flushing, N. Y. 11358
64. Beacon Mfg., Co.
 180 Madison Ave.
 N. Y., N. Y.
65. Beck Equipment Co.
 3350 W. 137th St.
 Cleveland, Ohio
66. Bee Chemical Co.
 2700 E. 170th St.
 Lansing, Ill., 60438
67. Beford Forge Co.
 22 Interstate St.
 Bedford, Ohio
68. Behlen and Brothers, Inc. wood
 10 Christopher St.
 N. Y., N. Y. 10014
69. M. A. Bell Co.
 217 Lombard St.
 St. Louis, Mo. 63102
70. Bethlehem Steel Corp.
 Bethlehem, Pa. 18016
71. Binks Manufacturing Co.
 Box 66090
 A.M.F. O'Hare
 Chicago, Ill. 60666

72. Binney and Smith
 41 E. 42nd St.
 N. Y., N. Y.
73. Birchwood Casey
 Div. of Fuller Lab., Inc.
 7900 Fuller Rd.
 Eden Prairie, Minn., 55343
74. Black and Decker Mfg., Co.
 Townson, Md., 21204
75. Blaisdell Pencil Co.
 Bethayres, Pa.
76. Bloomington Limestone Corp.
 110 E. 42nd St.
 N. Y., N. Y., 10014
77. Borden Inc.
 Chemical Div.
 50 W. Broad St.
 Columbus, Ohio 43215
78. Bortman Plastics Co.
 183 Essex St.
 Boston, Mass.
79. Robert Bosch Corp.
 2800 S. 25th St.
 Broadview, Ill. 60153
80. Bradford Park Corp.
 7 Tamarack Lane
 Elnora, N. Y. 12065
81. Brevel Products Corp.
 Broad Ave. and 16th St.
 Carlstadt, N. J. 07072
82. Bristol Saybrook Co.
 500 Coulter Ave.
 Old Saybrook, Conn., 06475
83. Brodhead Garrett Co.
 11425 Glenwood Ave.
 Cleveland, Ohio
84. Buck Brothers, Inc.
 Millbury, Mass. 01527
85. Burning Bar Sales Co.
 6010 Yolanda Ave.
 Tarzana, Calif. 91356
86. Cadet Chemical Co.
 c/o McKesson and Robbins
 155 E. 44th St.
 N. Y., N. Y. 10017
87. Cadillac Plastic and Chemical Co.
 Box 810 or 15111 Second Ave.
 Detroit, Mich. 48232
88. Calbar, Inc.
 2612-26 N. Martha St.
 Philadelphia, Pa. 19125
89. California Chemical Co.
 Oronite Division
 1 Rockefeller Plaza
 N. Y., N. Y. 10020

90. Calwis Co.
P.O. Box 994
Green Bay, Wisconsin

91. Can Pro Corp.
Fond Du Lac, Wis.

92. (The) Capwell Mfg. Co.
61 Governor St.
Hartford, Conn. 06102

93. (The) Carborundum Co.
Bonded Abrasives Div.
Box 337
Niagara Falls, N. Y. 14302

94. Cast Optics Corp.
1966 S. Newman St.
Hackensack, N. J. 07602

95. Catalin Corp. of America
1 Park Ave.
N. Y., N. Y. 10016

96. Cedar Heights Clay Co.
50 Portsmouth Rd.
Oak Hill, Ohio 45656

97. Cee-Bee Chemical Co., Inc.
9520 E. Ceebee Dr.
Downey, California 92041

98. Central Neon Supply Co.
1616 Cuming St.
Omaha, Nebraska 68102

99. Cerro Sales Corporation
300 Park Ave.
N. Y., N. Y. 10022

100. Charles B. Chrystal Co., Inc.
53 Park Place
N. Y., N. Y. 10007

101. Chase Brass and Copper Co.
Waterbury, Connecticut 06720

102. Chemetron Corp.
Welding Products
111 E. Wacker Dr.
Chicago, Ill. 60601

103. Chemical Development Corp.
Danvers, Massachusetts

104. Chicago Wheel and Mfg. Co.
1101 W. Monroe St.
Chicago, Ill. 60607

105. Christman Engraving Co.
2822 Wilber St.
Battle Creek, Michigan

106. Cincinnati Foam Products Division
Box 9013
Cincinnati, Ohio 45209

107. Cincinatti Milacron, Inc.
Products Div.
Box 9013
Cincinnati, Ohio 45209

108. Cincinnati Tool Co.
5901 Creek Road
Cincinnati, Ohio 45242

109. Clementina Ltd.
2277 Jerrold Ave.
San Francisco, Calif. 94124

110. Cleveland Chaplet and Mfg. Co.
26470 Lakeland Blvd.
Cleveland, Ohio 44132

111. Cleveland Metal Abrasive Co.
888 E. 67th St.
Cleveland, Ohio

112. Coastal Sales Co.
1112 E. Yandell
El Paso, Texas 79944

113. Coastal Sales Co. N. W.
2825 S.E. Stark St.
Portland, Oregon 97214

114. Coastal Sales Co., N. W.
3412 16th Ave., West
Seattle, Wash. 98119

115. Coast Pro-Seal and Mfg. Co.
2235 Beverly Blvd.
Los Angeles, California

116. Continental Felt Co.
22-26 W. 15th St.
N. Y., N. Y.

117. Cook Paint and Varnish Co.
Box 389
Kansas City, Mo. 64141

118. Core-Lube Inc.
P.O. Box 811
Danville, Ill. 61832

119. CPR Division
The Upjohn Co.
Box 2978, Annex
555 Alaska Ave.
Torrance, Calif. 90503

120. (The) Craftool Co. tool
1 Industrial Rd.
Woodridge, N. J. 07075

121. Craftools, Inc.
396 Broadway
N. Y., N. Y., 10013

122. Crossley Machine Co.
Trenton, N. J.

123. (The) Cutawl Corp.
Bethel, Conn. 06801

124. Damon Chemical Co.
Alliance, Ohio

125. Dawson MacDonald Co., Inc.
141 Pearl St.
Boston, Mass. 02110

126. Dayton Electric Mfg. Co.
5959 W. Howard St.
Chicago, Ill. 60648

127. Del-Glo Co.
Box 930
Cheyenne, Wyo.

128. Delhi-Foundry Sand Co.
6326 Gracely Dr.
Cincinnati, Ohio 45233

129. Delta Milwaukee Industrial Machine Tools
Rockwell Mfg. Co.
Milwaukee, Wis. 53201

130. Dennis Chemical Co.
2701 Papin St.
St. Louis, Missouri 63103

131. Denver Fire Clay
2401 E. 40th Ave.
Denver, Colo. 80217

132. Deco Products Distributors
4329 Woodman Ave.
Van Nuys, California 91408

133. (The) Desmond-Stephan Mfg. Co.
317 S. Walnut St.
Urbana, Ohio 43078

134. Despatch Oven Co.
619 Southeast Eighth St.
Minneapolis, Minnesota 55414

135. De-Sta-Co Division (or Detroit Stamping Co.)
Dover Corporation
350 Midland Ave.
Detroit, Mich. 48203

136. Devcon Corp.
59 Endicott St.
Danver, Mass. 01923

137. (The) DeVilbiss Co.
300 Phillips Ave.
Toledo, Ohio 43601

138. Dewalt, Inc.
Lancaster, Pa.

139. Dexter Chemical Corp.
819 Edgewater Rd.
N. Y., N. Y., 10059

140. Diamond Alkali Co.
Plastics Div.
300 Union Commerce Bldg.
Cleveland, Ohio 44114

141. Diamond Neon Supply Co.
3740 47th Ave. North
Box 11804
St. Petersburg, Fla. 33733

142. Dixon, Joseph Crucible Co.
167 Wayne St.
Jersey City, N. J. 07303

143. Dixon, William Co.
750 Washington Ave.
Caristadt, N. J. 07072

144. Douglas Aircraft Co., Inc.
3000 Ocean Park Blvd.
Santa Monica, Calif.

145. Dow Chemical Co.
Midland Rd.
Midland, Mich. 48640

146. Dremel Mfg. Co.
4915 21st St.
Racine, Wis. 53406

147. Dry Clime Lamp Corp.
Greensburg, Ind., 47240

148. Drying Systems Co.
7845 Merrimac Ave.
Morton Grove, Ill. 60053

149. (The) Dumore Co.
1300 17th St.
Racine, Wis., 53403

150. Du Pont de Nemours, E. I., and Co.
Arlington, N. J.

151. Durkee-Atwood Co.
215 N.E. Seventh St.
Minneapolis, Minnesota

152. Durochrome Decalcomania Co.
1215 Rio Vista Ave.
Los Angeles, California 90023

153. Eastman Chemical Products Inc.
Box 431
Kingsport, Tenn. 37662

154. Edmund Scientific Co.
700 Edscorp Bldg.
Barrington, N. J. 08007

155. Edwin L. Wiegand Div.
Emerson Electric Co.
7500 Thomas Blvd.
Pittsburg, Pa. 15208

156. E. I. Du Pont De Nemours and Co., Inc.
Electrochemicals Dept.
1007 Market St.
Wilmington, Del. 19898

157. Ekstrom-Carlson and Co.
1400 Rallroad Ave.
Rockford, Ill. 61110

158. Electrical Products Supply Co.
1200 N. Main St.
Los Angeles, Calif. 90012

159. Electric Hotpack Co., Inc.
5083 Cottman St.
Philadelphia, Pa. 19135

160. Electro Chemical Laboratories Corp.
530 S. Lewis Ave.
Tulsa, Oklahoma

161. Ellen Products Co.
125 South Liberty Dr.
Stoney Point, N. J. 10980

162. Engelhard Industries, Inc.
Hanovia Loquid Gold Div.
1 W. Central Ave.
East Newark, N. J. 07029

163. Erdle Perforating Co., Inc.
100 Pixley Industrial Parkway
Box 1568 T
Rochester, N. Y. 14603

164. Erico Products, Inc.
Plastic Equipment Div.
34600 Solon Rd.
Cleveland, Ohio 44139

165. Ettl Studios
213 W. 58th St.
N. Y., N. Y. 10019

166. Eutectic Corp.
40-40 172nd St.
Flushing, N. Y. 11358

167. Everseal Products Co.
13686 Elmira Ave.
Detroit, Mich. 48227

168. Exide Industrial Div.
Electric Storage Battery Co.
5675 Rising Sun Ave.
Philadelphia, Pa. 19120

169. Exolon Co.
949 E. Niagra St.
Tonawanda, N. Y.

170. Fairmont Products Co.
P.O. Box 443
Fairmont, North Carolina

171. Fenton Foundry Supply
134 Gilbert Ave.
Dayton, Ohio

172. Fernholtz Machine Co.
8468 Melrose Place
Los Angeles, Calif. 90046

173. Ferro Corp.
Color Div.
Cleveland, Ohio 44105

174. Fezandie and Sperrle, Inc.
102 Lafayette St.
N. Y., N. Y. 10013

175. Foredom Electric Co.
Blackston Industries, Inc.
Rt. 6
Stoney Hill
Bethel, Conn. 06801

176. Formax Mfg. Co.
3171 Bellevue Ave.
Detroit, Mich. 48207

177. Forrest Mfg. Co.
231 Rt. 17
Rutherford, N. J. 07070

178. Foseco
20200 Sheldon Rd.
Cleveland, Ohio 44135

179. Foundry Service and Supply Co.
1505 Greenwood Rd.
Baltimore, Maryland 21208

180. Freeman Supply Co.
4125 W. Fullerton Ave.
Chicago, Ill. 60639

181. Freeman Supply Co.
1152 E. Broadway
Toledo, Ohio 43605

182. Fulton Metallurgical Products Corp.
4710 Ellsworth Ave.
Pittsburgh, Pa. 15213

183. Functional Products Div.
Playtime Products Inc.
442 N. Detroit St.
Warsaw, Indiana

184. Gardner-Denver Co.
Quincy, Ill.

185. Gehnrich Oven Div.
W. S. Rockwell Co.
214 Eliot St.
Fairfield, Conn. 06430

186. Geigy Chemical Corp.
Geigy Industrial Chemical Div.
Ardsley, N. Y.

187. General Controls Co.
125 Indian Ave.
Fort Washington, Pa.

188. General Electric Co.
Industrial Sales Operation
1 River Rd.
Schenectady, N. Y.

189. General Electric Co.
Nela Park
Cleveland, Ohio 44112

190. General Neon Equipment Co.
1630 W. Thompson St.
Philadelphia, Pa. 19121

191. George Fetzer
1205 17th Ave.
Columbus, Ohio 43211

192. George Gorton Machine Co.
1100 W. 13th St.
Racine, Wis.

193. Georgia Marble Co.
11 Prizor St. S. W.
Atlanta, Georgia 30303

194. Gilman Brothers Co.
100 Main St.
Gilman, Conn. 06336

195. Glas-Craft of California
9145 Glenoak Blvd.
Sun Valley, Calif. 91352

196. (The) Glidden Co.
Graphic Arts and Sign Finishes Div.
11001 Madison Ave.
Cleveland, Ohio 44102

197. Glidden-Durkee Division of S.C.M. Corp.
900 Union Commerce Bldg.
Cleveland, Ohio 44115

198. Globe Laboratories
P.O. Box 5553
Sherman Oaks, Calif.

199. Goergen-Mackwirth Engineering Co.
813 Sycamore St.
Buffalo, N. Y. 14212

200. Goldsmith Precious Metals Div.
N. L. Industries Inc.
1300 W. 59th St.
Chicago, Ill. 60636

201. Granite City Tool Co.
Barre, Vermont

202. Granite City Tool Co.
St. Cloud, Minnesota 56301

203. Great Lakes Foundry Sand Co.
1217 Francis Palms Bldg.
Detroit, Mich. 48201

204. Green Instrument Co., Inc.
295 Vassar St.
Cambridge, Mass.

205. Grieve Corporation
500 Hart Rd.
Round Lake, Ill. 60073

206. G. S. Blodgett Co. Inc.
50 Lakeside Ave.
Burlington, Vermont

207. Gulf Oil Corp.
Gulf Bldg.
Houston, Texas 77002

208. Hammond Products
217 Hammond Dr.
Stockton, Mo.

209. Hanson-Van Winkle
Division M and T Chemical Inc.
Rahway, N. J. 07065

210. Hanson-Van Winkle-Munning Co.
Matawan, N. J.

211. Harry Miller Corp.
4th and Bristol Sts.
Philadelphia, Pa. 19140

212. Hastings and Co., Inc.
2314 Market St.
Philadelphia, Pa. 19103

213. Hawkridge Bros. Co.
303 Congress St.
Boston, Mass.

214. H. C. Spinks Clay Co.
1103 First National Bank Bldg.
Cincinnati, Ohio 45202

215. Heathkit Electronic Center
35W. 45th St.
N. Y., N. Y., 10036

216. Hendrick Mfg. Corp.
11 Selman St.
Marblehead, Mass. 01945

217. Henry W. Geering Co.
2221 N. Elston Ave.
Chicago, Ill.

218. Hi-Alloy Weld Specialties, Inc.
Div. of Van Dreser and Hawkins, Inc.
Box 916
Pearland, Tx. 77581

219. Hill and Griffith Co.
Birmingham, Ala.

220. H. K. Porter Co., Inc.
Riverside-Alloy Metal Div., Inc.
Riverside, N. Y.

221. Hossfeld Mfg. Co.
Iron Bender Div.
Winona, Minn. 55987

222. Hotpack Corp.
5083-A Cottman Ave.
Philadelphia, Pa. 19135

223. Howard C. Hunt Pen Co.
7th and State Sts.
Camden, N. J.

224. H. P. Preis Engraving Machine Co.
651 U. S. Highway 22
Hillside, N. J.

225. Hudson Gas Appliances
Englewood, N. J.

226. Humble Oil and Refining Co.
Esso Region
City Line Ave. and Esso Rd.
Bala-Cynwyd, Pa.

227. Humble Oil and Refining Co.
Esso Standard
Eastern Region
P.O. Box 2180
Houston, Texas

228. Humble Oil and Refining Co.
Houston, Texas 77001

229. Humble Oil and Refining Co.
P.O. Box 120
Denver, Colorado

230. Hunt Mfg. Co.
P.O. Box 560
Camden, N. J. 08101

231. H. V. Hardman Co., Inc.
600 Cortlandt St.
Belleville, N. J. 07109

232. Hydor Therme Corp.
7155 Airport Highway
Pennsauken, N. J. 08109

233. Hydrel Mfg. Co., Inc.
9415 Telfair Ave.
Sun Valley, Calif. 91352

234. Hypressure Jenny Div.
Homestead Valve Mfg. Co.
11 Johnson St.
Coraopolis, Pa. 15108

235. Illinois-Research Laboratories
22 Madison Ave.
Chicago, Illinois 60602

236. Indiana Limestone Co.
40 E. 41st St.,
N. Y., N. Y. 10017

237. Indian Hill Stone Co.
Bloomington, Ind.

238. Industrial and Domestic Silicone Distr.
19547 Victory Blvd.
Reseda, Calif.

239. Industrial Engineering and Equipment Co.
24 Hanley Industrial Ct.
St. Louis (Brentwood), Missouri

240. Industrial Polychemical Service
17116 S. Broadway, P.O. Box 471
Gardena, Calif. 92047

241. Ingersoll-Rand Co.
11 Broadway
N. Y., N. Y. 10004

242. Insta-Foam Products, Inc.
880 S. Fiene Dr.
Addison, Ill. 60101

243. Instuments and Control Systems
P.O. Box 2025
Radnor Pt., Pa. 19089

244. Integrity Mill Ends
Oxford and Howard Sts.
Philadelphia, Pa. 19122

245. International Mineral and Chemical Corp.
5401 Old Orchard Rd.
Skokie, Ill. 60076

246. International Neon and Fluores
1042 W. Madison
Chicago, Ill. 60607

247. Interstate Electric Co.
3641 10th Ave.
Los Angeles, Calif. 90013

248. Jackson Buff Corp.
21-03 41st Ave.
Long Island City, N. Y. 11101

249. James Varley and Sons, Inc.
1200 Switzer Ave.
St. Louis, Missouri 63115

250. Jax Chemical Co., Inc.
78-11 267th St.
Floral Park, N. Y. 11004

251. Jeffrey Mfg. Co.
Div. of Jeffery Gallion, Inc.
907 N. 4th St.
Columbus, Ohio 43216

252. Johnson Gas Appliance Co.
1940 O'Donnell
Cedar Rapids, Iowa 52400

253. Kaiser Refractories and Chemicals
Refractories Div.
300 Lakeside Dr.
Oakland, Cal. 94604

254. Kamweld Products Co., Inc.
90 Access Rd.
Box 91
Norwood, Mass. 02062

255. Keller Division
Sales Service Mfg. Co.
2363 University Ave.
St. Paul, Minn. 55114

256. Ken-Nite Co.
2926 W. Hancock
Detroit, Mich. 48208

257. Kett Tool Co.
5055 Madison Rd.
Cincinnati, Ohio 45227

258. Keystone Refining Co., Inc.
4821-31 Garden St.
Philadelphia, Pa. 19137

259. Kim Lighting and Mfg. Co.
Box 1275
City of Industry, Calif. 91747

260. Kingsley Machine Co.
850 Cahuenga Blvd.
Hollywood, Calif.

261. Kirkhill Rubber Co.
300 E. Cypress St.
Brea, Calif.

262. Kish Industries Inc.
1301 Turner St.
Lansing, Mich.

263. Knape and Vogt Mfg. Co.
658 Richmond Ave.
Grand Rapids, Mich. 49504

264. Knu-Vise Products Div.
Lapeer Mfg. Co.
3056 Davison R.
Lapeer, Mich

265. Koppers Co., Inc.
Chemicals and Drystuffs Div.
Koppers Bldg.
Pittsburg, Pa. 15219

266. Krieger Color and Chemical Co.
6531 Santa Monica Blvd.
Hollywood, Calif.

267. Lafayette Radio
111 Jerico Turnpike
Syosset, N. Y. 11791

268. Lafayette Saw and Knife Co.
87 Guernsey St.
Brooklyn, N. Y.

269. La Salle Sign and Artist Supply
10225 Puritan Ave.
Detroit, Mich. 48236

270. L. D. Davis Co.
Bristol, Pa.

271. Lea Manufacturing Co.
237 E. Aurora St.
Waterbury, Connecticut 06720

272. Lemmon and Snoap
2618 Thornwood S.W.
Grand Rapids, Mich. 49509

273. Lilly Industrial Coatings
666 So. California St.
Indianapolis, Indiana 46225

274. Liteweight Products
707 Funston Rd.
Kansas City, Ks. 66115

275. L. and R. Specialties
Sherwood Rd.
Rt. 8
Box 349B
Springfield, Mo. 65840

276. Lutron Electronic Co., Inc.
Coopersburg, Pa. 18036

277. Lydon Bros., Inc.
85 Zabriskie St.
Hackensack, N. J. 07602

278. Machine and Tool Blue Book
Hitchcock Pub. Co.
Hitchcock Bldg.
Wheaton, Ill.

279. Magnuson Products, Inc.
50 Court St.
Brooklyn, N. Y.

280. Maid-Easy Cleaning Products Corp.
25 Elm Ave.
Mt. Vernon, N. Y.

281. Marblette Corp.
37-21 30th St.
Long Island City, N. Y. 11101

282. Masco Chemical Co.
58-64 John Hay Ave.
Kearny, N. J.

283. Master Appliance Corp.
Box 545
1745 Flett Ave.
Racine, Wis. 53403

284. Master Power Corp.
6225 Cochran Rd.
Solan, Ohio

285. Matchless Metal Polish Co.
726 Bloomfield Ave.
Glen Ridge, N. J. 07028

286. Matchless Metal Polishing Co.
840 W. 49th Pl.
Chicago, Ill. 60609

287. McAleer Manufacturing Corp.
101 S. Waterman Ave.
Detroit, Mich. 48217

288. McEnglevan Heat Treating and Mfg.
708 Griggs St.
Box 31
Danville, Ill. 61832

289. McEnglevan Speedy-Melt Div.
P.O. Box 31
708 Griggs St.
Danville, Ill. 61832

290. McKesson & Robbins Chemical Dept.
155 E. 44th St.
N. Y., N. Y. 10017

291. Merchandise Presentation, Inc.
2191 Third Ave.
N. Y., N. Y.

292. Merix Chemical Co.
2234 E. 75th St.
Chicago, Ill. 60649

293. Merrit Abrasive Products, Inc.
201 W. Manville
Compton, Calif. 90224

294. Metco, Inc.
1101 Prospect Ave.
Westbury, N. Y. 11590

295. (The) Meyercord Co.
5323 W. Lake St.
Chicago, Ill. 60644

296. M. Grumbacher, Inc.
460 W. 34th St.
N. Y., N. Y.

297. Microbeads Div.
Cataphote Corp.
Box 2369
Jackson, Ms. 39205

298. Micro-Beads Inc.
 2505 Albion St.
 Toledo, Ohio 43610
299. Micro-Surface Finishing Products, Inc.
 Box 249
 Burlington, Iowa 52601
300. Midwest Sculpture Products
 Box 301
 Portage, Mich. 49081
301. Midwest Sign Supply Co.
 2428 University Ave.
 St. Paul, Minnesota 55114
302. Miller, Bain, Beyer and Co., Inc.
 1025 Arch St.
 Philadelphia, Pa. 19107
303. Miller Electric Mfg. Co.
 781 Bounds St.
 Appleton, Wis. 54911
304. Miller Falls Co.
 Greenfield, Massachusetts 01301
305. Minnesota Mining and Mfg. Co.
 900 Bush Ave.
 St. Paul, Minnesota 55106
306. Mirror Bright Polish Co.
 365 N. Altadena Dr.
 Pasadena, Calif.
307. Mirror Glaze Distributors
 61 War Trophy Lane
 Media, Pa.
308. Mixing Equipment Co., Inc.
 138 Mt. Read Blvd.
 Rochester, N. Y. 14603
309. Mobile Oil Co.
 Commercial Sales Div.
 20525 Center Ridge
 Cleveland, Ohio
310. Monsanto Chemical Co.
 Springfield, Mass.
311. Monsanto Co.
 Inorganic Chemical Div.
 800 N. Lindberg Blvd.
 St. Louis, Mo. 63166
312. Montroy Supply Co.
 4165 Beverly Blvd.
 Los Angeles, Calif. 90004
313. Murex Metal and Thermit Corp.
 Box 5342
 Church St. Station
 N. Y., N. Y. 10008
314. Murphy Neon Supply Co.
 2050 W. 7th Ave.
 Denver, Colorado 80204

315. Mystik Tape
 Div. of Borden Chemical Co.
 1700 Winnetka Ave.
 Northfield, Ill. 60093
316. Nalco Chemical Co.
 Metal Industries Div.
 9165 South Harbor Ave.
 Chicago, Ill. 60617
317. Narmco Materials Div.
 Elecomputing Corp.
 Costa Mesa, Calif.
318. N. A. Strand Flexible Shaft Inc.
 601 S. Washienaw Ave.
 Chicago, Ill. 60612
319. National Chemsearch Corp.
 P.O. Box 10087
 Dallas, Texas 75207
320. National Decalomania Corp.
 236 N. 60th St.
 Philadelphia, Pa. 19139
321. National Electronic Indicator, Inc.
 P.O. Box 2365
 Fresno, California
322. National Sculpture Service
 9 East 19th St.
 N. Y., N. Y. 10003
323. National Time and Signal
 21860 Wyoming Ave.
 Oak Park, Mich.
324. Neon Accessory Co.
 1535 N. Lawndale Ave.
 Chicago, Ill. 60651
325. Neon and Fluores Supply Co.
 4145 Papin St.
 St. Louis, Missouri 63110
326. Neon Engineering, Inc.
 535 Morosgo Dr.
 P.O. Box 13761
 Station K
 Atlanta, Ga. 30324
327. Neon Engineering, Inc.
 1425 Springlawn Ave.
 Cincinnati, Ohio 45223
328. Neon Materials Co.
 2343 W. Potomac Ave.
 Chicago, Ill. 60622
329. Neon Sign Supply Co.
 3050 N. 34th St.
 Milwaukee, Wisconsin 53210
330. Neon Sign Supply Co.
 1010 W. Main St.
 Oklahoma City Oklahoma 73106
331. New England Sign Supply Co.
 19-23 Pittsburgh St.
 Boston, Mass. 02210

332. New Hermes Engraving Machine Corp.
154 W. 14th St.
N. Y., N. Y. 10011

333. Norton Coated Abrasive Division
Norton Co.
50 New Bond St.
Worcester, Mass 01606

334. Oceana Tool Mfg. Co., Inc.
4143 Glencoe Ave.
Venice, California

335. O-Cedar of Canada, Ltd.
Stratford, Ontario
Canada

336. Ohaus Scale Corp.
29 Hanover Rd.
Florham Park, N. J. 07932

337. (The) Ohio Flock-Cote Co.
5713 Euclid Ave.
Cleveland, Ohio 44103

338. Onsrud Cutter Mfg. Co.
800 E. Broadway St.
Libertyville, Ill. 60048

339. Pacific Metals Co.
3100 19th St.
San Francisco, Calif.

340. Packaging Industry Sales Corp.
Airport Rd.
Hyannis, Mass. 02601

341. Park Chemical Co.
8074 Military Ave.
Detroit, Mich. 48204

342. Parr Paint and Color Co.
Compound Div.
18400 Syracuse Ave.
Cleveland, Ohio 44110

343. Peck, Stow and Wilcox Co.,
Mill St.
Southington, Conn. 06489

344. Peerless Mineral Products Co.
Conneaut, Ohio

345. Peerless Pump Div.
FMC Corp.
Box 88114
Indianapolis, Ind. 46208

346. Peerless Roll Leaf Co., Inc.
Div. of Howe Sound Co.
4511-23 New York Ave.
Union City, N. J.

347. Permacel
U.S. Highway No. 1
New Brunswick, N. J. 08903

348. Perma-Flex Mold Co.
1919 Livingston St.
Columbus, Ohio 43209

349. Perry Equipment Corp.
1421 North 6th St.
Philadelphia, Pa. 19122

350. Peterson Supply Co.
1570 Indiana St.
San Francisco, Calif. 94107

351. Petrolite Corp.
Bareco Div.
Drawer K
6910 E. 14th St.
Tulsa, Okla. 74115

352. Pierce Roberts Rubber Co.
1450 Heath Ave.
Trenton, N. J.

353. Pioneer Neon Supply Co.
342 Marietta St. N.W.
Atlanta, Ga. 30313

354. Pioneer Neon Supply Co.
2734 Penn Ave.
Pittsburgh, Pa. 15222

355. Pioneer Supply Co.
12025 Woodrow Wilson
Detroit, Mich. 48206

356. Pittsburgh Corning Corp.
One Gateway Center
Pittsburgh, Pa. 15222

357. Pittsburgh Plate Glass Co.
Grant Bldg.
Pittsburgh, Pa. 15219

358. Plaster Supply House
5346 East St.
Country Side
Brookfield, Ill. 60513

359. Plastex, Inc.
P.O. Box 174
Charlotte, N. Carolina

360. Plastics Color
Div. of Crompton and Knowles Corp.
22 Commerce St.
Chatham, N. J. 08928

361. Plastic-Vac, Inc.
214 Dalton Ave.
Charlotte, N. Carolina 28205

362. (The) Polymer Corp.
P.O. Box 422
Reading, Pa. 19603

363. Polyproducts Corp.
13810 Nelson Ave.
Detroit, Mich. 48227

364. Porter-Cable Machine Co.
Subsidiary of Rockwell Mfg. Co.
400 N. Lexington Ave.
Pittsburg, Pa. 15208

365. Potter Bros., Inc.
Box 14
Carlstadt, N. J. 07072

366. Powermatic Division
Houdaille Industries, Inc.
Highway 55
McMinnville, Tenn. 37110

367. Power Tool Div.
Rockwell Mfg. Co.
400 N. Lexington Ave.
Pittsburgh, Pa. 15208

368. Precise Products Corp.
3715 Blue River Rd.
Racine, Wis.

369. Precision Coating Co.
Needham, Mass.

370. Presstite Div.
American-Marietta Co.
39th and Chouteau
St. Louis, Missouri 63110

371. Pre-Vest, Inc.
23420 Lakeland Blvd.
Cleveland, Ohio 44123

372. Price-Driscoll Corp.
Farmingdale, N. Y.

373. Products Research Co.
2919 Empire Ave.
Burbank, California

374. P.S.H. Industries, Inc.
3713 Grand Blvd.
Brookfield, Ill. 60513

375. Pulmosan Safety Equipment Corp.
30-46 Linden Place
Flushing, N. Y. 11354

376. Quaker City Felt Co.
1734 Ludlow St.
Philadelphia, Pa. 19103

377. Quaker Oats Co.
Chemical Div.
Merchandise Mart
Chicago, Ill. 60654

378. Radio Shack
730 Commonwealth Ave.
Boston, Mass.

379. Ram Chemicals
Div. Whittaker Chemical Corp.
210 E. Alondra Blvd.
Gardena, Calf. 90247

380. Ramco Hemp Fiber Co.
6272 W. North Ave.
Chicago, Ill. 60639

381. Ransburg Electro-Coating Corp.
Box 88220
Indianapolis, Ind. 46208

382. (The) Ransom and Randolf Co.
324 Chestnut
Toledo, Ohio 43604

383. Reece Supply Co.
2455 Irving Blvd.
Dallas, Texas 75207

384. Reece Supply Co.
102 Sampson St.
Houston, Texas 77001

385. Reece Supply Co.
714 W. Craig
San Antonio, Texas 78212

386. Regional Sign Suppliers
352 Paxton
Salt Lake City, Utah 84101

387. Reichold Chemicals, Inc.
525 N. Broadway
White Plains, N. Y. 10602

388. Ren Plastics, Inc.
5656 S. Cedar
Lansing, Mich.

389. Resin Coating Corp.
3593 N. W. 74th St.
Miami, Fla. 33147

390. Rew Sales Co.
P.O. Box 159
Moorstown, N. J.

391. Reynolds Aluminum Supply Co.
325 West Touhy Ave.
Park Ridge, Ill. 60068

392. Rezolin Inc.
1651 18th St.
Santa Monica, Calif.

393. Ridgeway Color & Chemical
75 Front St.
Ridgway, Pa. 15853

394. R. M. Hollingshead Corp.
Camden, N. J.

395. Rockwell Mfg. Co.
Power Tool Div.
662 North Lexington Ave.
Pittsburg, Pa. 15208

396. Rohm and Hass
Independence Mall West
Philadelphia, Pa. 19105

397. Rubatex
Div. of Great American Industries Inc.
Bedford, Virginia

398. Ruemlin Mfg. Co.
3860 N. Palmer St.
Milwaukee, Wis. 53212

399. Saunders, Alexander and Co.
Rt. 301
P.O. Box 265
Cold Spring-On-Hudson, N. Y. 10516

400. Schaffer Mfg. Co., Inc.
21 Schaffer Center
Pittsburg, Pa. 15202

401. Schwartz Chemical Co., Inc.
50-01 Second St.
Long Island City, N. Y. 11101

402. S. C. Johnson and Son
Racine, Wis. 53403

403. Scott Aviation Corp.
225 Erie St.
Lancaster, N. Y.

404. Sculpture Associates
101 St. Marks Place
N. Y., N. Y. 10009

405. Sculpture House
38 East 30th St.
N. Y., N. Y. 10016

406. Sculpture In Wood
127 East Branch St.
Arroyo Grande, Calif. 93420

407. Sculpture Service, Inc.
9 East 19th St.
N. Y., N. Y. 10003

408. Seeger Brass Co.
23 St. Clair St.
Toledo, Ohio 43602

409. Selectrons Ltd.
116 East 16th St.
N. Y., N. Y. 10003

410. (The) Servwell Products Co.
6541 Euclid Ave.
Cleveland, Ohio 44103

411. S. G. Metal Ind., Inc.
2nd and Riverview
Kansas City, Kans.

412. Shell Chemical Co.
Polymers Div.
One Shell Plaza
Houston, Texas 77002

413. (The) Sherwin Williams Co.
101 Prospect Ave.
Cleveland, Ohio 44101

414. Sign Control
Time-O-Matic Inc.
Danville, Ill.

415. Silicone Ind., Inc.
790 Commonwealth Ave.
Boston, Mass. 02115

416. Simonds Abrasive Co.
Tacony and Fraley Sts.
Philadelphia, Pa. 19137

417. Simond Saw and Steel
Div. Wallace Murray Corp.
Intervale Rd.
Fitchburg, Mass. 01420

418. Simoniz Co.
2100 Indiana Ave.
Chicago, Ill. 60616

419. Skil Corp.
5043 Elston Ave.
Chicago, Ill. 60630

420. Smith Granite Co.
Westerly, Rhode Island 02891

421. Smith Welding
Equipment Div. Tescom Corp.
2633 4th St.
Minneapolis, Minn. 55414

422. Smooth-On, Inc.
1000 Valley Rd.
Gillette, N. J. 07933

423. Socony Mobil Oil Co.
150 E. 42nd St.
N. Y., N. Y. 10017

424. Southern Sign Supply, Inc.
2231 N. Monroe St.
Baltimore, Maryland 21217

425. Southwest Smelting and Refining Co.
1708 Jackson St.
Box 2010
Dallas, Texas 75221

426. Special Asbestos Co.
3628 W. Pierce St.
Milwaukee, Wis. 53215

427. Sponge Products Div.
The B. F. Goodrich Co.
Shelton, Connecticut

428. Spraylat Corp.
1 Park Ave.
N. Y., N. Y. 10016

429. Spray Plating Systems, Inc.
Box 6468
Greensboro, N. C. 27405

430. Standard Ceramic Supply Co.
Box 4435
Pittsburg, Pa. 15205

431. Standard Equipment
3175 Fulton St.
Brooklyn, N. Y.

432. Standard Oil Co. of Kentucky
Louisville, Ky.

433. Standard Oil Co. of Ohio
Midland Bldg.
Cleveland, Ohio 44115

434. Stanley Power Tools
Division of the Stanley Works
77 Lake St.
New Britain, Conn. 06050

435. Starlite Industries, Inc.
58th at Market Sts.
Philadelphia, Pa. 19139

436. (The) Starret, L. S. Co.
Athol, Mass. 01331
437. Steiner-Ives
Div. of Temperature Engineering Corp.
50 Tempcor Blvd.
Riverton, N. J.
438. (The) Stelhorn Co.
300 S. Summit St.
Toledo, Ohio 43602
439. Studio Supply Co.
23 Judge St.
Broklyn, N. Y.
440. Sun Oil Co.
1608 Walnut St.
Philadelphia, Pa. 19103
441. Surefire Products Corp.
6445 Bandini Blvd.
Los Angeles, Calif. 90022
442. Swift and Co.
Adhesive Products Dept.
115 W. Jackson Blvd.
Chicago, Ill. 60614
443. (The) Tap Cartridge Co.
326 Railroad Ave.
Cincinnati, Ohio 45217
444. Terminal Electric Co.
1011 Washington Ave.
Minneapolis, Minnesota 55415
445. Thermatron
Div. of Willcox and Gibbs, Inc.
60 Spence St.
Bayshore, N. Y. 11708
446. 3M Company
3M Center
St. Paul, Minn. 55101
447. Time-O-Matic
1106 Bahl St.
Danville, Ill.
448. Tompkins Kiel
35-08 Vernon Blvd.
Long Island City, N. Y. 11106
449. Trani Marble and Tile Works
437 E. 23rd St.
N. Y., N. Y. 10010
450. Tremco Mfg. Co.
10701 Shaker Blvd.
Cleveland, Ohio 44140
451. Trent Inc.
201-299 Leverington Ave.
Philadelphia, Pa. 19127
452. Trow and Holden Co.
Barre, Vermont
453. Tuscora Foundry Sand Co.
Canal Fulton, Ohio

454. Union Carbide Corp.
Chemicals and Plastics
270 Park Ave.
N. Y., N. Y. 10017
455. Unit Chemical Corp.
4161 Redwood Ave.
Los Angeles, Calif. 90066
456. United Cutter Mfg. Co.
P.O. Box 161
Montville, N. J. 07045
457. United Laboratories Co.
801 E. Linden Ave.
Linden, N. J. 07036
458. United States Radium Corp.
P.O. Box 246
Morristown, N. J.
459. United States Steel Corp.
525 William Penn Place
Pittsburg, Pa. 15230
460. U.S. Bronze Powder, Inc.
Rt. 202
Flemington, N. J. 08822
461. Used Equipment Directory
Main Office
70 Sip Ave.
Jersey City, N. J. 07306
462. U.S. Gypsum Co.
101 S. Wacker Dr.
Chicago, Ill. 60606
463. U.S. Industrial Tool and Supply Co.
13541 Auburn
Detroit, Mich.
464. USM Corp.
140 Federal St.
Boston, Mass. 02107
465. U.S. Paint, Lacquer and Chemical Co.
Subsidiary of Grow Chemical Co.
Singleton at 21st St.
St. Louis, Missouri 63103
466. U.S. Rubber Co.
1230 Avenue of the Americas
N. Y., N. Y.
467. Utility Chemical Co.
145 Peel St.
Paterson, N. J.
468. Utrech Linen
3303 5th St.
Brooklyn, N. Y.
469. Vermarco Supply Co.
3321 Prospect Ave.
Cleveland, Ohio 44115
470. Vermont Marble Co.
101 Park Ave.
N. Y., N. Y. 10017

471. Vermont Marble Co.
Proctor, Vermont, 05765

472. Walker Jamar Co.
365 South First Ave. East
Duluth, Minn.

473. Warwick Industrial Furnace and Engineering
Corp.
452 W. Chicago Ave.
Chicago, Ill. 60610

474. Wedron Silica Div.
Del Monte Properties Div.
400 W. Higgins Rd.
Park Ridge, In. 60068

475. West Chemical Products Inc.
West Disinfecting Div.
42-46 West St.
Long Island City, N. Y.

476. Western Reserve Laboratories, Inc.
1438 St. Clair Ave.
Cleveland, Ohio 44114

477. Whitehead Metal Products Co.
303 W. 10th St.
N. Y., N. Y.

478. Whiting Corp.
Harvey, Ill.

479. Wiegand, Edwin L.
Div. Emerson Electric Co.
7500 Thomas Blvd.
Pittsburg, Pa. 15208

480. Wilco Co.
4425 Bandini Blvd.
Los Angeles, Calif. 90023

481. Willson Products Div.
Ray-O-Vac Co.
Div. of Electric Storage Battery Co.
Reading, Pa.

482. Wilson Products Div.
ESB Incorporated
Box 622
Reading, Pa. 19603

483. Wm. Dixon, Inc.
34-42 Inney St.
Newark, N. J.

484. Wolverine Foundry Supply Co.
14325 Wyoming Ave.
Detroit, Mich. 48238

485. (The) Woodshed
105½ St. Marks Place
N. Y., N. Y. 10009

486. Wood Carvers Supply Co.
3112 W. 28th St.
Minneapolis, Minn. 55416

487. Woodcraft Supply Corp.
313 Montvale Ave.
Woburn, Mass. 01801

488. Worner Electronic Devices
Dept. T.
Rankin, Ill.

489. Worrell-Consolidated Laboratories Inc.
1470 S. Vandeventer Ave.
St. Louis, Missouri 63110

490. Worthington Corp.
401 Worthington Ave.
Harrison, N. J.

491. W. W. Graingers Inc.
Gen. Offices
5959 Howard St.
Chicago, Ill. 60648

492. Wyandotte Paint Products Co.
P.O. Box 255
Norcross, Ga. 30071

493. (The) Wyco Tool Co.
223 N. California Ave.
Chicago, Ill. 60612

494. X-Acto, Inc.
48-41 Van Dam St.
Long Island, N. Y. 11101

495. Zanesville Stoneware Co.
Zanesville, Ohio

496. Local paint stores
497. Local hardware stores
498. Local auto parts houses
499. Local builders' supply
500. Local marine supply
501. Local drug stores

Index